NORTH ITALIAN PAINTING OF THE QUATTROCENTO

NORTH ITALIAN PAINTING OF THE QUATTROCENTO

EMILIA

by

ADOLFO VENTURI

HACKER ART BOOKS
NEW YORK
1974

Originally published in two volumes

First published 1931 in Florence
by Pantheon

Reissued 1974 by
Hacker Art Books, Inc.
New York, New York 10019

Library of Congress
Catalogue Card Number 73-79045

ISBN 0-87817-134-7

Printed in the
United States of America

CONTENTS

LIST OF PLATES

SYNOPSIS

I

Berlin, the Christ between two Angels in the Museum at Pesaro. ⚊ His masterpiece: the head of St. John the Baptist in the same museum. ⚊ Traces of the art of Giambellino in the last-named picture and in the St. Jerome in the Pinacoteca at Bologna. ⚊ Two wings of a polyptych by Marco Zoppo in the National Galleries of Dublin and Edinburgh. ⚊ One of his greatest works: the St. Paul in the Ashmolean Museum at Oxford. ⚊ The leader of the Ferrarese school of Renaissance painting: COSMÈ TURA. ⚊ The influence of German Late Gothic and of the Tuscan Renaissance in his earliest known work, the Allegory of Spring, formerly in the Layard collection. ⚊ Comparison between the latter picture and MICHELE PANNONIO's Spring in the Gallery at Budapest. ⚊ Paduan features in the Annunciation in Ferrara Cathedral, in the Berlin altar-piece and in the Pietà in the Museum at Vienna. ⚊ The individuality of Cosmè asserts itself more and more in the incisive, broken and twisted outlines and in the splendour of the metallic tints. ⚊ Reminiscences of Mantegna in the Saints in the wing of the Roverella altar-piece, now in Palazzo Colonna at Rome. ⚊ Insertion of northern decoration, complicated and capricious, amidst the Renaissance architectural forms in the centre portion of the Roverella altar-piece, now in London, and the types of Cosmesque beauty, delicate and at the same time animated, in the Angel Musicians. ⚊ The lunette from the Roverella altar-piece now in the Louvre. ⚊ Tondi belonging to this period, in which Cosmè was creating types of ideal gentleness: the Adoration in the Fogg Museum, Cambridge (U. S. A.), the Flight into Egypt, formerly in the Benson collection in London, and the Circumcision in the Gardner collection at Boston. ⚊ The figures of St. Peter and St. John in the Johnson collection at Philadelphia, probably fragments from the same altar-piece to which belong the three tondi. ⚊ Two gems of Cosmesque colouring: the small damaged altar-pieces in the Accademia at Venice and in the Pratt collection at New York. ⚊ After this period, during which a breath of lyric gentleness seems to have pervaded his tempestuous art, Cosmè's style becomes more and more violent and crude in the figures of St. Christopher and St. Sebastian (Kaiser Friedrich Museum, Berlin), of St. Francis (Louvre), of St. Dominic (Uffizi), probably parts of a polyptych, the centre panel of which was the Madonna in the Accademia Carrara at Bergamo, and in the St. Jerome and the Annunciation in the National Gallery in London. ⚊ Paintings by Cosmè and his followers in Palazzo Schifanoia at Ferrara. ⚊ Three anonymous followers of Cosmè: the author of a Madonna in the Pinacoteca at Bologna and of paintings in Sant'Antonio in Polesine and at Nonantola; the author of the Charity in the Museo Poldi-Pezzoli at Milan; and the painter of the figures of St. Louis and St. Bernardino in the Pinacoteca at Ferrara. ⚊ The second Master of the great Ferrarese triad: FRANCESCO DEL COSSA. ⚊ Echoes of the art of Mantegna in his first work: the statuesque St. Jerome in the Pinacoteca at Ferrara. ⚊ Reminiscences of Piero della Fran-

cesca and of Cosmè in the little panels of St. Lucy and St. Liberale formerly in the Spiridon collection, and in the Lehman Crucifixion at New York. ⸗ Further approach to the art of Cosmè in the frescoes in Palazzo Schifanoia and in the triptych of the Life of St. Vincent Ferrer, now divided between the National Gallery, London, the Brera and the Vatican. ⸗ For Cosmè's colouring, which seems to emanate from incan⸗ descent metals, Cossa substitutes his luminous enamel⸗like colour⸗schemes. ⸗ Examples of Cossa's painting on glass in the church of San Giovanni in Monte at Bologna, in the Museum of Industrial Art at Berlin, and in the Musée André at Paris. ⸗ His return to calmer outlines and to more balanced poses; the statuesque figures in the Annuncia⸗ tion at Dresden, in the midst of a fantastic decoration of marbles and enamels. ⸗ The less brilliant colouring and the stronger chiaroscuro in the Virgin with St. Petronio and St. John the Evangelist in the Pinacoteca at Bologna, one of his last works, in which the figures seem modelled by a sculptor of the crude and realistic Emilian school.

A follower of Francesco del Cossa's early forms: the Cremonese ANTONIO CICOGNARA, author of a little altar⸗piece in the Cologna collection at Milan, and of two wings of a triptych in the National Gallery at Edinburgh. ⸗ Followers of Cossa during his Bolo⸗ gnese period: the painter of the Dreyfuss diptych, with figures of Giovanni Bentivoglio and his wife, and the author of an altar⸗piece in tempera in San Giovanni in Monte at Bologna. ⸗ Another follower of Francesco del Cossa: LEONARDO SCALETTI.

The art of the Modenese brothers, AGNOLO and BARTOLOMEO DEGLI ERRI, who col⸗ laborated in the triptych of the Galleria Estense; their derivation from Mantegna, and their affinity to Cosmè Tura and Francesco del Cossa. ⸗ Works by AGNOLO DEGLI ERRI in the Museo Civico at Padua, in the Brera at Milan, and in the Este Museum in Vienna. ⸗ Works by BARTOLOMEO DEGLI ERRI in the gallery at Strasburg and in the Museo Civico at Modena.

The third Master of the great Ferrarese triad: ERCOLE DE' ROBERTI, a faithful follower of Francesco del Cossa in his early works: the St. Catherine and St. Jerome formerly in the Benson collection, and the Madonna in the Edinburgh National Gallery. ⸗ The characteristics of Ercole's own style assert themselves in the Madonna adoring the Child of the Kaiser Friedrich Museum in Berlin. ⸗ Manifestation of Ercole's aristocratic per⸗ sonality in the Brera altar⸗piece. ⸗ The little picture of the Argonauts in the gallery at Padua, and the St. John the Baptist in the Berlin gallery. ⸗ The drawings preserved of Ercole's frescoes in the Garganelli chapel. ⸗ Romantic tendency in the altar⸗piece for⸗ merly in San Giovanni in Monte at Bologna, and now divided between Dresden and the Roscoe Museum at Liverpool. ⸗ Ercole's approach to Giambellino's gentle humane spirit in the St. John the Evangelist in the Accademia Carrara at Bergamo. ⸗ Works of his followers: Medea and her children, in the Richmond Gallery, probably painted by

3

GIAN FRANCESCO DE' MAINERI; the Strozzi altar-piece in the National Gallery, London; the St. John the Evangelist in the museum at Budapest; the Blumenstihl Pietà and the Deposition from the Santini collection at Ferrara. ⁄ The illuminator GIAN FRANCESCO DE' MAINERI; subjects repeated by him with slight variations: The Holy Family in the Testa collection at Ferrara, in the Kaiser Friedrich Museum at Berlin, in the Prado at Madrid and in the museum of Gotha; Christ carrying the Cross in the Galleria Estense at Modena, the Galleria Doria at Rome, the Uffizi at Florence, in Casa Mazzocchi at Rome and in Casa Donesmondi at Mantua. ⁄ Reminiscences of Venetian art in the Flagellation at Richmond and the Madonna in the Accademia Albertina at Turin. The works in which he is most akin to Ercole: the Birth of St. Dominic in the gallery at Vicenza, and above all, the diptych in London. ⁄ LUDOVICO MAZZOLINO follows Ercole in his early picture, the Pietà at Cassel, the romantic element in which is drawn from the great master's work. ⁄ Influence of German art in his popular and joyful works. ⁄ A mediocre imitator of Ercole: the Ferrarese MICHELE COLTELLINI. ⁄ Traces of Ercole's forms in the first works of DOMENICO PANETTI. ⁄ His influence on the Modenese paintings of FRANCESCO BIANCHI FERRARI, who in his first work, the Crucifixion in the Galleria Estense, seems to apply his colour with the diligence of a miniaturist decorating the page of a missal; he shows himself in all his works to be a gentle and pious painter, delicate in his colouring and studious of every particular in the drawing of his figures. ⁄ A collaborator of Bianchi Ferrari in the Annunciation of the Modena Gallery: ANTONIO SCACCERI and his Christ in the Sepulchre in the same gallery. ⁄ Masters of Reggio Emilia who come within the orbit of Ferrarese painting: the painter of a little chest in the museum at Reggio, an imitator of Tura; FRANCESCO CAPRIOLI, a follower of Ercole. ⁄ Painting in Bologna: FRANCESCO FRANCIA, a follower of Ercole in his earlier works: the Crucifixion in the Museo Civico at Bologna, the Nativity in the Corporation Gallery at Glasgow, the Martyrdom of St. Stephen in the Galleria Borghese at Rome, the Madonna with Angels in the Alte Pinakothek at Munich, the Baptism in the possession of Messrs. Cassirer at Berlin. ⁄ The Venetian influence combined with that of Ercole is found in such works as the Holy Family in the Kaiser Friedrich Museum at Berlin, the Auspitz portrait, the Christ supported by two angels in the Pinacoteca at Bologna, and the altar-piece in San Giacomo Maggiore at Bologna. ⁄ The altar-piece in the Hermitage at Leningrad. ⁄ Influence of Perugino in the Assumption of the Kaiser Friedrich Museum at Berlin, in the Portrait of Evangelista Scappi and the St. Sebastian at Hampton Court. ⁄ Elongation of the forms in the frescoes in the oratory of Santa Cecilia at Bologna, in the Madonna of the Rosebushes at Munich, in the Deposition in the Pinacoteca at Parma and in other works of this period. ⁄ The Master's last paintings.

4

Anonymous followers and imitators of Francia. ⁄ IACOPO BOATERI. ⁄ SIMONE DE’ MARTINAZZI, called DELLE SPADE. ⁄ GIACOMO and GIULIO FRANCIA. ⁄ Francia’s greatest disciple: TIMOTEO DELLA VITE. ⁄ The Brera Trinity. ⁄ The Apollo and the Muse Thalia in the Corsini Gallery at Florence. ⁄ Timoteo’s masterpieces: his paintings on glass and maiolica. ⁄ Diminishing influence of Francia as shown in the Brera Annunciation. ⁄ His approach to Perugino in the altar-piece in Urbino Cathedral. ⁄ His return to his early forms in the Cagli Magdalen. ⁄ His adherence to Quattrocento forms till well on into the sixteenth century, and the inspiration drawn from Raphael in the Noli me tangere in the Confraternita di San Michele at Cagli. ⁄ The prophets in the church of Santa Maria della Pace at Rome are probably by another hand.

LORENZO COSTA of Ferrara a follower of Cosmè Tura in his first work, the St. Sebastian in the Gemäldegalerie at Dresden, and in the Portrait of a Musician in the Dublin National Gallery. ⁄ Attribution to Costa of an altar-piece depicting the Virgin with four Saints in the Berlin Gallery. ⁄ First approach to Ercole de’ Roberti in the Bentivoglio altar-piece at Bologna and in the large canvases showing the Triumphs of Fame and Death. ⁄ Greater breadth of form and plastic relief in the Portrait of Giovanni II Bentivoglio and in the St. Sebastian of the Cassoli collection at Reggio Emilia. ⁄ Appearance of Venetian elements, especially of the art of Antonello, in the two last-named works, in the San Petronio altar-piece at Bologna and in the Portrait of a Youth in Berlin. ⁄ Approach to Francia in the subsequent works: the Virgin adoring the Child in the Lyons gallery, the altar-piece in San Giovanni in Monte at Bologna, and the Christ in the Sepulchre formerly in the Benson collection. ⁄ Development of his later manner in the slender forms and monotonous regularity of line in the Adoration of the Magi at the Brera. ⁄ Similar characteristics to be found in a whole series of Costa’s paintings: the Circumcision and the Deposition in the Kaiser Friedrich Museum at Berlin, the Ascension in San Nicola in Carcere at Rome, the Holy Family in the National Gallery at Dublin, the picture in the museum at Orleans, and the allegory painted for the study of Isabella d’Este and now in the Louvre. ⁄ Series of portraits by Costa in the museum at Lille, at Hampton Court, and in the Mumm von Schwarzenstein collection at Frankfort. ⁄ Costa’s last works: The Assumption in San Martino Maggiore at Bologna, the St. Anna in the Brivio collection at Milan, the picture representing the Reign of the god Comus in the Louvre, the Apotheosis of Federico Gonzaga, now in the castle of Prince Clary Aldringen at Teplitz.

An anonymous Ferrarese follower of Costa: the painter of the Magdalen in the Pinacoteca at Ferrara. ⁄ Other works by the same master. ⁄ A follower of Francia and Costa: CESARE TAMAROCCIO, their collaborator in the oratory of Santa Cecilia at Bologna. ⁄ Another collaborator of the two masters in the oratory of Santa Cecilia: the eclectic

Amico Aspertini and his bizarre compositions. ⁄ A faithful disciple of Costa: Giovan Maria Chiodarolo, who also painted in the oratory of Santa Cecilia. ⁄ Iacopo Ripanda, like Amico Aspertini, an eclectic artist. ⁄ Antonio Pirri, a follower of Costa. ⁄ Pellegrino Aretusi, called Munari, of Modena, related to Bianchi Ferrari in his early works. ⁄ Araldi, a follower of Costa. ⁄ The Cotignola painters, Bernardino and Francesco Zaganelli and Girolamo Marchesi, eclectic painters who display the influence of Costa in their early works. ⁄ Lazzaro Grimaldi, of Reggio Emilia, who copies the types of Costa and Bianchi Ferrari. ⁄ Reminiscences of Costa in the fresco of St. Sebastian by an anonymous painter in San Petronio at Bologna. ⁄ Another picture by the same painter in the André collection at Paris. Influences of the art of other regions brought to Emilia by a group of masters: reminiscences of Lombard art in the Death of the Virgin by Baldassare d'Este, in the same painter's portrait in the Cook collection at Richmond, and in the decoration of the sacristy of San Giovanni at Parma, painted by Cesare Cesariano, a disciple of Donato Bramante. ⁄ Traces of Venetian art in the pictures of Filippo Mazzola and in those of Bernardino Loschi, of Parma, and of Giovanni del Sega, of Forlì, who collaborated in the decoration of Alberto Pio's castle at Carpi. ⁄ A Lombard master who follows first Ercole de' Roberti and then the Venetian school: the Cremonese Boccaccio Boccaccino. ⁄ A Ferrarese follower of Boccaccino: Benvenuto Tisi, called Garofalo. ⁄ Romagnol masters who followed the Venetian school: Lattanzio da Rimini and Niccolò Rondinello of Ravenna. ⁄ Influence of Umbrian art on Emilian painting, especially on Marco Meloni of Carpi, an imitator of Perugino. ⁄ Giovanni Battista Bertucci, a master who combines the forms of Francia with those of Perugino. ⁄ A masterpiece of Emilian art from the decadent period at the end of the Quattrocento: the pictorial decoration in Palazzo Costabili at Ferrara.

THE GOTHIC TRADITION IN EMILIA DURING THE FIRST HALF OF THE FIFTEENTH CENTURY

I N THE first decades of the fifteenth century, the Gothic tradition which had come from Venetia to Ferrara still pervaded the whole of Emilian art. The influence of Ferrara, in its turn, strengthened that of Venice throughout the towns subject to the Estes, such as Modena and Reggio, and passed beyond to Bologna and Romagna, where other examples of Venetian art arrived directly from the shores of the Adriatic. The Venetian tradition also reached Mantua, which was afterwards to open its doors to the architects Alberti and Luciano Laurana, and to the all-powerful painter Mantegna. From Mantua it spread to Parma.

There is hardly any trace of fourteenth-century painting extant at Ferrara, and the documentary records referring to it are by no means trustworthy. One may suppose, however, that a reflection of Byzantine art passed from Venice to Ferrara and that within the walls of that town there were, as in the cities of the lagoon, the so-called "madonneri" who turned out compositions time after time without variation for pictures representing the Almighty, the Virgin, or Saints. A Ferrarese painter called Gelasio, who was active towards the middle of the thirteenth century, had learned his art in Venice under Maestro Teofano of Constantinople.[1] Another master, Giorgio del *quondam* Salvatore, also of Constantinople, was living in Ferrara at the beginning of the fifteenth century.[2] This reflection of oriental art in Ferrara is easily explained if we remember the relations between Ferrara and Venice, which had been very close ever since the time of the Countess Matilda. A Venetian governor exercised privileged jurisdiction at Ferrara. The Estes frequently visited the Queen of the Adriatic, sometimes followed by bands of knights and pages to joust in the Piazza San Marco, sometimes furrowing the Grand Canal with their galleys to take part in some celebration of the Carnival. Servants of these princes went to Venice continually to buy glass or spices, perfumes or goods from the East, and the painters did likewise to provide themselves with ultramarine or with varnishes.

Besides the artists who drew their inspiration from Greek sources, there were naturally others who sprang from the native Italian tradition. It may be called to mind that, according to tradition, Giotto was once at Ferrara to work in the Augustinian church of Sant'Andrea and in the Palazzo Estense, and that after the great master, his disciple Ottaviano da Faenza painted frescoes there. In his work in the church of San Giorgio, belonging to the Olivetan monks,[3] he proved himself, according to Vasari, "a very able painter". To Ferrara[4] there

came also certain fresco-painters who had accompanied Giovanni Baronzio from the Marches, and who, after having left examples of their work in the Palazzo del Paradiso at Ferrara, passed on to Rimini and Ravenna and thence to Collalto near Treviso. From Modena came Serafino de' Serafini to paint in the church of San Domenico (1373), and a certain Iacopo, a Bolognese, perhaps to be identified with Iacopo di Paolo, who in 1419, according to the account of a chronicler,[5] was cured of a terrible "disease in the mouth" by a miracle wrought by St. Maurelio, the patron saint of Ferrara. A contemporary of Giusto, Altichiero and Avanzo, and perhaps a collaborator with Miretto in the decoration of the Salone del Podestà at Padua, was Stefano da Ferrara, praised by Michele Savonarola (1440)[6] for the old paintings of the miracles of St. Anthony in the church of this saint.

DURING the lordship of Niccolò III of Este (1393-1441), and especially in the last years of this period, the arts flourished at Ferrara. In the opening period of his rule we find the Fraternity of the Battuti Neri burying the bodies of those who fell in the civil struggles in the neighbourhood of Ferrara, while villas were burnt and destroyed, rebels were tortured in the streets, reprisals taken against the neighbouring cities; and Terzi, tyrant of Reggio, was treacherously assassinated. But after these tragedies, and that of Hugo and Parisina, put to death in the dungeons of the Castello Estense while faithless wives were being dragged out into the squares of Ferrara to pay for their sin with the penalty of death, Niccolò III seemed to modify his fierce character, almost as if his son Lionello had had a softening effect upon him. He was wise enough to choose as Lionello's master the Veronese Guarino, the "missionary of the Greek and Latin religion",[7] and to be "liberal and courteous" to him, admiring "his great merits and virtues, the fidelity and devotion he bore, the love and charity he showed."[8] Lionello, who came back instructed in the use of arms by Braccio da Montone, brought to the Estensian castle the Sienese gentleness of his mother and the vigour of Lombardy. Guarino educated him, and taught him to prefer the Muses to Mars, and the writings of Socrates, Caesar and Dante to arms. The Renaissance soon beat at the gates of Ferrara, which in 1436 called Brunellesco within its walls, and gave a spirited welcome to Leon Battista Alberti, afterwards judge and arbiter in the competition for the erection of the equestrian monument to Niccolò III. Iacopo della Quercia worked for the cathedral of Ferrara, and admired his fellow-citizen Giovanni da Siena, who was in the service of the Marquis of Ferrara, of whom Iacopo speaks in these words: "he builds him a great strong castle within the city, and gives him 300 ducats a year... and this man is not a painter with a trowel in his hand, but an architect and an engineer."[9] And if the archi-

8

tects and sculptors constructed the triumphal arch of the Renaissance, it was the painters of Flanders, Spain and Italy who adorned it with the loveliest colours. All the great masters, from Pisanello to Iacopo Bellini, from Piero della Francesca to Angelo Parrasio of Siena, from the Lendinara brothers to Mantegna, from Rogier Van der Weyden to Alfonso of Spain, meet in the study of Lionello and create a new art, using Ferrara as a great centre for the spread of painting throughout Emilia.

During the reign of Niccolò III the foremost Ferrarese painter was Antonio Alberti, who had been working for Braccio da Montone at Perugia when Lionello d'Este went there to fight under that condottiero. Braccio had had the fortress of Montone built by Fieravante Fieravanti[10] and frescoed by Alberti in the years 1423 and 1424. While the latter was painting at Montone at the cost of the Commune of Perugia, he broke off his work to return in 1423 to Urbino, where he had already lived before that year, and where he worked from 1424 onwards, decorating, in 1430, the "Cappelle dei Signori" in San Francesco. The polyptych (No. 114) with the date 1439 in the centre panel, and a panel (No. 24) which represents a female martyr, and a banner, are still preserved at Urbino and are now to be seen in the Ducal Palace. In 1437, by the order of the Bishop, Giovanni Sclani,[11] he had painted the still extant Oratory at Talamello in Montefeltro. On the vault we see the four Doctors; in the centre lunette the Annunciation, while there is a Purification in the lunette on the left, and an Adoration of the Shepherds in that on the right. Beneath the central lunette are figures spoilt by attempts at restoration. On the side walls, below the main pictures, are male and female saints. The summary quality of the painting, with draperies falling in pointed folds, swollen faces and convex foreheads, with light and rose-coloured tints, belongs to the Late Gothic style, not without Venetian influence, but the author is celebrated more for the rarity of a Ferrarese painter's rising to fame in the first half of the fifteenth century than for any real excellence in his art.

In 1438, at Urbino, Antonio Alberti was painting the banner already alluded to, now in the Ducal Palace, for the Fraternity of Sant'Antonio Abate, and in the same year he perhaps returned to Ferrara to portray some incidents of the Church Council then being held in his native city. In September 1439 he was again at Urbino and completed for the Padri Zoccolanti the polyptych, also mentioned above, bearing the inscription: *1439. Antonius de ferraria p.* He died after 1464, leaving two children, Traiano and Calliope, the latter of whom became the mother of Timoteo della Vite.[12] The figures of Antonio Alberti have little movement; the draperies stuff them out, giving them a padded effect. They seem to cleave to their axis as if they could not detach themselves without effort from their central pivots, and they all stand separate and parallel, like puppets strung on vertical wires. The

costumes are contemporary, and it is only in the folds which twist and curve, and in the pointed and triangular lappets, that we see the so-called international painting of the first half of the fifteenth century.

WHILE this painter was working at Urbino, at the Estensian Court of Ferrara three other painters were requested by Parisina, before 1430, to give their services. One of these was Giovanni della Gabella, who painted a marriage-chest for the daughter of Iacopo, called Zoesio (afterwards Parisina's betrayer), and also frescoed a chapel in San Francesco, the church near which, a few years later, Parisina was buried with her stepson Hugo. Together with his name are recorded those of Giacomo da Bologna (perhaps Giacomo Ursini, who painted a banner in 1418) and of Andrea da Vicenza, who served the Estes for many years, and executed, in 1424, a votive offering for Parisina.[13]

The artistic impulse represented by Antonio Alberti of Ferrara is also exemplified in the frescoes by an anonymous master in the chapel of St. Catherine in the pilgrimage church of Carpi. At the back, on the altar, is the Mystic Marriage; in the lunette above, the Condemnation of the Saint, and the Saint at the Stake; on the walls, the Disputation of St. Catherine, the Conversion of the Empress, the Beheading of the Empress, and the Death and Burial of the Saint; above the entrance arch is the Annunciation. These pictures also have a northern Venetian touch in the ample folds of the robes and in the angular lines of the little heads and of the sharp features.[14] The Gothic element is shown by the tall tapering figures, and the long oval folds of the draperies, that fall in characteristic sweeping curves. The impression left by these figures is one of northern sombreness. Nevertheless, the anonymous painter is more noteworthy, for the energy of his drawing, than the clumsy Alberti.

In the first decades of the fifteenth century, while the chapel of St. Catherine was being frescoed, there was living at Bologna Giovanni da Modena, a painter much esteemed by Giovanni Alcherio, who, on the 13th of February 1410, copied from a book lent to him by that master certain instructions concerning the art of painting. In 1420 he was asked to portray some stories from the Old and New Testaments in the chapel of San Giorgio, now that of Sant'Abbondio,[15] in the cathedral.

The Bolognini Chapel in San Petronio was also attributed to him, but it is probably the work of the Bolognese Iacopo di Paolo, an antiquated painter still affecting the lank gaunt forms of the fourteenth century. The compositions all stand out with clear-cut contours, on a background of deep blue; the flesh has deep shadows produced after the Byzantine method, as if by searing the wood with a red-hot iron; the figures are lean, wiry and ta-

pering, with energetic countenances, flowing robes, exaggerated movements and pointing index fingers. The buildings in the background are white or pink, with cornices painted red or green; the mountains are cut like trunks of old chestnuts, and dotted over with a few little trees; even a squirrel is to be seen. The painter does not show himself responsive to the new art, except in a few details, as for example in the picture of the Magi seated in a boat on the sea, at the mercy of the tempest; on the shore are some sailors, one of them bent and seen from behind with some attempt at foreshortening.

Another master, Giovanni da Bologna, "a slavish imitator of Lorenzo Veneziano",[16] like Iacopo di Paolo, the probable painter of the Bolognini chapel, keeps, like him, in line with the older style of Venetian art.

Better than all these, Michele di Matteo, another Bolognese (not to be confused with his namesake who has left us pictures of figures with staring eyes and grim distorted faces in the gallery at Bologna), proves himself a direct follower of Gentile da Fabriano. He is known by only one painting, in the Accademia at Venice. In it this elegant, refined master, *Plate 1* lavish of embroidered robes, gold fringes and borders charactered in letters like old Arabic, keeps close to Gentile's Quaratesi picture, while in the small predella he adopts the ornate, somewhat garrulous style of his master, with a great wealth of costume, profusion of ornament, and an artificial Gothicism.

Another master belonging to the Late Gothic tradition, not inspired, like Michele Mattei, by Gentile da Fabriano, but by the northern forms which had been growing up in Central Europe, was the painter of a little panel from the Certosa of Ferrara, ordered as a votive offering during the episcopate of Pietro Boiardi (1400-1431) and presented to the *Plate 2* Virgin by the donor, a certain Pietro Lardi, who is seen kneeling before the Virgin, attended by his patron saint, Maurelio. In this work the Late Gothic style acquires an Italian strength, and comes closer to life. The garments are still ornate, and fall in curving folds, but the decoration does not interfere with the constructional scheme, while by arranging the figures of the Virgin and of San Maurelio placed three-quarters-face the painter obtains an effect of depth, and with it the necessary space for the figure of the kneeling donor.[17]

This little picture has a great affinity with certain pictures at Parma, particularly with the fragments discovered on the walls of the cathedral apse, where there is a Madonna which can be considered, like the *Ex-voto* of Pietro Lardi, as one of the finest flowers of fifteenth-century Gothic in Emilia. At Parma there are frequent examples of painting in Late Gothic style from the beginning of the fifteenth century, including the frescoes of the Rusconi Chapel in the cathedral crypt, which show an affinity with Venetian art, especially in the trite Gothic decoration, with its flanking pillars. Here we find the Madonna enthroned,

and on either side John the Baptist and St. John the Evangelist, the latter leading the Bishop-patron of the chapel. All this is contained within a large lunette, framed by the heads and shoulders of child angels in the dress of the period. Before the throne is a meadow with a rabbit. The movements of the figures are archaic and the garments Gothic, while the saints' eyes have a fixed look; the brushwork shows a certain facility, especially in the delineation of the cheek-bones.

The Rusconi frescoes were used as models for those of the Ravacaldi Chapel (also in the cathedral crypt), with incidents from the life of the Virgin and the childhood of Christ, and also for the paintings in the Valeri-Baganzola and Municipal side-chapels. Here, however, this art has become more popular and Bartolino Grossi is badly imitated by his son-in-law and follower, Iacopo Loschi. The chapel of the Valeri must have been frescoed by Loschi, who on March 7th 1459 appears in the Baptismal Register of the Parma Baptistery as godfather to a daughter of Iacopo Valeri, a nephew of Cristoforo, the founder of the chapel. The work was begun about the year 1460 by order of Count Cristoforo, and continued and completed by his son Andrea, who was invested by Filippo Maria Visconti with the fief of Baganzola. That the frescoes were painted but a short time after 1460 is indicated by the dates scratched on other frescoes of the cathedral of Parma, bearing an obvious resemblance to them and to those in the two chapels, namely, the frescoes in the chapel of the crypt under the high altar, called of the Ravacaldi and of the Canons, showing incidents from the life of the Virgin. The earliest date we find is MCCCCLX. Apart from the Ravacaldi, Valeri and Municipal Chapels, painted by Bartolino Grossi and his co-operators and followers (chief of whom was Iacopo Loschi), one may easily recognize the style of this once aristocratic and now plebeian art in many works, such as: a series of small panels in the gallery at Parma, attributed to Andrea Campana; an *ex-voto* in San Girolamo, in the Oratory built by the Valeri; two panels in the Parma gallery (Nos. 53 and 55); the frescoes of the Carmine, with stories of the Life of the Virgin; the small maiolica plaques of the Archaeological Museum;[18] an *ex-voto* in the third apse to the right in the Baptistery of Parma; and finally in a Madonna suckling the Child on the first pillar to the right in the cathedral at Busseto.[19] One finds other examples of the work of these popular image-makers scattered in various galleries. Thus, in the Estensian Gallery at Modena there is the story of San Giovanni Boccadoro painted on the front of a chest; in the Louvre we find another painted chest, and in the Print Room at Dresden a drawing which is perhaps part of a representation of the three living and the three dead kings.[20]

But the most perfect examples of the Late Gothic style in Emilia are to be found in the works of Pisanello. Abandoning fanciful northern designs, and the features peculiar to

illumination, found in his earlier panels, he succeeded in restraining the Gothic flourishes within the limits of his regular constructions, and in overcoming the habits of the illuminator in his own style by means of the new technique of the medallist. It was this that taught him how to give delicate relief to the heads, and induced him to avoid all strong contrasts, to graduate the colours with the delicacy of the graduation of planes in a medal. For this reason it has been possible to consider Pisanello as bearing a part in the reforms of the Renaissance, for he transformed the undulating planes of Gothic into the broad surfaces of the new movement.

At Ferrara as at Venice, in the first half of the fifteenth century, the gay note of Veronese painting had already been heard. Gentile da Fabriano and Pisanello, in the frescoes of the great Council-Hall of the Ducal Palace, had left models to all the Venetian painters, and even to those of Ferrara, which forms, as it were, the apex of an equilateral triangle of which the base lies between Verona and Venice. Even if Gentile da Fabriano was never in person at Ferrara, certainly his name resounded there; so much so, that Cosmè Tura, having been commissioned to paint the chapel of Belriguardo for Borso d'Este, was asked, before undertaking the work, to go to Brescia, to see the chapel painted there by Gentile.[21] His art was in any case known at Ferrara through his chief follower, Iacopo Bellini, who, like Pisanello, approaches to the Renaissance, obtaining a plastic effect in the enlargement of the forms inherited from his master.

Pisanello stayed at the court of the Gonzagas at Mantua from 1424 to 1426,[22] and left for Rome to continue the work of Gentile da Fabriano in San Giovanni Laterano.[23] He worked in Rome until 1432, when Pope Eugene IV gave him a safe-conduct to return to his own country.[24] On leaving Rome, he had left a picture as a gift to Lionello d'Este, who charged his brother Meliaduse to send it on to him.[25] A servant of Pisano arrived at Ferrara from Verona on the first of February, 1435, and in the name of the painter presented Lionello d'Este with a "Divi Julii Cesaris effigiem", which was perhaps a small panel.[26]

In 1438, the painter lived at Ferrara during the sittings of the great Church Council, and cast the medal of the Emperor John Palaeologus, showing him, on the obverse, with a bizarre hat after the Greek fashion, and, on the reverse, in the act of adoring the Cross set upon a rock. It was about this year that Guarino praised the merits of his fellow-citizen who had brought the art of the medallist into honour, recording how Antonio Pisano had presented him with a painting of St. Jerome, that can be identified with the picture in the National Gallery of London, bearing the apocryphal signature of Bono da Ferrara.[27] In 1439, Pisano was in Mantua, painting in a church, perhaps that of Santo Paolo in the monastery of Corpus Christi,[28] but from the 17th to the 20th November he was present

at the entry of Piccinino and Francesco Gonzaga into Verona, and left the city as soon as the two captains had to abandon it.[29] The painter, having passed to the court of Filippo Maria Visconti, was present in the Ducal Hall of the Palazzo dell'Arrengo, on the 11th of May, 1440, as a witness to the formal account of the conquest and subsequent loss of Verona on the part of Piccinino and Gian Francesco Gonzaga, intended to perpetuate the memory of those events.[30]

In the first half of 1441, Pisanello was painting a portrait of the Marquis Lionello d'Este at Ferrara:[31]

> *Quando il Pisan tra le famose imprese*
> *s'argumentò cuntender cum natura*
> *e convertir l'immagine in pictura*
> *del nuovo illustre Lionel marchese*
> *già consumato havea il sexto mese*
> *per dare propria forma alla figura,*

when there arrived Iacopo Bellini, "the consummate artist" who surpassed him:

> *che la sua vera effigie faze viva*
> *ala sentencia del paterno amore*
> *onde lui primo et poi il pisan secondo.*

Since we know that Pisanello left for Mantua on the 16th of August 1441, and that Iacopo Bellini had "a gift of corn" on the 26th of the same month, we may imagine that by August the competition was already ended. The portrait is perhaps that very one of which Ludovico Carbone speaks in his Latin oration of 1460, composed to celebrate the wedding of Sara dell'Assassino, and eulogizing the bride's uncle, Galeotto dell'Assassino. The learned teacher and poet, after having spoken of the paintings he possessed, said:

> *Nunquam illam Leonelli aspicio, quam Antonius*
> *Pisanus effinxit, quin mihi lacrimae ad oculos*
> *veniant, ita illius humanissimus gestus imitatur.*[32]

As we have said, Pisanello left Ferrara for Mantua on the 16th of August, 1441, with three packed chests, "valixe e bixage".[33] He had been at Mantua even before this, for on the 27th of March of that year 100 ducats were deducted from his salary, by the consent of the Marquis, to pay his debts.[34] He had been considerably longer in the service of the Gonzagas than in that of the Estes, for, after having been their stipendiary, in 1424/5,

14

he was again at their court in 1439 and in 1441, both before and after the competition with Iacopo Bellini. But he soon had to abandon this hospitable court, because, having been with Francesco Gonzaga at the taking of Verona, his name was mentioned in the *descriptio* sent by the rulers of Verona to the Coucil of Ten at Venice among those of the citizens of Verona "who came with the Marquis of Mantua when he entered Verona, and worked for him to the disadvantage of the Signory of Venice, and went away with him when he was expelled." He was registered thus: "Pisano, the painter, doing evil in the house of Andrea della Levada."[35]

On the 7th of February, 1442, the Commune of Verona begged Venice to permit the return of certain Veronese exiles, among whom was Pisanello; and the Serenissima showed herself inclined to pardon, on condition that before the end of the next March these exiles should justify themselves, declaring at the same time that those who did not present themselves for this purpose would be considered rebels.[36] For Pisanello the matter became so serious that on the 7th of October, 1442, the municipal attorney proposed to the Venetian Government that he should be led out into the square of San Marco, "between the two columns", and that as he had, together with Ludovico Gonzaga, slandered the Republic at Mantua with foul and scandalous words, his tongue should be cut out, and he should subsequently be banished for ever from Venice and from all Venetian territories.[37] The Council of Ten, having heard the attorney and listened to the reading of the documents proving that the painter had in reality, together with Ludovico Gonzaga, at Mantua, used "foul and scandalous words concerning the Republic", decided that he should be confined in Venice, losing his right to sell his own property without leave of the Council, and that in case he broke bounds, he should be treated as a rebel, and his property be confiscated.[38] On the succeeding 21st of November, Pisanello presented himself to the Council of Ten and obtained leave to go to Ferrara to exact certain payments, and for other business of his own, on condition that he should remain only two months and that he should not go to Verona or into Veronese territory, nor to Mantua, nor into the lands of its Marquis.[39] This permit must have been prolonged, because the Marquis Ludovico Gonzaga, having learnt that the painter was at Ferrara, wished to know whether he had really been forbidden to return ever again to Mantua under the threat of losing all his property.[40] This enquiry was made on the 18th of February, 1443, when the two months granted to Pisanello by the Council of Ten had already elapsed. On the 3rd of March following, the painter was still in Ferrara, as also on the 11th of September and on the 10th of November, when the Marquis asked him for the panel with a canvas over it, once painted by him at Mantua, and representing "Il nostro signor

15

Dio."[41] In 1444 and throughout the greater part of 1445 Pisanello resided at Ferrara, casting medals in honour of Lionello, one of which was to celebrate the Marquis's marriage, "Gener. Regis Aragoniae". He also painted a panel for the Marquis's palace at Belriguardo, receiving for it an advance of fifty gold ducats.[42]

After the 15th of August, 1445, the date of this payment, he was probably at Rimini at the court of Sigismondo Pandolfo Malatesta, where he cast the prince's medal, which shows him, on the reverse, riding armed in front of a battlemented tower. The severe orders of the Venetian Republic had evidently lapsed, because in 1447 Pisanello must have been in Mantua, where he portrayed Cecilia Gonzaga on an elegant medal. He was at Ferrara again in 1447 when he received twenty-five gold florins from the state agents, and on the 18th of August, 1448, when Lionello d'Este sent Pier Candido Decembrio a medal he had had cast by Pisanello in honour of the author of the life of Filippo Maria Visconti.[43]

Probably he left about that time for Naples, where we find him on the 14th of February, 1449, receiving privileges and payments from Alfonso of Aragon, and casting the medal of the king which bears that date. After this we hear no more of the medallist painter, praised by Porcellio at Naples, as previously by Guarino at Ferrara and by Basinio at Rimini. Only Bartolomeo Facio in his *De Viris Illustribus*, wrote: "Pisanus Veronensis in pingendis rerum formis, sensibusque exprimendis ingenio prope poetico putatus est." He had therefore been dead for some time when Facio wrote these words. The series of records which exists continuously from 1438 to 1450 breaks off then, undoubtedly on account of the death of the great artist.

These notices on the life of Pisanello show how he was, before the promoters of the Renaissance, one of the most vital factors in Emilian art at the end of the Late Gothic period. Although he is the principal representative of the Gothic tradition in North Italy, yet he stands on the threshold of the Renaissance itself with his portrait medals, and heralds the new style at Ferrara, Mantua, and Rimini, and at the courts of the Estes, Gonzagas and Malatestas.

Plate 3 To Guarino, the tutor of Lionello, the painter probably presented his St. Jerome, which was greatly admired by the Humanist, who praised the profoundly meditative expression of the saint, his piercing glance and his absorbed attitude as of one far away from earthly life, plunged, as it were, into painful depths of thought. It is one of Pisanello's most archaic paintings, still showing golden lights on the rocks, a reminiscence of the art of illumination which he probably practised in his youth.[44]

The shading by means of parallel lines, clearly visible on the gilded rocks, on the rough material of the saints's garment, and in the thick coat of the lion, the clear-cut outline of

16

the mountains standing out against the bright sky, the varied structure of the dwarfed and gnarled tree-trunks and of the pointed leaves lit up by golden lights among the green, the freshness, the modest grace of the small flowers dotting the grass, like little stars, on the top of the cliff, the powerful modelling of the saint's head, standing out in strong relief from the background, are all such unmistakable indications of Pisanello's art as to deprive of all value the signature of Bono, which was certainly added to the picture at a later date. The lion, a superb, lithe beast, is rendered with most delicate intuition in the luminousness of its coat, and in the movement of its muscles, which quiver beneath its glossy hide. It is no tame lion, no heraldic beast, such as was repeated in the art of the fifteenth century. It is shown couched, but its tail is about to lash the ground. The head, enframed by the mane, rests on the paws, and seems to be repressing a roar, while the eyes have a phospho-rescent gleam. The animal, in its grand and terrible majesty, seems to tremble, crouching before its tamer. The torrid light of the sky, the contrast between the deep shadow cast by a rock and the luminous background, also recall the black shade of the firs upon the iridescent background of the Saints Anthony and George in the National Gallery in Lon-don, a work of Pisanello's best period.

The great Veronese painter has conceived Jerome seated alone on a rock, with his books and a Cardinal's hat near him, in the midst of a wild and bizarre landscape with jagged rocks, trees rising from clefts, great tower-like cliffs, bare mountains and dizzy jutting pre-cipices. The only living creatures in this wild hermitage are the crouching lion at the feet of the Saint and the grazing fawn on the hillside. The sombre stillness of the drooping trees, and the roughness of the ground strewn with stones and boulders, express the silence and desolation of the hermitage.

At Ferrara Pisanello painted the Portrait of an Estensian Princess, now in the Louvre, *Plate 4* and that of Lionello d'Este in the Accademia Carrara at Bergamo. The two portraits seem to be carved out with medal-like decision, in very low relief. The white profile of the Prin-cess, who wears the crest of Lionello embroidered on her robe, is set off against a flowery hedge of columbines and carnations. The Marquis's profile instead is relieved against a uniform brown background. No one can look at the knights and ladies of the Chantilly Museum and of the Bonnat collection at Bayonne, clothed by Pisanello in multi-coloured robes embroidered with peacock's eyes, without dreaming of birds with iridescent plu-mage and peacock tails, passing through the Gothic streets of Verona, Ferrara and Mantua in the first decades of the fifteenth century.

Another portrait among Pisanello's greatest productions is that of a gentlewoman, now in the Clarence Mackay collection.[45] The effect is here obtained by the contrast between *Plate 5*

17

the shadows that smother the light of the embroidered flowers and of the little golden fili-gree balls and the whites of the face, the linen lappets and the fur.

Obviously contemporary with the portrait of Lionello is a little picture representing the *Plate 6* Virgin with Child on high, with St. Anthony Abbot and St. George beneath, against a dark grove of fir-trees. The head of the warrior saint vies with that of Lionello in the de-licacy of the relief and in the subtlety of the profile.

These and other examples of Pisanello's art were before the eyes of the Emilian painters together with his wonderful medals. No medallist ever equalled his pictorial effects, the precision of his contours, the liveliness of his modelling, the inexhaustible inspiration of his allegorical compositions, and his faultless rhythm. As a painter, he closed an epoch with aristocratic elegance. As a medallist, he had a host of followers, though none inherited his wonderful intuition of the mutual relations between bust, inscription and rim, the precision of his proportions and the decorative character of his lines, which still retain something of the grace and elegance of Late Gothic.

Another Veronese artist, according to some a pupil of Pisanello, is Matteo de' Pasti, who came three times from Verona to Ferrara, carrying ten quires of illuminated pages of a breviary commissioned by the Marquis from "Zorzo de Alemagna". Probably about the same time, he cast the medal of Guarino, following close in the footsteps of Pisanello, without having his fine intuition for form. The two artists left the Estensian court to go to that of Sigismondo Pandolfo Malatesta. Between Ferrara and Rimini there was a continual coming and going of artists; or rather, at the time of Lionello d'Este, art turned from the first to the second of these centres of Humanism.

Matteo de' Pasti imitated Pisano, but without his force, in the medals he cast, for the most part in honour of Sigismondo and of the divine Isotta. For Piero de' Medici, father of Lorenzo the Magnificent, he painted the *Triumphs* of Petrarch. He was described as being "remarkable in painting and sculpture", by Roberto Valturio, the author of the work *De Re Militari*.[46] When he began to work in the church of the Malatestas at Rimini, he gave expression in the powerful, exuberant decoration to his pictorial fancy as a Pisa-nellian medallist and as a Veronese mindful of Northern Gothic. Already baroque in the fifteenth century, he developed his capricious motives with great freedom of rhythm, and directed Agostino di Duccio, Francesco Laurana and other masters, great and small, in the vast undertaking of the decoration of the church. Always a fervid artist and able cour-tier, he describes himself as an architect in an inscription in the interior of the church.[47]

Another follower of Pisanello was Giovanni da Oriolo, who in 1446 painted the por-traits of Elisabetta and Barbara Manfredi, the daughters of Astorgio II. In 1447, drawing

his inspiration from the great prototype of the Veronese painter, he drew a portrait of Lionello,[48] now in the National Gallery of London, but it is a mere lifeless imitation.[49]

Not unmindful of the Late Gothic style was the art of illumination at Ferrara, as may be seen in the fantastically coloured decorations of the Bible of Borso d'Este, Lionello's successor, now back in the Modena library. It is a masterpiece of its kind, executed under the guidance of Giorgio d'Alemagna, who had previously been called by Lionello to Ferrara from Padua. He was the leader of the new school of illuminators, which included Franco di Giovanni de' Russi of Mantua, Taddeo Crivelli the Lombard, and Marco dell'Avogaro. This famous Bible, begun in 1455 and finished in 1461, was illustrated with little figures clothed in contemporary costumes, reminiscent of those of Pisanello, and was adorned in the borders with the gayest flowers and beasts, the latter also influenced by Pisanello, the perfect animal painter. It is a veritable profusion of flowers and gold, of little genii and vases and pearls and beads, among the emblems of Borso and the crests of the Estes, in which the white eagle stands out on the azure field. "The pages laugh" within their borders with their little fluted columns and pilasters, their loggias and buildings opening out on to a sky, enlivened by the flight of coots and herons. Such is the setting for biblical characters dressed in the French or Catalan fashion, and with the great hats of the eastern priests seen at Ferrara in 1438 during the Council. All the wealth of the velvet, satin and damask costumes of this gay court is thus showered upon these little figures, transforming them into courtiers of the House of Este.

THE BEGINNINGS OF THE RENAISSANCE IN EMILIA

THE FIRST signs of the Renaissance in Emilia can be seen at Ferrara in a fresco in the choir of the church of Sant'Apollinare, representing the Resurrection. The last figure of the date is now lost and one can only read the figures 144. Christ is shown about to arise from a sarcophagus of red Veronese marble, with a banner bearing the sign of the cross, the streamers fluttering in the wind; he has set his right foot on the edge of the tomb and his pierced hand is raised to bless. At each end of the front of the tomb is a sleeping warrior, his figure standing out against his large shield, and behind, as if they had come out of some cave, are the brethren praying with clasped hands. There are marks of the Gothic style in the sinuous folds of the banner, as in those of the mantle with its repeated oval curves, in the archaic minuteness of the other figures compared with the gigantic form of Christ, in the curving contours of the jagged rocks, in short, in the survival of a certain Gothic calligraphy. And yet the new style is felt in the tendency to regulate the composition according to a system of vertical parallel lines and to fix the figure of Christ in a static position somewhat reminiscent of the Risen Christ of Andrea del Castagno in the Duveen collection.

TODAY it is well known how in 1442 Andrea del Castagno frescoed the ribbed vault of the chapel of San Tarasio in San Zaccaria in Venice with figures of the Evangelists.[50] The voice of Andrea del Castagno sounded abroad throughout the lagoons and beyond; and certainly it was not without giving some incitement to the new style that the sculptured Evangelists leaned out from the Gothic vault of San Zaccaria. If the fame of the Tuscan did not get to Ferrara, to the ears of the anonymous painter of the church of Sant'Apollinare, there came to Venice the conception of a predella of which a fragment exists in the Duveen collection at Paris. The subject represented is the Resurrection.[51]

During the fourteenth century the theme of the Resurrection is almost always united to that of the Noli me tangere; and it is but rarely represented by itself. First among the great artists of the fifteenth century in Tuscany, Andrea del Castagno treated the subject twice: in a fresco in the church of Sant'Apollonia in Florence and in a part of the above-mentioned predella. In the Ferrarese picture the structure of the composition has the geometrical perspicuity of the architecture of the early Renaissance. In the centre lies the sarcophagus, which seems to have been brought into that stern country out of some Brunelleschian cha-

pel, with its stone panels, closed in straight-lined frames, and its porphyry and serpentine tondos. On either side of the sarcophagus are two symmetrical rocks, crowned by tufts of dark trees. Behind the two rocks, at a distance about equal to that between the sarcophagus and the foreground of the picture, is the chain of wooded hills, defined by a line which is nearly horizontal, affording full play for the light of a limpid sky. This composition, with its calculated balance of masses and free space, holds the germ of that volumetric architecture which was to be the glory of the whole current of Tuscan art.

A vague reflection of this structural scheme is to be found in the anonymous master of Sant'Apollinare, before Piero della Francesca arrived in Ferrara to elevate and purify pictorial forms.

Tuscan art, which had flowered in the first glow of the Renaissance, acquired a new supremacy, and also spread its conquests into Emilia. Already Niccolò III of Este, in 1436, had had recourse to "Pesello the painter" to record his exploits and arms, on the canvas which covered the wooden pedestal of the equestrian statue in wax, erected by him as a votive offering in the church of the SS. Annunziata in 1435.[52]

Sculpture at Ferrara was entirely in the hands of Florentines. In 1438 a certain Cristoforo of Florence made a statue of the Virgin, which is to be seen in the principal loggia of the cathedral; and the Sienese Iacopo della Quercia left there a marble polyptych, of which the fragment of a statuette of St. Maurelio is still preserved.[53]

After the death of Niccolò III, Lionello bethought him of perpetuating the memory of his father, who had consolidated the House of Este and chosen as his successor himself, a natural son, instead of one of his legitimate children. He decided therefore to erect an equestrian statue, the heroic monument *par excellence*. After the monument to Theodoric in Ravenna, this was the first equestrian statue to appear in Italy, erected not in the semi-obscurity of a church, or in an arched niche of a cathedral, nor yet in a merchants' loggia, but in the open air and sunlight, in front of the imposing castle.

Lionello's great idea could only be put into execution by Florentines of the school of Filippo Brunellesco or of Donatello. Antonio di Cristoforo and Niccolò Baroncelli competed for the work. According to Leon Battista Alberti, the college of the twelve *Savi* found that "both the statues resembled the Marquis Niccolò; both were excellently made and only the most expert in painting could judge which was the better". It was then that Alberti himself was consulted about their respective merits. He was at that time unoccupied and at Ferrara, where he had received a most cordial welcome from Lionello, and he willingly accepted the position of arbiter. "To my own satisfaction," he writes, "is added the pleasure of finding a most delightful motive for exercising my judgement accord-

ing to my custom. I did it most willingly so as to give pleasure to you, Lionello, and to myself. Your fellow-citizens, having decided to raise at immense cost an equestrian statue to your father in the square, and having called together highly-skilled artists, chose me, who delight so much in painting and sculpture, to be judge and arbiter." Following the advice of Alberti, the twelve *Savi* met again on the 27th November, 1444. The model of Antonio di Cristoforo was accorded six votes, and that of Niccolò Baroncelli five; and thus it was decided that Antonio di Cristoforo should execute the statue and Niccolò the horse.

Leon Battista Alberti had been in Ferrara once before, in 1438, when the Church Council was being held in the city in the presence of the Pope Eugene IV and the Emperor John Palaeologus. The learned humanist had then become firm friends with Lionello d'Este and dedicated to him his comedy *Philodoxios;* but in that first stay in the capital of the Estes, while ecclesiastical questions were all to the fore, he did not turn to figurative art. In his second sojourn at Ferrara the master applied himself to this branch of study, and was judge in the competition between Antonio di Cristoforo and Baroncelli, as he himself tells us in his pamphlet *De equo animante*, dedicated to his friend the Prince and suggested to him by the models of the equestrian statue "prepared with marvellous skill." [54] In the division of labour for the equestrian statue no reference was made to the base, which has elements so nobly classical and so many affinities with the architectonic forms of Alberti at Rimini, that it leads one to think that it was the Florentine classicist who suggested to Lionello the idea of a Roman triumphal monument as a base for the statue. In this fully developed classical form is reflected the spirit which animated the author of the treatise on architecture dedicated to Lionello d'Este.

The sculptor, Antonio di Cristoforo, having finished his share of the work, repaired to Venice, while Niccolò Baroncelli (called Niccolò dal Cavallo, for the part he had taken in the sculpture) remained at Ferrara, and kept a workshop with his son, Giovanni, his son-in-law, Domenico Paris of Padua, a certain Meo di Cecho of Florence, Lazzaro da Padova, Baccio de' Netti, a Florentine, and others. Besides the two sculptors of the statue of Niccolò III, there was at Ferrara Michele da Firenze, spoken of as "an excellent maker of figures" (perhaps Michele di Nicolaio or Michele dello Scalcagna, who had helped Ghiberti with the doors of the Baptistery), who in 1441 made an altar-piece, probably in terra-cotta, for the church of Belfiore.

From Tuscany, throughout Emilia, arrived fresh sculptors. At Bologna there was the prince of artists, Iacopo della Quercia. At Mantua the followers of Donatello were working for the Gonzagas, among them being Luca Fancelli, interpreter of the architectural designs of Alberti. At Modena Agostino di Duccio, in 1442, decorated the altar of

St. Geminiano in the Duomo. At Rimini the same sculptor, with Ottaviano his brother and others, adorned the Malatesta church with exquisite designs set into Alberti's own architectonic schemes.

AS REGARDS the art of painting, there now arrived, also from Tuscany, the master who was destined to illuminate the whole of Central Italy, namely, Piero della Francesca.[55]

Vasari wrote that Piero, "having gone to Pesaro and Ancona, was in the height of his work summoned to Ferrara by Duke Borso, where in the Ducal Palace he painted many rooms that were afterwards spoilt by Duke Ercole when the palace was modernized, so that in that city nothing remains by the hand of Piero except a chapel in Sant'Agostino, painted in fresco, and even that has suffered much from the damp." The palace of which Vasari speaks cannot in any way be identified with that of Schifanoia, erected by Borso d'Este in the last years of his reign; and of the frescoes in Sant'Agostino, already ruined by damp in Vasari's time, there is no longer any trace. Some years ago two fragments of figures of saints were transported from the church of Sant'Andrea at Ferrara to the town gallery. One of these fragments is a St. Christopher and the other a St. Sebastian, and both were presented as examples of the work of Piero della Francesca. They are, however, fragments of Ferrarese painting of the period of Francesco del Cossa.

One work only at Ferrara can give us some indication of the influence first exercised by Piero della Francesca on local art, and this is the great picture in the gallery of that city, *Plate 7* which bears the legendary name of Galasso Galassi. It represents the Entombment amid the lament of the Marys and of the saints come to swell the funeral group around the dead Christ. The postures express restrained sorrow; the thin lips are twisted, and the expression dazed and distorted by grief. The figures are flat, with the colour, as it were, inlaid, on a ground of dark grey. The centralization of the perspective is timid, and the effect of distance is reduced to a minimum. Unusual in Piero's work is the contorted movement of the two saints at the side, which has, especially in the figure of the Bishop, a certain tormented effect, characteristic of the Ferrarese style. For such features, as also for the clarity and transparency of the colours, it is natural to attribute the Entombment to an early Ferrarese follower of the great Master of Borgo San Sepolcro.

This might actually be Galasso di Matteo Piva, mentioned by Vasari under the name of Galasso Galassi, and by Ariosto as the painter who used to represent the devil as having "a beautiful face, beautiful eyes, and beautiful hair". According to Vasari, Galasso of Ferrara "seeing Pietro dal Borgo a San Sepolcro rewarded by that Duke for the works

24

that he had executed, and, besides that, honourably kept by him at Ferrara, was by such an example fired to dedicate himself to painting, with the result that in Ferrara he acquired fame as a good and excellent master." Ciriaco Anconitano, the celebrated collector of epigraphs, who was in Ferrara in the first days of July, 1449, tells us that Angelo da Siena, called Il Maccagnino, and Galasso learned their technique and the use of oil-colours from Rogier Van der Weyden.

Since Galasso, before learning the practice of oil-painting, had, according to Vasari, been urged on by the example of Piero, one may argue from this that Piero della Francesca had been at Ferrara before 1449. Let it not be supposed that we are taking Vasari too much at his word in order to show that Piero was at Ferrara before 1450. We are also helped to this conclusion by the fact that Galasso, already master of his art, painted in that year in collaboration with Bono da Ferrara, in the Loggia del Migliaro, in the palace of Belfiore, and also in the houses of Casaglia, by order of the Estes, lords of Ferrara. Further, in 1451, together with Cosmè Tura, the chief of the Ferrarese school, he valued some pennons painted by Giacomo Turola. We have insisted upon this point, because the ascertainment of the time at which Piero della Francesca was at Ferrara has an essential bearing upon the study of the development of art in Northern Italy. Besides Galasso, Bono too, his fellow-worker of 1450, betrays the influence of Piero in the paintings executed in the church of the Eremitani, at Padua, in 1451 or shortly after.

As Galasso and Bono had done, Lorenzo da Lendinara, who in 1449 was at Ferrara and working with his brother Cristoforo to help Arduino da Baiso in carving the inlays in Lionello d'Este's study at Belfiore, made friends with Piero della Francesca, according to the testimony of Luca Pacioli. "I promise," he writes, "to tell you all about perspective, using the documents of our fellow-countryman, the expert of our day in this science, Master Pietro de' Franceschi, from whom I have taken most careful notes for your benefit, and of his friend, dear to him as a brother, Master Lorenzo Canozo da Lendinara, who likewise in this science was supreme in his day, as is shown by all his famous works in inlay."

We may suppose then that Piero della Francesca was in Ferrara from 1448 onwards, and that the following year saw the arrival of Rogier Van der Weyden, who brought with him a triptych for Lionello's study. During these years, when art flourished at Ferrara at the court of the humanist Marquis, there was a continual influx of masters. Pisanello left for Naples in 1448, but meanwhile there had arrived Angelo Maccagnino, called Parrasio, of Siena, Alfonso of Spain, Rogier Van der Weyden and the young Andrea Mantegna, while the Ferrarese masters later to acquire fame, Bono, Galasso, Cosmè Tura and Francesco del Cossa, were learning their art.

25

From Ferrara Piero della Francesca went to Rimini, and in 1451 painted a fresco of Sigismondo Malatesta in prayer before his patron saint, in the church of the Malatestas. In the decorative frieze which surrounds this famous fresco there is a tondo representing the castle of Sigismondo Pandolfo with the inscription: "Castellum Sigismundus Ariminensi M.CCCC.XLVI." Another inscription under the fresco runs thus: "Sanctus Sigismundus. Sigismundus Pandulfus Malatesta. Pan. F. Petri de Burgo opus M.CCCC.LI."

Sigismondo Malatesta, in a letter to Lorenzo the Magnificent written during the siege of Cremona in 1449, begged for a "master painter", saying that he neeeded his services, not as yet for the chapels in the church of San Francesco (which were still too recently built to be frescoed), but, while waiting for the opportune moment for these, for yet other works. And he added his intention of pensioning such a painter and keeping him permanently at his court.

Sigismondo, who had drawn masters from Ferrara, among them Pisanello, and had learnt from Alberti of Lionello d'Este's enthusiasm for art, after having applied to Lorenzo the Magnificent, probably turned to the Marquis of Ferrara. In 1449 the chapels of his church were too new to be worked on, says the letter, but in 1450 they may have been ready for the painter's hand. The date of 1451, to be read on Piero's fresco, although restored, seems indisputable.

In the fresco at Rimini (1451) representing Sigismondo Pandolfo Malatesta kneeling before St. Sigismund, the relief is very flat. Fluted pillars and large medallions decorated with landscapes adorn the background, producing the effect of light-coloured bands; a compact wreath hung from column to column cuts into the light background with its heavy green; strips of tapestry and strips of marble alternate in the pavement, repeating the contrast of warm and cold tones, of velvets and marbles, already expressed in the Baptism at the National Gallery by the pools of water and the patches of grass.

The great bell-like mass of the Lord of Rimini's golden robe is, as it were, inlaid into the background; the arched hands and the profile of the head stand out clear-cut in space, as within the rim of a medal, with slight and delicate shades of relief. The archaic Piero never seems to us more archaic than in this immobile figure, set, so to speak, into the background like a mosaic of various colours, and in the other figure of the royal saint seated on his throne, with his feet fixed on the tapestry-covered base. The same symbolism is inherent in the rigid figure of Sigismondo and the rapt figure of the saint, the worshipper and his idol; and the jewelled orb and sceptre in the hands of the old king become pure symbols.

Alabastrine clusters of fluted pillars, great bell-shaped robes, and thick wreaths hanging from the volutes of the capitals, medallions with little inlaid landscapes of the castle of Ri-

26

mini, the heraldic shield with its quarterings of gold and white chequers and the sinuous S wreathed about the rigid stem of the I, build up a composition governed by faultless rule, and form a bas-relief of infinite delicacy.

This picture by Piero della Francesca, which seems to have inspired Melozzo da Forlì, in Romagna, makes us lament the absence of the still greater work which he must have accomplished at Ferrara, whence its influence extended to the art of the founder of Venetian painting, Giovanni Bellini.

During these years in which the master of Borgo San Sepolcro was at Ferrara, Andrea Mantegna, who afterwards became at Mantua the "king of painting in his day", as Piero had become for Central Italy, at nineteen years of age carried the first fruits of his art to the capital of the Estes. Lionello had a brotherly affection towards his follower Folco di Villafora, and not content with ordering the preparation of a sumptuous room in his court for him, had built for him also a palace worthy of a prince, decorated by his own sculptors and painters. The decorators and goldsmiths of the court loaded his rich clothes with silver. He wore on his finger a gold ring with the name of Lionello, and it was Mantegna who in 1449 was called to record the friendship of the Lord of Ferrara for his Chamberlain, in a picture with the portrait of the former on the one side and of the latter on the other. The document that records this fact, mentioned by Crowe and Cavalcaselle under the erroneous date of 1459, led to their giving an exaggerated importance to Mantegna's first sojourn at Ferrara, but it is certain, nevertheless, that the painter, who a few years later was working with masterly skill in the chapel of the Eremitani at Padua, had already reached a high grade of excellence in his art. Already enrolled at ten years of age in the guild of Paduan painters, and at seventeen the painter of an altar-piece (now lost) in Santa Sofia at Padua, at nineteen he may well have painted this diptych for the Marquis of Ferrara. The document already referred to bears witness to the fame that the young man must already have acquired for himself; so that, without supposing that he then dominated Ferrarese art, as he might have done in 1459, one may admit that from that time onwards he guided it towards Padua, the scene of his first triumph. Bono da Ferrara, thought to be a disciple of Pisano because of a false inscription, worked together with Mantegna and under his direction, in the chapel of the Eremitani. Cosmè Tura reflects the Paduan realistic manner, and so more or less do all the Ferrarese artists of the fifteenth century.

While Mantegna was at Ferrara, there arrived from Flanders Rogier Van der Weyden, who left there a triptych, a portrait of a prince of the House of Este,[56] and introduced the practice of painting in oils. Ciriaco Anconitano, who was in the city at the beginning of July, 1449, saw the Flemish triptych hanging on the walls of the study that Lionello d'Este

was having prepared for himself in his palace of Belfiore. "Eius est," writes Facio, "tabula altera in penetralibus principis Ferrariae in cuius alteris valvis Adam et Eva nudis corporibus a terrestri Paradiso per Angelum ejecti quibus nihil desit ad summam pulchritudinem; in alteris Regulus quidam supplex: in medio Christus a Cruce demissus, Maria Mater, Maria Magdalena, Josephus, ita expresso dolore ac lacrymis, ut a veris discrepare non existimes."

Ciriaco Anconitano also describes it and is seized with great admiration at the sight of those figures, "that seem to breathe as if they were alive," at the gold-embroidered robes, the garments of varied colours, the green meadows embellished with flowers and leafy trees, the ornate arches, the superb porticos. "You would say," he writes, "that these things were not produced by the hand of an artist, but created by omnipotent Nature." The triptych, with the figure of Regulus taken from the Apocryphal Gospels on one of the wings, has been lost, unless the suggestion of Crowe and Cavalcaselle should prove to be valid, by which they sought to identify the centre portion with the Pietà in the Uffizi at Florence. Lionello d'Este and his court could not but be surprised at the finish, at the extraordinary effect of realism, and at the splendour of this oil-painting. Ciriaco Anconitano calls Rogier Van der Weyden the glory of painting, and says that at Brussels he was considered the most celebrated painter after Jan Van Eyck. As soon as he returned to his native country after the Jubilee, he received money from Paolo di Lucca, a merchant at Bruges, "for certain paintings for our most illustrious Lord (Lionello), made for his study at Belfiore by the excellent and famous painter Master Rogier... pro parte solutionis nonnullarum picturarum."

At Ferrara, as in other parts of Italy, attempts had been made to paint in oils, but the knowledge of this art was very imperfect. Rogier Van der Weyden, mentioned by Filarete, together with Jan Van Eyck, as the master who had "adopted to excellent purpose these oil-colours", taught the use of them, according to Ciriaco Anconitano, to Angelo da Siena, called the Maccagnino, and to Galasso. The testimony is worthy of credence for Ciriaco, on July 13th, 1449, was at Ferrara, and enjoyed the liberality of Lionello.[57]

Angelo da Siena, called the Maccagnino, was at the capital of the Estes from 1447 onwards, when he received from the Marquis the order for "certain works of his art in our study at Belfiore". Ciriaco, who saw his paintings here, calls him Parrasio, describing the Nine Muses painted on nine panels for that study. At the time of Ciriaco's visit to Ferrara, only two of these were finished, Clio and Melpomene. "The former, conspicuous for her dress embroidered in purple and gold, and for her blue chlamys, holds in her right hand a trumpet, in her left an open book, and with a certain modest hilarity in her expres-

sive face, and something in the glance of her eyes, seems to urge men on to glory"; the other, "her shoulders covered by a purple robe, lightly touches the strings of her harp, turns her rapt gaze towards Olympus, and with modest and grave enthusiasm tunes her songs to the harmony of her chords." Ciriaco gives other details about Angelo's pictures, but, on account either of the faultiness of his Latin prose, or of the miserable transcription made out of the fragments left of it, and because of the complete lack of punctuation, it is impossible to understand the whole of his description, in which he was enthusiastic enough to repeat the old comparison of the bees deceived by the flowers amidst the grass at Melpomene's feet. Today nothing remains to us of the work of Angelo Parrasio. We know that he had been in prison at Nocera for the murder of a man from Camerino in 1439, and that the republic of Siena begged repeatedly for his liberation. From 1447 until the end of his days he lived highly honoured at Ferrara, laden with favours, first by Lio-nello, and then by Borso. In 1449 Lionello gave him a dress "di pano roxado de grana"; in 1455 he was endowed with a fief by Borso, on condition that he should present him every year with the tribute of a flower, a rose, and a lily, painted on wood or parchment.

Another painter, Alfonso of Spain, not mentioned by Spanish historians, was painting in the study of Lionello d'Este at Belfiore in the year 1450, and received for his work, ac-complished between June and September, the sum of twenty gold ducats, which was as much as Rogier Van der Weyden had had for other pictures.[58]

THE NAME of Galasso, the other artist who, together with Angelo da Siena, learnt the practice of oils from Rogier Van der Weyden, reminds us again of Piero della Francesca. After 1451, when, together with Cosmè Tura, he was employed to value a small picture, Galasso abandoned Ferrara, and at Bologna, whither he now repaired, he received orders from Cardinal Bessarione. He painted his portrait and also a picture of the Assumption in San Giovanni in Monte, where he frescoed a chapel, boasted of as the work of "Ga-lasius ferariensis ingeniosus juvenis". In the long period in which the painter remained at Bologna, where he died in 1470, we find no works which we can attribute to him with any degree of certainty.

Only two fragments of an altar-piece, probably an Assumption, once preserved in the house of the Marquis Nerio Malvezzi at Bologna and now in the gallery of Budapest, *Plates 8, 9* show an artist akin to Tura, but subject to the influence of Piero della Francesca. And since they also reveal a painter of remarkable individuality, one might suppose that they belonged to the Ferrarese Galasso, a follower of Piero and the undisputed leader of painting at Bo-

29

logna until the advent of Francesco del Cossa, also from Ferrara. Let us add that the two Angel Musicians, originally in a church at Bologna, and the other picture that may be associated with them, the personification of Autumn in the Kaiser Friedrich Museum at Berlin, reveal a Ferrarese master of the artistic generation which grew up about 1450, when Galasso appears for the first time with Bono and Cosmè Tura.

Plate 10

The two angels stand out against a luminous sky, across which run long strips of silver cloud, and the morning light is reflected in the ribbons round the head of the flute-player and in the white outline of the robe and the slashed sleeves. The arrangement of the figures against the sky, and the effect of transparency in the flute-player's neck, are features characteristic of Piero della Francesca, and are accompanied by a certain nervousness in the posture, in the fingers, and in the twisted folds of the drapery, which is characteristic of the Ferrarese painting of the Renaissance. The oval form of the heads recalls Piero della Francesca, and still more so does the Autumn of the Berlin Museum, where the forms have more precision, and the colouring is clear, shot through with white light, while the green plateau, cultivated and planted with trees, has its ploughed furrows divided by hedges in geometrical order. And yet even here, while the influence of Piero is evident, the Ferrarese elements cannot be disguised, in the robes moulded to the shape of the body and even in the pointed left ear with its lower lobe rounded, after the manner of Cosmè Tura.

To Galasso, if one considers as his the two Angel Musicians of Budapest, and the Berlin Autumn, must also be assigned the taroc-cards generally attributed to Mantegna.[59] In playing-cards the people found a compendium of all their knowledge, an illustrated encyclopaedia, where were represented the heroes created by their ingenuous imagination to express doctrinal conceptions, as well as classical allegories — the whole mirroring the social customs and life of the times.

The taroc-cards attributed to Mantegna reveal themselves to be akin to the two Angel Musicians in the National Gallery at Budapest. The affinity, nay the identity, of authorship leaps to the eye when one takes into account the inevitable difference between engravings on copper and oil-paintings, finished with every care and delicacy. It would suffice to persuade us of this identity if we compared the figure of Euterpe (on the eighteenth card) with the flute-player of Budapest. In both figures we find the full folds, cylindrical and broken, the hands with their shining nervous fingers, the same long oval faces, the disproportionate foreheads, the straight noses somewhat wide at the point and touched with light. One can imagine beneath the beautiful velvet sleeves of the Budapest musician the tapering arms and round shoulders of the Muse Euterpe. The same affinity of type is found in other figures, particularly in the Music and Temperance (on the twenty-sixth and thirty-eighth

cards, respectively); others again, resemble more the work of Cossa, as, for example, the angel of the *Primum Mobile* and the Muse Thalia. Again, the backgrounds are similar to those in the pictures of the supposed Galasso; the undulating plain of the Berlin Autumn should be compared with the plateau in the card representing Urania, and so also the winding ribbons of roads in both landscapes.

If some of these popular engravings do not achieve the grace of the two Budapest figures, others are very fine, such as the figure of the old exhausted beggar and the "fameio", all elastic dash and lithe Gothic curves, from the line of the hair to the furred border of the bodice. Others reveal a talent for capricious decoration, as, for example, Melpomene, who, in the lines of her body, bent like a bow, and in the curves of her sleeves and of her tunic lifted by the wind, gives a rhythmical symphony of curves on the motive of the lamp that she holds in her hands, or the *Primum Mobile* (afterwards imitated by Raphael in the Chigi chapel at Santa Maria del Popolo in Rome) with its magnificent winding folds and its baroque scrolls, in which the shadows have the transparency of alabaster with bright points of light, even in this monochrome of black and white.

In the small scenes with little figures, and above all in those representing the Moon, a few rapid lines suffice to suggest delicate harmonies between the sea-shore and the arch of the celestial chariot. Such refined touches in this story-teller, who at times amuses himself by creating figures worthy of appearing on a Carnival chariot, and by using the rough and lively voice of dialect, serve to indicate the delicate painter of the Budapest musicians.

Bono da Ferrara, who was working with Galasso for the Ferrarese court in 1450, painting the palace of Belfiore, and in the houses of Casaglia, and at the decoration of the Loggia del Migliaro, was, like his companion, under the influence of Piero della Francesca. As long as the signature of Bono in the little picture of St. Jerome in the National Gallery of London was held to be authentic, it was believed that the painter had passed from the workshop of Pisanello to that of Piero; but once that signature is proved false, there remains to us only the painter of the frescoes of St. Christopher with the Infant Jesus at the river- *Plate 11* ford, in the Eremitani at Padua, that is to say, a painter derived from Piero, but of little worth. And besides the touches which recall Piero, there are others that remind us of the Paduan school as inspired by Donatello, particularly in the figure of the Child borne on the shoulders of the Canaanite, and in the angels supporting the festoons.

Bono worked in the chapel of the Eremitani with another Emilian, Ansuino da Forlì, *Plate 12* who in the years 1434-1437 had collaborated with Filippo Lippi in the frescoes in the chapel of the Podestà, and who then followed the types which reached maturity in Padua, principally through the agency of Donatello and of Andrea Mantegna. But in Romagna

and, in fact, in Ansuino's native town, the example of Piero della Francesca gave rise to the work of Melozzo da Forlì (1431-1494), who nevertheless did not understand the full significance of his master's art. He created a type of heroic beauty, abandoning the severe impersonal types of Piero, and changing the latter's abstract greatness into terms of human grandeur. He gave to his first conceptions a hieratical majesty, which he soon abandoned to create human forms warm with life, amid rich surroundings, renouncing for ever the profound calm, the statuesque character of Piero's superhuman symbolic forms. The frequent use of foreshortening, the attempt to obtain lightness of movement, still hampered by the weight of the massive bodies, prepare the advent of sixteenth-century vault-painting. When, later on, Correggio painted his Virgin with trembling outstretched arms within the circle of the Blessed, he was following the road marked out for him by Melozzo.

Among the masters who followed Piero della Francesca were also the celebrated sculptors and inlayers Lorenzo and Cristoforo Canozzi da Lendinara. In 1449 we find them described as "fabri lignarii de policino Rodigis", and working together with the famous masters of inlay, Arduino and Alberto da Baisio (or Abaisi), called to decorate the study of Belfiore, in which Biagio da Bologna, Agostino, Leonardo and Simone de Alemagna were also employed. The Lendinara brothers are once referred to in the Este registers, on the 16th of August 1449, as "workers for Master Arduino", but afterwards, in the many other documents relative to the work in the study of Belfiore, their name is no longer united with that of this master. They worked for the same study from 1449 till 1453, and when they were about to return to their own home Borso d'Este ordered that "the young men of Lendinara" should be paid. These princes of the art of inlay carried the logic and elegance of the Renaissance into wood decoration. The study at Belfiore, for which so many artists were employed was certainly the first example of a retreat where a prince might shut himself up with his classics and dispute with the learned men of his court and with the students of the schools.

Lorenzo, the brother of Cristoforo, is referred to by Luca Pacioli in the *Divina Proportione,* as a man "dear as a brother" to Piero della Francesca, with whom he probably became acquainted at Ferrara between 1449 and 1450. We possess no signed picture of his, but we may attribute to him the little panel in the Accademia Carrara at Bergamo, representing the Blessed Lorenzo Giustiniani, a half-length figure enclosed in an ogival arch. The head, that seems made of small blocks of inlay, stands out from a dark ground, above the conical fluted cape, framed within the arch with the short intrados in perspective. The figure curves languidly behind a parapet with a marble disc, repeated in the curvilinear triangles on the sides of the Gothic arcade. The name of Lorenzo da Lendinara

may well be attached to this little portrait of a human candle about to flicker out, and with this style as of painted inlay work, as much for the Paduan characteristics as for some hint of Piero della Francesca to be found in the whiteness of the light.

The inlays executed for the choir of the cathedral of Modena show an artistic derivation from Piero. Besides these, four others are seen in the Sacristy, representing half-length figures of the Evangelists, in which, in woods of various colours, the essential physiognomical traits are seen enclosed in a strictly geometrical design. The forms of Piero are united in these four pictures with those of Mantegna, and the energy of the former is combined with the geometrical regularity inculcated by the latter. The combination of these two artistic principles must have come about after the period of the activity of the two brothers at Ferrara, because they were afterwards at Padua, working in the church of Sant'Antonio. It is felt even in the Madonna, signed by Cristoforo da Lendinara, and painted in 1482, now at Modena in the Estensian Gallery. In the oval shape of the head the earlier influence of Piero is still felt, but in the broad disposition of the bones one is reminded of the crude female heads of Francesco del Cossa. The whole reveals an artist more used to the file than the brush, more accustomed to inlaying coloured planes with strong contrasts than to distinguishing them by delicate gradations of light. The necessary simplicity of the inlayer's means, and the summary character of the colouring are also reflected in this picture. Cristoforo da Lendinara also painted the Madonna della Colonna, placed in the cathedral of Modena in 1479, and, in 1482 and 1488, other works in the church of San Martino at Lucca.

Another painter who was probably influenced by the art of Piero through that of the Lendinara brothers was the Modenese Bartolomeo Bonascia, of whose long and busy life as painter, inlay-artist and architect, there remains, as a specimen only, the Pietà (1485) in the Estensian Gallery at Modena. In this work, following the pictorial tradition for allegorical representation of the Mass of St. Gregory, we find around the dead body of Christ the Symbols of the Passion, so strongly coloured as almost to deceive one by their realism. Thus the figures recall the powerful manner of Francesco del Cossa in a form that betrays the geometrician and architect. To Bartolomeo Bonascia may very possibly belong some frescoes in the church of the Badia at Nonantola, and, in part, the paintings of the first chapel to the right in the cathedral of Modena. The character of these frescoes, resembling great coloured inlays, leads one to think that Bartolomeo Bonascia, also an inlayer, must have learnt his art from the Lendinara brothers, who, in fact, combined the method of Piero della Francesca with that of Mantegna.

Towards the end of Lionello's reign, all the artistic lights seemed to have come together

Plates 13, 14

Plate 15

in his study at Belfiore, and from this spot there seems to have sprung up the most glorious generation of Emilian painters, who, fired by the enthusiasm of the humanists, flocked around the Marquis of Ferrara, to sing the praises of the Greek and Roman masterpieces, and repeat the names of Praxiteles and of Polycletus, of Apelles and of Zeuxis.

THE DEVELOPMENT OF EMILIAN ART IN THE QUATTROCENTO

OF THE Emilian painters, Marco Zoppo of Bologna[60] alone lived for many years at Padua, working in Squarcione's workshop at a period when the humanistic forms introduced by Donatello and continued by Mantegna were flourishing. There is a certain echo of the broad sweep of their style in the Madonna suckling the Child, in Lord Wimborne's collection at Canford Manor, bearing the inscription "Opera del Zoppo di Squarcione". The figure of the Virgin, massive, heavy and composed, towers behind a marble parapet, against the background of a Renaissance niche of variegated marble, adorned with festoons of fruit, caught up with ribbons with dangling medallions — a device which the Paduans, and among them Andrea Mantegna, borrowed from Donatello. The motive of the music-making putti, who serve as caryatids and surround this placid rustic Virgin with a veritable feast of infancy, is also Donatellian.

But later the painter abandoned the heavy complications of form of this large statuesque figure. Already in the Richmond Madonna, signed "Marco Zoppo da Bologna opus", *Plate 16* he imparts to his figures a nervous movement, and draws contours full of sharp angles and curves, with strident and dissonant elements which give his art, though much poorer, a certain resemblance to that of Cosmè, Mantegna's collaborator in the vault of the Eremitani. The traits are more curved; the contours of the Virgin's face, like those of the Christ, are angular, and set off by a vitreous light round the edges. The right hand is sharply bent at the wrist and tense, all sinews and nerves, and the whole group seems to writhe. The sharpness of the contours is almost brutal. Only for a moment, in 1471, when he was painting the altar-piece in the Kaiser Friedrich Museum at Berlin, did the painter infuse calmness *Plate 17* of pose and plastic roundness into his figures of the Virgin and Child. This altar-piece shows, especially in the central group, an approach to the forms of Bartolomeo Vivarini.

Still more bristling and tormented is Marco Zoppo's drawing in the Dead Christ between two angels in the museum at Pesaro, with the lips curved as in a grimace and wisps of hair lying on the forehead. In the same museum there is a head of St. John the Baptist, also attributed to Marco Zoppo, admirable for the energy of its metallic outline, for the decorative quality of the hair, like shining seaweed; surpassing in beauty anything else in the master's work.

Marco Zoppo twice painted St. Jerome Penitent. One of these pictures is in the Kaufmann collection — a small figure with crude and vulgar traits. The other is in the Pina-

Plate 18 coteca at Bologna; and here the painter is influenced by the art of Giambellino, of whom we are reminded in the landscape, with its white ribbon-like roads amidst the dark green of the country, as also in the figure of the Crucified, unusually soft and clear for Marco. Of a polyptych of his I recognized two wings, each with a couple of Saints, in the Dublin and Edinburgh galleries. The colours of the garments are metallic, almost strident; the flesh is reddish, the features tormented. One of Zoppo's greatest works is his St. Paul, in the Ashmolean Museum at Oxford, notable for the austere solemnity of the pose and the funereal contrast of the hawk-like profile with the pitch-black locks, beard and wild eyebrows.

There is a brutal energy in the works of the Bolognese, with his colours which have the bone-like firmness characteristic of Squarcione's Lazzara polyptych, his metallic forms, hammered out, as it were, with a visible effort, and his thorny outlines.

IN EMILIAN painting the art of Marco Zoppo and Cosmè[61] is parallel to that of the Paduan school, whence Marco issued. Cosmè, on the other hand, when he was working with Mantegna in the Ovetari chapel, had already expressed his entire personality in the Allegory of *Plate 19* Spring, which probably adorned the study of Belfiore. What is the origin of his style of painting, with its many sharp points and its enamel-like colours, which finds a parallel in Venice in the angular figures, the sharp-folded draperies and the bright metallic colours of Carlo Crivelli? The solution of this problem is perhaps not to be sought in Italy. Giovanni, Antonio Vivarini's partner, had arrived from Germany, and had surrounded his steely figures with a Venetian Late Gothic setting. In Ferrara itself, Michele Pannonio, who *Plate 20* was Cosmè's inferior, was working with that painter on the allegories of the seasons. Around his figures, purely German in type, we find lilies with metallic, curled petals and leaves like sharp iron tongues. In the Tyrol, Michael Pacher, Cosmè's contemporary, drew similar forms in the four Doctors on the organ-front in the Alte Pinakothek at Munich. Here he surrounds his figures with sharp contours, and gives to the colours of the draperies and marbles the splendour and brilliancy of precious metals. The relations between southern Germany and northern Italy, so evident during the golden age of the Late Gothic, continue to appear during this period of the Renaissance in the twisted curves.

Yet in the Paduan and Ferrarese schools new Renaissance elements were introduced, brought from Florence to Venice by Andrea del Castagno, to Ferrara by Piero della Francesca, and to Padua and Mantua in the humanistic art of Mantegna. In the picture formerly in the Layard collection, the architecture of the throne on which the figure of Spring is seated is a masterpiece of the goldsmith's art. The bizarre genius of Cosmè has

given full play to its brilliant fancy, substituting for the smooth Tuscan frames an arch of dolphins with sharp pointed fins, saw-like teeth and ruby eyes set in gold. Other dolphins are curved to form the arms of the throne, while others twine around the base. In the composition of this throne the painter seems to have united all the wealth of sea and earth — the shining fish, the pearls glittering like Chinese lanterns in a festoon above the head of the figure of Spring, the wondrous gems from the royal coffers, and the shell-shaped canopy which seems to be born from the *ensemble* of these riches of the sea. But the shape of the throne in its main lines resembles those of the Tuscan painters, despite the fantastic ornamentation, all angles and points, rugged and baroque in its rude splendour. Michele Pannonio tries to adapt himself to Renaissance forms by placing little pillars and brackets upon a heavy classical architrave. Yet he does not succeed in harmonizing all these pretentious architectural fragments, whereas Cosmè creates a perfect and living form out of bizarre and complex elements. With him, a clearly recognizable framework holds up the entire rugged structure, and every detail contributes to the life of the whole. The pose of the figures, with one arm resting on the knee and the other raised to hold, sceptre-wise, a symbolical branch, is similar in the pictures both of Pannonio and of Tura. Yet whereas in the former there is no energy in the curve of the arm, in Cosmè Tura's work, on the other hand, the angular bend of the arm completes the structural value of the rugged composition. In this picture, therefore, the oldest known to us by Tura, the painter appears under the typical aspect he maintained throughout his life, with its crudeness and its splendour, its organic qualities and its complicated twisted lines, and wafts us into a marvellous world of monsters and precious gems, of rare marbles and brilliant metals. Francesco del Cossa changes in character from his first statuesque works to those of his maturity, all broken up and full of flourishes and twisted lines; similarly, Lorenzo Costa passes from the strength and crudeness of his earlier figures to the contortions and languor of his later ones. Cosmè, however, hardly betrays the slightest variation from beginning to end in the fantastic world of his imagination.

Reminiscences of Padua are evident in the Annunciation in the cathedral at Ferrara, with its double vault adorned with rosettes and its fruit-laden festoons. The bronze figures, relieved against the panelling of the walls, are a free rendering of Donatello's putti on the altar of Sant'Antonio at Padua. The Renaissance forms, complicated by a luxuriant and fantastic ornamental flora, find a wider sphere in the Berlin altar-piece, in the many-storied throne, with its predellas adorned with bas-reliefs and its deep recess, and in the figures arranged on three levels — the two male Saints, the two female Saints, and the two little angels, at measured distances and in perfect architectonic harmony, as though they were

themselves organic parts of the throne, the ornate mass of which they reinforce and sustain with monumental solidity, like pilasters or columns. Behind the throne the wall is pierced by two archways, and above these follow curving lunettes with statues of prophets against a background of gold mosaic-work. The cool limpid light of the sky contrasts with the glowing tones of the figures, whose draperies have all the transparence of agate and onyx. The putti on the arcade are like lamps burning with a ruddy flame. Everything seems to be kindled with a fire which strikes sparks from the mosaics in the lunettes and from the multi-coloured scales of the marbles. This beautiful altar-piece, peopled by solid and statuesque figures, which recall the monumental stasis of the forms of Piero della Francesca, dazzles us with the richness of its furnishing, and its profusion of metals and marbles. The Emilian tradition of jewel-like colouring, which will be reflected even under Correggio's soft half-shadows and in Dosso Dossi's scenographic phosphorescences, has its beginning in the art of Cosmè, that marvellous smith, who hammered out his figures on the anvil, so that the light might be more gloriously refracted on the prisms of the drapery and on its sharp-cut edges.

Plate 21 IN THE Berlin altar-piece the Child is stretched on the knees of the Virgin, who worships him with clasped hands, as in Antonio and Bartolomeo Vivarini's altar-piece of 1450 at

Plate 22 Bologna. In the Pietà in the Kunsthistorisches Museum of Vienna, the composition, which shows Christ supported by two angels, is the same as was taught to the Venetians by Donatello and became traditional in the fifteenth century at Venice as well as in Emilia, from Carlo Crivelli to Giambellino and from Cosmè to Costa and Francia. Yet the monumental calm preserved by Cosmè's earlier figures even amidst the gay complications of the decoration, a mark of Piero della Francesca's influence upon an art otherwise entirely dominated by a northern spirit, tends gradually to disappear, overcome by the impetuous dash and wild energy of the Ferrarese artist. It is as though a gust of wind sweeps up the little weeping angels and the stricken Christ, and everything whirls round before our eyes — both the figures and draperies. The forms become cruder; the arms of the Christ look like dry branches about to break under the stress of the storm; the eyes are closed tight under the contracted eyebrows, deep furrows cut into the foreheads, and the facial traits are deformed by the contractions of anguish. Yet even in this crude and powerful work one finds the usual brilliancy of Cosmè's gem-like colours, which transform, as it were, into wondrous lamps the distant profiles of the Marys, illumined by an inner fire.

The saints of the surviving wing of the Roverella altar-piece, now in Palazzo Colonna

in Rome, are amongst the clearest examples of the influence of Mantegna on the work of Cosmè Tura. They appear, large and solemn, together with the figure of the praying Bishop, in a Renaissance loggia with capitals adorned with Donatellian sculptures. Fragments of classical architraves, piled one upon the other, form the base of the Virgin's niche. The classical form of the latter, reminiscent of L. B. Alberti in its dignified breadth, almost disappears beneath the baroque tablets, with inscriptions, the strange shells and cornucopias, and the figures of the angels reclining upon the arch to hold up the balustrade of a little balcony, set strangely enough on the top of this kind of triumphal arch. The figures themselves, which still sustained the throne in the Berlin altar-piece, are now placed freely in a zig-zag fashion like joyous birds, while the little musicians complete the capricious decoration of the temple — the expression of a fresh and youthful gaiety, unexpected in the rough and violent art of this painter. The two angel musicians kneeling before the throne are fair and graceful flowers blossoming among the thorns and prickly acanthuses of Cosmè's style.

The open-work vault which rises with elastic spring above the throne of Mary in the picture at the National Gallery spans the lunette at the Louvre, justly considered to have *Plate 23* formed the upper part of the Roverella altar-piece, as is obvious from the identity of the architectural motives and from the delicate beauty of the kneeling female figure on the left. There is great depth of space behind the group, composed, as it were, of statues in polychrome, with an architectonic disposition which once again reveals in the rude and angular artist, with his black, broken, and contorted outlines, the true follower of the Renaissance. The figure of St. John, cut into great facets, is all angles and does not seem to be too far removed from Florentine art, if we compare it, for instance, with some work of that crude artist Andrea del Castagno. Grief contorts the faces; the hands seem to be contracted by cramp, and the faithful, gathered around Christ, who lies like a broken mast, shriek aloud as in the Pietàs of Crivelli. The nude torso is a masterpiece of anatomical science in the delicately suggested relief of the muscles, which seem to quiver.

To this period, in which the expression of ideal gentleness sometimes appears in the art of Cosmè, must, I believe, belong the tondi of the Adoration (now in the Fogg Museum, Cambridge, u. s. a.), the Flight into Egypt (formerly in the Benson collection, London) and the Circumcision (Gardner collection, Boston), where we again find the strange tablets from the throne of the Roverella Madonna, and, in the virginal grace of Mary, the angels and Madonna of the Annunciation of the same altar-piece. Here too, together with the capriciousness of Cosmè's genius, we see his constructive skill in deepening the space behind the carefully-balanced figures of the Circumcision, and in intro-

ducing behind the group of the Adoration rocky vaults of evident Mantegnesque type.

Plate 24 These precious tondi, together with the Pietà in the Museo Correr, with its Calvary built in circles like the mountain of Dante's Purgatory, and the London St. Jerome and Annunciation, are superb examples of Cosmè's landscapes, sketches of polar lands, where plains and mountains are slabs and walls of glass or ice, lit up by the reflection of coloured lights.

There is not a single tree on the road in the Flight into Egypt, which leads through a rugged mountain gorge, opening in the distance to a desert plain, to set off the group of the Virgin and Child; even the little donkey is bent into a curve, and Mary appears to maintain her balance by a miracle upon his arched back. The nervous writhing spiral, which emulates the effects of the energetic lines and plastic planes of the Florentines, is twisted in a thoroughly baroque manner. The rectangular figure of Joseph, as solid as a pilaster, grand and meditative, is typical of the Mantegnesque Renaissance. The folds, which writhe around the person of Mary, fall heavily and simply from his motionless figure.

The figures of St. Peter and St. John in the Johnson collection at Philadelphia are probably fragments of the same altar-piece to which the three tondi belonged. The affinity of the types is self-evident, and as in the tondi, Cosmè's vibrating, intense colour dies out and becomes ashy. The two Saints move in a desolate sandstone country where the roads, cut in the living rock and steeply inclined, seem to be circles of Dante or the edges of a well.

Plate 25 In the altar-piece at Venice of the Virgin with the Sleeping Child we have powerful, uncouth forms, on which glitter the gayest enamels of the Ferrarese jeweller's art. They are placed on a background of pendant bunches of enormous grapes, like shining beads, which, together with the iridescent feathers of a bird, complete the gaily-coloured effect. The type of decoration divulgated by Mantegna in Venetia and Emilia, acquires, under the brush of Cosmè, a brilliant vivacity of its own. In another little altar-piece, which has

Plate 26 passed from the Kleinberger collection in Paris to that of Harold I. Pratt in New York and comes near in date to the Roverella altar-piece, Cosmè recalls the hedges dear to the Late Gothic style and dots the curled leaves with brilliant golden oranges. The Virgin has the tormented and angular contours characteristic of this artist, but her head, which is bent over the little Jesus fallen asleep between her knees, is aglow with motherly tenderness. A silvery veil covers her brows, falling down from the crown of her head in two points, like icicles, while in the loops of a fantastic M, like a miniature initial, are the figures of an Annunciation. From the inlaid seat to the golden oranges and the tiny feet of the child, the whole picture is a precious little trifle of the goldsmith's art in all its details.

After these works Cosmè's style becomes more and more violent and crude. The contours of the bony heads become increasingly tormented and contorted, the veins swollen,

the knotted fingers more and more like claws. The balls of the eyes press upon the eyelids, as in the bronze statues of Antonio Pollaiolo, the lips are arched in bitter curves. One would think that the painter, in his passionate search after energy, was ever more and more inclined to abandon beauty and grace. In the pictures of St. Christopher and St. Sebastian (Kaiser Friedrich Museum, Berlin), of St. Francis (Louvre), of St. Dominic (Uffizi), all probably panels of a single polyptych of which the central part was the Virgin with Child in the Accademia Carrara at Bergamo, we find large heads on slender necks. The joints become smaller, the bones press out against the skin, the framework of the top of the throne appears sharp beneath the drapery that covers it, while even the ringlets of the Virgin are little coils of steel.

St. Jerome, in the picture at the National Gallery, seems to threaten heaven itself with the stone of his penitence. He rises like a statue of incandescent metal in a spectral world, amidst heights and slopes of glass, like those which lead from the throne of the Virgin of the Annunciation, in the same gallery, to the shadowy distant city buried in a frozen land. Cosmè's landscapes are desert and bare; the folds of his draperies are like masses of contorted roots, the contours twisted even to paroxysm; but even in his later works, when he left the school of Tuscany and Mantegna behind him and merely followed his own barbaric and indomitable energy, his colours keep their enamel-like glitter, and he makes the very roughness of the figures yield life and energy. He has a passion for everything that glitters, for enamels and transparent marbles illuminated by an inner light, and he is thus the founder of the Ferrarese colour tradition, with all its flaming splendour.

THE PALACE of Schifanoia was the school-room of Cosmè Tura's collaborators. Here, through the agency of Domenico di Paris, the master carried out his decorative fancies[62] in the stuccos, representing, in the midst of cornucopias, shells and dolphins, allegorical figures and little genii with butterfly wings. Here, too, he initiated the vast pictorial decoration with a group of horsemen, undoubtedly inspired by Flemish prototypes (perhaps of Rogier Van der Weyden), but typical of himself in the powerful drawing of the restive horses, the big-boned warriors and the curled pennons.

A weaker painter filled in the allegorical frescoes of June and July,[63] outlining his figures coarsely with their rhomboid, wide-open eyes, and their disproportionate forms. He is the same vulgar dauber who painted a shapeless Virgin and Child in the gallery of Bologna, a rough frieze with medallions of saints and star-shaped panels as ceiling decoration in the convent of Sant'Antonio in Polesine, and a panel at Nonantola, representing the

Apparition of Christ to the Virgin and the Apostles. A follower of Cosmè painted the Charity in the Museo Poldi-Pezzoli in Milan, on a throne similar to that of the Madonna in the Accademia Carrara at Bergamo, between dancing putti. The painter deforms and contorts the lineaments in his efforts to approach Cosmè's style, but his twisted contours do not enclose bodies gifted with the powerful energy of the Master. The round, calm head of the Virgin, recalling Lombard types, has no connection, even a superficial one, with the great prototype which the painter took as his model. To this group of weak followers of Cosmè belongs the author of the Saints Louis and Bernardino in the Pinacoteca at Ferrara. He is incapable of indicating the distance between the shapeless hollow of the niche and the Saint, or that between the Saint and the paper roses which fall over him.

MEANTIME, the second master of the great Ferrarese triad was rising to fame. This was Francesca del Cossa,[64] who continued Cosmè's work in the decoration of the palace of Schifanoia. He shows a clearer and more immediate dependence upon the Paduan School than we find in Cosmè. Echoes of Piero della Francesca's passage through Ferrara are not lacking in his works. A clear proof is to be found in the oval shape of the head of the St. Lucy in the Spiridon collection in Paris, and in certain female figures of the Vatican predella, which represents the Miracles of St. Vincent Ferrer.

Plate 27 Francesco del Cossa's first work is the most faithful echo in Italian art of the statuesque forms of Mantegna. The dignified figure of St. Jerome, set on its round pedestal and closed in the tubular folds of the tunic which mould the body and lengthen it out, rises, motionless and grand, with an open book resting in his left hand, beneath a Renaissance triumphal arch. The blue sky is crossed by little parallel clouds, and forms the background to the imposing figure. Only the knotted fingers, the metallic contours and the dolphin decorations recall the bizarre ornamentation of Cosmè in the midst of the classical simplicity of the limpid architecture, whose harmony nothing disturbs. But the dolphin decoration is a motive common to Paduan art, and the rhythmical, symmetrical ornamentation of the panels is far from the exuberant fancy and nervous vitality of Cosmè's designs. The powerful and solemn figure stands motionless, turned slightly sideways beneath the arch, as if by slow rotation on its axis. One foot presses on the edge of the pedestal as if to cling to it. The head is not bent, nor does the direction of the gaze deviate from the vertical in falling on the book. Even the little lion on guard at the Saint's feet contributes to the statuesque pose of the figure. The humanistic dreams of Mantegna at Padua and of Alberti at Ferrara are reflected in this monument erected to the Doctor Saint beneath a triumphal arch.

42

Yet the Ferrarese environment soon attracted Cossa to itself, and, after the model of Cosmè, he soon began to break up his architecture, in order to obtain variety of line, and to curl up his draperies and set them fluttering. Symptoms of this change are already visible in two fragments of an altar-piece formerly in the Spiridon collection, St. Lucy and St. Liberale, looking out as if from a window, in statuesque poses governed by a strict study of balance. But the thin and steely curves of the mouth of St. Liberale, his frowning eyes, the tubular folds of his mantle, are unmistakable signs of an approach to Cosmè. There is already a certain restlessness in the solemn poses of the two saints. One other work alone represents this exceptional moment in the art of Francesco del Cossa, when the Cosmesque contractions of the lineaments are barely visible in the Pierfrancescan balance of the composition. This is a tiny tondo — the admirable Crucifixion in the Lehman collection *Plate 28* in New York. The composition is schematic, governed by a few schematical lines: the little marble bridge is the chord of a circle of which the arms of the Cross and the figures of Mary and John are other chords; while the Cross itself is a diameter. The painter has calculated the spaces between the units of the composition with the precision of an architect or a medallist. The spaces are broad, the rhythm perfect, the tones of the draperies velvety and intense, setting off the pure light of the alabastrine body of Christ. There is not an element, a line, a colour, lacking in balance in this wonderful composition worthy of a Renaissance medal. The transformation produced in Francesco del Cossa's style by the resolute approach to the method of Cosmè is seen in the March, April and May of the Schifanoia frescoes. Reflexes of the art of Piero are still visible, as in the motionless maiden *Plates 29-32* viewed from behind in the March panel, and in the monumental white horses, firmly planted on the ground, of the hunters round Duke Borso; but the capricious architecture, the tense attitudes and the curved, crude outlines, prove how, side by side with the Mantegnesque and Pierfrancescan tradition, there is now a basic Ferrarese element.

Next to the group surrounding Borso as administrator of justice, which recalls Mantegna's pictures in the castle of Mantua, and next to the group of horses in the style of Piero della Francesca, we have the falconer reining in his fiery steed; here the spirit of Cosmè lives again in the spontaneity of the movement, in the twisted curves of the mouth, and in the metallic borders of the draperies, fluttering in the wind.

Similar baroque flourishes are frequent in the predella of the triptych dedicated to St. Vincent Ferrer. In the days of Vasari, who attributed it to Lorenzo Costa, it was in the Griffoni chapel in San Petronio at Bologna, but it is now divided between the National Gallery of London, the Brera and the Vatican. The Saint in the central panel, as in the picture of St. Jerome, rises with statuesque solidity and perfect balance from a *Plate 33*

polygonal basis, and the strings of coral beads and pearls hanging from a rod placed above the abacus of the column are, as it were, the chains of the scales on which the painter has weighed the perfect equilibrium of his composition. But the background of the houses, bridges and rocks, all broken and angular, shows how he has abandoned the academic simplicity of his earlier work, in which the statue was enframed in a dignified triumphal arch. Similarly, the peaks of the rocks in the background reappear in the sharp-pointed wings of the angels standing round a Mantegnesque Christ and holding the Instruments of the Passion.

Plate 34 But the affinity with the Schifanoia frescoes is especially seen in the predella. Here we find buildings adorned with capricious corbels, among rocks shaped like African huts or dolmens, and jagged cliffs pointing to the sky. Everywhere there are bridges and arches, and beneath the arches strange little temples peeping out, in which Renaissance elements appear under baroque cupolas; while ruined walls lay bare brickwork and marble slabs, like the works of some laborious mechanism. The whole background gives the impression of some great unfinished building with certain details complete and all the rest in disorder. There are traces of stone work among the bare rocks and among the crystalline cliffs, the work of an architect. The effect is completed by the scroll-like design of the workmen's clothes and the flaming hair of the running women. The contrast we have noticed between architectural fragments with smooth silky surfaces and other fragments of disordered and bizarre constructions is found again in the figures: side by side with statuesque groups reminding us of Mantegna and Piero della Francesca, other groups with snake-like contours hurl themselves as it were into space. The personality of Francesco del Cossa expresses itself fully in this picture; there are figures in it as, for example, that of the work-

Plate 35 man bending over a cistern, drawn with such plastic perfection in the effect of the limbs as to seem worthy of a Luca Signorelli. The nervous strength that animates Francesco's figures is revealed everywhere: both in the running woman and in the one mounting the steps of the shrine upon which stands the risen child. This is a particularly graceful figure, elastic and at the same time tense in its palm-like flexibility. Here too Mantegnesque motives reappear, but the roundness of the contours, the pronounced moulding of the limbs, the search after movement, are Ferrarese reflexes of the art of Cosmè. The brusque and powerful drawing of the features breathes the greatest sincerity and the most burning passion. The colours glitter, as in a goldsmith's window, with the intense luminosity of enamels, so as to vie with the iridescent tints of the stained glass which is amongst Cossa's finest productions in the Church of San Giovanni in Monte, in the Museum of Industrial Art at Berlin, and in the Musée André at Paris.

44

The movement is calmer in the pictures that follow, beginning with the Annunciation *Plate 36* of the Dresden Gallery, executed immediately after the St. Vincent. The figures are once more statuesque, petrified in their pose and aiming at balance in their gestures, as in the artist's earlier works. The marble column which supports the rich loggia, helps us to measure the distance between the angel and the Virgin. It is the centre of gravity of the composition. Not a quiver disturbs the firm gesture of the greeting angel. Like Crivelli in his picture in the National Gallery, Cossa does not show the Virgin in a humble cell, but in a kingly palace built of rare marbles and richly decorated, and all the houses along the road in the background are built of precious materials. The purest of rubies composes the coverlet of the Virgin's bed; the angel's profile is illuminated by an inner light, like a lamp of transparent alabaster, and his peacock-coloured wings complete, with their jewelled eyes, the profusion of bright colours and marbles round the Virgin.

The great wealth of colour diminishes in one of Cossa's last works, the altar-piece repre- *Plate 37* senting the Virgin and Saints Petronio and John the Evangelist, painted to the order of Alberto dei Cattanei and Domenico degli Amorini in 1474. The chiaroscuro is stronger and darker, and the figures are frowning and severe. Bishop Petronio, with his wrinkled face, looks like a mastiff on guard by the side of the throne. St. John shows the rough and heavy build of a peasant. The figures stand out in relief from the picture as in a group by Mazzoni.

Francesco del Cossa died young, in the full vigour of his genius, which had shown its power and self-possession from his very first work. More varied than Tura in his artistic expression, he, like his great predecessor, comes before us from the beginning with com- plete mastery over his art. Although he derives from Piero della Francesca not only the early aristocratic models of female heads, but also architectural proportion, and although he learnt from Cosmè how to draw crude and steely contours and to disdain regularity of form, yet Andrea Mantegna was the principal inspirer of his art. Nevertheless, Fran- cesco del Cossa differs from Mantegna in his conception of classical art. In spite of rounded arches, of cornices with egg-moulding in high relief, and of columns of classical type, the buildings in his backgrounds reveal, rather than the forms of ancient Roman monuments, those of the Renaissance and of L. B. Alberti, as enriched with friezes and marbles by Ferrarese architects. The reed-like moulding on the arches, such as is to be seen in the loggia of the Dresden Annunciation, shows us that he found his models in the architecture of his own town. Mantegna, the greatest painter of Humanism, wished to reproduce the ancient world in his great statuesque paintings. Francesco del Cossa found types of plastic strength in the forms of his great model.

THE CREMONESE Antonio Cicognara was a follower of the early forms of Francesco del Cossa. He is easily recognizable by his pale colouring and oval heads, out of proportion to the short bodies. Of his works we know a small signed altar-piece in the Cologna collection in Milan, a little picture in the Accademia Carrara at Bergamo, and a triptych (with the central panel missing) attributed to the school of Andrea del Castagno in the Edinburgh gallery.

Francesco del Cossa had a greater number of followers in Bologna, who derived their inspiration from his later works. The author of the Dreyfuss diptych, representing Giovanni II Bentivoglio and his wife Ginevra, shows, in his chastened colouring and reduced relief, the forms of Cossa's altar-piece in the Pinacoteca of Bologna. Another painter, the author of an Annunciation in the Massari collection in Ferrara, differs from his model in the sweetness of his figures and in his scrupulous symmetry. Related to the latter master is also the author of a tempera altar-piece in San Giovanni in Monte at Bologna, dated 1493. It is an imitation of the group of the Madonna and Child in Cossa's altar-piece in the Bologna Pinacoteca, but the whole aspect is gentler, while the hair of the angels now twines in graceful curls, and the chapel is filled with decorations. Probably this follower of Francesco had seen the works of Francia, and endeavoured to imitate their religious sweetness and their painstaking illumination.

In Romagna there is Leonardo Scaletti, a painter of delicate and bloodless figures, far removed from the plastic modelling and rough power of the master. In his picture in the Faenza Pinacoteca he recalls the art of Francesco by his backgrounds of jagged rocks, by the profiles of the little figures standing out against the light beneath an arch, and by the decorations of the arch closing the niche of the Virgin. There is a particular gentleness in this picture, due to the grace of the slender, anaemic figures, with their eyes half-closed as if shrinking from the light. The painter is incapable of giving relief to the figures, and brings slenderness to the verge of caricature in the portrait of the saintly monk, but he finds accents of peculiar gracefulness in the group of the Virgin and Child and in the four little angels at the foot of the throne.

FORMS of art similar to those of Cosmè Tura and Cossa, and connected like them with the Paduan school of Mantegna, are found, in more modest proportions, in Modena, in the work of Agnolo and Bartolomeo degli Erri.[65] They belonged to a family of painters and worked together on the altar-piece for the Oratory of the Ospedale della Morte in Modena (now in the Galleria Estense), for which Agnolo had been commissioned, but

which was finished by Bartolomeo in 1466. In its rich and heavy frame in the Late Gothic *Plate 39*
style, with lobed arches, little flanking turrets, and pinnacles in which there rise figures of
St. John and the Virgin in poses reminiscent of Giotto on either side of the Crucified, one
can distinguish the two hands with sufficient certainty. The central part, with the Corona-
tion against the background of a choir filled with little angels praying in the stalls, and a
gallery occupied by a group of singing angels, shows signs of the influence of Cosmè in
the bony head of the Christ. There is also an evident Paduan note in the choir itself adorn-
ed with panels of dark marble and a gallery with balustrades, from which a harmoniously
designed group of rosy-cheeked angels looks out and bends over the psalter, zealously sing-
ing the lauds of the Virgin. Forms akin to those of the Virgin and the Christ, and clearly
dependent upon the Paduan school, can be seen in a Madonna and Child in the Museo
Civico at Padua, and in two parts of a predella with scenes from the life of St. Jerome,
in the Brera Gallery at Milan, characteristic in the clearness of the composition and in the
little figures with angular, broken and fragile contours.

Bartolomeo degli Erri, on the other hand, who was probably the author of the predella
and of the pairs of saints in the wings of the Modena triptych, and who is distinguished
by a greater breadth of form and by rounded contours after the manner of Cossa, is easily
recognizable in the stout and placid Madonna and Child of the Strasburg museum (once
in the possession of a Modenese family), very similar to the St. John the Evangelist of the
triptych. His hand is also distinguishable in a series of little panels transferred from a pri-
vate house to the Museo Civico of Modena, and representing traditional figures of fa-
mous women.

The masterpieces of the Erri are, however, the twelve little pictures of the life of St. Vin- *Plates 40-43*
cent Ferrer in the Estensian gallery in Vienna. But they are all indubitably by a single
hand, and I believe I can recognize that of Agnolo by means of the many Paduan fea-
tures, united to elements drawn from Tura and Cossa, and in the types of the figures with
minute traits thrown into relief by glassy lights, instead of the broad and rounded features
proper to the works of Bartolomeo. In the whole series of pictures the painter presents him-
self to us with all his undoubted merits and the conscientious humility of his work. He
is as sure of his perspective as the Lendinara brothers, and aims at gradations of luminosity
in the transparent half-lights of the cloisters, of the little courtyards of the bourgeois houses
or of the vaulted naves of the churches. He avoids all noisy effects, and shows a fondness
for quiet colouring. He uses pale tints for his costumes and golden reds for his brick archi-
tecture and he paints flesh in monochrome with vitreous reflections. He is a robust pro-
vincial, square-shouldered and solid and sure of himself. While Francesco del Cossa, in

the scene of the Resurrection of the Child cut in pieces by its Mother, throws everything into confusion and disarray, as if a gust of madness were sweeping through space, and distorts his lines and gives trumpet tongues to his enamel-like colours, the Modenese Master gives us quiet figures, in composed attitudes, set in orderly spaces. He does not disturb the silence with the vivacity of a gesture; nor does he vary from the fair order so dear to him. Fifteenth-century Modena has no work greater than this, in its admirable simplicity and clearness of vision.

ERCOLE DE' ROBERTI[66] is the last of the great triad of leaders of the Ferrarese school. He is the aristocrat, the nobleman, among his violent and unpolished predecessors, introducing into art a note of calm, a sense of proportion, a delicacy, which at times bring him near to Giovanni Bellini. The chief source of Ercole's inspiration is Francesco del Cossa, to whom two precious fragments of a youthful work of his follower were attributed: St. Catherine and St. Jerome, formerly in the Benson collection.

The two Saints appear to us in the delicate half-shadow of a niche hollowed out of the wall itself, as in the St. Anthony Abbot of the Auspitz collection at Vienna, draped in mantles with broad folds which seem to stand upright, as it were by their own force. Their features are very small, their fingers are thin and flexible, their attitudes lively and ready. In the St. Jerome the subtle eyelids seem to vibrate, and the expression of thoughtful meditation is far removed from the sullen dignity of the St. Jerome of Francesco del Cossa. In the little figure of St. Catherine, the dainty girdle and the veil filigreed with pearly light, a crystalline ornament to the shapely head, are characteristic marks of Ercole's style. The dry tall figure of St. Anthony Abbot, held at supreme tension, and all resplendent in the reflection of the folds like the facets of a crystal, is more clearly detached from the manner of Francesco del Cossa. One almost sees in this image of adamantine solidity and nervous construction the prelude to the dry forms of the St. John Baptist at Berlin. The pointed folds of the mantle bring it near to the figure of St. Anthony Abbot, which in its turn differs, in the softness of the hands, from the St. Apollonia, which the Louvre has made up into a diptych with another marvellous figure in a niche: St. Michael, an image of iron clad in iron armour.

Another work of his is known, belonging to the period of the influence of Cossa. It *Plate 44* is to be seen in the Edinburgh gallery under the fantastic name of Francesco Mosca. In this delightful little picture Cossa's partiality for baroque flourishes and intricacies of line is united to the dignified rigidity of forms proper to Ercole. The sacred figures and the light

48

blue sky, traversed by white filmy clouds, appear within a simple wooden frame, to which are attached the remains of a metallic foil, all twisted and curled, and similar to the paper-like veil framing the swan-like neck and astonished head of the Virgin. The colour has the shrill and mannered tonality of Ferrarese enamels in the intense green of the Virgin's mantle and in the ruby slippers on the pointed feet of the angels, whose black wings pierce the sky. Strength and delicacy of outline and colour go to the making of a perfect master-piece. The slim and rigid figures, like rare flowers, rise up against the wind-swept sky with an elegance of line proper to Ercole only on Ferrarese soil. The flesh is transparent, the little heads of the angels are adorned with flaxen curls, and the sleeping Child, similar to the one on the lap of the Berlin Madonna, seems made of glass, so fragile and transparent it is, clinging precariously to the Virgin's girdle. Never did the art of Francesco del Cossa, of which we are here so often reminded, possess notes of such refined elegance as are found in this crystalline picture, with its rigid forms amidst the disarray of draperies fluttering in the wind of a frosty morning.

In the divine little picture of the Berlin gallery Ercole de' Roberti is still farther away *Plate 45* from the forms of Francesco del Cossa. The painter recalls the style of Cosmè in his treat-ment of the subject of the Virgin with the Child lying on her lap, a subject beloved of the Vivarini and treated with profound sweetness by Giambellino in his painting in the Ac-cademia at Venice. The tall figure of the Virgin is set on a throne adorned with elegant candelabra and rises like an icy lily on the dark background of the tapestry; motionless in body, she bends her glance on her Child. In Cosmè's altar-piece in the same museum the hands of the Mother have the tips of two fingers joined like iron hooks. The hands of Ercole's Virgin are similarly arranged, but form a Gothic arch of ethereal transparency and lightness. His blues, reds and greens are still precious enamels, but the light lessens the intensity of the red and blue around the white figure.

The altar-piece of the Brera Gallery, which Ercole was commissioned to paint by the *Plate 46* Canonici Portuensi, recalls, in the composition of the figures and the throne, Cosmè's altar-piece in the Berlin Museum. Thus, through the open-work pedestal of the throne, there appears the sea; the figures in relief in the spandrels of the arch are on a background of golden mosaic, while monochrome reliefs adorn the foot of the throne. But whereas in Cosmè's picture the sumptuous throne harmonizes with the rich decoration of the chapel and as it were fills it, in Ercole's picture the architecture, in spite of the rich orna-mentation of the chapel, is left slim and airy, and the throne becomes narrower at the top, so as to allow the light of the sky to flood the scene freely. Empty spaces — which are few in Cosmè's work — here predominate. The glaring baroque of the decoration disappears,

49

and the ornamental elements acquire clarity and order in the clear-cut composition. From its broad and light base the throne tapers and lengthens out, forming a niche for the figure of the Virgin, a flower of humanity. On her face there is none of the steely energy of Cosmé or of the simple and profound tenderness of Giambellino, but there is an ideal sovereignty. Moral elevation and peace take the place of Cosmè's overwhelming restlessness. Similarly, in the monochrome ornaments, each of them a masterpiece, the severe Roman classicism of Mantegna is transformed into archaic elegance; the poses are restrained, and at the same time living, in spite of their archaic rigidity; they are stylized as in ancient Greek reliefs.

Plate 47 Akin to the Milan altar-piece is the little picture representing the Expedition of the Argonauts, attributed to Parenzano in the Paduan gallery. Near a panorama of cliffs and shores dotted with round shrubs the ship appears between the half-columns of an elegant loggia, in which the stamp of the Ferrarese Renaissance is clearly visible. The peculiar arrangement of the scene, the sumptuous elegance of the ship, which seems to carry to a tournament knights led by a gigantic Hercules, the city in the distance, almost carved out of the living marble of the cliffs, remind one of some theatrical display destined to amuse the leisure hours of a court. The two knights emerging from a narrow defile have the clear-cut and minute features of the figures in the Brera altar-piece. The cliffs are not the confused and shapeless masses of Parenzano, who could never have known how to give such alabaster transparency and such clear-cut outlines to the buildings, nor have imagined the sinuous elegance of line which harmonizes the slim body of the little knightly figure of Jason with the energy of the beaked prow and the baroque shield. Everything reveals the genius of Ercole, his aristocratic refinement, his masterly sureness of touch. A comparison of the curved figure of Jason with that of a soldier in the drawing for the relief of the Massacre of the Innocents, which adorns the throne of the Brera Madonna, will further confirm our attribution of this picture to him.

Plate 48 The peculiar features stamped by Ercole de' Roberti on the chiaroscuro of the Brera altar-piece may be found again in the admirable picture of St. John the Baptist in the Berlin gallery. The figure rises tall and spectral from the earth parched by the blood-coloured heavens. The squalid landscape, an arm of the sea among arid cliffs and rocky hills, stretches out, indeed, as it were, flattens out, to form a base of layers of schist for the worn figure of the ascetic, which rises solitary, with the iron cross, in the torrid light of the sky. The mantle, falling back to the ground from his shoulder, is gathered together like a stalactite to prop up the bronzed body.

Plates 49-52 Of the paintings executed by Ercole for the Garganelli chapel to carry on the work of Francesco del Cossa, only the drawings remain; and the wonderful altar-piece once in

50

San Giovanni in Monte is now partly in Dresden (the Agony in the Garden, the Betrayal and the Road to Calvary) and partly in the Roscoe Museum at Liverpool (the Pietà).

The parched plateau from which rises the figure of Christ praying beneath the dawn, is the only example of a romantic landscape in Italian fifteenth-century art. The Apostles, Mantegnesque in form, are asleep, either stretched out like slabs of stone, or curled up like rocky heaps in that desert world overhung by the shades of night. A solitary cliff towers on the right like a monumental sphinx rising from the sands of the desert, and watches like a petrified monster over the Victim's prayer. The shadow cuts into the motionless profile of the Redeemer in the light of the dawn which the white-clad angel brings with him, and lights up the garment of Christ and the mantles of two of the Apostles. Ercole de' Roberti and Giambellino, treating the subject of the Agony in the Garden, both reveal their descent from the art of Mantegna, but while the spirit of the Venetian induces him to surround Christ with a varied and gay landscape, lit up by the fresh light of the morning, and to express the calm breathing of sleep in the figures, an entirely different spirit makes the Ferrarese set his Christ in a tragic solitude, and transform into granite the figures of the Apostles, sublime examples of plastic synthesis.

The breath of tragedy which pervades the works painted in the Garganelli chapel reaches its climax in the group of women round the fainting Virgin and in the Liverpool Pietà. The gloomy cliffs of the first repeat the line of the group of figures tapering into a pyramid, while from the levelled ridge a sharp peak pierces the sky. There is not a plant, not a trace of vegetation in that parched and fearsome world whence all life has fled. The landscape, romantic in its poverty, is a living part of the scene. A powerful dynamic effect is produced by the contrasted oblique positions of the rugged mountain and of the group round the two thieves.

Between the two paintings, the one representing the Agony in the Garden and the Kiss of Judas, and the other the Journey to Calvary, there was the Liverpool Pietà. Far away *Plate 53* in the distance, like luminous ghosts in a haze which deprives them of colour, people crowd round the three tall crosses standing out against the misty sky. In the foreground, which is separated from the crowd by a row of rocks, is seen in tragic solitude the group of the Mother and Son, framed in by the dark mantle of the Virgin as by a funeral pall. The whole of the spectator's attention is concentrated upon the Virgin, all absorbed in her grief, and upon her worn countenance, which seems to flicker in the light like a flame about to die out. With her thin and contracted left hand she touches the beloved body, overcome by cruel death.

For its human sweetness, the St. John the Evangelist, in the Accademia Carrara at Ber- *Plate 54*

gamo, can only be compared with the art of Giovanni Bellini. The youthful figure, in its bright-coloured garments, is relieved against a dark column and the light background of a massive wall, while through the alabastrine flesh there shines a light, clearer and more precious than that of marble. The mantle and the edge of the tunic still have the metallic curves and the broad folds beloved by Cossa. The curls of the hair, twisted, as it were, one by one with the delicacy of the goldsmith's art, and pointed in different directions, make a flowery garland round the head of the Saint, who gazes straight before him with pure eyes, and daintily holds the palm of martyrdom and the rich chalice. He stands within the holy enclosure above fields from which rise tapering cypresses.

This figure of thoughtful grace and incorruptible candour, rising beneath the folds of the mantle in a monumental pose worthy of Piero della Francesca, is the last certain work of Ercole de' Roberti, who transforms the thorny acanthuses of Cosmè into stiff lilies and frigid blooms. Like Cosmè and Cossa, he possesses the nervous vitality which breathes in every manifestation of the early Ferrarese Quattrocento, and closes the finest period of the Emilian Renaissance before Correggio. Neither the artificial Costa nor the pure and devout Francia was destined to bring these glorious times to life again.

To the last decade of the fifteenth century belongs a group of works which show the influence of Ercole, without reaching his perfection and strength.

The first is a painting of Medea and her children in the Cook collection at Richmond. The face of Medea, contorted by her cries, recalls certain types of women of the predella of the Milan altar-piece. Her hands, with their slender fingers, and the ivory tones of the back of one of the children, recall the St. John the Evangelist of the Accademia Carrara. The numerous flowing folds of the mantle also show some connection with those of the woman leading a child among the crowd following Christ in the Milan predella. An illuminator's hand, perhaps that of Gian Francesco de' Maineri, has painted the cap of Medea, her hair, lit up strand by strand, and the little golden flames which flicker from the symbolical base of the cornices and broken columns.

Another work which shows an unmistakable connection with the art of Ercole de' Roberti is the Strozzi altar-piece in the London National Gallery, where one can detect, as later in the paintings of Costa and Francia, traces of Venetian influence. The St. George, in his emphatic pose, recalls the Venetian altar-pieces of the school of Antonello, while the round head of the angel reminds one of the similar translucid ball out of which the Messinese has carved the head of the Child in the arms of the Benson Madonna. The contours of the mantle which unfolds from the lap of the Virgin, though softer, are reminiscent of the metallic contours of the mantle of the Bergamo Evangelist, which is also re-

called by the hand, with its flattened, slender fingers, detached one from the other. However, the character of the figure is changed by the soft shadows which encircle the eyes, mould the traits, and mark with a peculiar softness the relief, up till now determined by the geometrical construction of the planes. In spite of the gracefulness resulting from a search after nuances, and the feminine beauty of the face of the St. George, one feels, looking at these soft and polished figures, that this sentimental gracefulness is all at the expense of strength and style. The languid and soft figures of Costa come very near to this Virgin with her dark-circled eyes and the figure of the Evangelist, and a comparison between the London altar-piece and Costa's St. Sebastian at the Uffizi would in itself be enough to establish such an affinity.

The St. John the Evangelist of the Budapest Museum of Fine Arts is probably by the same hand. Like Ercole's Bergamo St. John, the figure rises from the ground, merely indicated by the tops of cypresses and rocks in the diffused light of the sky. But the indolent figure assumes an S pose, with undulations which seem to presage the rhythm of Correggio. The velvet mantle opens into broad and harmonious folds. The beautiful head is inclined, as if dreaming, to allow our eye the better to follow the grace of the contours and of the spiral curls, similar to those of the St. George of the London altar-piece, and illuminated in the same way. In this picture, with its delicacies of line and light, and a softness prophetic of Correggio in the eyelids and the tender lips, the colour is still more harmonious than in the London altar-piece, and the red glare of the horizon is reflected on the hands, and lights up the ruby of the mantle. No documentary evidence bears upon the authorship of these two works, attributed by Morelli to Ercole Grandi, and by me, in the third part of Volume VII of my *Storia dell'Arte Italiana,* to Ercole de' Roberti.

Documents are also lacking concerning two other pictures, once attributed, like these, to Ercole Grandi — the Pietà of the Blumenstihl collection, and the Deposition from the Cross, once in the Santini collection at Ferrara. In the first, Mary kneeling at the feet of Christ and the old man crossing his hands on his breast recall certain types in the procession in the Dresden Journey to Calvary, while the Magdalen, a plump housewife, with dull eyes and affected gesture, and a languid Judith under the curve in the archway, are far beneath the great art of Ercole in the vulgar and excessive sweetness of the faces and in the spineless rotundity of the figures. The tone of the colouring is warm, with prevalence of loud reds, in harmony with the dramatic gesture of the St. John, and the rhetorical sweep of the arch.

The Deposition, which passed from the Santini collection into the possession of the antiquary Tavazzi at Rome, was finished at a much later date by Bastiano Filippi; only

53

the Virgin, the Mary Magdalen, the Christ, and the St. John belong to the Master of the Blumenstihl Pietà, reproducing its types, especially in the puffy-faced Magdalen and in the St. John, who clasps his fingers with such force as to form sharp angles.

Like Francesco del Cossa in his last period, the painter seems profoundly influenced by the art of terracotta, and makes his figures stand out from the background like statues in the round. Strong in his plastic elements, he confines himself in the Deposition in the Ferrara gallery merely to hinting at the stone base beneath the drawn winding-sheet which marks its sharp outlines. The winding-sheet itself is like marble, as is the polished nude of the Christ and the graded folds of the scarf on the shoulder of Nicodemus. The elements of the composition are simplified in the extreme. The oblique pose of the Virgin is sufficient to mark the depths of the space. The locks of John are transposed into fine silky curls, and the painter renders the velvety softness of the lips of the Virgin and the expression of death in the Redeemer's head, furrowed by short deep shadows. But above all he delights in bringing out the strong build of John and the plastic value of the Christ and of the Virgin, flattening the folds across the bosom so as not to hide the careful modelling of the body.

These are the works which approach most nearly to the art of Ercole de' Roberti, whose fame reached great heights. Vasari, who mentions only one Ercole — Ercole da Ferrara — relates his life in a way which he reserved for only the greatest non-Tuscan artists. With Ercole the Emilian art of the Quattrocento closes its most glorious phase, from the steely harshness of Cosmè to the stiff elegance of the Edinburgh and Berlin Madonnas and the tragic *élan* of the Liverpool Pietà.

Plate 55

GIAN FRANCESCO DE' MAINERI,[67] who undertook to finish an altar-piece that Ercole de' Roberti had been commissioned to paint in 1494, was both illuminator and painter. It has been possible to reconstruct his work on the basis of a signed picture from the Testa collection in Ferrara. It represents the Holy Family against the background of an altar, within a niche adorned with Lombard designs; the Virgin is seen in the act of raising a veil from the couch of the Child, while Joseph, Montagnesque in type, looks on adoring. The delicacy with which gold threads are interwoven in the edges of the garment, the fineness of the hair, the web of the veil raised by the Virgin, the crystalline haloes, reveal the illuminator. The subject was repeated more than once by Maineri, with slight variations. In the Kaiser Friedrich Museum picture we even find again the little statues of Adam and Eve on each side of the arch. In the Prado picture the same Holy Family is placed on a

landscape background, and even in the case of the picture in the museum at Gotha, where the painter represents the Virgin and Child alone, he repeats, with the omission of Joseph, the group of the Holy Family once in the possession of Elia Volpi in Florence. Above everything else in his paintings, Maineri takes a delight in adorning his marbles with delicate filigree designs, and in reproducing with a Flemish minuteness the vitreous reflections on the neat caps of the Virgin, the silvery locks clustering on the forehead of St. Joseph, and the gossamer veils. The illuminator supersedes the painter. Like all his fellow-countrymen towards the end of the Quattrocento, in his monotonous repetitions of the subject of the Holy Family, beginning with the Testa picture, which is still hard in its lines and marble-like in colour, he tends more and more towards soft shades and poses of sentimental tenderness.

This sentimentalism becomes more and more visible in another subject dear to this painter — Christ bearing the Cross. There are many versions of this composition; in the Este Gallery at Modena, in the Doria Gallery at Rome, in the Uffizi at Florence, in the Palazzo Mazzocchi at Rome, and in the Palazzo Donesmondi in Mantua. Here too the illuminator aims above all at giving the subtle texture of the eyelids, at interweaving rays of light among the flowing curls, and at rendering the movement of the wrinkled skin on the contracted hands, and the fibres of the wood of the Cross. The colouring is fluid and brilliant. The expression is pathetic and tends to the rather sickly pietistic sentimentalism of a fifteenth-century Dolci.

The picture of the Flagellation of Christ at Richmond is like the page of an illuminated missal, recalling the Venetian scenes of Carpaccio and Mansueti, and not lacking in northern features. The connection with Venice is again found in the landscape of a Madonna in the Accademia Albertina at Turin, one of Maineri's finest works for the thought- *Plate 56* ful grace of the face and the subtlety of the light playing on the shining colours.

The Birth of St. Dominic in the gallery of Vicenza is very near to Ercole in the types, in spite of the Mantegnesque putto. It is one of his works in which the painter has set himself especially to illuminate the candelabra with minute patterns and to draw the veil which covers the head of one of the women with the fineness of a spider's web, and to give the transparency of the most delicate ivory to the complexions of his personages.

The diptych of the National Gallery representing the Nativity and Christ in the Sepulchre adored by St. Jerome approaches this picture and its miniature-like refinements. Nearer than any other painting of Maineri's to the style of Ercole, it is a work of extraordinary delicacy. The pure Virgin, whose face is, as it were, illuminated by the crystalline veil, with her slender fingers clasped in prayer, recalls to our minds the white Madonna of the Ferrarese master in the Kaiser Friedrich Museum at Berlin.

THE ART of Ludovico Mazzolino [68] is an offshoot from the vigorous tradition of Ercole. He is a painter of joyous pictures where ruddy tints illuminate round-shaped heads and nudes, and where the lively poses, the massive bodies, the noisy clash of colours, remind one of the merry Kermesses of the Flemings. However, this gay artist shows himself to be among the most faithful heirs of Ercole in one of his earliest works, the Cassel Pietà, conceived, no doubt, under the influence of the Liverpool picture. We do not see in the distance the three crosses upon Golgotha, nor the two soldiers carrying away the ladder. The tragedy is over. The Mother, alone, in the shadow of a desolate cliff, contemplates the body of her Son, done to death. There are no clearly-defined details —neither the marble base nor the slopes of Golgotha, painted in with dashing rapidity. Yet precisely this lack of definition contributes to the impressiveness of the scene. The cliff seems about to topple over upon the group, glowing in the light of a fiery sunset. The arms of the Virgin, extended in a zig-zag line, her contracted mouth, the tension of the veil which tapers down to two points, the broken lines of the figure of Christ, seem to pierce that solitude with cries. More than any other Ferrarese, Ludovico Mazzolino seems to have been acquainted with German painting.

Plate 57

Even in this work, which is so close to the style of Ercole, and more especially in the drawing made for it, the Christ, with the harsh shape and the pitiless dryness of the contours, recalls the Basle Holbein.

When, at a later date, Mazzolino returns to the subject of the Pietà, in the Doria Gallery in Rome, without the guidance of the wonderful art of Ercole, he gives us one of the usual compositions, where everything runs in curves: the outlines of the groups, of the heads and round figures, and the background composed of strange, spaceless landscapes and marble fragments with vitreous reliefs. But here too, if the type of the St. John distantly recalls Ercole, the contortion of the line of the features in the heads of the old men and of the women shows how close the painter stands to German art.

In a late picture, the Lineage of St. Anna, at Florence, in which the figure-group is profiled against a phantasmagorical construction of crystal under moonlight, the aged Joachim recalls the personages of Dürer, and the curly-haired St. John Evangelist the round heads with abundant locks of Lucas Cranach. The forms are repeated without variation in the numerous pictures of Mazzolino scattered throughout the galleries of Europe: the female heads with waxy pallor, draperies of red, azure, orange and green, folds with lines and outlines built up of a system of curves, rounded figures which from a distance seem mere heaps of many-coloured balls. Examine from a slight distance the Passage of the Red Sea in the gallery of Dublin. It is like a festive shower of multi-coloured billiard-balls

spilt over a table! All the artistic impressions which guided the painter, all the reminiscences of Ercole, Costa and Francia, and of the German examples certainly seen by him are confused in his strange and joyful invention.

A LESSER Ferrarese master also follows in the footsteps of Ercole de' Roberti. This is Michele Coltellini, whose first work, dated 1502, the Death of the Virgin, was once in the Santini collection at Ferrara. One finds in it the forms of Ercole, though as it were shrivelled, fleshless and carved in wood. The group of angels round the Redeemer, who bears the soul of the Virgin, are an echo of Montagna. The same sharp-featured figures are repeated in the altar-piece of the gallery of Ferrara and in the picture in the Kaiser Friedrich Museum in Berlin, representing the Redeemer with Saints, where we have three exceedingly long, stiff figures in a row, with small wooden heads on immensely tall bodies, and two others kneeling in the foreground with the usual long beards and sharp unsymmetrical features. The painter lacks the most elementary sense of proportion, as is easily seen in the fingers of the hands, and in the long thumb of the Dominican saint, like a flexible rod. The influence of Francia, Costa and Perugino modifies Coltellini's figures in the picture of 1506, once in the Santini collection, but the new models infuse no new blood into the art of this poor Ferrarese painter of marionettes.

Some echo of the forms of Ercole is also to be found in the earlier works of Domenico Panetti, who, beginning with the picture in the Kaufmann collection in Berlin, dated 1503, comes nearer and nearer to the art of Costa. Superior to Coltellini, he obtains gay notes of colour from the carpets, from the decorations on the throne, and from the garments of the curly-haired St. George in the Kaufmann altar-piece. He draws with broad sweep the figures of the three saints in the Bergamo Accademia, and infuses depth into the melancholy landscape of the picture in the Kaiser Friedrich Museum, until he finally appears completely bloodless in the Visitation in the Gallery of Ferrara, in which he follows the latest style of Costa, lengthening and narrowing out the figures, which betray uncertainty of equilibrium. Everything seems to be on the point of falling — Anna, who leans towards the Virgin, and the trees which raise their enormous tufts of leaves above trunks as bare as broomsticks. There is a progressive diminution in the life of the figures. Their movements seem to be restrained and suffocated by conventions. This weak master disguised the poverty of his imagination beneath the brightness of his colours, and his work, as a whole, though not without technical merit, betrays a mechanical operation, which is industry rather than art.

FROM Ferrara and Bologna the influence of Ercole reached Modena with Francesco Bianchi Ferrari.[69] He is a painter of devout and melancholy figures, with little relief and construction, defined in their smallest details, from the bright curls to the minute folds, with bloodless, delicate flesh, often set off by beautiful ruby-coloured velvets. His first work, the Crucifixion in the Estensian Gallery in Modena, shows how he tries to follow Ercole, whose oblong facial type he aims at repeating, in making the scene lifelike, from the crowd round the crosses to the convulsive agony of the impenitent malefactor and the peacefulness of the Christ and the penitent thief. But where Ercole sounds the highest notes of tragedy, Francesco Bianchi Ferrari merely gives us pious images, languid with grief, or horrible faces fit to frighten children with. This gentle painter is incapable of rendering the life of the crowd or the true proportions of the various figures, or of constructing the landscape, with its strange rocky pinnacles. His figures are flat, like long boards covered with beautiful draperies, and he renders the luminous contours of the faces, the embroideries on the caps, the gold rings and the shiny red mantle of the Magdalen with the precision of an illuminator. From a distance, the picture looks like a great page from an illuminated missal.

Yet, though incapable of real construction, he sounds delicately graceful notes in the large altar-piece in San Pietro at Modena, both in the little wax-like angels on the steps of the throne, and, above all, in the cherubs floating among the clouds beside the Almighty, in the upper part of the picture. These cherubs, in their vaporous lights, are preludes to the vision of infant grace created by Correggio in the Dresden altar-piece. Still more than in his first picture, the Modenese here proves himself to be a fine colourist, lowering more and more the tone of the flesh, making the base of the throne of precious agate, crowning the little angels with jasmine garlands, and shedding the light of the clouds on the heads of the cherubs in the gable. Every gesture is delicate, every tint is choice, to make up for the poverty, weakness and uncertainty of the forms. As in the art of Francia, the countenance of the Virgin reflects the peace of the cloister.

Plate 58

Plate 59 The Christ in the Garden of Gethsemane, in the Corsini Gallery in Rome, and the St. John at the Louvre are painted by Bianchi Ferrari with religious fervour and with the diligence of the illuminator, but they are sacred images for the devout, the work of a fifteenth-century Dolci. In the former the breath issues from the half-open mouths; in the carefully disposed curls one can detect golden hairs worked in like filigree; little glassy tears trickle from the eyes of the Christ, while a groan seems to issue from the lips of St. John. The little Baptist at the Louvre, with his sharp profile, the slight relief of the alabastrine flesh, the contours marked by a thin ray of light on his slender arm, and the golden sheen

of the hair, is a typical work of this painter, in whom the Emilian artistic tradition, principally based on the statuesque types of Mantegna, attains a timid bloodless grace, loses all relief, and acquires a glassy brittleness of aspect. The pictorial statuary of Mantegna and the geometrical construction of Ercole are turned into mere illumination and images for the devout. Akin in style to Bianchi Ferrari is the author of a *Christ in the Sepulchre* in the Estensian Gallery at Modena, which suggests, in its strange manner of touching with red the greenish flesh tints, the name of Antonio Scacceri, who was commissioned to complete the *Annunciation* of the Modenese master in the same gallery.

The art of Reggio, like that of Modena, revolves around the orbit of the painters of Ferrara and Bologna. Two figures of angels with the monogram of St. Bernardino, painted on a small chest in the museum of Reggio, are the work of a superficial imitator of Tura, while another minor artist of that city, Francesco Caprioli, who presents himself to us in a *Baptism of Christ* painted in fresco on a wall of the Baptistery of Reggio, approaches the manner of Ercole de' Roberti, with forms not unlike those of Bianchi Ferrari, but flatter, more emaciated, and more uncertain.

ERCOLE DE' ROBERTI's paintings in San Pietro at Bologna served as models for Francesco Francia.[70] His facial types, inscribed as it were in a rectangle, lived once more in the panels of this pious goldsmith painter, who transformed the strength of Ercole into religious compunction and ever infused the silent peace of the cloister into his serene figures and calm, clear-cut landscapes.

From the models of Ercole he borrows the oval face of St. John, and still more the curve of the head of St. Jerome in the *Crucifixion* in the Museo Civico at Bologna, drawn as with the compass. But there is here no echo of the tragic impetus that Ercole breathed into his scenes of the Passion, with their gloomy backgrounds and anguish-stricken figures. The goldsmith in Francia dots the country-side with little trees touched by golden lights against the green and blue hills, and carves out two hollows on the hillside so that the saints may have their niches, and so that the shadow may set off the full value of the brightness of the hair like spun gold, of the drapery of rare metals and of the gemmed borders. The nude figure of the Christ is of a polished ivory, unmarked by shadows. Whereas Ercole broke his lines to express the anguish of his tragic figures, Francia's patient hand draws them out in peaceful continuity. It is the hand of a mediaeval monk who introduces into painting the quiet of the cloister. The image of God must be beautiful, serene, untouched by pain. Precious stuffs must clothe the flesh of the saints. No sound must

Plate 60

59

disturb the silence of prayer. Thus the mild Francia continued to paint, from his first works where the goldsmith still predominates, to his last, broader and more plastic paintings of the sixteenth century, aiming at harmony of line and clarity of colour, and inspiring into his figures the formal dignity which Raphael was to inherit from him through the intermediary of Timoteo della Vite.

Plate 61 The Nativity in the Glasgow Corporation Gallery clearly shows itself to be a derivation from the school of Ercole. The minute proportions of his figures, the enamel finish of the draperies, the patient chisel-work which embellishes every detail, the golden filigree designs on the beauteous garments of the angels, on their wings and their curly hair, the ruby of the Virgin's tunic all show us the delicate craftsman in Francia, accustomed to chisel silver in order to reveal its glitter.

Plate 62 The little picture of the Martyrdom of St. Stephen in the Borghese Gallery in Rome looks like a metal plate slightly embossed, and is one of the rarest gems which ever came out of the workshop of this painter, for the fineness of the gemmed arabesques in the yellow satin which adorns the dalmatic, for the marble decoration in slight relief, transparent, with varied gradations of light. The head, with its sweet expression, is set off by a splendour as of enamels and jewels. Like the Bologna St. Jerome, who turns three-quarters round to look, not on the Cross, but outside the picture, and like the little Glasgow Madonna who turns her pretty demure face to the spectator, so this St. Stephen does not seem, so to speak, to live in his martyrdom, but tries to attract the attention of the people by his gentle countenance seamed with blood. Like Bianchi Ferrari, and like Maineri, Francesco Francia also paints pious images for the faithful.

Plate 63 We are reminded of the St. Stephen in the two angels which accompany the Madonna with the Goldfinch in the Alte Pinakothek of Munich. They are gentle maidens, with pearly lights in their large eyes and curls twisted into golden ringlets. The face of the Virgin is soft, with downcast look — a humble flower blossoming in a cloister garden — enframed by the crystalline veil which descends on the brow like a nun's wimple. Delicate garlands gracefully deck the pure foreheads of the angels. Content with revealing the beauty of the saintly figures, the painter does not hesitate to turn the heads of the angels somewhat inharmoniously, while, in a rather later panel, once the property of Messrs. Wolfrum in Vienna, he restores the proper balance by turning the heads of the angels towards the Virgin. This picture is worthy of the signature it bears: "Francia aurifex Bononiensis f."

The little trees, like golden feathers, light and luminous, which gleam from the vaporous clarity of the plain in the Vienna picture, spring up on the banks of the river in the Baptism, once in the Cassirer collection at Berlin, as brilliant and frail as the ringlets which

adorn the heads of the angels. They also sprinkle the landscape in which the St. George of the Corsini Gallery at Rome brandishes his sword like a harmless walking-stick over the monster, and that misty valley, which in the picture at the Louvre enframes the Virgin, St. Joseph, and the angels adoring the Child. In all these works Francesco Francia derives his form and types from the works of Ercole de' Roberti and his immediate followers, not without some influence of Perugino, specially evident in the last-named Nativity, in the attitude of the Babe and in the gentle little Virgin.

In other works, perhaps of an earlier date, Venetian elements are mingled with the Ferrarese in the art of Francia. He had probably been in Venice, and, like Cosmè Tura, Ercole de' Roberti and Costa, had seen the forms of Antonello mirrored in the art of Alvise Vivarini. A proof of this may be found in various pictures: in the Holy Family in the Kaiser Friedrich Museum in Berlin, where the figures are wooden and heavy, and stand out in relief, while the drapery round the head of the Virgin falls in angular curves like those of Montagna of Vicenza; in the Auspitz portrait, which also seems constructed in wooden planes, and shows the influence of Antonello in the cut of the eyelids over the motionless pupils, and in the subtle pastiness of the linen round the neck; and finally in the Bologna Christ, supported by two angels as in the Pietà of Giambellino. But in these works the characteristic expression of Francia remains intact — not indeed the profound and gentle humanity of Giambellino, but monastic peace and devotion, without mystical flights and without passion.

Like the followers of Ercole, Francia is also induced by the example of the Venetians to give plastic relief to his figures, as in the Bologna Pietà, in the Madonna in the collection of Princess Eugenia, and in his altar-pieces, especially in that in the church of San *Plate 64* Giacomo Maggiore, in which the types of Ercole are found again more rounded and flourishing, in calm peaceful poses. As in the Felicini altar-piece, we find a Venetian motive in the two angels seated on the steps of the throne.

In all these works the painter tends to draw his figures in the round, increasing the plastic values, and though in the San Giacomo Maggiore altar-piece the decoration of the capitals and the pilasters is finely chiselled, the goldsmith's work is diminished, and the line becomes calligraphic in the undulating contours of the draperies, while the figures lose their earlier freshness and delicate youthful expressions. The Virgins become grave, thoughtful and devout matrons, and seem to grow older with the painter.

In the altar-piece in the Hermitage at Leningrad we find Francia constructing, for the *Plate 65* first time, in accordance with a system which he was to maintain till the end of his life, having given up his former architectural frame-work. It is a noble and simple scheme, im-

parting a certain grandeur to the picture, in which the curve of an arch is barely suggested by means of slender profiles of trees.

In painting the Assumption in the Kaiser Friedrich Museum in Berlin, Francia places the ecstatic Saints and the Virgin in a mandorla framed by cherub's heads, and follows in the footsteps of Perugino, as also in the beautiful portrait of Evangelista Scappi and in the St. Sebastian at Hampton Court. But his own personality is once more triumphant in *Plate 66* the two frescoes in the Oratory of Santa Cecilia in Bologna (1506), especially in the scene of the Nuptials, full of monastic peace and virgin grace. The sinuous lines of St. Cecilia have a gentle rhythm, while the face of the veiled woman seems to prelude the art of Raphael in the delicacy of its design.

Plate 67 In this happy period Francia painted the Madonna of the Rosebushes in the Alte Pinakothek of Munich. A mystical hedge of roses separates the Virgin from the flowery country-side. She is bending slightly forward to contemplate the Child, and seems about to fall upon her knees. The long garment which covers her whole figure and falls to the ground, the flowing locks, the absorbed pose, all recall the St. Cecilia of the frescoes at Bologna. The rose-hedge seems to shut in the group of the Mother and Child as in a heavenly garden, and even the clouds, advancing like pointed arrows from the sides of the picture towards the Virgin's head, accentuate the effect of mystical isolation.

Already in these last two pictures one may notice the progressive elongation of the figures which reaches a climax in the Parma Deposition, in the Coronation in Ferrara Cathedral, in the Immacolata in San Frediano at Lucca, and in the Adoration of the Dresden gallery. The figures, as they lengthen, become as slender as reeds. Ribbons and scrolls are seen waving about as if, by diminishing the volume of the bodies, the painter found it easier to give them lively motions. But in this effort after movement the painter often misses the sense of balance, so that the woman running towards the Dead Christ in the Parma picture seems about to fall.

Francia, who had given full play to his fancy only when creating the Madonna of the Rosebushes, goes on repeating in his later years with but few variations his monastic Virgins and solemn infants, but at the same time he shows the most delicate rhythmical sense in the way he fits the Besançon Christ into its tondo. He here approaches the art of Raphael. He moulds with delicate relief the face of Bernardino Vanni in the Henry Heugel collection in Paris. He marks with delicate concave lines, which Raphael would have stripped of their calligraphic features, the horizon of the valley in which the Redeemer is being baptized in the Dresden picture; and in painting the Pietà in the lunette of the Buonvisi altar-piece, now in the National Gallery in London, he obtains, with the

dark background against which the beautiful silent figures are placed, that sense of mystery which affects one so profoundly in the interiors of Christian cathedrals. In one of his last works, the picture in the collection of Baron Speck von Sternburg at Lützschena, Francia repeats once more the old group of Mother and Child, serious and meditative, laying on the colour of the flesh with delicate lightness, and obtaining in the curves of the meadows that sweet monotonous harmony listened to by Raphael in his youthful days.

In the course of time Francia's figures become more and more mature, heavy and devout, but they keep their brightness untarnished. A most delicate touch interprets the ecstasy of hearts and the humbleness of faith; and familiar sentiments acquire a holy expression. Virgins and Saints rise above the bunches of flowers on the altars and bend against the blue background of skies, inviting to meditation and to silence. Thus the pious Francia, from the bejewelled works of his youth down to the Lützschena picture, recounts, with unchanging voice, his dreams of claustral silence and the aspirations of his tranquil heart.

AMONG the large number of Francia's pupils many are merely imitators, we might almost say copyists of the master's work. But the mere copy lacks that indefinable perfume of inspired art. One of the artist's assistants at the time that he was executing the Brera Annunciation and the Parma Pietà painted the Holy Family in the Barberini Gallery in Rome, forcing the figures as it were into long narrow rectangles. Another, laboriously imitating the lines of the great original, copied, in the poor Sterbini picture, the Madonna once in the Wolfrum collection in Vienna. Yet another executed the Madonna with two saints and an angel in the Museo Civico at Verona, dinting the faces, as it were, with shadows. A more able follower, leaning rather more towards the sixteenth century in his forms, painted the Virgin with angels in the National Gallery of Budapest and the Madonna and Child in the Mansi collection at Lucca. All these imitators, these *ritardatari,* who in the sixteenth century still keep slavishly to the types of Francia, impoverish the master's art in their figures, in which the devout calm is transmuted into mere exhaustion and religious unction, and the harmonious calligraphy into empty linearism, as is shown in the trailing folds of the Virgin's mantle in the Budapest picture. The climax of this artistic decadence is reached in the insipid figures of the Dresden Virgin with Jesus and John.

The hand of a Lombard follower of Francia, perhaps that Giovanni da Milano mentioned by Malvasia, is recognizable in a picture in the collection of the Prince of Trabia, at Palermo, where the Virgin, seated in the open country with the Child and a curly-haired St. Sebastian, has her face drawn on the model of the refined oval of Luini.

Iacopo Boateri was one of the most scrupulous and at the same time one of the best followers of Francia. He copies, not without a certain nobility of conception, the models of his master in his Holy Family in the Pitti at Florence and in the other in the Museo Borgogna at Vercelli, constructing the saint's long head and hand with a certain strength, while he aims on the other hand at soft subdued tints in the Wedding of St. Catherine in the Morrison collection at Boston. Of a Parmesan pupil of Francia's, Simone de' Martinazzi, nicknamed delle Spade, we only know one signed picture, dated 1504, in the Kaiser Friedrich Museum at Berlin with forms akin to those of Timoteo, but weaker — and the wretched altar-piece in the Steccata at Parma.

In the Madonna of the Raczynski Gallery in Berlin Giacomo Francia tries to break the calm of Francesco's composition with the pose of the Child, who stretches forward vivaciously from his Mother's arms to touch the wounded hand of St. Francis. Similarly, the Child Jesus of the Madonna in Glory in the Bologna gallery springs up as if to escape into the clouds from his Mother's arms. The pure and melancholy glance of Francesco's figures becomes troubled and unquiet, and a feeling of restlessness agitates the four saints round the holy group in the Louvre altar-piece, as well as the little angelic musician at the foot of the throne. In this work one begins to feel the artist's effort to approach the forms of Dosso and his attempt to give motion to figures by placing vivid lights among the shadows. But in spite of this, Giacomo Francia and his brother Giulio (who worked with him, adding his signature to that of Giacomo on the altar-pieces in the Kaiser Friedrich Museum in Berlin, in the Estense Gallery at Modena and in the church of San Giovanni at Parma) remained insignificant *ritardatari*.

Francia's forms, now turbid and bereft of his gem-like luminousness of colour, are found again in Timoteo's picture at the Brera, in the figures of the young knights, Crescenzio and Vitale, gently reclining their heads, in the little angel musician seated on the ground, and in the circular folds of the draperies round his arms.

In the general design of the figures, in the folds, and in the hair, which almost looks like a tangle of silk thread, the portrait of the Man with an apple, attributed in the Pitti Gallery to Francia and Raphael, rather approaches the Brera picture, even to the point of leading one to suspect that it is the work of Timoteo and not of Francia. The latter in fact models his faces with undulating lines, hollowing out little dimples in the shadows, whereas in the Pitti picture the surface is smooth and drawn. It is probably a late work, painted by Timoteo when he had already seen Raphael's Florentine portraits, and shows the lack of experience of the artist in his inability to foreshorten. Yet the taut skin, the line of the thin mouth and the bright glance are of rare delicacy. This portrait is a work created in

a happy moment by Francia's pupil and is not equalled by another in the same gallery, undoubtedly of identical authorship.

Francia's sweet curves give grace to Timoteo's Apollo bending his languid face over *Plate 68* the viol in the Corsini Gallery in Florence. Like Francia in the Crucifixion in the Museo Civico of Bologna, Timoteo has hollowed out a shadowy niche in the rock in the background, both for the figure of the Apollo, and for that of the Muse Thalia, which both belong to a group of pictures in which Giovanni Santi and his pupil Evangelista di Piandimeleto also collaborated. With this niche the dark background sets the figures off better.

Timoteo's most attractive works are paintings on glass and maiolica. In the small win-*Plate 69* dow-paintings at Urbino we find the figures of the Annunciation all lit up by the glitter of their colouring. The angel with his delicate curls recalls Francia, while the thoughtful Virgin, with her mass of fair hair, is a forerunner of Raphael's gentle Madonnas. The tondos of the Faenza factory, amongst the rarest works of art in the Correr Museum in Venice, waft us into a world of fairies. It was while preparing the models for these tondos that Timoteo began to diverge from Francia, accentuating the contrast between lights and shadows, and giving special prominence to certain masses of colour, until finally, in the Brera Annunciation, though it still partly reminds us of the master's work in its composition, he uses loud tints, and broken lights and shadows. The clear limpidity that illumines Francia's forms disappears, and the clouds gather dark round the halo of the Infant Jesus. The contours of the mountains stand out crudely against the sky, and reflections of light appear frequently among the heavy shadows.

Timoteo drifted further and further away from Francia in painting the altar-piece in the Duomo of Urbino, with Saints Martin and Thomas adored by Bishop Arrivabeni and Duke Guidobaldo. Here he follows in the steps of Perugino in the meticulous symmetry and in the types of the fleshless and languid Bishops. In painting the penitent Magdalen, who is but a porcelain doll with fair tresses knotted on her bosom, Timoteo had in mind the series of the Muses and Apollo, and repeated the effect of a bright little figure standing out in relief against the shadow of a grotto. He still remained true to the types of the fifteenth century, when, well on in the sixteenth, he drew his inspiration from the art of Raphael in painting the *Noli me tangere* for the Confraternita di San Michele at Cagli. Vasari, followed in this by an entire literary tradition, considered him to be the author of the Prophets in the Chiesa della Pace at Rome, and the collaborator of Raphael in many of his works. But Timoteo della Vite, who had taught his fellow-countryman Francia's gentle rhythms for the Fortitude in the Collegio del Cambio, at Perugia, the Trinity of Città di Castello, and the Dream of the Knight, was a *ritardatario* even in his latest works. For the

65

broad forms of his disciple, who had become his teacher, he substituted polished and exact ones, and brought together in his landscape backgrounds, rocks, trees, houses and roads like fragments set one beside the other, without any attempt at organic grouping. Even in the altar-piece of the church of Cagli, one of the last certain works of this painter, the echoes of Raphael are too weak to enable us to say that he had been aware of the transformation undergone by art at the beginning of the century. If the figures indeed changed, the old schemes remained as before.

THE FERRARESE Lorenzo Costa derives not from Ercole de' Roberti, but from Cosmè Tura.[71] This is clearly visible in the St. Sebastian in the Dresden gallery, attributed to Tura. Yet, if the crude vibrating contours of the traits are clear reflexes of the art of the great master, there is nothing of his steely force in the nude figure supported with difficulty by the crossed legs. An even greater weakness is seen in the structure of the little warrior — a glassy locust-like creature, whose legs, which are also crossed, would be incapable of supporting him without the help of the wall. The loin-cloth does indeed curl up, but only to form lifeless spirals and flourishes, not the master's metallic scrolls. The identity of the follower who painted the St. Sebastian is shown us by the Hebrew inscription.

The typical knotted knuckles of the fingers of the Martyr, the woolly eyebrows, the crude traits of Cosmè, are found again in the Portrait of a Musician, in the Dublin National Gallery. The unknown sitter, who is tuning his instrument to translate into action his motto " el començar non fia per tempo mai", frowns with a ruthless expression which gives individual character to his irregular and tormented features. Certainly, amongst Costa's youthful works, the Dublin picture, a rare example of a fifteenth-century portrait showing action, is one of the most singular.

The little glassy and spineless figure of the knight beside the Dresden St. Sebastian reappears, under a more youthful aspect, in the St. George, who, with three other saints, accompanies the Virgin in an altar-piece at Berlin, a hitherto unknown work of the master. In the arms of the strange seat we find again the Egyptian motives and the great rings bound with cords seen in the pillar of the St. Sebastian. Even the flowing locks, falling in a fringe over the brow of the warrior saint, are marked like little curved feathers, as in the martyr saint at Dresden. The sickly Child seated on one of the Virgin's knees has the dull expression of the Infant in the Bentivoglio altar-piece at Bologna; and the little figures in relief upon the base are drawn like those in the latter picture, while the facial traits are rounded, without any delicacy.

In the picture painted for the Bentivoglio Chapel in San Giacomo Maggiore at Bo, *Plate 70*
logna, the construction of the vaulted chapel and the figures in the bas-reliefs, tall, slender,
and elongated, recall the forms of Ercole, but, on the other hand, the round heads of the
angels, the construction of the over-decorated throne, composed of fragments and adorned
at the base with an irregular shield, the persistent rounding of every line in the faces, still
show the painter to be a follower of Cosmè, though lacking his exuberant fancy and pow-
erful energy. The sons and daughters of Bentivoglio stand in order of seniority on either
side of the throne like so many mannequins all cast in the same mould, apart from the
differences in height, with long garments covering their flat bodies. Their features are thick
and flabby and deprive their faces of any youthful freshness.

Impressions of the paintings of Ercole in the Garganelli chapel appear also in the great
canvases of the Bentivoglio chapel, which represent the Triumphs of Fame and of Death;
as, for example, in the woman with the naked child, and in the horseman in shining ar-
mour, seen from behind. But one may still note the predominance of types with coarse,
pasty features, and the figures, without any reflection of the life of Ercole, still stand straight
and silent to gaze and to be gazed at. No distance is given to the landscape. The mountains
overhang the figures, and the perspective science of the Florentines and of Mantegna seems
to be completely forgotten in the composition, limited entirely to the frontal plane. The
little groups which illustrate scenes alluding to Fame are disposed as in a kaleidoscope,
within a great enclosing circle. The rounded, swelling features, the chalky modelling
of the faces as in the Bentivoglio altar-piece, the minute and delicate meticulation of
flower-patterns in the stuffs, the knotted hands, just as we found them in the two earlier
works, reveal to us Lorenzo Costa in that follower of Tura who painted a family por-
trait in the Alte Pinakothek at Munich. This is a strange picture, in which three portly
figures, who would fit so well into a place in the row of wooden dolls of the Bentivoglio
altar-piece, cling to one another with their knotty fingers.

In the portrait of Giovanni II Bentivoglio in the Pitti, certainly painted after 1490, the *Plate 71*
year in which Lorenzo Costa finished his Triumphs, and still more in the plastic St. Se-
bastian in the Cassoli collection at Reggio Emilia, the forms acquire breadth, solidity *Plate 72*
and sculptural relief. Undoubtedly, this tendency towards painting in the round owes some-
thing to the Venetian school, and especially to the art of Antonello. In the St. Sebas-
tian the shadows are more marked, the colours crude and shining, the face derives a pow-
erful lifelike expression from the severe glance and from the nostrils which seem to be
drawing in the breath with energy. The blood circulates in the figures, which have now
become more massive.

Plate 73

The Venetian influence becomes more and more visible in the altar-piece in San Petronio at Bologna, which is Costa's masterpiece. As in the Berlin altar-piece, which I have just attributed to Costa, little pillars like glass tubes hold up the pedestals upon which stand small statues of the Virgin and the Archangel Raphael, but the extravagant architecture of the throne has become more organic, though still retaining a typical Ferrarese character. The profusion of mosaics glittering with gold above the Virgin's head, as in the chapels painted by Giambellino, the gentleness of the gesture of the Child, whose figure is now drawn with greater softness, the delicate hands of the Virgin, all show that the study of Venetian art, and, above all, of that of Antonello in Venice, had deeply affected the painter. The composition is large and well balanced, and the poses of the figures on guard around the throne, with books in their hands, are dignified, while in the head of the St. Sebastian, and in the curved fringes of the hair, the influence of the plastic art of Antonello is evident.

An Antonellian character is also imparted to the Portrait of a Youth at Berlin, derived from the usual scheme of the great Messinese, not only for the cut of the shoulders, but also for the rounded plasticity of the eye, the nostrils and the lips. The cord-like hair, and the eyelashes rendered with minute skill, the slow and bovine gaze, the broad margin of light which outlines the lips, indicate in this picture, which is attributed to Antonello, a work of Costa executed at the moment when his art enters the orbit of the Venetians.

The traces of this brief enthusiasm for the forms which flourished at Venice soon disappeared from the works of the Ferrarese. He is next attracted by Francia, at that time working in Bologna, and derives from him the devout grace of the female martyr in the altar-piece in the Bologna gallery, and the flowing rhythm of the folds. The same influence is to be seen in the grave oblong countenance and the more nun-like veil of the Virgin adoring the Child in the picture in the gallery of Lyons, as well as in the angelic

Plate 74

musicians and the weak-armed Child in the altar-piece in the church of San Giovanni in Monte. In this last picture there is no trace of Venetian influence. The painter's models are Ercole and Francia, and in the elongated figures and symmetrical curves of the Bishop-saints we already find symptoms of the trailing cadences of Costa's latest works.

The forms of the nude are still constructed in bold relief in the Christ in the Sepulchre formerly in the Benson collection, which derives from Francia the calm of its angelic faces, but already reflects, in the slenderness of the arms, in the curves of the angels wrapping the corpse, in the re-echoing spirals of the folds, the particular tendency of Costa to a calligraphic linearism, to a melody of line which is not to be found in the art of Francesco Francia, and which will be taken up and developed by the genius of Correggio.

This last tendency becomes more and more accentuated in Costa's art, and exhausts his

scanty energies even from his earliest pictures. The slender figures in the Adoration of the Magi in the predella in the Brera, which was formerly in the church of the Misericordia at Bologna, seem to quiver like flexible rods, as do those in the large picture on the high altar in San Giovanni in Monte at Bologna. As in his youthful paintings of the Triumphs, the figures of the Virgin, Christ, the Almighty, and the silly little angels are scattered about in the great flood of light. The painter had obviously seen Perugino's altar-piece, now in the Bologna Pinacoteca, and tries to give an ecstatic expression to his clownish saints, laboriously placed in accordance with a very superficial scheme, as it were along the strokes of a capital M. After having constructed, with true sense of space, following Venetian examples, Costa begins again, as in his earliest works, to decorate his pictures with superficial lines. In the altar-piece representing St. Petronio between St. Francis and St. Anthony of Padua, in the Bologna gallery, the architectural background of the chapel is replaced by an arch, barely outlined against the blue sky. The bodies lengthen out within schematic lines, and the throne, no longer so complicated as of old, continues, with its high back and the two stiff streamers falling downwards, that elongation of line seen in the dummy-like figures which resemble wooden boards wrapped in flowing draperies.

In the Circumcision and in the Deposition of the Kaiser Friedrich Museum in Berlin, and in the Ascension in the Church of San Nicola in Carcere at Rome, Costa still disposes the weak, wavering figures according to lines of superficial regularity and symmetry. Even the draperies, falling as they do in long curved folds, increase the fragility of the figures, which look like reeds bent by the wind, against landscapes which become more and more misty and unreal, while their colouring is even less clearly defined.

Thus the landscape shades off, passing from yellowish green to palest blue, in the background of the Holy Family at Dublin, and the folds of the veil and of the mantle of Mary swirl in undulating elliptical curves. The heavy ovals of the faces of the Virgin and the Child recall the example of Francia in the picture in the museum at Orleans, and the calligraphic folds of the tunic, and the little festoons formed in the veil by its hem of white light and at the neck by the black ribbon display the conventionality of a moribund art.

No one would ever realize that the affected and languid painter of these pictures was one and the same person as the author of the Dresden St. Sebastian, the seeker after Cosmesque energy; or the strong and plastic designer of the portrait of Giovanni Bentivoglio in the Pitti Palace. The sickly Virgin droops; the folds swirl in knots following the cadence of a slow rhythm.

Towards the beginning of 1506 Costa was working for Isabella d'Este's little study at an allegorical composition, now in the Louvre, suggested by Paride Ceresara, and trans-

69

formed by Costa into something intermediate between a coronation of the Virgin and a court ceremony. A lady with a long train is being crowned, in the distance, by a little genius placed on the knees of another lady. Two youthful musicians, symmetrically placed, recall the angels of Perugino, and two damsels seated in the foreground take the place of the angels that Francia used to put on the steps of the throne. Even the two standing figures by the side of these maidens are placed like saints flanking a sacred group. The figures express increasing listlessness, melancholy and timidity. They are awkwardly arranged on a vast stage and their delicate pliable bodies stand with difficulty.

In the portrait in the Lille museum, once attributed to Chiodarolo, and by me in *L'Arte* [72] to Costa, the plastic qualities still recall the works executed soon after what we may call his Venetian period, and especially the Uffizi St. Sebastian. The oval head and the hair pressed close to the forehead so as not to interrupt that regularity of volume also evoke Antonellian models. The features are rectangular; the full bust curves; the long and flexible neck is bent as it were in involuntary relaxation, letting the head with its pointed oval and salient cheek-bones emerge against its background.

In this figure, which is remarkable for the contrast between its solid construction and its languor and for its delicate charm, and which brings us back to the artist's best period,

Plate 75 there is a plastic element lacking in two graceful portraits of women at Hampton Court and in the Mumm von Schwarzenstein collection at Frankfort, both of which repeat the same type, characteristic of Costa's later works, an oval of geometrical regularity, drawn, one would say, by the aid of a compass, between elliptical contours represented by the hair and the hems of veils. In each case the pose is harmonious, with the neck drawn back to allow the face to stand out better on the shades of the background; every hair is lit up with meticulous care, and smoothed down to form a silky band round the temples and cheeks; every contour is adapted to a rhythm of curves, delicate in its superficial elegance.

Costa's figures continue to bend like weeping willows in the two pictures of the oratory of Santa Cecilia, in the *Assunta* of the church of San Martino Maggiore at Bologna, and in the St. Anna of the Brivio collection at Milan, a work amongst the best of this last period, for the harmony between the pre-Correggesque melody of curve in the mantle and veil of Anna, and the vagueness of the chiaroscuro, which gives a gossamer lightness to the landscape. Notwithstanding the absolute predominance of calligraphy over form, we find in the St. Anna and in her trailing garments a most obvious prelude to the Benson *Congedo* by Correggio, just as also the delicate angular form of the Virgin, like a tall and artificial doll, whose profile is modelled directly by the light, is a prelude to Correggio's Judith. But above all, the dainty landscape, lost in a haze of azure, leads our

thoughts to the atmosphere of the first backgrounds of Correggio. The picture in the Brivio collection forms, in its harmonious grace, an exception among the late works of Costa, who elaborated at Mantua, with an eye upon the works of Mantegna, a composition less artificial than usual for the picture of the reign of the god Comus, now in the Louvre.

Mantegna was Costa's model in the large picture of the Apotheosis of Federigo Gonzaga, ensign of the Holy Roman Church, now in the castle of Prince Clary Aldringen at Teplitz, which was intended to be hung in the palace of San Sebastiano, together with Andrea Mantegna's Triumph of Caesar. But even the heads, which are imitated in every detail from his model, lose all imperial grandeur, and, as always with Costa, the figures are bent in spineless obsequiousness. Mantegna's example could not infuse strength into the more and more indolent and bloodless Emilian artist, who had, nevertheless, issued from the powerful school of Cosmè Tura. Roman triumphal hymns could find no echo in his monotonous sing-song.

AMONG the Ferrarese who most faithfully followed in Costa's footsteps we must mention the anonymous master of the Magdalen, once known by the name of Ercole Grandi.[73] It hardly seems credible that the architect of Santa Maria in Vado should have painted pictures at Bologna without a trace of constructive value in the composition, and only an extreme fidelity to the later calligraphic forms of Costa, whose follower Grandi was, however, according to Vasari. The slender and slightly unsymmetrical lineaments, characteristic of the figures in the little altar-piece once in the Santini collection in Ferrara, are found again in the angels who adore the Magdalen in the picture in the gallery at Ferrara, together with the same pale complexions and shining evanescent plains, in which the stretches of land and water are hardly distinguishable. Both in the flesh and and in the landscapes the colours shade off, as it were, and in the latter case into watery blues. In the picture in the Noseda collection at Milan, the nude St. Sebastian, with flowing locks and the loin-cloth gathered together in symmetrical curves, goes back to the types of Perugino rather than to those of Costa, but the landscape, with curious little hills outlined in geometrical curves, fades away in the distance into the usual transparent and colourless stretches of hazy land and water. The originality of the painter, who faithfully follows the models of Costa, lies in the calmness and balance of the picture, and in the landscape stretching as smooth as a mirror towards the distant horizon.

Cesare Tamaroccio, who was working as a youth, in 1506, with Francia and Costa in the Oratory of Santa Cecilia in Bologna, assimilated something from each of his teachers.

He painted the Baptism of Valerian and the Martyrdom of St. Cecilia. In the first of these frescoes he followed with greater fidelity the polished forms of Francia; in the other he was influenced rather by the tall figures, curved folds and long trains of Costa. But this minor painter drew with difficulty. He had no freedom of movement nor could he express his subject properly. All his figures have large flattened faces and thick heavy garments, so that they look like peasants. The imitation of his models is uninspired. With equally obvious effort he painted the Madonna with the vacant smile in the Museo Poldi-Pezzoli at Milan, against the background of a veiled filmy landscape of Costesque type.

Amico Aspertini[74] also worked with Francia and Costa in the Oratory of Santa Cecilia. He made his entry into art with the Adoration in the Bologna gallery, the first example of his confused style and of his search after fantastic effects. The Babe is stretched upon the grass amid a garland of saints, with childish round flattened faces; but behind the group a chapel with angels springs up in the open country; one of the angels seems to be skipping on the arch of the frame, while in the chapel above the altar a crowd of smaller figures in relief are heaped together. Giovanni Achillini in the *Viridario*, calls him "more bizarre than the reverse of a medal". He crowds shining figures into his Nativity in the Kaiser Friedrich Museum at Berlin, and behind them places a sarcophagus with the relief and the base of a column — reminiscences of Roman antiques — besides the hut and a top-heavy mass of rocks. At the same time he carefully fills up all the empty spaces with grass and flowers. In the excess of gay details one may already notice an approach to the art of Pinturicchio.

Aspertini's compositions are the expression of an inharmonious fancy, and combine poses characteristic of Francia with motives from Ercole de' Roberti, and types drawn from Costa and Pinturicchio with memories of Roman monuments and encaustic paintings, copied by the painter with zealous eagerness. His figures are covered with ornaments, often in relief, necklaces, crowns, flowers and so forth; the backgrounds are enlivened with little figures and towers and pierced cliffs. Costa's schemes, composed along superficially geometrical lines, lose their clearness in Aspertini's imitations.

Aspertini shows himself to us as an inordinately confused narrator in the two frescoes in the Oratory of Santa Cecilia — the Martyrdom of Valerian and the Burial of Valerian and Tiburtius — as also in the frescoes in the church of San Frediano at Lucca, and in the Nativity illuminated for the Thompson codex, within a border filled with grotesques. In Aspertini's pictures the details crowd upon one another as in Parenzano's Padua pictures. The Child in the Thompson codex lies by the side of a stream with swans. In the Burial of the Martyrs in Santa Cecilia at Bologna a group of figures stands in an opening

made within the thickness of the side of a sarcophagus, and beside the crown of roses fallen from the brows of a beheaded martyr lie skulls and bones dug up from a cemetery. With the progress of time Aspertini's art became more and more slovenly, confused and clumsy, and we realize how true and apposite was Vasari's masterly description of him. He tells us how "he painted with both his hands at once, holding a brush with light colours in one hand, and one with dark colours in the other... and stood with cans of tempered colours stuck all round his girdle, so that he looked like the devil of San Macario with all his phials!" Of a frieze in San Salvatore at Bologna Vasari expresses the summary judgement that "it would draw a laugh from one who felt most like weeping."

More faithful to Lorenzo Costa than all the foregoing painters was Giovan Maria Chiodarolo, who painted two frescoes in the Oratory of Santa Cecilia at Bologna under the master's guidance: Cecilia and Valerian crowned by an Angel and Cecilia before the Plate 76 Prefect Almachius. Both the compositions are undoubtedly by Costa, but the turbid colours, the faces furrowed by shadows, the thick folds, and certain figures reminiscent of Pinturicchio, as, for example, that of Cecilia crowned by angels, the landscapes with confused and inorganic details, such as are found again behind the Madonna of the Deposition in the Bologna gallery, all belong to this lesser painter. The fine thoughtful head of the angel crowning the two saints looks like a work of Costa's. In the Madonna of the Ryerson collection in Chicago Chiodarolo betrays forms akin to those of Pinturicchio, in his varied and detailed landscapes and in the lighting of the trees. But he is reminiscent of Costa in the chubby Madonna in the Doria Gallery, and still more in the St. Helena at Hampton Court, which is a typical work of his for the minute facial traits, and the meticulous attention paid to details, such as the single hairs, the fibres of the wood and the small folds of the veils. He is a weak painter, and repeats with wearisome fidelity the forms of his master Costa, aiming at a certain effect of taste and moderation, but without being able to infuse a breath of his own life into his second-rate works.

Akin to the erratic Aspertini is the Bolognese, Iacopo Ripanda, the author of drawings in the Louvre and in the Heubel collection in Berlin, as well as of frescoes in the Palazzo dei Conservatori in Rome. The latter represent episodes of the Punic wars and other events in Roman history,[75] but are disordered, superficial compositions, series of warriors all of the same cardboard appearance, on a landscape background in which the trees look as if they had no roots in the earth.

In his female figures there is an effort to obtain softness and a drooping gracefulness, inspired by the art of Sodoma. He is a second-rate and conceited painter, who crowds buildings and groups of figures into his foreground without any capacity for harmony of

proportion, and is attracted not only by the sentimental airs of Sodoma, but also by the mannerisms of the Umbrians. Like Amico Aspertini, he is an aimless eclectic and by failing to understand the true essence of ancient monuments transforms the heroic humanism of Mantegna into a clumsy parody of the antique.

The name of the Bolognese Antonio Pirri, another follower of Costa's, is inscribed on the robe of a gentlewoman in the train of the Virgin in the picture of the Visitation in the Museo Poldi-Pezzoli at Milan. The mountain ridges which stand out dark against the whitish sky and the group of the three gentlewomen in the middle distance are reminiscent of Ercole, who had been forgotten by the other members of Costa's school. Struggling to observe the due proportions between the figures, this little painter tries partially to hide those in the foreground behind little mounds, and depicts Mary and Anna in the act of embracing, with their foreheads pressed close together. He is the opposite of Amico Aspertini, in that, in spite of the scarcity of his resources, he endeavours to achieve the balance entirely lacking in the works of his fellow-townsman. He leaves empty spaces between the various groups, and strives above all to define the oval of the gentlewoman in the foreground of the Visitation and of the effeminate and insipidly beautiful St. Sebastian in the same museum. In this latter work Antonio Pirri comes near to the forms of Bernardino da Cotignola.

In the art of Pellegrino Aretusi, called il Munari,[76] and mentioned by Vasari as a disciple of Raphael, the characteristics of the school of Costa are also hardly distinguishable. His first work was a Virgin enthroned between St. Geminiano and St. Jerome, and is perhaps the picture that was framed by Bartolomeo Bonascia in the church of the Battuti and exhibited in 1509. Here we find once more the forms of Bianchi Ferrari, though rounder, more massive, with rustic vigour and solemn gravity of expression. The painter's serious and solid qualities are seen in two saints, like strong trees fast rooted to the earth, in the varied and luminous landscape beneath a sky filmed over by clouds, and above all in the well-calculated distances behind the tondo of the Nativity. The reliefs and the St. Jerome recall the Ferrarese art of Ercole de' Roberti.

Araldi approaches closer to Costa than the artists just mentioned. He decorated the room near Correggio's in the monastery of the Oratory of Santa Caterina at Parma. His figures have soft and rounded traits, with light colouring and delicate shading. Similar features are noticeable in the Louvre altar-piece, once attributed to Bianchi Ferrari. It is clearly the work of a follower of Costa, who laboriously carves out hard outlines, as if he were working in marble, and foreshortening the heads of the children, distorts them. But at the same time he imparts to the faces a thoughtful sobriety of his own, and gives an

air of severe grandeur to the hilly backgrounds. Like Pellegrino Munari, he obtains in the Louvre altar-piece metallic lights from the cope of the Bishop who stretches his head forwards with intent look and lifelike expression. In another work of his, the *Annunciata* between St. Catherine and St. Sebastian, in the gallery at Parma, Araldi inclines towards the manner of Francia. The change was, however, at the expense of the thoughtful and concentrated figures in the Louvre picture and of the St. Catherine holding the palm of martyrdom. Furthermore, the landscape, varied and somewhat trivial, loses its severe simplicity.

Araldi, too, is one of the eclectics. In a fresco in the Oratory of Santa Caterina some of the figures with their drawn contours look as if incised in marble and still recall Cossa and Ercole de' Roberti.

Among the Romagnol painters who originated in the Ferrarese tradition we must place Bernardino and Francesco Zaganelli of Cotignola and their fellow-townsman, Girolamo Marchesi.[77] In Bernardino Zaganelli's picture in the Somzée collection at Brussels his debt to Costa is clearly visible in the type of the Virgin, in the calligraphic linearism of the contours of light delimiting the veil and in the nebulous gradations of the chiaroscuro. The head of the Virgin, broad and flattened, is in strong contrast with the long and almost rectangular head of the Child, with his enormous forehead, while the figures of the Bishop and the praying nun are smaller, after an archaic fashion. Bernardino is but a mediocre painter, arranging his compositions on vertical lines, and incapable of sounding a new note, even on the very threshold of the sixteenth century.

But it is the period of eclecticism, and Bernardino, who in this picture and in the Nuptials of St. Catherine in the Strasburg museum is entirely dominated by the influence of Costa, barely recalls this master in the insipid and flattened face of the Virgin in the altar-piece of the Brera Gallery, painted in collaboration with his brother Francesco. Here he composes after the model of Palmezzano as regards the poses of the angels and saints, and at the same time recalls the immediate successors of Ercole at Ferrara. Bernardino, the author of the Somzée picture, of the Deposition in the Rijksmuseum at Amsterdam, and of the predella with the Agony in the Garden in the gallery at Ravenna, comes nearer to the Ferrarese school. In the Deposition the rectangular scheme of the little figures, swathed in their draperies, is taken from Ercole, while the Agony in the Garden is a free imitation of Ercole's Dresden masterpiece. The elements typical of Palmezzano and of the school of Vicenza (already gradually fused in Palmezzano's own style with others drawn from Melozzo) predominate in the earlier pictures of Francesco Zaganelli. The altar-piece in the Brera Gallery, painted by the two brothers in collaboration, with the highly-decorated niche and the tense figures of the saints, and also the gloomy painting in the Musée Condé

at Chantilly, both recall Bartolomeo Montagna and Marescalco. Whereas Bernardino, in the excellent lunette in the Albani collection at Rome, and in the National Gallery St. Sebastian, echoes Ercole de' Roberti and Francia, Francesco, on the other hand, in the Forlì picture faithfully follows Palmezzano, arranging his figures between series of vertical lines, while in the Ravenna Nativity he is curiously eclectic, abandoning the normal rigidity of his schemes to imitate the agitated compositions of Signorelli. The latter's influence is visible in the figure of the large angel bending over to read, and in the vivid lights thrown across the scene. Of course the imitation is purely superficial, so that the energy of the prototype merely becomes disorder, and the sweetened expression of the faces has lost any resemblance to Signorelli.

It is not always easy to distinguish between the work of the two brothers, but it may be observed that for the most part Bernardino indulges in nebulous chiaroscuros recalling Costa, while Francesco, who must have taken a predominant part in the Brera picture, often enlivens the faces of his figures with patches of shading, and adorns his architecture with friezes, aiming from the first at that vibration of light which becomes so strongly marked in his late Ravenna Nativity. The two painters occupy a place by themselves among the minor masters of Emilia and Romagna, and are not without merits, but they offer one of the strangest examples of the predominant eclecticism of those regions on the very threshold of the sixteenth century.

The two tendencies, that towards the Romagnol art of Palmezzano and that towards the Ferrarese art of Costa, are united in the work of Girolamo Marchesi of Cotignola, who approaches the forms of the two Zaganellis in his picture in the Museo Civico at Vicenza. There are the same tall angels, swathed in long robes, but there is a nearer approach to Costa in the affected poses and languid curves. The influence of Costa predominates both in this work and in the Brera Assumption of the Virgin, signed and dated 1513, though in the ecstatic poses of the latter there is something of Francia. Only in the upper part of the picture does the figure of the Almighty, surrounded by plump cherubs, re-echo Palmezzano, whom the author faithfully follows in the Annunciation in the Kaiser Friedrich Museum at Berlin, merely taking from Francia the unusual treatment of the subject.

Of Lazzaro Grimaldi, a native of Reggio, we know that he was called upon by the Estes to paint the fable of Psyche in one of the rooms of Belfiore, and that he collaborated with Costa, Boccaccino and Nicola Pisano in the decoration of the choir of the cathedral of Ferrara, but we only possess one picture of his, a Madonna with four saints, once in the Wesendonck collection in Berlin. It is a weak piece of work, and we may well be astonished at the favour the artist met with at the court of the Estes. The tall lanky figures have some-

76

thing of Costa and Bianchi Ferrari, reminiscences of whom are also seen in the glassy heads of the cherubs among the clouds. This pre-Correggesque motive is the only notable thing in the picture, which is the work of an illuminator who fits in, one by one, the little plants in the foreground, the spirals of the curls, and the distant rocks, and adorns with minute arabesques the base of the throne, as if it were the margin of a missal. The insipidity of the smiles of the Virgin and of St. Sebastian is characteristic of this painter.

Barely an echo or two of Costa's art may be traced in afresco in the church of San Petronio at Bologna, containing some charming Umbrian types. The work, of anonymous authorship, is of considerable importance in the decadent field of Emilian art of the early sixteenth century, for its light and delicate tones and for the novelty of its composition, with groups of figures radiating like the spokes of a wheel from the angles of the polygonal pedestal on which the Saint stands. The two small angels who hold the wreath of flowers behind St. Sebastian's head, preparing to crown him, seem to leap into the air like two little frogs, but the young and rather effeminate ensign rides his somewhat wooden steed with the slim grace of a Joan of Arc. There is vigour in the angular portrait of the warrior, and echoes of Signorelli can be detected in the head of the St. Sebastian and in the archer preparing to draw his bow. Indeed, the sharply-bent figure of the archer in the foreground is the centre of this animated scene.

The sharp profiles, the wooden outline of the faces, the whitish colouring, all betray the hand of the same anonymous painter in the Martyrdom of St. Sebastian in the André collection in Paris. Among the elements common to the two pictures we may mention the elegance of the figures, the varied and animated landscapes, the Mantegnesque attitudes of the scattered little figures, and the Peruginesque pose of the angel preparing the crown of martyrdom. The archer, in the foreground of the picture at Bologna, is now seen in profile, in the same angular pose. The remaining archers and the captain, in their tight-fitting garments, with their hair divided into little shining waves, flaunt their smiling youth, as if they had met round the pillar for a trial of skill, and not for their cruel task. The beautiful body of the Saint curves out elegantly from the pillar, and his ecstatic face is turned towards the angels as if listening to words of love. This unknown painter, who delights in the energy of angular contours and shows great constructive capacity, possesses a very notable sense of knightly elegance, especially pronounced in the André picture, in which the crude Sebastian of Bologna is transformed into a fair, lovesick squire.

OTHER painters imported artistic elements into Emilia from the regions in which they had lived, departing more than those we have just mentioned from the local tradition. Among those who did so least was Baldassare d'Este,[78] who was still in Milan in 1469. The composition of his Death of the Virgin, in the Massari collection, and the forms of the apostle on the right, with the folds of the mantle like twisted roots, recall the Lombard bas-reliefs of the school of Omodeo. One of the angels shows reminiscences of Foppa. Still, the painter has points of contact with the masters of his own region, such as Ercole de' Roberti, and more especially Marco Zoppo, who was nearest to him on account of his Paduan training. The sharp profile of St. Thomas seems indeed taken from the works of the latter master.

Baldassare is rough and rude in his art and cuts the heads of the Apostles out of the gold of the background, as if from a thin metal plate. The hands are all nerves and sinews, and the rolling eyes are meant to express sorrow. Yet, though he huddles his figures together without paying due attention to proportions, and though, through deficient foreshortening, the bent heads of the Apostles seem detached from their bodies, the head of the St. Peter is powerfully modelled, and the face of the Virgin, furrowed by shadows, is skilfully drawn. His Lombard-Mantegnesque training is still more evident in the signed portrait in the Cook collection at Richmond, which seems to prelude the forms of Ambrogio de' Predis and Bernardino de' Conti. The two portraits of husband and wife in the Kestner Museum at Hanover derive, on the other hand, from Ferrarese prototypes, with their light-coloured profiles standing out against the dark background of a door.

The sculptured decorations of the Lombard palaces are echoed in the ornamentation which the architect Cesare Cesariano crowded into the tondos in the sacristy of San Giovanni at Parma.[79] Traces of Leonardo can be detected in the soft female heads, with fluttering curls, and echoes of Bramantino in the transparency of the faces, which seem lit up from within. In the whole of the decoration this disciple of Donato Bramante reveals his delight in the geometrical disposition of his lines and in illusionistic effects. Yet his work lies rather outside the true field of pictorial art.

Venetian influences were introduced into Emilia by Filippo Mazzola, Bernardino Loschi, Temperello and Zarotti.[80] Uncertain traces of Antonello's influence are to be seen *Plate 77* in Mazzola's portraits at Brunswick (Vieweg collection), Milan (Brera), and Rome (Doria Gallery). Cristoforo Caselli, nicknamed il Temperello, recalls the work of Cima in the altar-piece in the Parma gallery. In the praying Madonna in the same collection he follows Bartolomeo Montagna. Even the author of the fresco on the tomb of Brother Dominic, Bishop of Lydda, at the entrance of Parma Cathedral, probably Gio-

van Pietro Zarotti, is reminiscent of the school of Vicenza. But the hands and the head of the big-boned donor vie with the terra-cottas of Mazzoni in their plastic vigour and in the extreme, almost materialistic, attention paid to detail.

Vague echoes of the Venetian style may be detected in the meagre art of Bernardino Loschi of Parma, who, together with Giovanni del Sega of Forlì, decorated the palace of Alberto Pio at Carpi. The altar-piece in the Modena gallery shows, on an over-decorated throne of Lombard type, a Virgin and Child, distantly reminiscent of Bellini, with two angelic minstrels standing near the throne as in Giambellino's altar-piece at the Frari. But under the brush of this weak painter the great models are transformed into wooden figures, covered with coloured stucco. In the frescoes of the castle at Carpi, illustrating the life of Alberto Pio, the author feels even less at home. His awkward figures, carved in wood, which give the impression of walking on stilts, recall Gentile and Mansueti. We have a portrait of the Lord of Carpi painted by him with meticulous symmetry, and showing uncertain reminiscences of Dürer and Bartolomeo Veneto.

From this host of mediocre painters, closing with the third-rate Loschi, one figure alone emerges — that of the elegant and delicate Boccaccio Boccaccino[81] of Cremona. In his first work, the Journey to Calvary, in the National Gallery in London, he takes his place amongst the followers of Ercole de' Roberti. The rhythm of the composition, with figures distributed as in a wide festoon on the background of a luminous valley, immediately reveals his tendency towards unusual effects — a tendency which was to increase as time went on. Already in this early picture we find him intent on giving vitreous transparency to the amber-coloured eyes, metallic reflections to helmets, and golden sheen to hair, while he encloses his figures in tight-fitting garments, and aims at all kinds of subtleties and virtuosities. The delicate low-toned flesh tints set off the bright enamel-like colours of the clothes. In the Adoration of the Magi in the gallery at Nice the Ferrarese element is still dominant, whereas hardly a trace of it remains in another of Boccaccio's masterpieces, the Venice Holy Conversation, famous for the wonderful elegance of the figure of St. Catherine, a veritable queen of fairyland, with the brilliant gold of her garments and the silky rustle of her royal mantle. The Saint, proud of her delicate beauty and gorgeous apparel, receives the ring from the hand of Jesus without humility and without a smile. In the other jewel of Boccaccio's art, the Annunciation in the possession of Princess Nicoletta Boncompagni Ludovisi, the smooth rounded faces of the Virgin and of the angel recall the Ferrarese manner, and the glossy architecture, with its dash and delicacy, echoes rather the subtle and precious Renaissance style of Rossetti at Ferrara than the gorgeousness of the Lombards at Venice. But the setting, with its sense of breadth and depth, was

undoubtedly inspired by Venetian art. As Giambellino and Cima place their Virgins and Saints within golden apses, among columns and arches, so Boccaccino represents the Annunciation in an open temple. The manner in which the folds fall, the tension of the silk scarf hanging from the lectern, echo the forms of Iacopo de' Barbari. A true seeker after elegance in every detail, Boccaccino richly adorns the little chain from which hangs the crystal lamp, a motive dear to the Venetians. Everything looks like the work of a gold-smith: the rigid folds of the silk whence issue the Virgin's little hands, the blue and gold flower design on the angel's sleeves, the little wreath on his curly head, the fine gold thread which holds together the silky locks of the Virgin. The lamp is marvellous: a glitter of gems amidst golden plaques and transparent crystals. Only the Venice Conversation shows to the same extent as this picture the exquisite taste of this Cremonese painter, who worked in Ferrara and Venice without ever losing his native calm or his indifference to the dra-matic element, contented to live in the contemplation of whatever is richly decorated and glittering, and to reveal his virtuosity as a goldsmith painter.

Indications of an artistic education received under Boccaccino are to be seen in the work of Benvenuto Tisi, called il Garofalo, but only in some of his early works, which indeed cannot even be attributed to him with absolute certainty. In a pretty little picture of a predominantly Costesque type in the Layard collection at Venice, the flowery land-scape, and the Child, seated on the knees of the Virgin, have induced me to suppose that it might be a youthful work of Garofalo rather than of Ercole Grandi. The large Ma-donna in the Capitoline Museum, with the very high brow of the Child, the lighting of the hair obtained by means of little strokes of golden yellow, and the landscape with yel-lowish planes and houses outlined by white lights, is still more likely to be a youthful work of Garofalo, showing traces of the influence of Boccaccino in the rounding of the face and in the clear eyes of Mary. But Garofalo falls outside the limits of this book, though he may appear to us a fifteenth-century *ritardatario,* even when he enlivens his last pictures with the phosphorescences of Dosso.

The splendour of Venetian art attracted the Romagnols even more than the Emilians. Lat-tanzio da Rimini, in the picture in the Fabbriceria at Piazza Brembana, imitates Giambellino in the period of the Naples Resurrection, and clothes his figures in a snowy light, without, however, succeeding in making them transparent. Niccolò Rondinello of Ravenna, who in the Brera picture follows a painter of his own region, Marco Palmezzano, repeats with deadly monotony, in his many works scattered throughout the galleries of Europe, groups of the Virgin and Child, copied with few variants from Giambellino, without a trace of the latter's pure light and delicate grace on the coarse provincial faces and lifeless figures.

The art of Umbria, like that of Venice, also influenced the Emilian painters and, above all, Marco Meloni of Carpi. Already in his first picture, the Madonna enthroned between saints and worshippers in the Estensian Gallery at Modena, the painter begins to depart from the types of Francia, traces of whom, however, still remain, and to approach instead those of Perugino. On the basis of the latter's compositions he constructs his airy architecture, which allows him to raise the holy group into the blue sky, while the features of the Virgin and of the Baptist are also modelled upon those of the Umbrian painter. When, in 1504, he painted the other altar-piece in the Estensian Gallery at Modena, he was entirely under the influence of Umbrian art, for the drawn faces of the saints, hollowed as it were by shadows, the hard features of the Virgin and the form of the Child, are clearly constructed on the model of Perugino. Only the ungainly base of the throne with its niche for the saint's statue, adorned with sphynxes and cherubs, represents the bizarre decoration of the lesser Emilian painters. The best work of this uninspired imitator of Perugino is the portrait in the Liechtenstein gallery in Vienna, spoilt by the grass-greens and wine-reds of excessive intensity, which are very characteristic of its author.

The Romagnol Giovan Battista Bertucci also turned to Umbria, though he did not abandon native forms to the same extent as Marco Meloni. The Adoration of the Magi in the Kaiser Friedrich Museum at Berlin, once in the church of Santa Caterina at Faenza, is constructed on Umbrian lines and reveals an adaptation of the types of Francia to those of Perugino. The ample rounded forms, without sharp angles, are also derived from the types of Francia or Perugino. There is nothing Umbrian in the landscape that fills almost the whole of the upper part of the picture, nor in the figure of the donor Manzolini, drawn after the manner of Melozzo, but as pretentious and meaningless as the other figures, weighed down by their heavy draperies. No reflexion of the jewelled colours of Francesco Francia or of the clear lights of Pietro Perugino enlightens this murky picture.

FROM ITS great origin, Emilian and Romagnol art had fallen into a deplorable meanness, into an arid and empty eclecticism. There are few signs of life in this region of stagnant waters, which none the less had given birth to the violent art of Cosmè and the nervous elegance of Ercole de' Roberti. The end of the magnificent Estensian Ferrara of the fifteenth century promised to be a sad one, just when, at the beginning of the new century, art was beginning to flourish again in every other region of Italy. But already, before the genius of Correggio arose, the decoration of one of the most beautiful Ferrarese buildings — the Costabili palace — retrieved the honour of Emilian painting. This decoration,

the work of an unknown artist, is a most pure expression of the Ferrarese Renaissance. The art of Mantegna had furnished various hints for the dazzling and bizarre decoration of the palace of Schifanoia, which marked Ferrara's triumphal entry into the art of the *Plates 78-80* Renaissance; it now furnished hints for the paintings in the palace built by the Costabili for Lodovico il Moro, and gave new strength to the declining and exhausted art of Ferrara. The crudities of the Northern Gothic style, the nervousness of a constantly jerky line, dominate in the polychrome stuccos of Schifanoia. The clear-cut and powerful masses, the notable effect of projection of the brackets and balustrades of the gallery painted in the large hall of the Costabili palace bring us into the heart of the sixteenth century. These are the two extremes which mark the trajectory of Emilian art, falling more and more into decay after its first wonderful efflorescence. The painting of the sky which filled the grand and simple Mantegnesque window in the Camera degli Sposi in Mantua is now divided, as later in Raphael's Loggias, into four sections, separated by as many decorated panels leading up to a little twelve-sided cupola with small oval windows. The minute decoration of the panels, with monochrome cameos set among whorls, carries us back to the Lombard school, as also does the beautiful geometrical design of the rose in the middle of the ceiling. The architecture of the base of the cupola, on the other hand, seems to owe its origin to Donato Bramante, with the Ferrarese addition of great shells in the second row of sunken panels, above the oval windows.

Beneath the gallery supported by brackets there are decorated archivolts. Classical medallions, imitated from Mantegna, are placed between the archivolts, under each of which are monochrome lunettes with exquisite figures. In one of them, the oblong figure of Mercury recalls, in its archaic elegance, the common origin of Bramantino and the Ferrarese. In another, the gentleness of the contours of a woman kneeling in a temple, and the soft mass of her hair, prelude the figures of Correggio in the Convent of San Paolo. Entirely after the manner of Correggio is a little child to whom a kneeling woman offers a lily. The rounded forehead, the light curls, the graceful smile, appear again in the hunting putti of San Paolo. Still, this unknown artist is entirely lacking in that sense of pictorial life which the variations of the light and the mobility of shadows can impart to the figures. The light is diffused and bland; the outlines are clear-cut and almost blatant; the folds are obvious. As did Correggio later, this painter approaches Lombard art. We have already noticed in him elements akin to those of Bramantino and of Cesare Cesariano, and we may add that in the transparent forms of Vulcan and his little curly genii there are resemblances to the art of Luini in his Bramantinesque period.

The anonymous painter is an architect, who interprets, with a classical sense worthy

of Alberti, the volume of the brackets of the gallery opening on to the sky, as well as that of the dividing panels, and of the massive and elegant balustrades, with columns like two tulips, one above the other. He is a master of the science of perspective, and multiplies his optical illusions. Developing Mantegna's idea, he seems to inaugurate the art of decoration based on sham architecture, spread in Emilia by Mitelli and Colonna in the seventeenth century. The gallery is adorned with oriental carpets and rendered gay by festoons, not massive like Mantegna's, but swinging lightly between the rings to which they are tied. There are apples, lemons, grapes, all the gaiety of many-coloured fruits, round the beautiful figures leaning out from above to the sound of harps and viols, to gaze smilingly upon the world and upon life itself. The female faces of pointed oval shape often recall Costa, but the opal eyes have the transparency and languor of Boccaccio Boccaccino. Fair ladies pass among playful little genii and singers, and among poets and slaves, one of whom recalls the Mantegnesque type of St. Anna. They bend their heads over their shoulders and their faces are filled with dreamy languor, as it were smiling inwardly. Maidens and young men are playing; a group of singers surrounds a girl leaning over a sheet of music; another girl, touching a harp, reclining her head on the balustrade, is as if made faint by the sweet sound. Naked cupids, all lit up by smiles, sport with little monkeys or tear down bunches of grapes. A young woman, the image of fair and delicate youthfulness and exquisite womanhood, looks out over the parapet with her child, while another throws down a bunch of roses. This smiling vision of life in the midst of humanistic leisure and the joys of art and beauty closes the cycle of Emilian fifteenth-century art, when already the light of a new dawn was appearing in the first works of Antonio Allegri, better known as Correggio.

NOTES

1] BARUFFALDI, *Vite de' pittori e scultori Ferraresi con annotazioni*, Ferrara, Taddei, 1844-46.

2] N. CITTADELLA, *Notizie relative a Ferrara*, Ferrara, Taddei, 1864. Idem, *Documenti ed illustrazioni riguardanti la storia artistica ferrarese*, Ferrara, Taddei, 1868.

3] RODI, *Annali di Ferrara*. The manuscript is in the R. Biblioteca Estense at Modena.

4] L. NAP. CITTADELLA, *op. cit.*

5] CROWE and CAVALCASELLE, *History of Painting in North Italy*, Vol. I, London, Murray, 1864.

6] Cf. *Notizie di opere di disegno nell'Anonimo morelliano (Marcantonio Michiel)*, 2nd ed., Bologna 1884.

7] BURCKHARDT, *La civiltà del rinascimento in Italia*, Florence, Sansoni. GIOSUÈ CARDUCCI, *Delle poesie latine edite ed inedite di Ludovico Ariosto*, Bologna, Zanichelli, 1876.

8] Cf. ADOLFO VENTURI, *I primordi del rinascimento artistico a Ferrara*, in *Rivista Storica Italiana*, Vol. I, Fasc. 4, 1884.

9] ADOLFO VENTURI, *Architettura del Quattrocento*, in *Storia dell'Arte Italiana*, VIII, p. 2.

10] D. ZACCARINI, *Antonio Alberti, il suo maestro ed alcuni pittori ferraresi*, in *L'Arte*, 1914, pp. 161-180.

11] Cf. ORAZIO OLIVIERI, *Memorie del Montefeltro*, Pennabili, 1880, p. 825. - PIVA, *A zonzo per le Marche: Talamello*, in *Arte e Storia*, Vol. V, Florence, 1886, No. 32, pp. 233-4.

12] Cf. ZACCARINI, *op. cit.*

13] ADOLFO VENTURI, *I primordi del Rinascimento Artistico Ferrarese*, in *Rivista Storica Italiana*, Turin, Vol. I.

14] ADOLFO VENTURI, *Storia dell'Arte Italiana: La Pittura del Quattrocento*, VII, part I.

15] CROWE and CAVALCASELLE, *History of Painting*, Vol. IV, p. 95. - BIANCONI, *Guida di Bologna*, 1844, p. 107.

16] MOSCHETTI, *Giovanni da Bologna*, in *Rassegna d'Arte*, Feb.-Mar. 1903. - LIONELLO VENTURI, *Le origini della pittura veneziana*, Venice 1907, pp. 26-37.

17] Cf. ZACCARINI, *loc. cit.*; he attributes the little panel to the painter of the Crucifixion, initialled G. Z., with which it has no connection.

18] ADOLFO VENTURI, *La pittura parmigiana nel secolo XV*, in *L'Arte*, 1900, Vol. III, pp. 374-379.

19] ADOLFO VENTURI, *Storia dell'Arte Italiana*, VII, part I, p. 226.

20] *Ibid.*, pp. 221-223.

21] ADOLFO VENTURI, *I primordi del rinascimento artistico a Ferrara*, cit.

22] BIADEGO, *Pisanus Pictor*, in *Atti del Reale Istituto Veneto di Scienze, Lettere ed Arti*, 1909-1910, Vol. LXIX, part 2.

23] E. MÜNTZ, *Les arts à la Cour des Papes, pendant le XVᵉ et le XVIᵉ siècle*, part I, Paris 1878.

24] DOMENICO GNOLI, *Passaporto di Pisanello*, in *Arch. Stor. dell'Arte*, Vol. III, fasc. 9 and 10, 1890.

25] ADOLFO VENTURI, *Gentile da Fabriano e il Pisanello*, in *Le Vite del Vasari*, Vol. I, Florence 1896.

26] *Ibid.*, p. 11.

27] ADOLFO VENTURI, *Grandi artisti italiani*, Bologna, Zanichelli, 1925.

28] ADOLFO VENTURI, *Saggio di ed. delle Vite del Vasari*, cit., p. 44 ff.

29] GIUSEPPE BIADEGO, *Pisanus Pictor*, in *Atti del Reale Istituto Veneto di Scienze, Lettere ed Arti*, 1912-13, Vol. LXXII.

30] GEROLAMO BISCARO, "*Pisanus Pictor*" alla corte di Filippo Maria Visconti nel 1440, in *Arch. Stor. Lombardo*, Milan, Cogliati, 1911.

31] ADOLFO VENTURI, in essay mentioned above, p. 46 ff.

32] G. ZIPPEL, *Artisti alla corte degli Estensi nel Quattrocento*, in *L'Arte*, 1902, pp. 405-407.

33] ADOLFO VENTURI, in essay mentioned above, p. 47 ff.

34] UMBERTO ROSSI, *Il Pisanello e i Gonzaga*, in *Arch. Stor. dell'Arte*, Vol. I, fasc. XI and XII, 1888.

35] G. BIADEGO, *Pisanus Pictor*, cit., note 6, in *Atti etc.*

36] ADOLFO VENTURI, essay quoted above.

37] Cf. W. BODE, G. GRONAU, F. v. HADELN, in *Archivalische Beiträge zur Geschichte der venezianischen Kunst aus dem Nachlass Gustav Ludwigs*, Berlin 1911, pp. 120-121.

38] BODE, GRONAU, v. HADELN, *op. cit.*

39] G. BIADEGO, *op. cit.*, note 1.

40] A. LUZIO, R. RENIER, *Il Filelfo e l'Umanesimo alla corte dei Visconti*, in *Giornale storico della letteratura italiana*, 1890, Vol. XVI, p. 19 ff.

41] Cf. UMBERTO ROSSI, *Il Pisanello e i Gonzaga*, in *Arch. Storico dell'Arte*, 1888, p. 433 ff.

42] ADOLFO VENTURI, *Le Vite del Vasari*.

43] ADOLFO VENTURI, *Le Vite del Vasari*.

44] ADOLFO VENTURI, *Del quadro attribuito a Bono da Ferrara nella Galleria Nazionale di Londra*, in *L'Arte*, Vol. XXV, 1922.

45] ADOLFO VENTURI, *Grandi artisti italiani*, Bologna, Zanichelli, 1925.

46] ADOLFO VENTURI, *Storia dell'Arte Italiana,* VII, part I.

47] ADOLFO VENTURI, *Storia dell'Arte Italiana,* VIII, part II, pp. 511–527.

48] He is mentioned in the Estensian Registers, in the Modena State Archives, under the name of Giovanni da Faenza, thus: Giovanni da Faenze pittore 1447. Marquis Lionello d'Este gives 20 lire "uni M. Johanni de Faventia pictori nobilissimo qui pace aliorum dictum sit in ea arte politior ceteris et dignior inducendo vivos vultus haberi et censeri potest."

49] ADOLFO VENTURI, *Storia dell'Arte Italiana,* Vol. VII, part I.

50] GIUSEPPE FIOCCO, in *L'Arte* (1921): *Andrea del Castagno a Venezia.*

51] ADOLFO VENTURI, *La "Resurrezione" di Andrea del Castagno* in *L'Arte,* 1926, No. III.

52] The information concerning "Pesello the Painter" is drawn from the records of the Este archives in Modena.

53] ADOLFO VENTURI, *Storia dell'Arte Italiana: La Scultura del Quattrocento,* VI.

54] ADOLFO VENTURI, *Un'opera sconosciuta di Leon Battista Alberti,* in *L'Arte,* XVII, 2, Rome 1914.

55] ADOLFO VENTURI, *Pier della Francesca,* Florence, Alinari, 1921–22.

56] Published in the *Burlington Magazine* as a portrait of Lionello d'Este.

57] A. VENTURI, *I Primordi del Rinascimento Artistico a Ferrara,* in *Rivista Storica Italiana.*

58] For all this information see the article mentioned above.

59] A. VENTURI, *Arte Ferrarese del Rinascimento,* in *L'Arte,* Roma 1925.

60] Born in 1433, at 20 years of age he was in Squarcione's workshop, where he remained two years and four months, working for Squarcione's profit, and recompensed with empty promises. He then went to Venice where he was on September 16th 1462, and thence to Bologna. In 1471 he was back in Venice. In 1489 we hear of him for the last time — at Bologna.

61] Cosma Tura, called Cosmè, the son of Domenico di Tura, a cobbler, was born in the beginning of 1430. In 1451 we find him at the court of the Estes valuing, with Galasso, certain pennons painted by Giacomo Turola. In 1452, he was still in the service of the Este court, but later he passed on to Padua and Venice, where he remained till 1457. For the next few years he was a stipendiary of the Estes, but left them probably between 1465 and 1467 to decorate Pico della Mirandola's library. But he returned to Ferrara and to the Estes and worked with them till 1495, when he died (Bibliography: FRITZ HARCK, *Verzeichnis der Werke des Cosma Tura,* in *Jahrbuch der königlichen preussischen Kunstsammlungen,* 1888, I and II. – A. VENTURI, *Cosma Tura genannt Cosmè, ibid.,* 1888, I and II. – A. VENTURI, *Cosmè Tura ne la Cappella di Bel-*

87

riguardo, in *Il Buonarroti*, 1885. ⁄ A. Venturi, *Documenti relativi al Tura*, in *Arch. Stor. dell'Arte*, 1894. ⁄ C. Ricci, *Tavole sparse di un polittico di Cosmè Tura*, in *Rassegna d'Arte*, 1905).

62] Cf. Vol. XII (VIII, part II), *L'Architettura del Quattrocento*, in A. Venturi, *Storia dell'Arte Italiana*, Milano, Hoepli, 1924.

63] On the Schifanoia frescoes, see: Fritz Harck, *Die Fresken im Palazzo Schifanoia in Ferrara*, in *Jahrb. d. k. preuss. Kunstsamml.*, 1884. ⁄ A. Venturi, *Gli affreschi del palazzo Schifanoia a Ferrara*, in *Atti e Memorie della R. Deputazione di Storia patria per le Provincie della Romagna*, Bologna 1885.

64] He was probably born in 1436, the son of Cristoforo del Cossa, a stone-mason. In 1456, he worked for the Duomo at Ferrara; in 1462, he was at Bologna; at the beginning of 1470, after finishing the frescoes in the large hall of the Schifanoia palace at Ferrara, he again left for Bologna, dissatisfied with the payment received from Duke Borso d'Este. In 1472 he restored the Madonna del Baraccano; in 1474 he painted for the Foro de' Mercanti and designed windows for San Giovanni in Monte. In 1477, the year of his death, he painted the vault of the famous Garganelli chapel in San Pietro (Bibliography: A. Venturi, *Les arts à la Cour de Ferrare: Francesco del Cossa*, in *L'Art*, Paris 1888. ⁄ A. Venturi, *Due quadri di Francesco del Cossa nella raccolta Spiridon a Parigi*, in *L'Arte*, 1906. ⁄ L. Frati, *La Morte di Francesco del Cossa*, in *L'Arte*, 1900. ⁄ Francesco Filippini, *Francesco del Cossa scultore*, in *Bollettino d'Arte*, 1913).

65] Agnolo and Bartolomeo degli Erri, or dell'Er, or del R, painted together the piece for the high altar in the Ospedale della Buona Morte in Modena, from 1462 to 1466 (See: A. Venturi, *L'Oratorio dell'Ospedale della Morte*, in *Atti e Mem. delle Deputazioni per la Storia patria per le provincie modenesi e parmensi*, series III, part I, Modena 1885. ⁄ A. Venturi, *La pittura modenese nel secolo XV*, in *Archivio Storico dell'Arte*, 1890. ⁄ A. Venturi, *I pittori degli Erri o del R.*, ibid., 1894).

66] He was probably born between 1450 and 1460. The first mention of him is on February 3rd 1479; in 1480 he was at Ravenna; in 1482 at Bologna, where he worked in the Garganelli chapel in San Pietro and in San Giovanni in Monte. In 1486 he returned to Ferrara, which he never left again. He was the official painter of the House of Este and worked for them till his death, which occurred towards the end of June 1496 (See: A. Venturi, *Das Todesdatum Ercole de' Robertis*, in *Kunstfreund*, 1885. ⁄ A. Venturi, *Beiträge zur Geschichte der ferraresischen Kunst: Der angebliche Stefano der Brera*, in *Jahrbuch d. K. Preuss. Kunstsammlungen*, 1887. ⁄ A. Venturi, *Ercole de' Roberti fa cartoni per le nuove pitture della delizia di Belriguardo*, in *Arch. Stor. dell'Arte*, 1889. ⁄

A. VENTURI, *Ercole Roberti* in *L'Arte,* 1898. ∕ A. VENTURI, *Due nuovi quadri di Ercole de' Roberti nel Museo del Louvre,* in *L'Arte,* 1902).

67] We find him for the first time in 1489, at the court of Ferrara, for which he worked in 1492, 1493 and 1502. In 1503 he went to Mantua, where he remained to execute works commissioned by Isabella d'Este Gonzaga. In 1504, Clara di Francesco Clavée di Valenza desired him to return to Ferrara to finish the pictures ordered in 1494 from Ercole de' Roberti and left unfinished by the latter on his death (See: A. VENTURI, *Gian Francesco de' Maineri pittore,* in *Arch. Stor. dell'Arte,* 1888. ∕ A. VENTURI, *Gian Francesco de' Maineri da Parma,* in *L'Arte,* 1907, fasc. I. ∕ A. VENTURI, *A proposito di quadri del Maineri, ibid.,* 1907, fasc. II).

68] He flourished in the earlier years of the sixteenth century, and worked till 1528, when he made his will. From 1504 till 1508 he was painting for Santa Maria degli Angioli in Ferrara; from 1505 to 1507, for the boudoir of Duchess Lucrezia Borgia; in 1520 he painted two pictures for Sigismondo d'Este; and three more for Cardinal Ippo∕ lito II of Este; in 1524, in Bologna, one for Francesco Caprara and one for the poet Girolamo Casio, treating his favourite subject of Christ among the Doctors (See: A. VENTURI, in *Rassegna Emiliana,* Modena 1889. ∕ A. VENTURI, *Ludovico Maz∕ zolino,* in *Arch. Stor. dell'Arte,* 1889. ∕ A. VENTURI, *Ludovico Mazzolino, ibid.,* 1890).

69] We hear of him for the first time in 1480, and for the last in 1510, the date of his death and of his last picture, commissioned by the Company of the Annunziata. It was left unfinished, but it is this picture which has made it possible to reconstruct his work (See: A. VENTURI, *La pittura modenese nel secolo XV,* in *Arch. Stor. dell'Arte,* 1890. ∕ A. VENTURI, *Il Maestro del Correggio,* in *L'Arte,* 1898. ∕ A. VENTURI, in *Ras∕ segna Emiliana,* 1888. ∕ A. VENTURI, in *Jahrbuch d. k. preuss. Kunstsammlungen XI.* ∕ A. VENTURI, in *Le gallerie nazionali italiane.* ∕ A. VENTURI, in *Storia dell'Arte italiana,* VII. ∕ A. CAVAZZONI∕PEDERZINI, *Intorno al vero autore d'un dipinto attribuito al Francia* Modena 1864. ∕ AMADORE PORCELLA, *Un capolavoro inedito del Maestro del Correggio: il Calvario di Francesco Bianchi Ferrari, nella Raccolta Jannetti del Grande,* Rome 1926).

70] Born about 1450, he matriculated in the goldsmiths' guild in 1482; in 1485 he was mentioned as painter on the books of the Bologna Mint, and was praised as a greater painter, sculptor, and niello∕worker than Maso Finiguerra by the poet Angiolo Michele Salimbeni; his first dated picture belongs to the year 1492; it is the Mond Madonna in the London National Gallery. We last hear of him on January 5th 1517, the date of his death (See: A. VENTURI, *Il Francia,* in *Rassegna Emiliana,* Modena 1888. ∕ A. VENTURI, *La pittura bolognese nel secolo XV,* in *Arch. Stor. dell'Arte,* 1890. ∕ G. WILLIAMSON, *Fran∕*

cesco Francia, London, Bell, 1901. ⁄ T. GEREWICH, *Francesco Francia nell'evoluzione della pittura bolognese*, in *Rassegna d'Arte*, 1908. ⁄ G. LIPPARINI, *Francesco Francia*, Bergamo 1913. ⁄ ADOLFO VENTURI, in *Storia dell'Arte Italiana*, VII, part 3, Milan 1914).

71] Born about 1460, he was taught by Cosmè Tura. He worked at Bologna from 1483, and about 1488⁄90 painted in the Bentivoglio chapel in San Giacomo Maggiore. He continued working at Bologna till 1506, when, together with Francia, Tamaroccio, Chiodarolo and Amico Aspertini, he decorated the Oratory of Santa Cecilia. At the end of the year he was called to take the place of Andrea Mantegna at the court of the Gonzagas at Mantua. He worked for them till 1535, when he died. In his later years he had given up his place to Giulio Romano (See: T. GEREWICH, *Lorenzo Costa* in *Allgemeines Lexikon der bild. Kunst*, VII. ⁄ A. VENTURI, *Lorenzo Costa*, in *Arch. Stor. dell'Arte*, 1888. ⁄ A. VENTURI, in *Storia dell'Arte italiana*, Vol. VII, part 3).

72] Year 1925.

73] Ercole, son of Giulio Cesare Grandi, was already in the pay of the Estes in 1489. He is confused with Ercole de' Roberti, but he dedicated himself to architecture and de⁄ signed the basilica of Santa Maria in Vado, and the monument to Ercole I in the new square at Ferrara, now called Ariostea. No work remains of him as a painter, though we know that after Ercole I's death he worked with Mazzolino and others of the new generation of painters, in the rooms of the Duchess Lucrezia Borgia, in the Castle, and in the closets of the Este family.

74] See: A. VENTURI, *Amico Aspertini*, in *Arch. Stor. dell'Arte*, 1891.

75] See: GIUSEPPE FIOCCO, *Iacopo Ripanda*, in *L'Arte*, 1920.

76] See: A. VENTURI, in *Jahrbuch d. k. preuss. Kunstsammlungen*, 1887. ⁄ G. FIOCCO, in *L'Arte*, 1917.

77] See CORRADO RICCI, *D'alcuni dipinti di Bernardino da Cotignola*, in *Rass. d'Arte*, 1905. ⁄ G. FRIZZONI, *Girolamo Marchesi*, in *Bollettino d'Arte*, 1910.

78] He was a natural son of Niccolò III of Este. We first hear of him in 1461; he died towards the end of 1504 (Cf. A. VENTURI, in *L'Art*, Paris 1884. ⁄ E. MOTTA, *Bal⁄ dassarre da Reggio*, in *Archivio Storico Lombardo*, 1889. ⁄ A. VENTURI, *Baldassarre d'Este*, in *Künstler⁄Lexikon von U. Thieme*, Vol. II. ⁄ H. COOK, *Baldassarre d'Este*, in *Burlington Magazine*, 1911).

79] Cf. A. VENTURI, in Vol. VIII, p. 2, of *Storia dell'Arte Italiana: l'Architettura del '400*.

80] Cf. A. VENTURI, *Pittori Parmigiani del '400*, in *L'Arte*, 1900.

81] He was the son of an embroiderer to the Estensian Court and lived at Ferrara from 1498 to 1500.

GEOGRAPHICAL INDEX

BESANÇON
MUSEUM: Francesco Francia, *Christ*, 62.

BOLOGNA
R. PINACOTECA: Michele di Matteo of Bologna, *Paintings*, 11. ⁃ Marco Zoppo, *St. Jerome*, 36; plate 18. ⁃ Follower of Cosmè Tura, *Madonna*, 41. ⁃ Francesco del Cossa, *Madonna with St. Petronio and St. John the Baptist*, 45, 46; plate 37. ⁃ Francesco Francia, *Christ supported by two angels*, 61; *Felicini altar-piece*, 61. ⁃ Giacomo Francia, *Madonna enthroned*, 64. ⁃ Lorenzo Costa, *Altar-piece*, 68, 69. ⁃ Perugino, *Altar-piece*, 69. ⁃ Amico Aspertini, *Adoration of the Child*, 72. ⁃ Chiodarolo, *Deposition*, 73.
MUSEO CIVICO: Francesco Francia, *Crucifixion*, 59, 60, 65; plate 60.
ORATORY OF SANTA CECILIA: Francesco Francia, *Two episodes from the Life of St. Cecilia*, 62; plate 66. ⁃ Lorenzo Costa, *Two episodes*, 70. ⁃ Tamaroccio, *Two episodes*, 7172. ⁃ Amico Aspertini, *Two episodes*, 72. ⁃ Chiodarolo, *Two episodes*, 73; plate 76.
SAN GIACOMO MAGGIORE: Francesco Francia, *Altar-piece*, 61; plate 64. ⁃ Lorenzo Costa, *Madonna enthroned, with the Bentivoglio family*, 66, 67; plate 70; *The Triumphs of Fame and Death*, 67, 69.
SAN GIOVANNI IN MONTE: Francesco del Cossa, *Stained-glass window executed from his design*, 44. ⁃ Follower of Francesco del Cossa, *Altar-piece*, 46. ⁃ Lorenzo Costa, *Altar-piece in side chapel*, 68; plate 74; *Altar-piece of the high altar*, 69.
SAN MARTINO MAGGIORE: Lorenzo Costa, *Assumption*, 70.
SAN PETRONIO: Iacopo di Paolo, *Paintings*, 1011. ⁃ Lorenzo Costa, *Altar-piece*, 68; plate 73. ⁃ Anonymous painter, *Altar-piece of St. Sebastian*, 77.

BOSTON (U. S. A)
GARDNER MUSEUM: Cosmè Tura, *Circumcision*, 39.
MORRISON COLLECTION: Iacopo Boateri, *Nuptials of St. Catherine*, 64.

BRUNSWICK
VIEWEG COLLECTION: Filippo Mazzola, *Portrait*, 78.

BRUSSELS
SOMZÉE COLLECTION: Bernardino Zaganelli, *The Madonna adored by a Bishop and a Nun*, 75.

BUDAPEST
MUSEUM OF FINE ARTS: Galasso Ferrarese (?), *Two small pictures of Angel Musicians*, 2930, 31; plates 8, 9. ⁃ Michele Pannonio, *Allegory*, 36; plate 20. ⁃ School of Ercole de' Roberti, *St. John the Evangelist*, 53. ⁃ Follower of Francia, *Madonna and Angels*, 63.

BUSSETO
CATHEDRAL: Follower of Bartolino Grossi, *Madonna and Child,* 12.

CAGLI
CONFRATERNITA DI SAN MICHELE: Timoteo della Vite, *Altar-piece,* 65, 66.

CAMBRIDGE (U. S. A.)
FOGG MUSEUM: Cosmè Tura, *Adoration of the Magi,* 39-40.

CANFORD MANOR
COLLECTION OF LORD WIMBORNE: Marco Zoppo, *Madonna and Child,* 35.

CARPI
CHIESA DELLA SAGRA, Chapel of St. Catherine: *Frescoes from the beginning of the fif-teenth century,* 10.

CASTLE OF ALBERTO PIO: Bernardino Loschi and Giovanni del Sega, *Frescoes,* 79.

CASSEL
GEMÄLDEGALERIE: Ludovico Mazzolino, *Pietà,* 56; plate 57.

CHANTILLY
MUSÉE CONDÉ: Pisanello, *Drawings,* 17. ⁃ Francesco Zaganelli, *Altar-piece,* 75-76.

CHICAGO
RYERSON COLLECTION: Chiodarolo, *Madonna,* 73.

DRESDEN
GEMÄLDEGALERIE: Francesco del Cossa, *Annunciation,* 45; plate 36. ⁃ Ercole de' Ro-berti, *Predella,* 51, 53, 75; plates 51, 52. ⁃ Correggio, *Altar-piece,* 58. ⁃ Francesco Francia, *Adoration of the Magi,* 62; *Baptism of Christ,* 62. ⁃ Follower of Francia, *Madonna with the Child Christ and St. John,* 63. ⁃ Lorenzo Costa, *St. Sebastian,* 66, 69. ⁃ Print Room: *Drawing of the Parma school* (beginning of the fifteenth century), 12.

DUBLIN
NATIONAL GALLERY: Marco Zoppo, *Saints,* 36. ⁃ Ludovico Mazzolino, *The Passage of the Red Sea,* 56. ⁃ Lorenzo Costa, *Portrait of a Musician,* 66; *Holy Family,* 69.

EDINBURGH
NATIONAL GALLERY: Marco Zoppo, *Saints,* 36. ⁃ Antonio Cicognara, *Triptych,* 46. ⁃ Ercole de' Roberti, *Madonna,* 48-49, 54; plate 44.

FAENZA
PINACOTECA: Leonardo Scaletti, *Altar-piece,* 46; plate 38.

FERRARA

PINACOTECA: *Fragments of frescoes from the church of Sant'Andrea*, 24. ⁄ Anonymous Ferrarese Master (follower of Piero della Francesca), *Deposition* (attributed to Galasso), 24; plate 7. ⁄ Follower of Cosmè Tura, *St. Louis and St. Bernardino*, 42. ⁄ Francesco del Cossa, *St. Jerome*, 42, 48; plate 27. ⁄ School of Ercole de' Roberti, *Pietà*, 54. ⁄ Michele Coltellini, *Altar-piece*, 57. ⁄ Domenico Panetti, *Visitation*, 57. ⁄ Ercole Grandi (?), *Assumption of St. Mary Magdalen*, 71. ⁄ Pellegrino Munari, *Altar-piece*, 74.

CATHEDRAL: Cosmè Tura, *Annunciation*, 37. ⁄ Francesco Francia, *Coronation of the Virgin*, 62. ⁄ Cristoforo of Florence, *Statue of the Virgin*, 22. ⁄ Iacopo della Quercia, *Fragment of a statue of St. Maurelio*, 22.

SANT'ANDREA: *Fragments of frescoes*, see under Pinacoteca.

SANT'APOLLINARE: *Fifteenth-century fresco of the Resurrection*, 21-22.

CERTOSA: *Small altar-piece of Bishop Boiardi* (sold in Paris by Trotti), 11; note 17; pl. 2.

MONASTERY OF SANT'ANTONIO IN POLESINE: Follower of Cosmè, *Frieze and Paintings*, 41.

PALAZZO COSTABILI: Unknown Decorator, *Ceiling frescoes*, 81-83; plates 78-80.

PALAZZO SCHIFANOIA: Cosmè Tura, *Group of horsemen*, 41. ⁄ Follower of Cosmè Tura, *Frescoes alluding to the months of June and July*, 41. ⁄ Francesco del Cossa, *Frescoes alluding to the months of March, April and May*, 42, 43, 44; plates 29-32.

FORMERLY IN THE MASSARI COLLECTION: Follower of Cossa, *Annunciation*, 46. ⁄ Baldassare d'Este, *Death of the Virgin*, 78.

FORMERLY IN THE SANTINI COLLECTION: School of Ercole de' Roberti, *Deposition* (partly repainted by Bastiano Filippi), 53-54. ⁄ Michele Coltellini, *Death of the Virgin*, 57. ⁄ Ercole Grandi (?), *Small altar-piece*, 71.

FORMERLY IN THE ETTORE TESTA COLLECTION: Gian Francesco de' Maineri, *Madonna*, 54, 55; plate 55.

FLORENCE

UFFIZI: Gentile da Fabriano, *Quaratesi Altar-piece*, 11. ⁄ Rogier Van der Weyden, *Pietà*, 28. ⁄ Cosmè Tura, *St. Dominic*, 41. ⁄ Ercole de' Roberti, *Drawing*, 50; plate 49. ⁄ Lorenzo Costa, *St. Sebastian*, 53, 70. ⁄ Gian Francesco de' Maineri, *Christ bearing the Cross*, 55. ⁄ Ludovico Mazzolino, *The Virgin and Child, with St. Anna, Joachim and St. John*, 56.

PALAZZO PITTI: Iacopo Boateri, *Holy Family*, 64. ⁄ Timoteo della Vite (?), *Portrait of a Young Man with an apple*, 64, 65. ⁄ Lorenzo Costa, *Portrait of Giovanni II Bentivoglio*, 67, 69; plate 71.

GALLERIA CORSINI: Timoteo della Vite, *Apollo and the Muse Thalia*, 65; plate 68.

SANT'APOLLONIA: Andrea del Castagno, *Fragment of a fresco*, 21.

FORMERLY IN THE ELIA VOLPI COLLECTION: Gian Francesco de' Maineri, *Holy Family*, 55.

FORLÌ

MUSEO CIVICO: Francesco Zaganelli, *Painting*, 76.

FRANKFORT

FORMERLY IN THE MUMM VON SCHWARZENSTEIN COLLECTION: Lorenzo Costa, *Portrait of a Woman*, 70.

GLASGOW

CORPORATION GALLERY: Francesco Francia, *Nativity*, 60; plate 61.

GOTHA

GRAND-DUCAL MUSEUM: Gian Francesco de' Maineri, *Madonna*, 55.

HAMPTON COURT

ROYAL COLLECTION: Francesco Francia, *Portrait of Evangelista Scappi*, 62; *St. Sebastian*, 62. ⁄ Lorenzo Costa, *Portrait of a Lady*, 70; plate 75. ⁄ Chiodarolo, *St. Helena*, 73.

HANOVER

KESTNER MUSEUM: Baldassare d'Este, *Portraits of a married couple*, 78.

LENINGRAD

HERMITAGE: Francesco Francia, *Altar-piece*, 61-62; plate 65.

LILLE

MUSEUM: Lorenzo Costa, *Portrait*, 70.

LIVERPOOL

ROSCOE MUSEUM: Ercole de' Roberti, *Pietà*, 51, 54, 56; plate 53.

LONDON

NATIONAL GALLERY: Pisanello, *St. Jerome* (attributed to Bono), 13, 16-17, 31; plate 3; *St. Anthony Abbot and St. George*, 17, 18; plate 6. ⁄ Giovanni da Oriolo, *Portrait of Lionello d'Este*, 19. ⁄ Piero della Francesca, *Baptism of Christ*, 26. ⁄ Cosmè Tura, *Allegory of Spring*, 36-37; plate 19; *Madonna* (centre portion of the Roverella altar-piece), 39; plate 23; *St. Jerome*, 40, 41; *Annunciation*, 40, 41. ⁄ Francesco del Cossa, *St. Vincent Ferrer*, 43-44; plate 33. ⁄ Carlo Crivelli, *Annunciation*, 45. ⁄ School of Ercole de' Ro-

berti, *Strozzi altar-piece*, 52-53. ⋅ Gian Francesco de' Maineri, *Diptych*, 55. ⋅ Francesco Francia, *Pietà*, 62-63; *Madonna from the Mond Collection*, note 70. ⋅ Bernardino Za-ganelli, *St. Sebastian*, 76. ⋅ Bernardino Loschi, *Portrait of Alberto Pio*, 79. ⋅ Boccaccio Boccaccino, *The Procession to Calvary*, 79. ⋅ Garofalo, *Madonna and Child (from Layard Collection)*, 80.

FORMERLY IN THE BENSON COLLECTION: Cosmè Tura, *Flight into Egypt*, 39-40. ⋅ Ercole de' Roberti, *St. Catherine and St. Jerome*, 48. ⋅ Antonello da Messina, *Madonna*, 52. ⋅ Lorenzo Costa, *Christ in the Sepulchre*, 68. ⋅ Correggio, *Congedo*, 70.

FORMERLY IN THE YATES THOMPSON LIBRARY: Amico Aspertini, *Miniatures*, 72.

LUCCA

SAN FREDIANO: Francesco Francia, *Immacolata*, 62. ⋅ Amico Aspertini, *Frescoes*, 72.
MANSI COLLECTION: Follower of Francia, *Madonna*, 63.

LÜTZSCHENA

COLLECTION OF BARON SPECK VON STERNBURG: Francesco Francia, *Madonna*, 63.

LYONS

MUSEUM: Lorenzo Costa, *Madonna adoring the Child*, 68.

MADRID

PRADO: Gian Francesco de' Maineri, *Holy Family*, 54-55.

MANTUA

DONESMONDI COLLECTION: Gian Francesco de' Maineri, *Christ bearing the Cross*, 55.

MILAN

BRERA: Francesco del Cossa, *Two Saints*, 43-44; plate 33. ⋅ Agnolo and Bartolomeo degli Erri, *Parts of a Predella*, 47. ⋅ Ercole de' Roberti, *Altar-piece*, 49-50, 52; plate 46. ⋅ Timoteo della Vite, *Painting of the Knights Crescenzio and Vitale*, 64; *Annunciation*, 65. ⋅ Francesco Francia, *Annunciation*, 63. ⋅ Lorenzo Costa, *Adoration of the Magi*, 69. ⋅ Fran-cesco and Bernardino Zaganelli, *Altar-piece*, 75, 76. ⋅ Girolamo Marchesi, *Assumption*, 76. ⋅ Filippo Mazzola, *Portrait*, 78. ⋅ Niccolò Rondinello, *Painting*, 80.
MUSEO POLDI-PEZZOLI: Follower of Cosmè Tura, *Charity*, 42. ⋅ Tamaroccio, *Ma-donna*, 72. ⋅ Antonio Pirri, *Visitation*, 74; *St. Sebastian*, 74.
BRIVIO COLLECTION: Lorenzo Costa, *St. Anna*, 70, 71.
COLOGNA COLLECTION: Antonio Cicognara, *Signed altar-piece*, 46.
FORMERLY IN THE NOSEDA COLLECTION: Ercole Grandi (?), *St. Sebastian*, 71.

MODENA

R. GALLERIA ESTENSE: School of Parma, *Front of a chest* (beginning of fifteenth century), 12. ⁄ Cristoforo da Lendinara, *Madonna*, 33. ⁄ Bartolomeo Bonascia, *Pietà*, 33; plate 15. ⁄ Agnolo and Bartolomeo degli Erri, *Polyptych*, 46⁄47; plate 39. ⁄ Gian Francesco de' Maineri, *Christ bearing the Cross*, 55. ⁄ Francesco Bianchi Ferrari, *Crucifixion*, 58; *Annunciation*, 59. ⁄ Antonio Scacceri, *Christ in the Tomb*, 59. ⁄ Giacomo and Giulio Francia, *Altar⁄piece*, 64. ⁄ Bernardino Loschi, *Altar⁄piece*, 79. ⁄ Marco Meloni, *Madonna enthroned, with saints and worshippers*, 81; *Altar⁄piece* (1504), 81.
BIBLIOTECA ESTENSE: *Bible of Borso d'Este*, 19.
MUSEO CIVICO: Bartolomeo degli Erri, *Figures of Famous Women*, 47.
CATHEDRAL: Bartolomeo Bonascia, *Paintings*, 33. ⁄ Sacristy: Cristoforo and Lorenzo da Lendinara, *Inlays*, 33; plates 13, 14.
SAN PIETRO: Francesco Bianchi Ferrari, *Altar⁄piece*, 58; plate 58.

MUNICH

ALTE PINAKOTHEK: Michael Pacher, *Organ⁄front*, 36. ⁄ Francesco Francia, *Madonna and Angels*, 60; plate 63; *Madonna of the Rosebushes*, 62; plate 67. ⁄ Lorenzo Costa, *Family Portrait*, 67.

NAPLES

MUSEO NAZIONALE: Giambellino, *Resurrection*, 80.

NEW YORK

DUVEEN COLLECTION: Pisanello, *Portrait of a Princess* (now in the Clarence Mackay Collection), 17⁄18; plate 5. ⁄ Andrea del Castagno, *Resurrection*, 21. ⁄ Ercole de' Roberti, *Two Saints* (from the Benson Collection), 48. ⁄ Lorenzo Costa, *Christ in the Sepulchre* (from the Benson Collection), 68.
LEHMAN COLLECTION: Francesco del Cossa, *Crucifixion*, 43; plate 28.
PRATT COLLECTION: Cosmè Tura, *Madonna*, 40; plate 26.

NICE

ÉCOLE DES BEAUX⁄ARTS: Boccaccio Boccaccino, *Adoration of the Magi*, 79.

NONANTOLA

ABBEY CHURCH: Bartolomeo Bonascia, *Frescoes*, 33. ⁄ Follower of Cosmè Tura, *Apparition of Christ to the Virgin and Apostles*, 41⁄42.

ORLEANS

MUSEUM: Francesco Francia, *Madonna*, 69.

OXFORD

Ashmolean Museum: Marco Zoppo, *St. Paul*, 36.

PADUA

Museo Civico: *Madonna and Child* (akin to the style of the Degli Erri), 47. ⁄ Ercole de' Roberti, *The Argonauts,* 50; plate 47.

Salone del Podestà: Miretto, *Decoration,* 8.

Sant'Antonio: Stefano da Ferrara, *Paintings,* 8.

Church of the Eremitani, Ovetari Chapel: Bono da Ferrara, *Frescoes,* 25, 31; plate 11. ⁄ Ansuino da Forlì, *Frescoes,* 31; plate 12. ⁄ Cosmè Tura, *Frescoes,* 36.

PALERMO

Collection of the Prince of Trabia: Follower of Francia (Giovanni da Milano?), *Madonna and St. Sebastian,* 63.

PARIS

Musée du Louvre: Parma School, *Front of a chest* (fifteenth century), 12. ⁄ Pisanello, *Portrait of a Princess of the House of Este,* 17; plate 4. ⁄ Cosmè Tura, *Top portion of the Roverella altar-piece,* 39; *St. Francis,* 41. ⁄ Ercole de' Roberti, *St. Apollonia and St. Michael,* 48. ⁄ Francesco Bianchi Ferrari, *St. John,* 58-59. ⁄ Francesco Francia, *Holy Family and Angels,* 61. ⁄ Giacomo Francia, *Altar-piece,* 64. ⁄ Lorenzo Costa, *Allegories,* 69-70. ⁄ Iacopo Ripanda, *Drawings,* 73. ⁄ Alessandro Araldi, *Altar-piece,* 74, 75.

Musée Jacquemart André: *Stained-glass* from a design by Francesco del Cossa, 44. ⁄ Unknown painter, *Martyrdom of St. Sebastian,* 77.

Dreyfuss Collection: Follower of Cossa, *Diptych with portraits of Giovanni II Bentivoglio and his wife,* 46.

Duveen Collection: Andrea del Castagno, *Fragment of a Predella,* 21.

Henry Heugel Collection: Francesco Francia, *Portrait of Bernardo Vanni,* 62.

Formerly in the Spiridon Collection: Francesco del Cossa, *St. Lucy and St. Liberale,* 42, 43.

Formerly in the Trotti Collection: Unknown Ferrarese painter, *Altar-piece of Bishop Boiardi* (from the Certosa of Ferrara), 11; note 17; plate 2.

PARMA

R. Galleria: Bartolino Grossi and followers, *Small pictures,* 12. ⁄ Followers of Bartolino Grossi, *Paintings* (Nos. 53 & 55), 12. ⁄ Francesco Francia, *Deposition,* 62, 63. ⁄ Alessandro Araldi, *Annunciation,* 75. ⁄ Temperello, *Altar-piece,* 78; *Madonna,* 78.

MUSEO ARCHEOLOGICO: *Maiolica tablets* from designs by Bartolino Grossi, 12.

CATHEDRAL, Rusconi, Ravacaldi, Valeri-Baganzola and Municipal Chapels: *Frescoes,* 11-12. ⁄ Zarotti (?), *Fresco,* 78-79.

BAPTISTERY: Follower of Bartolino Grossi, *Ex-voto,* 12.

SAN GIOVANNI EVANGELISTA: Giacomo and Giulio Francia, *Altar-piece,* 64. ⁄ Cesare Cesariano, *Decoration of the Sacristy,* 78.

MADONNA DELLA STECCATA: Simone delle Spade, *Altar-piece,* 64.

CHURCH OF THE CARMINE, Follower of Bartolino Grossi, *Frescoes,* 12.

CONVENT OF SAN PAOLO: Correggio, *Paintings,* 82.

MONASTERY OF SANTA CATERINA, Oratory: Alessandro Araldi, *Frescoes,* 74, 75.

ORATORY OF SAN GIROLAMO: Follower of Bartolino Grossi, *Ex-voto,* 12.

PERUGIA
COLLEGIO DEL CAMBIO: Raphael, *Fortitude,* 65.

PESARO
MUSEO CIVICO: Marco Zoppo, *Christ between two Angels,* 35; *Head of St. John,* 35.

PHILADELPHIA
FORMERLY IN THE JOHNSON COLLECTION: Cosmè Tura, *St. Peter and St. John,* 40.

PIAZZA BREMBANA
FABBRICERIA: Lattanzio da Rimini, *Painting,* 80.

RAVENNA
MUSEUM: Bernardino Zaganelli, *Predella,* 75. ⁄ Francesco Zaganelli, *Nativity,* 76.

REGGIO EMILIA
MUSEUM: Follower of Cosmè Tura, *Painted Chest,* 59.

BAPTISTERY: Francesco Caprioli, *Baptism of Christ,* 59.

CASSOLI COLLECTION: Lorenzo Costa, *St. Sebastian,* 67; plate 72.

RICHMOND
COOK COLLECTION: Marco Zoppo, *Madonna,* 35; plate 16. ⁄ School of Ercole de' Roberti, *Medea and her children,* 52. ⁄ Gian Francesco de' Maineri, *Flagellation,* 55. ⁄ Baldassare d'Este, *Signed Portrait,* 78.

RIMINI
TEMPIO MALATESTIANO: Piero della Francesca, *Fresco* (1451), 26-27.

ROME

STRASBURG

TALAMELLO

TEPLITZ

TURIN

INDEX OF ARTISTS

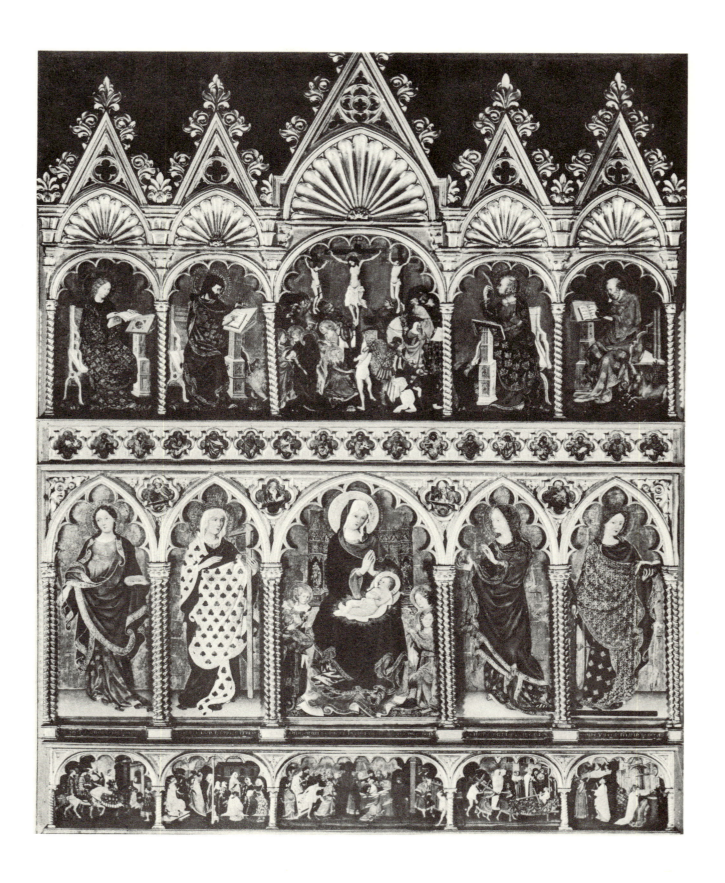

1

MICHELE DI MATTEO
Polyptych.
VENICE. ACCADEMIA

Photo Alinari

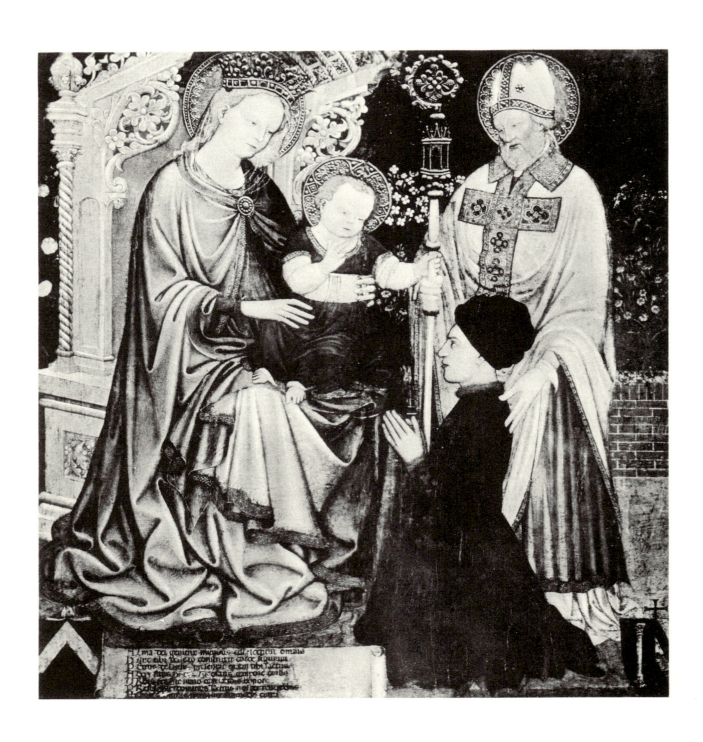

2

UNKNOWN FERRARESE PAINTER
Madonna and Child, with St. Maurelio presenting
a devout personage.
Paris. Formerly in the possession of Messrs. Trotti

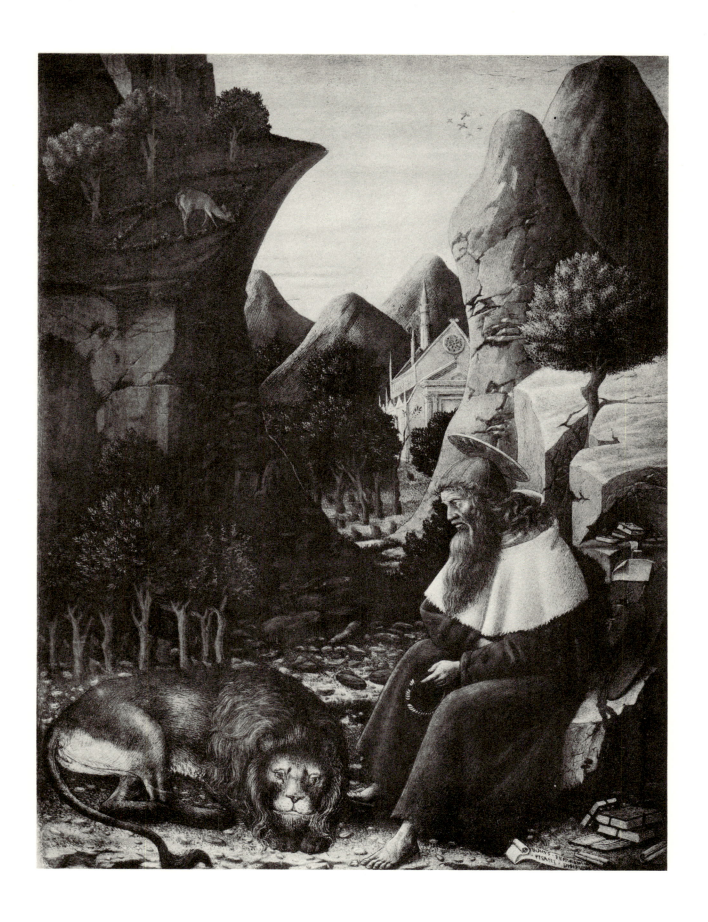

3

PISANELLO
St. Jerome.
LONDON. NATIONAL GALLERY
Photo Anderson

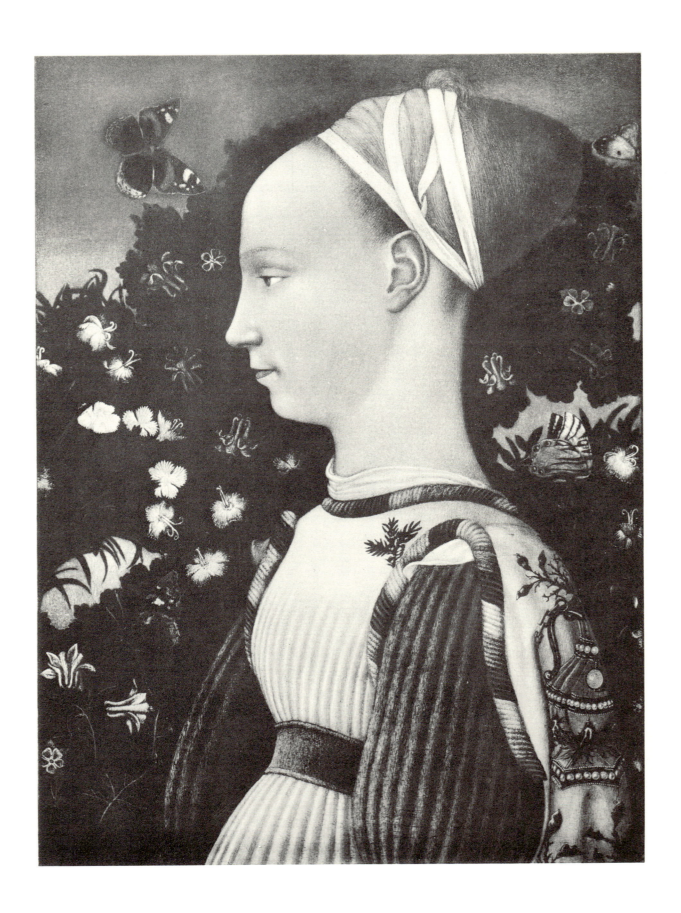

4

PISANELLO
Portrait of a Princess of the House of Este.

PARIS. MUSÉE DU LOUVRE

Photo Anderson

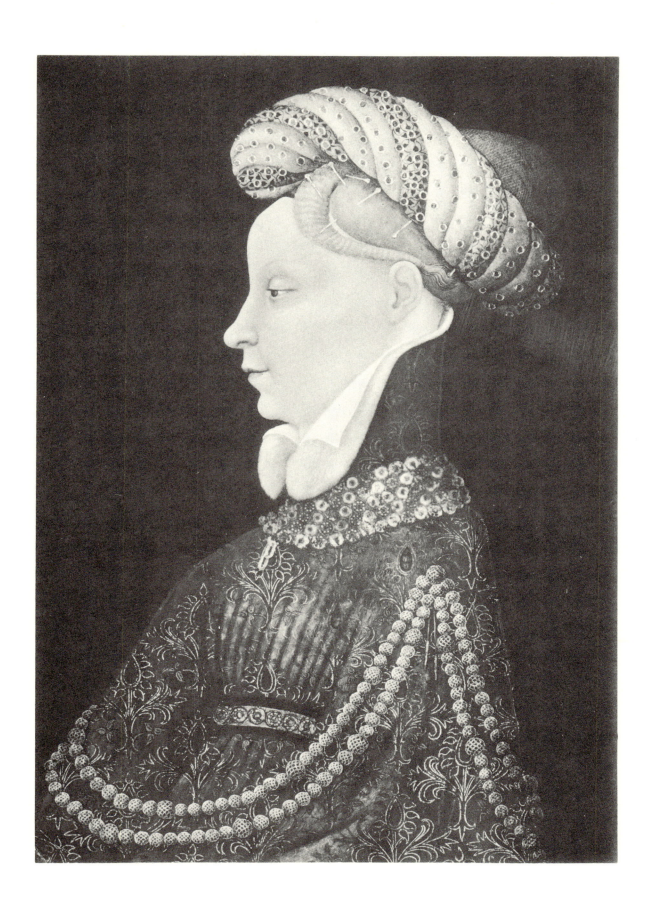

5

PISANELLO
Portrait of a Princess.
New York. Collection of Mr. Clarence Mackay

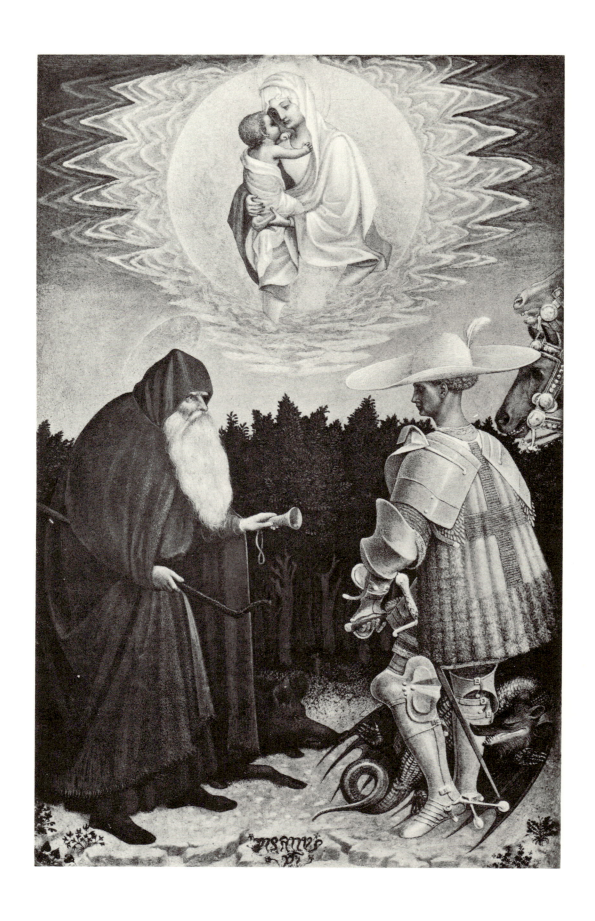

6

PISANELLO
Apparition of the Virgin to St. Anthony Abbot and St. George.
LONDON. NATIONAL GALLERY
Photo Anderson

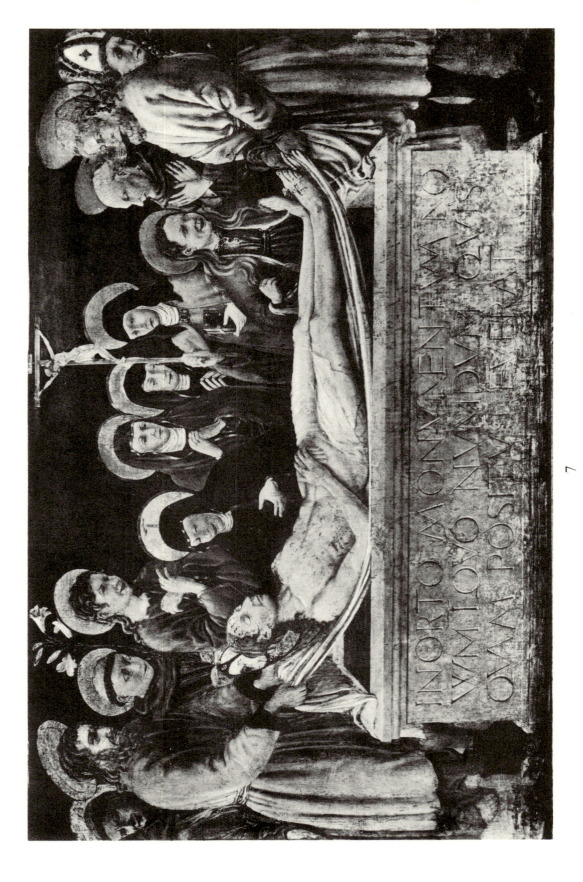

7

UNKNOWN FERRARESE PAINTER
(Follower of Piero della Francesca)
The Deposition.
Ferrara. Pinacoteca

Photo Anderson

8

GALASSO FERRARESE (?)

Angel Musician.

BUDAPEST. NATIONAL GALLERY

9

GALASSO FERRARESE (?)

Angel Musician.

BUDAPEST. NATIONAL GALLERY

10

GALASSO FERRARESE (?)

Autumn.

BERLIN. KAISER FRIEDRICH MUSEUM

11

BONO DA FERRARA
Fresco: St. Christopher with the Infant Christ on his shoulders.
PADUA. CHURCH OF THE EREMITANI

Photo Alinari

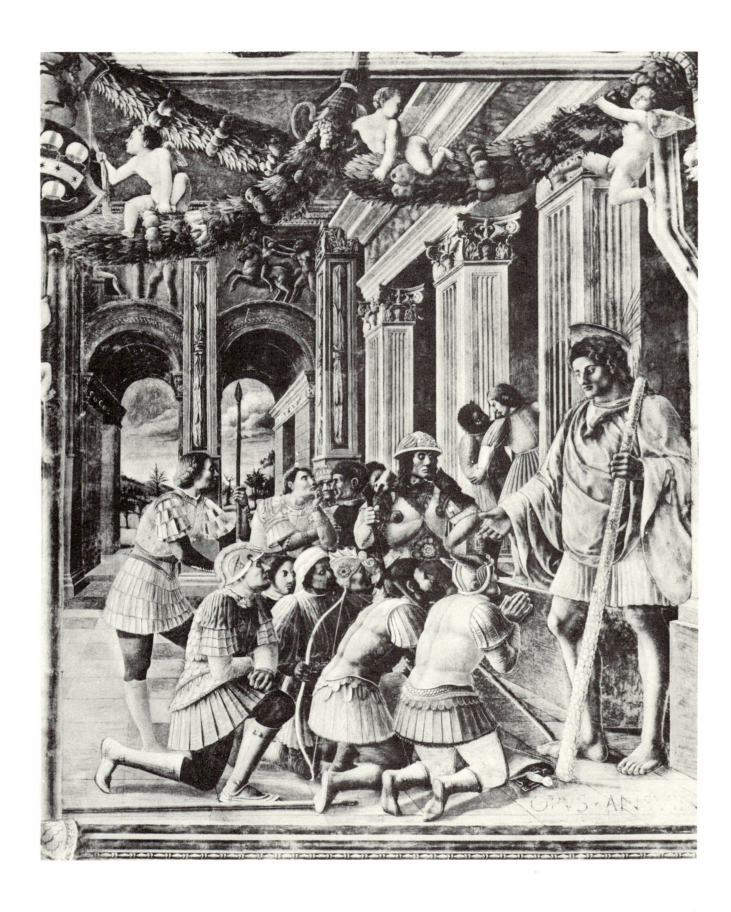

12

ANSUINO DA FORLÌ
Fresco: St. Christopher preaching.
PADUA. CHURCH OF THE EREMITANI

Photo Alinari

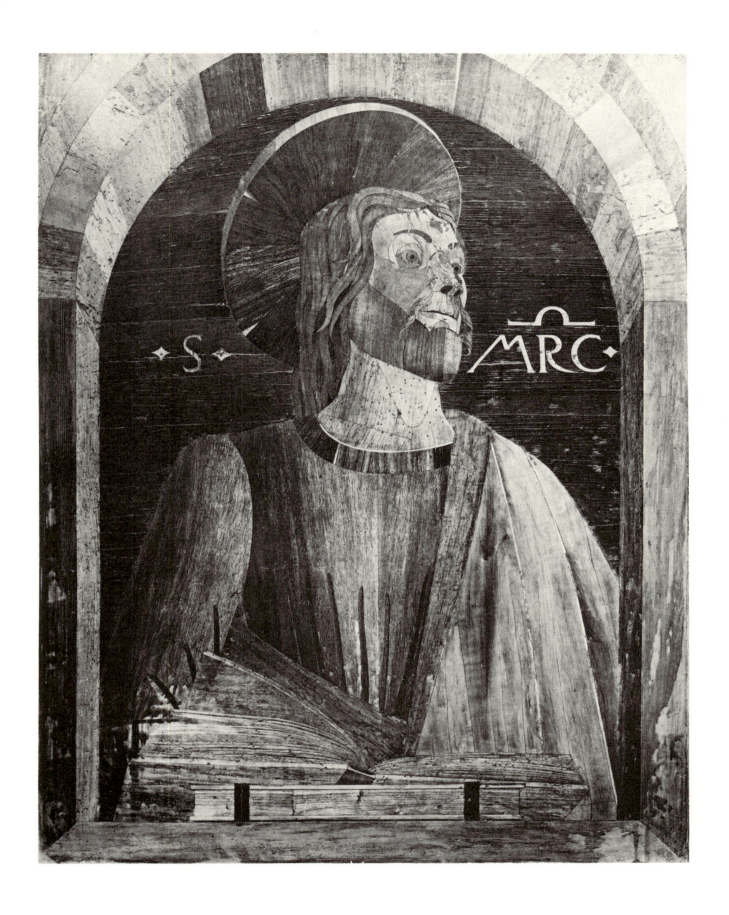

13

CRISTOFORO DA LENDINARA

St. Mark.

Modena. Sacristy of the Cathedral

Photo Anderson

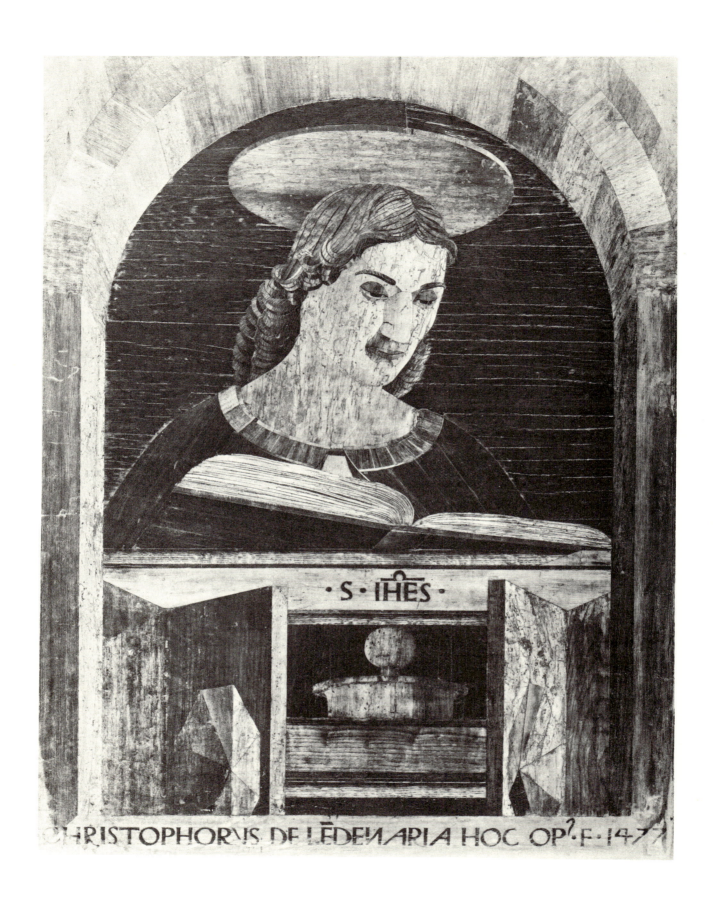

14

CRISTOFORO DA LENDINARA
St. John the Evangelist.
Modena. Sacristy of the Cathedral

Photo Anderson

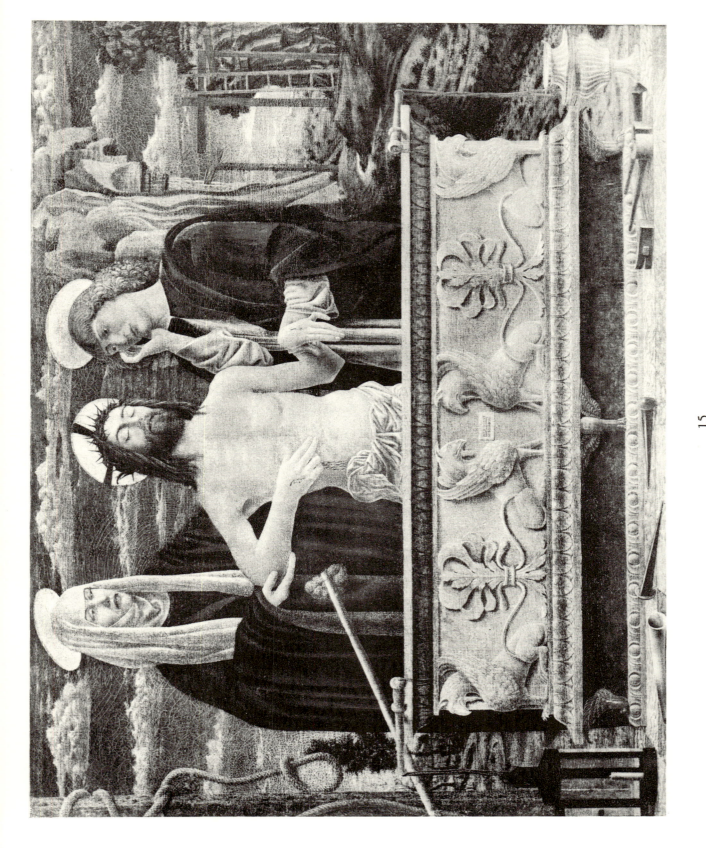

15

BARTOLOMEO BONASCIA

The dead Christ.

MODENA. GALLERIA ESTENSE

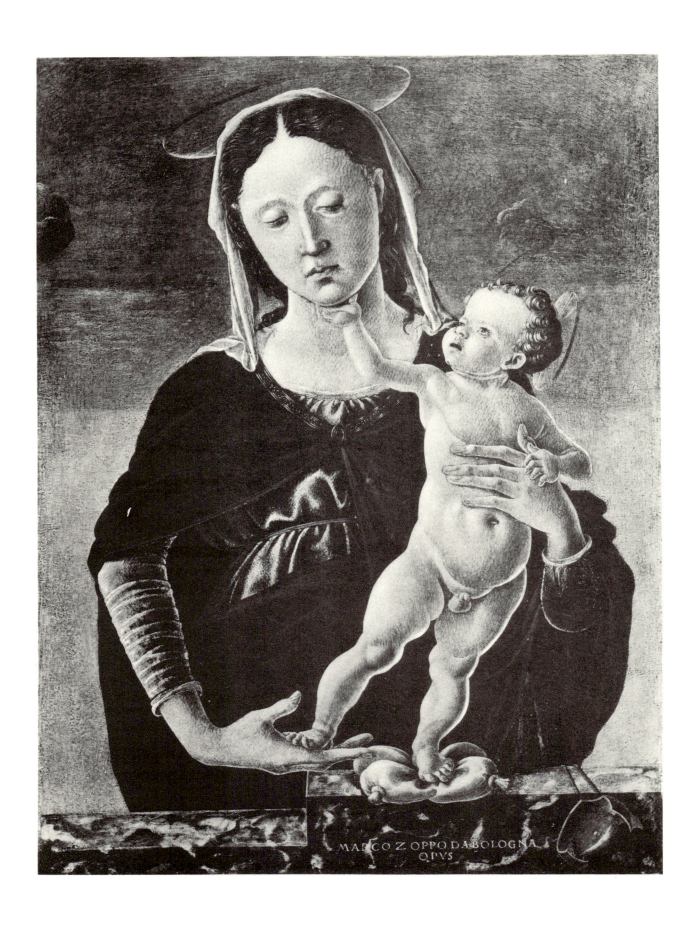

16

MARCO ZOPPO

The Virgin with the Child Jesus.

RICHMOND. COOK COLLECTION

Photo Anderson

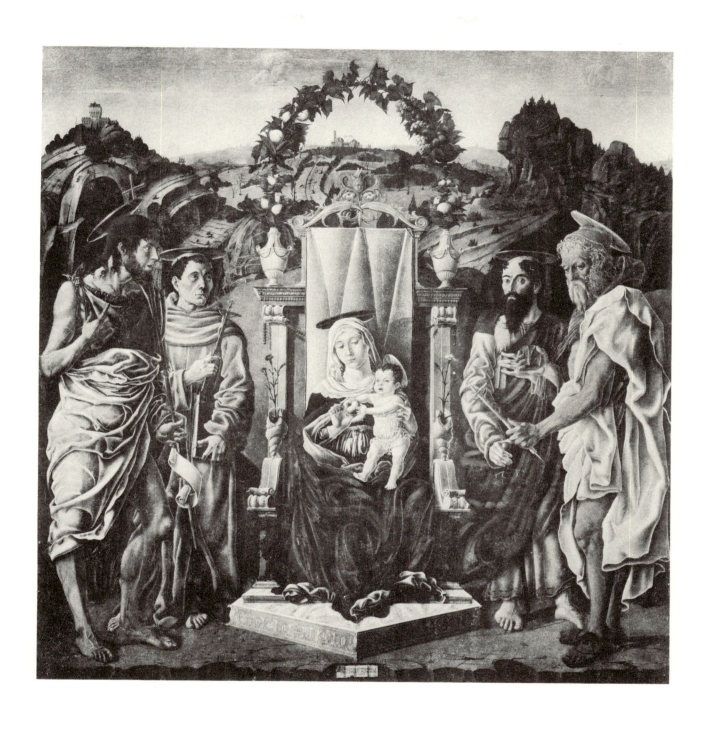

17

MARCO ZOPPO

Altar-piece: The Virgin with the Child and Saints.

BERLIN. KAISER FRIEDRICH MUSEUM

Photo Braun

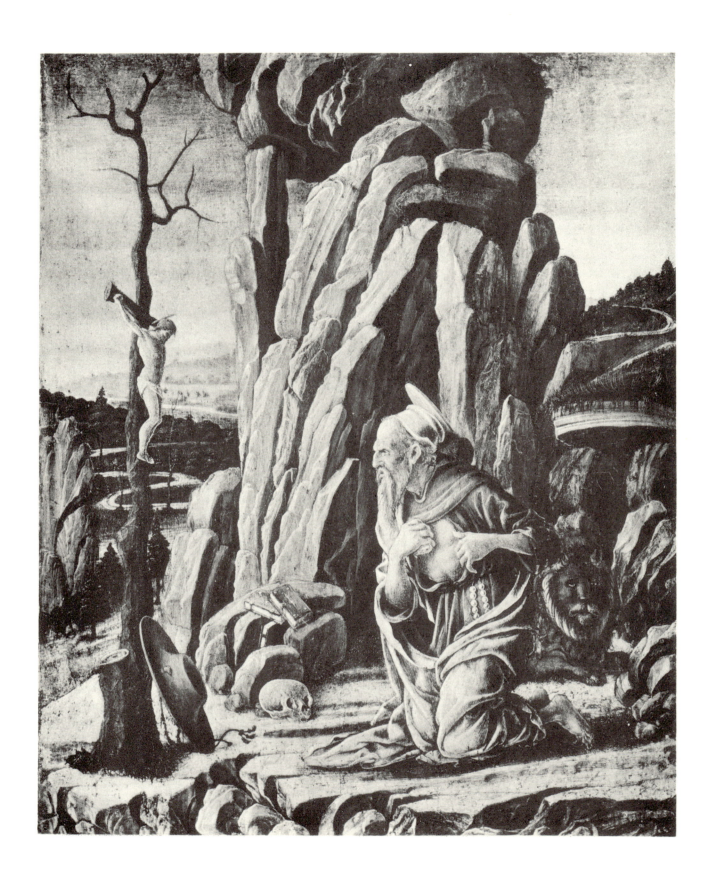

18

MARCO ZOPPO

St. Jerome in the Desert.

BOLOGNA. PINACOTECA

Photo Anderson

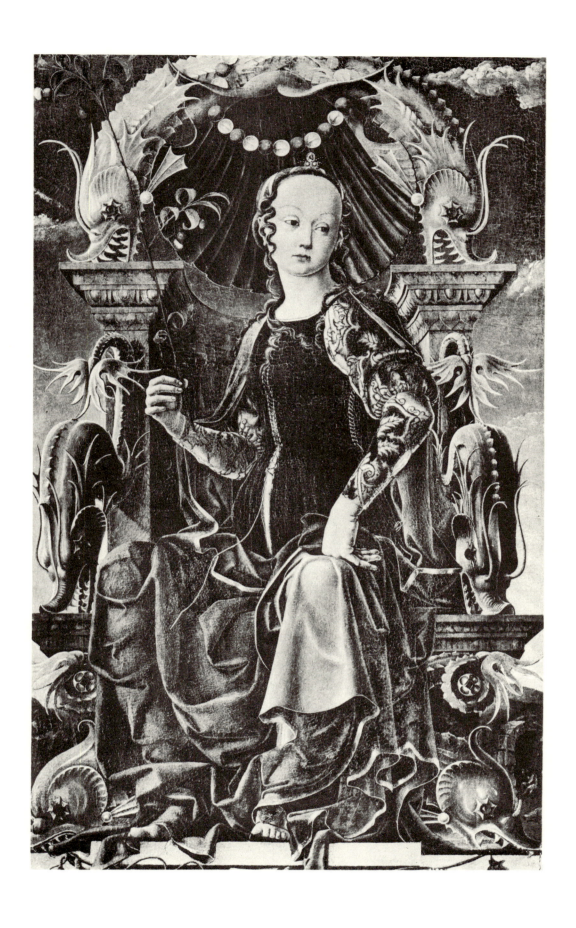

19

COSMÈ TURA
Allegory of Spring.
LONDON. NATIONAL GALLERY
Photo Anderson

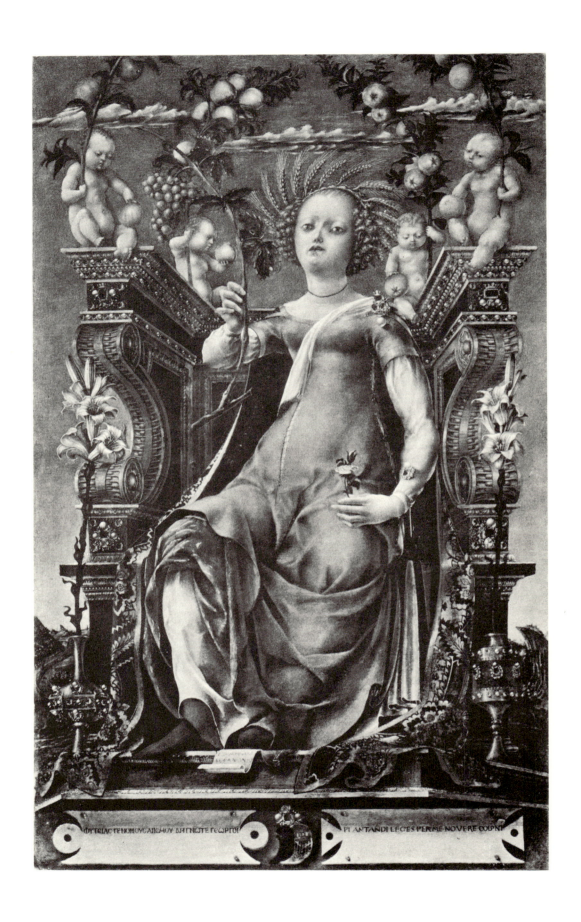

20

MICHELE PANNONIO
Ceres enthroned.
BUDAPEST. NATIONAL GALLERY
Photo Hanfstaengl

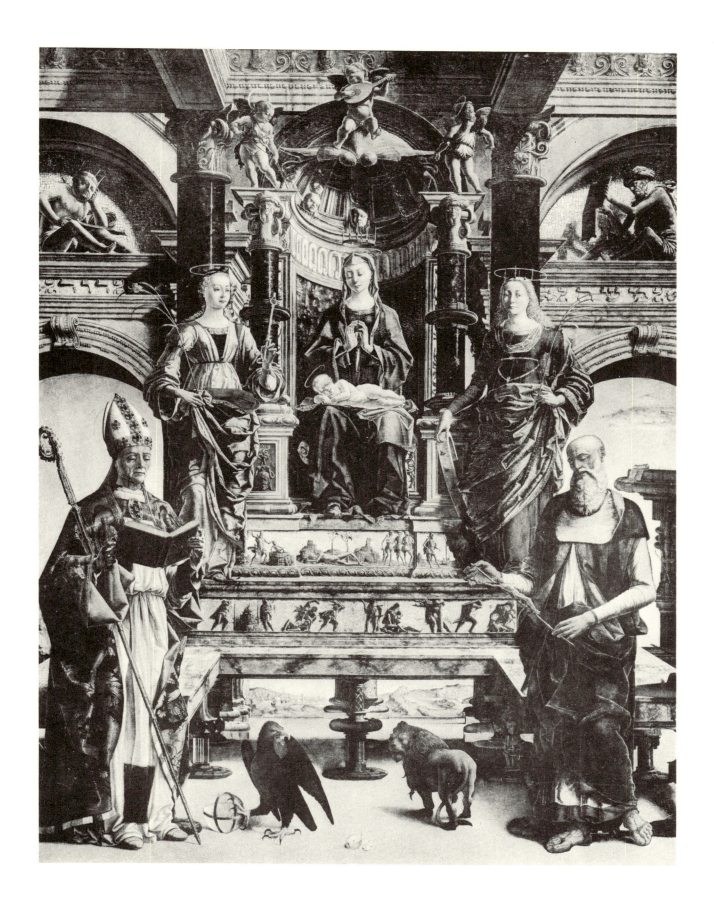

21

COSMÈ TURA
Altar-piece: The Virgin with the Child and Saints.
BERLIN. KAISER FRIEDRICH MUSEUM
Photo Hanfstaengl

22

COSMÈ TURA
Pietà.
VIENNA. KUNSTHISTORISCHES MUSEUM
Photo Wolfrum

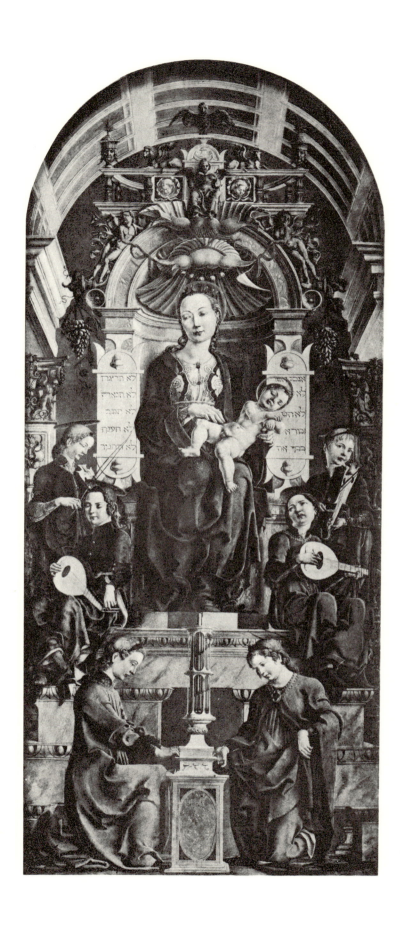

23

COSMÈ TURA
Madonna and Angel.
LONDON. NATIONAL GALLERY
Photo Anderson

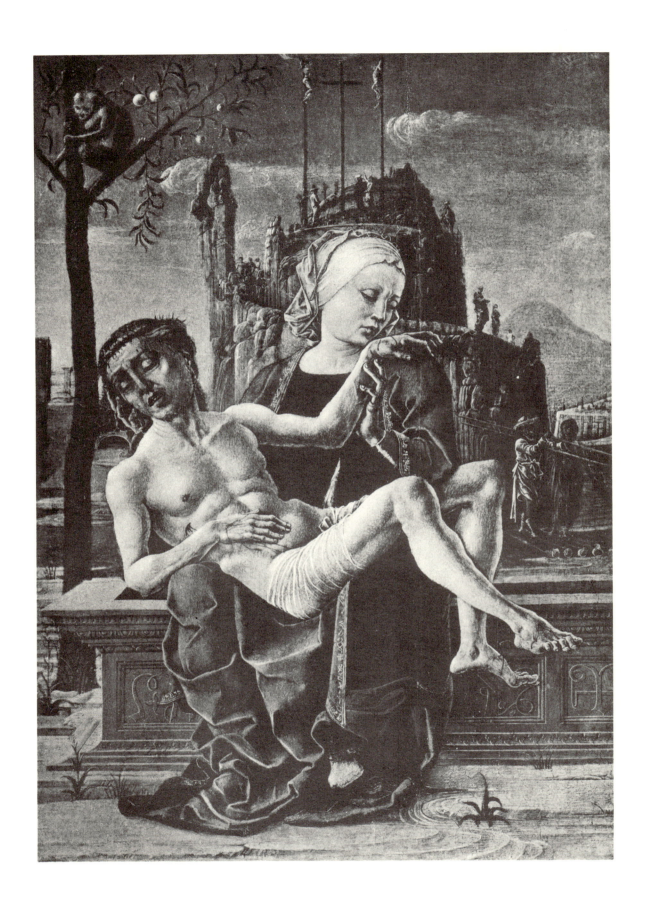

24

COSMÈ TURA
Pietà.
VENICE. MUSEO CORRER
Photo Alinari

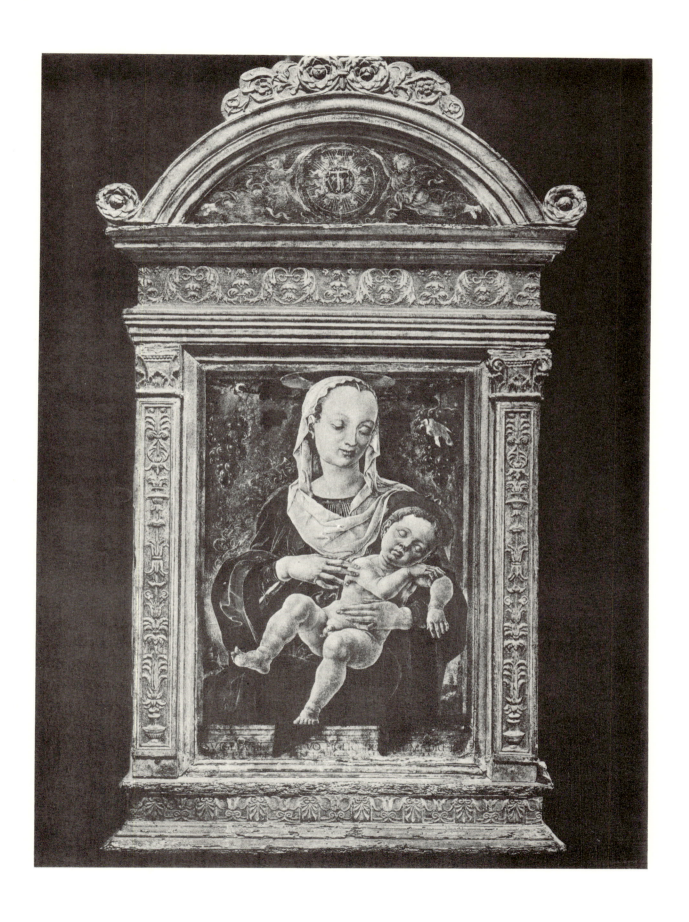

25

COSMÈ TURA
Virgin and Child.
VENICE. ACCADEMIA

Photo Anderson

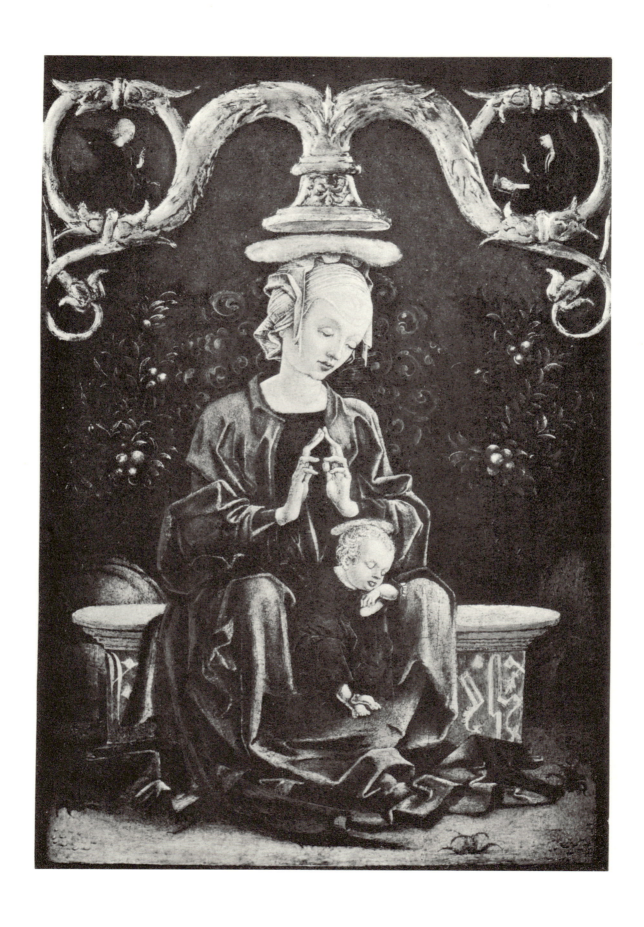

26

COSMÈ TURA
Madonna.
NEW YORK. PRATT COLLECTION

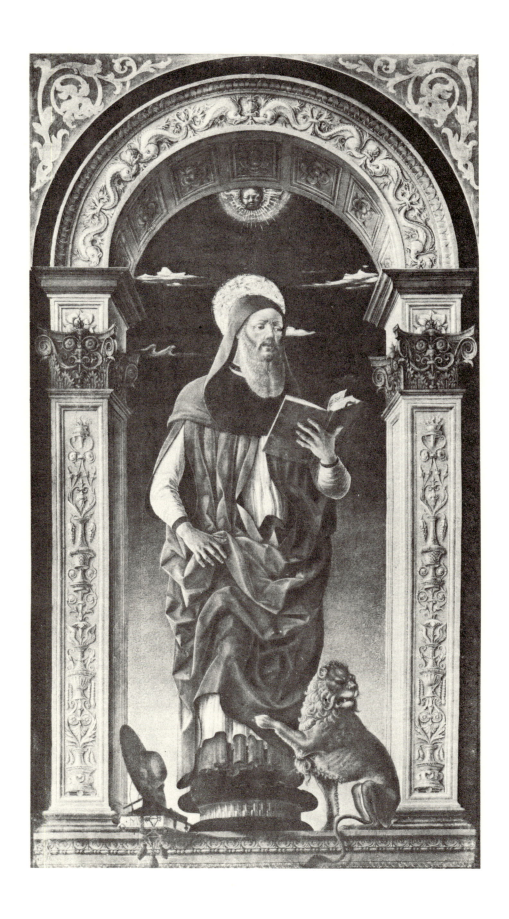

27

FRANCESCO DEL COSSA
St. Jerome.
FERRARA. PINACOTECA
Photo Anderson

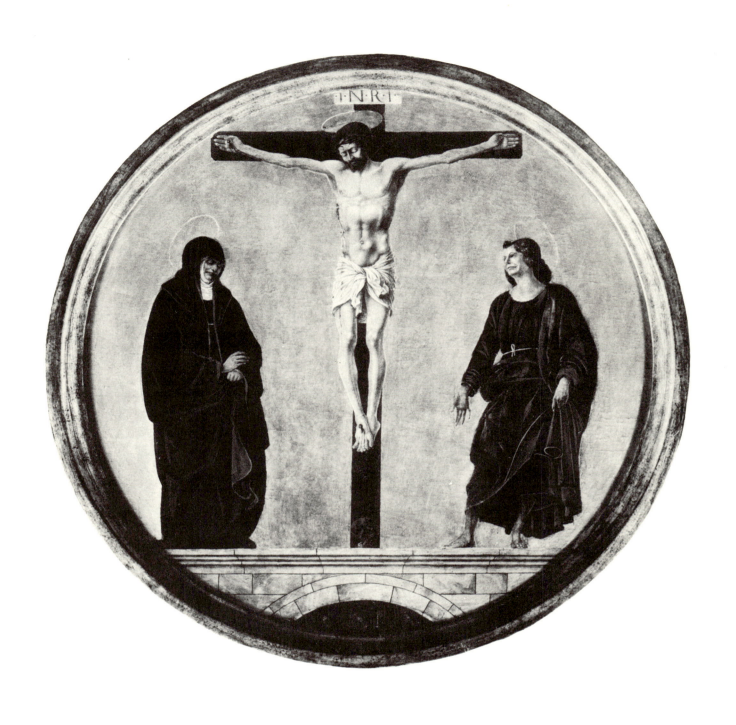

28

FRANCESCO DEL COSSA

The Crucifixion.

NEW YORK. LEHMAN COLLECTION

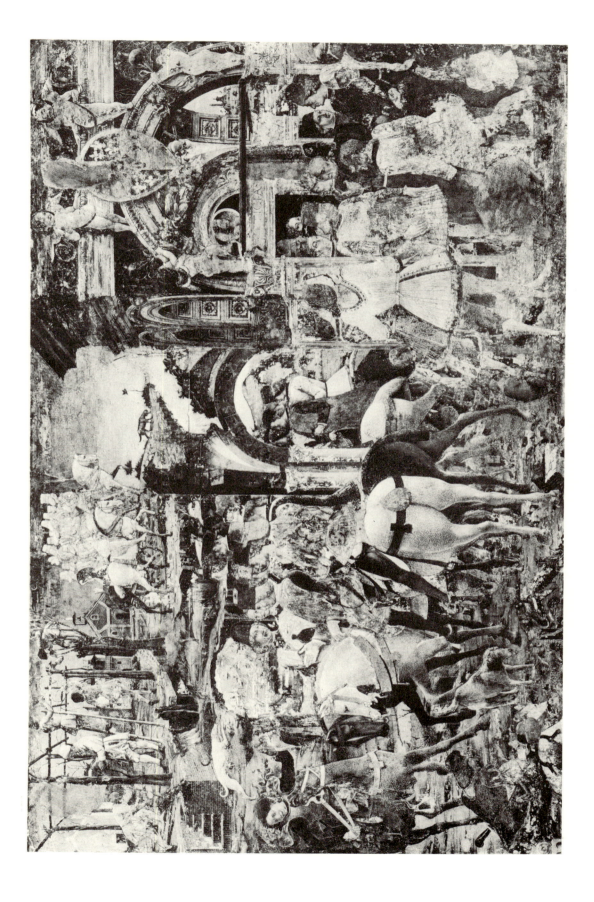

29

FRANCESCO DEL COSSA

Fresco: Duke Borso goes hunting.

FERRARA. PALAZZO SCHIFANOIA

Photo Anderson

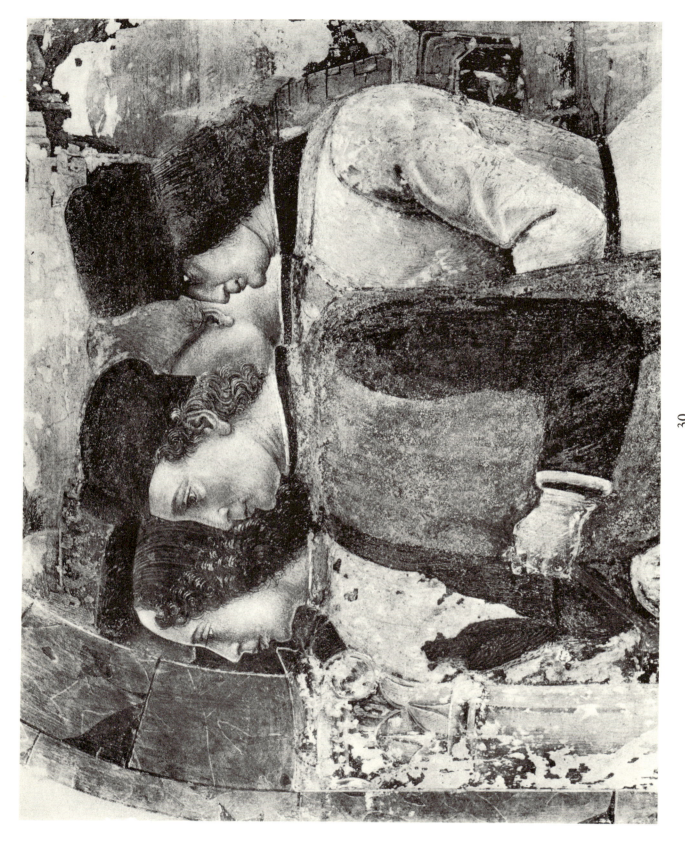

30

FRANCESCO DEL COSSA
Detail of Fresco.
FERRARA. PALAZZO SCHIFANOIA

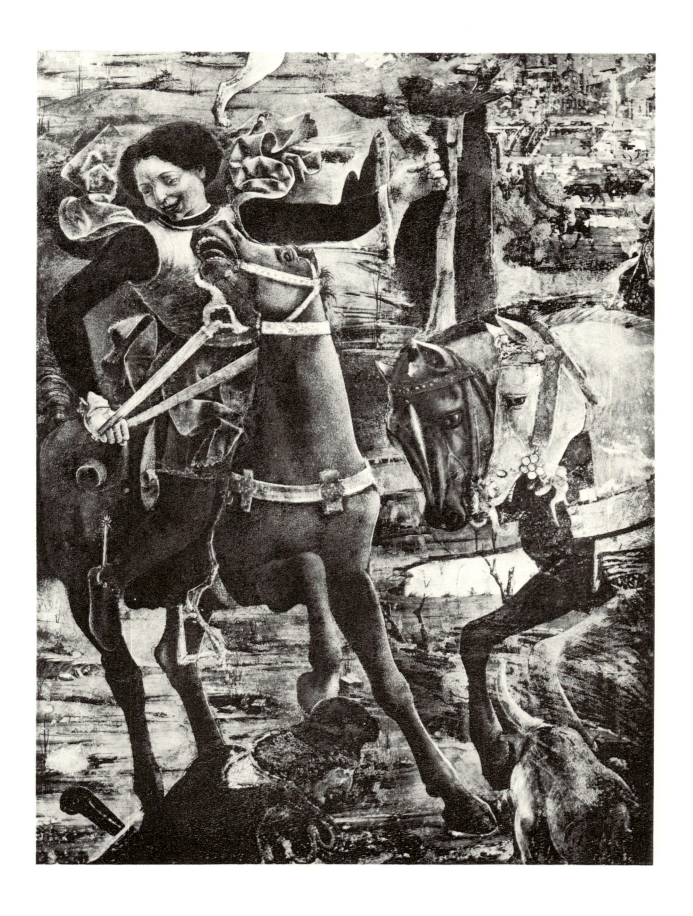

31
FRANCESCO DEL COSSA
Detail of Fresco.

FERRARA. PALAZZO SCHIFANOIA

Photo Anderson

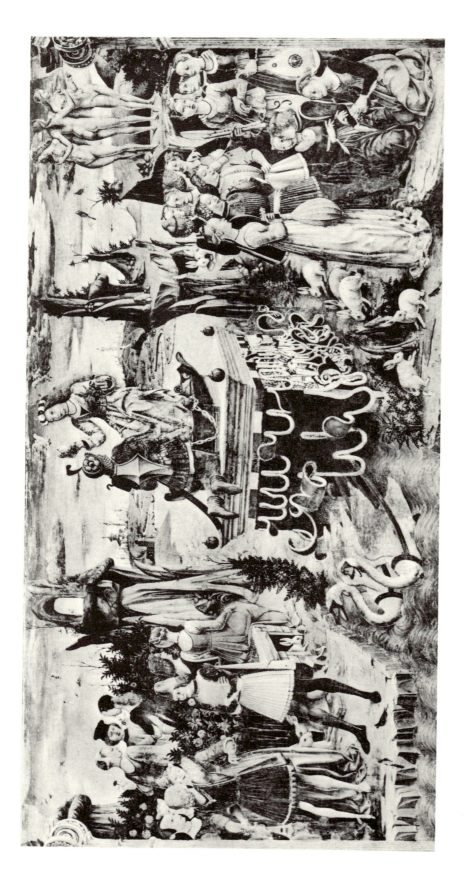

32

FRANCESCO DEL COSSA
Fresco: The Triumph of Venus.
FERRARA. PALAZZO SCHIFANOIA

Photo Anderson

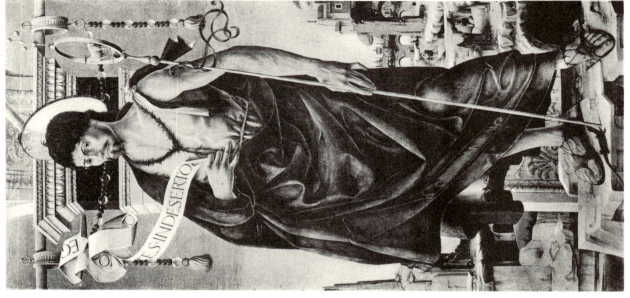

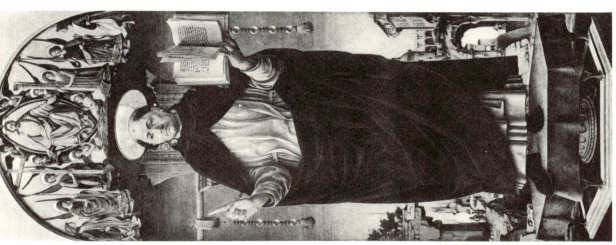

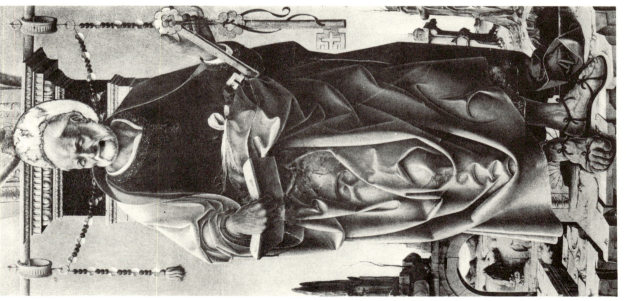

33

FRANCESCO DEL COSSA
Triptych.
London. National Gallery (centre)
Milan. Brera (side panels)

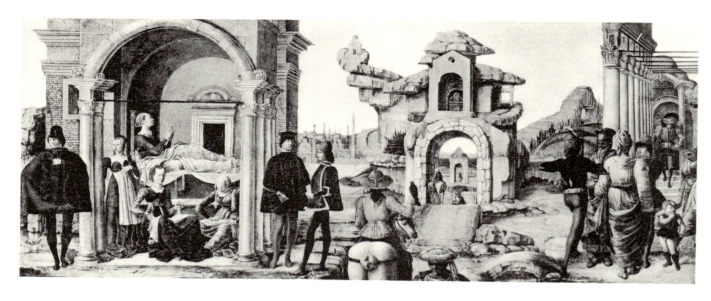

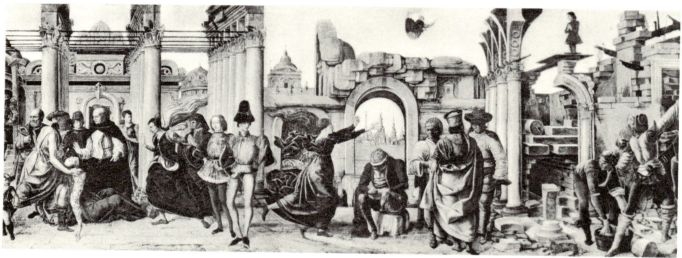

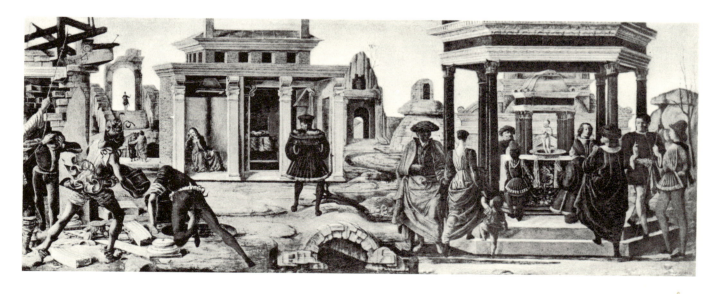

34

FRANCESCO DEL COSSA
Predella representing scenes from the life of St. Vincent Ferrer.
ROME. VATICAN GALLERY
Photo Anderson

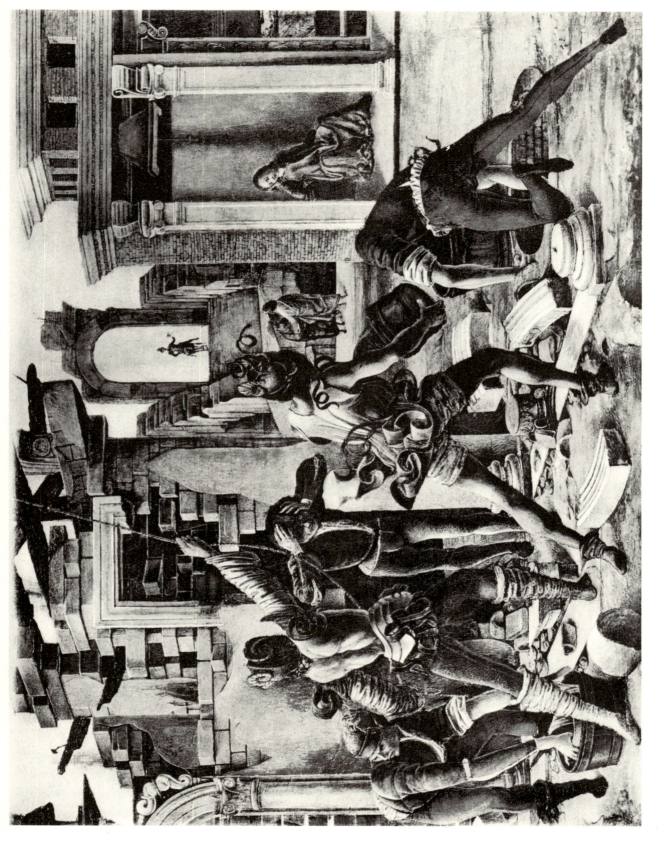

35

FRANCESCO DEL COSSA
Predella representing scenes from the life of St. Vincent Ferrer:
Detail.
ROME. VATICAN GALLERY
Photo Anderson

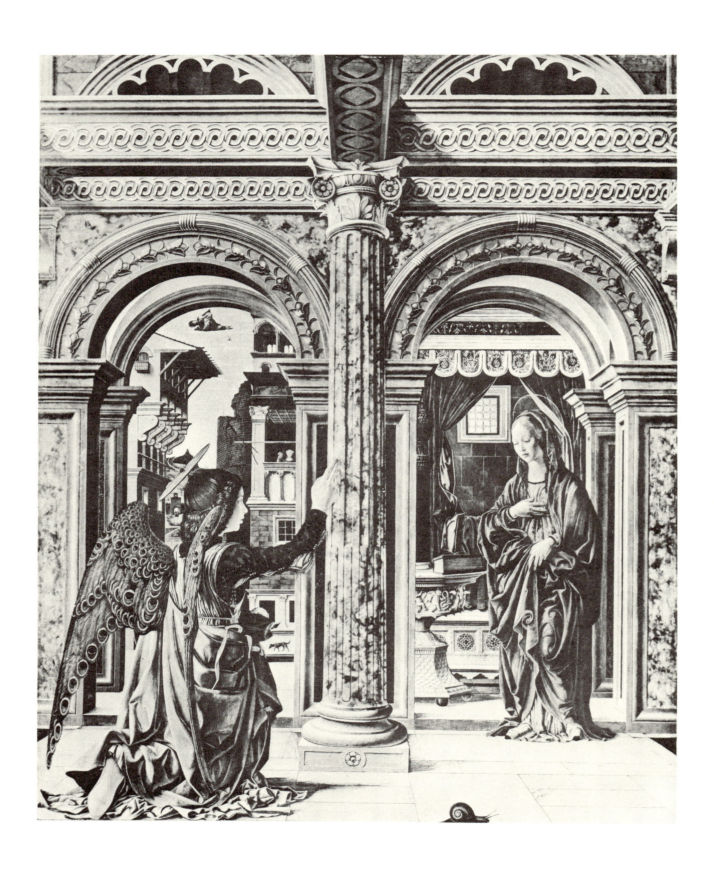

36

FRANCESCO DEL COSSA
The Annunciation.
DRESDEN. GEMÄLDEGALERIE
Photo Alinari

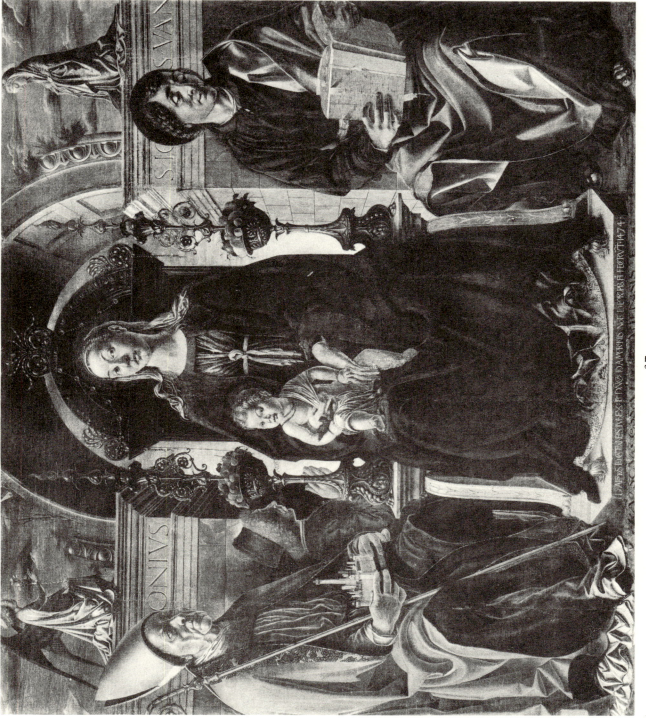

37

FRANCESCO DEL COSSA

The 1474 altarpiece.

BOLOGNA. PINACOTECA

Photo Anderson

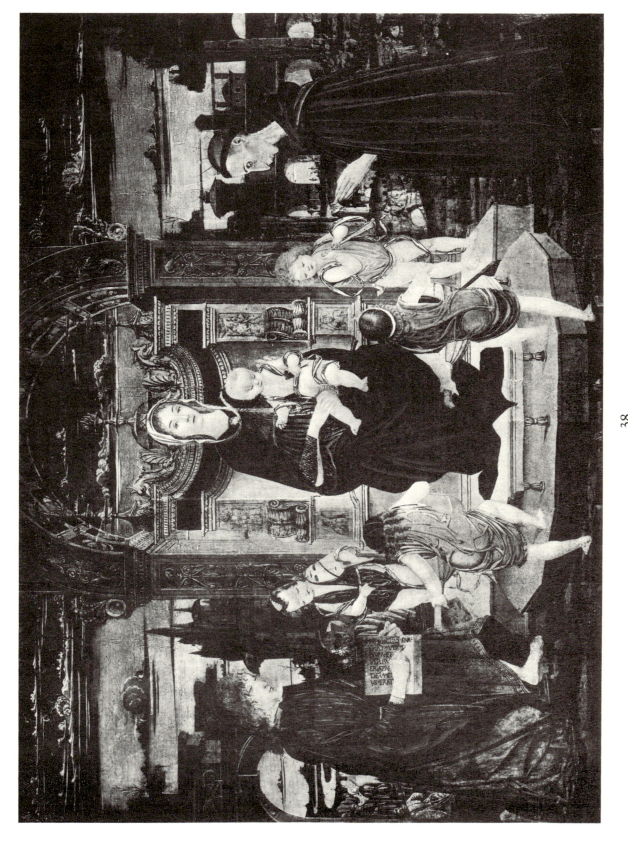

38

LEONARDO SCALETTI
Madonna and Saints.
FAENZA. PINACOTECA
Photo Alinari

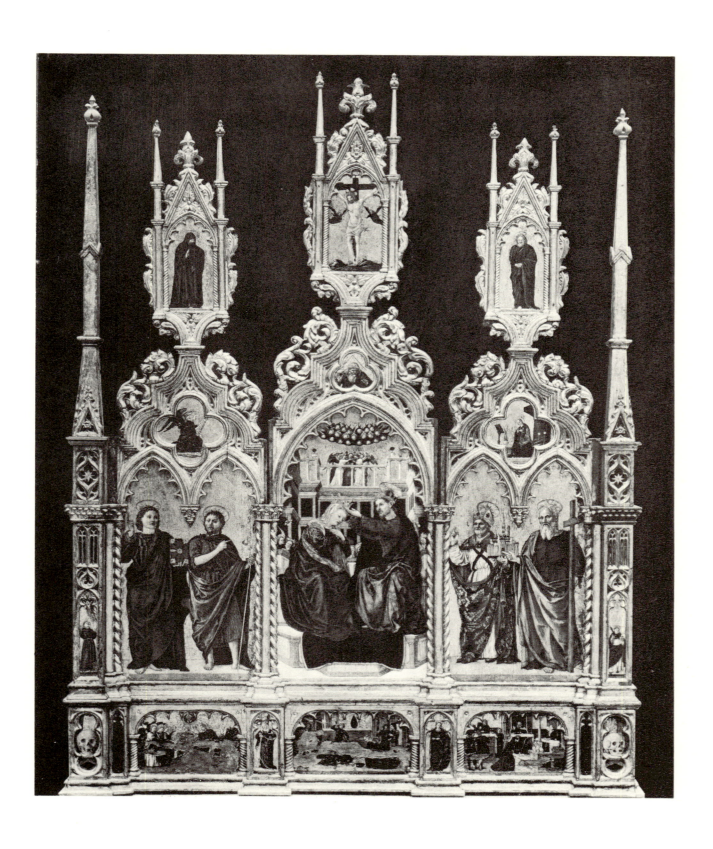

39

AGNOLO AND BARTOLOMEO DEGLI ERRI
Polyptych.
Modena. Galleria Estense

Photo Anderson

40

AGNOLO DEGLI ERRI

Small panels representing scenes drom the life of
St. Vincent Ferrer.

Vienna. Este Museum

Photo Anton Schroll

41

AGNOLO DEGLI ERRI
Small panels representing scenes from the life of
St. Vincent Ferrer.
VIENNA. ESTE MUSEUM

Photo Anton Schroll

42

AGNOLO DEGLI ERRI
Small panels representing scenes from the life of
St. Vincent Ferrer.
VIENNA. ESTE MUSEUM
Photo Anton Schroll

43

AGNOLO DEGLI ERRI
Small panels representing scenes from the life of
St. Vincent Ferrer.
VIENNA. ESTE MUSEUM
Photo Anton Schroll

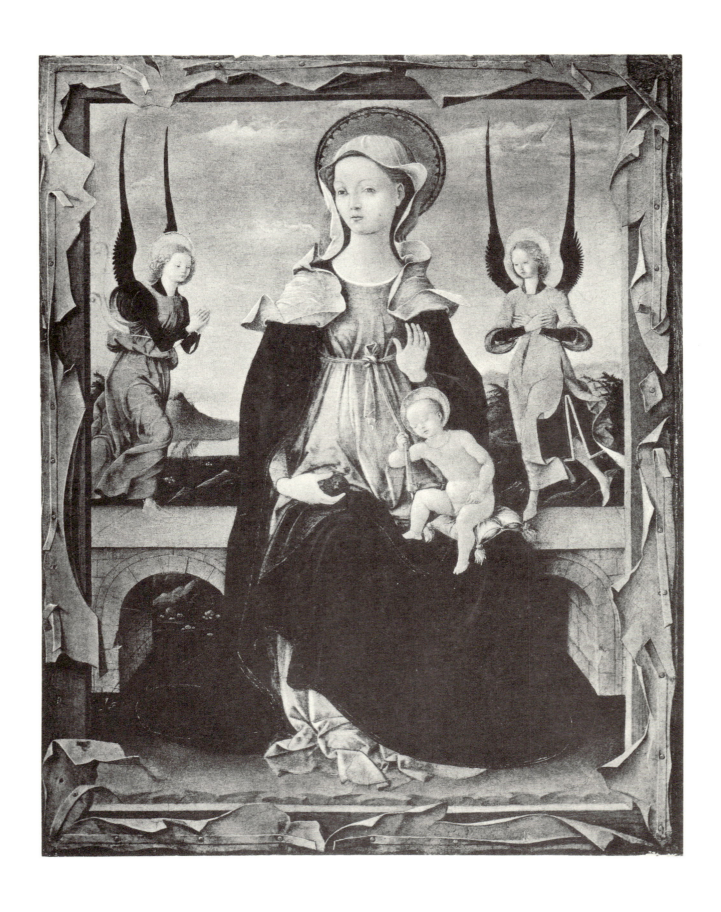

44

ERCOLE DE' ROBERTI
Madonna and Angels.
EDINBURGH. NATIONAL GALLERY

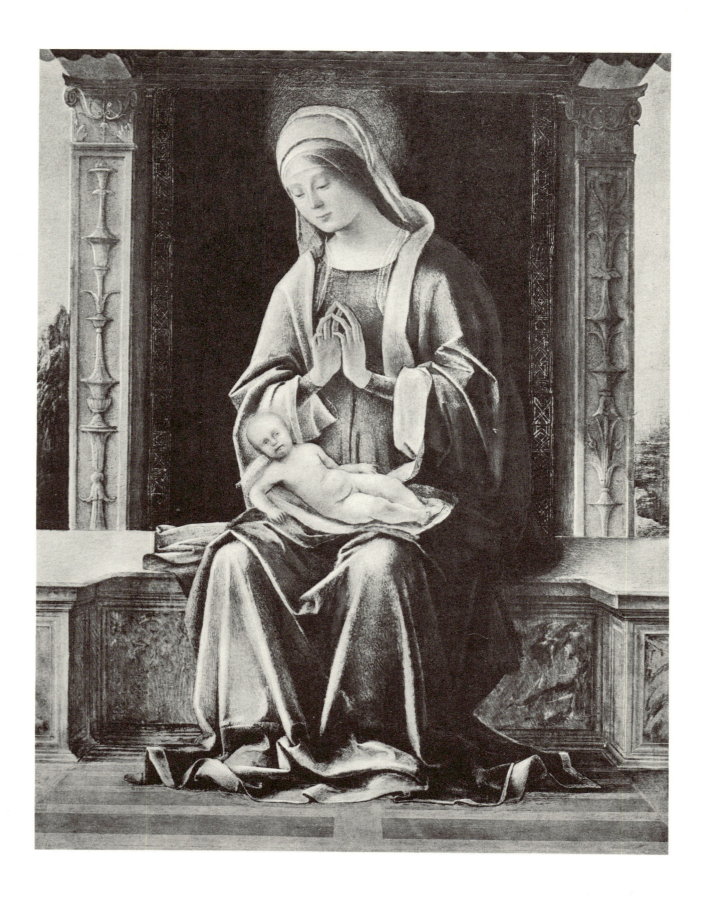

45

ERCOLE DE' ROBERTI
Madonna.
BERLIN. KAISER FRIEDRICH MUSEUM
Photo Hanfstaengl

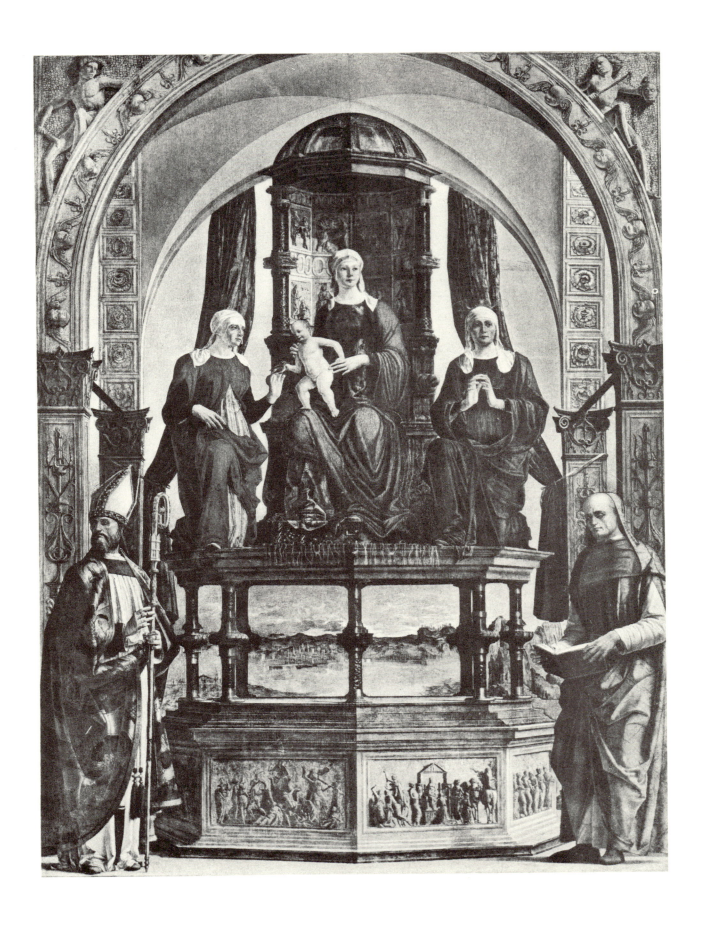

46

ERCOLE DE' ROBERTI
Altar-piece painted for the Canonici Portuensi.
MILAN. BRERA

Photo Anderson

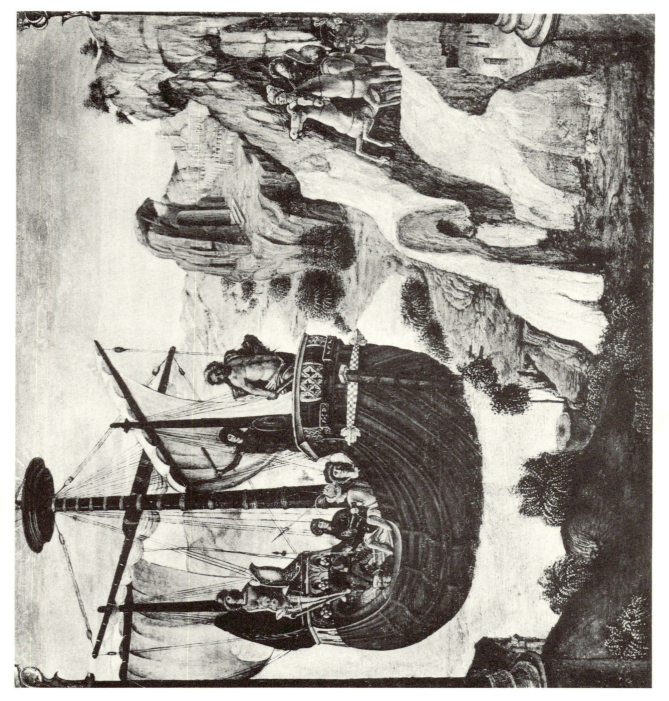

47

ERCOLE DE' ROBERTI
The Argonauts.
PADUA. MUSEO CIVICO
Photo Anderson

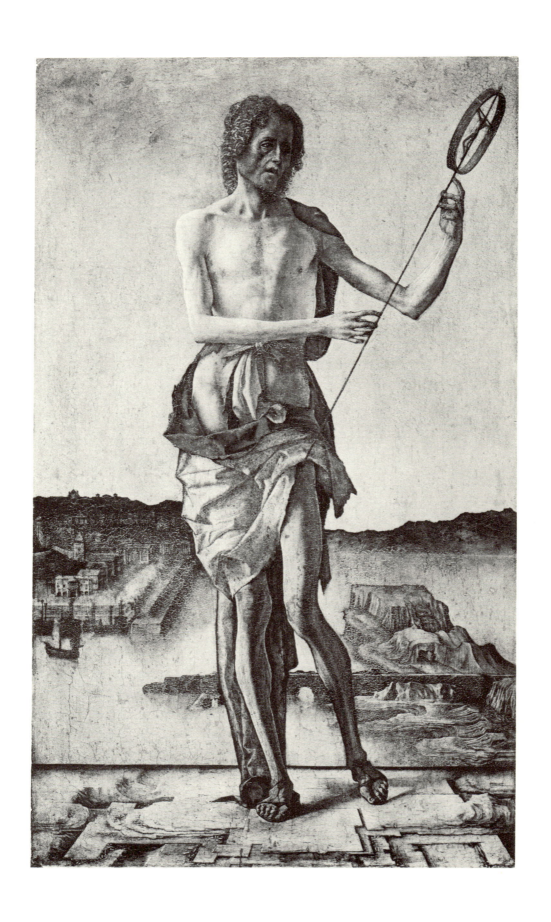

48

ERCOLE DE' ROBERTI
St. John the Baptist.
BERLIN. KAISER FRIEDRICH MUSEUM
Photo Kaiser Friedrich Museum

49

ERCOLE DE' ROBERTI
Drawing: The Betrayal of Christ.
FLORENCE. UFFIZI

Photo R. Soprintendenza, Florence

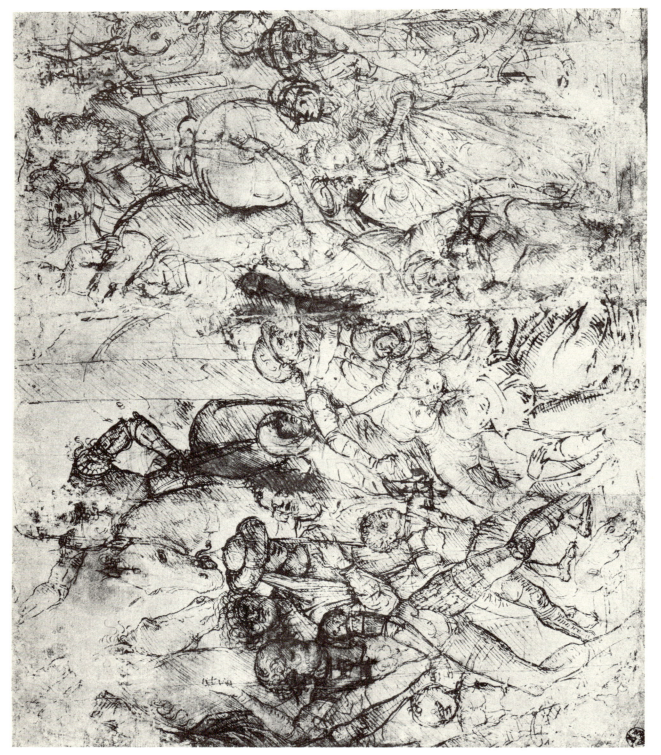

50

ERCOLE DE' ROBERTI
Drawing: The Betrayal of Christ, Detail.
BERLIN. KAISER FRIEDRICH MUSEUM, PRINT ROOM

Photo Kaiser Friedrich Museum

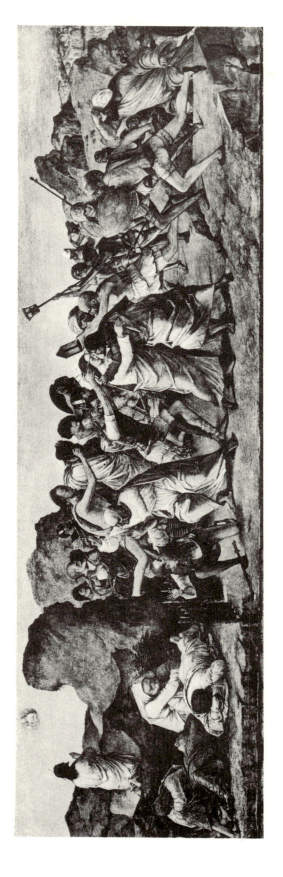

51

ERCOLE DE' ROBERTI
The Betrayal of Christ.
DRESDEN. GEMÄLDEGALERIE

Photo Hanfstaengl

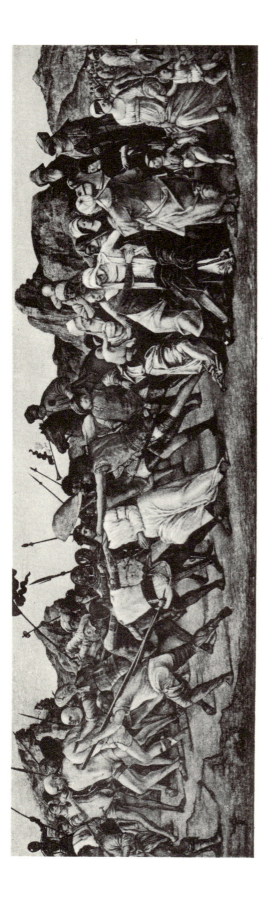

52

ERCOLE DE' ROBERTI
The Road to Calvary.
DRESDEN. GEMÄLDEGALERIE
Photo Alinari

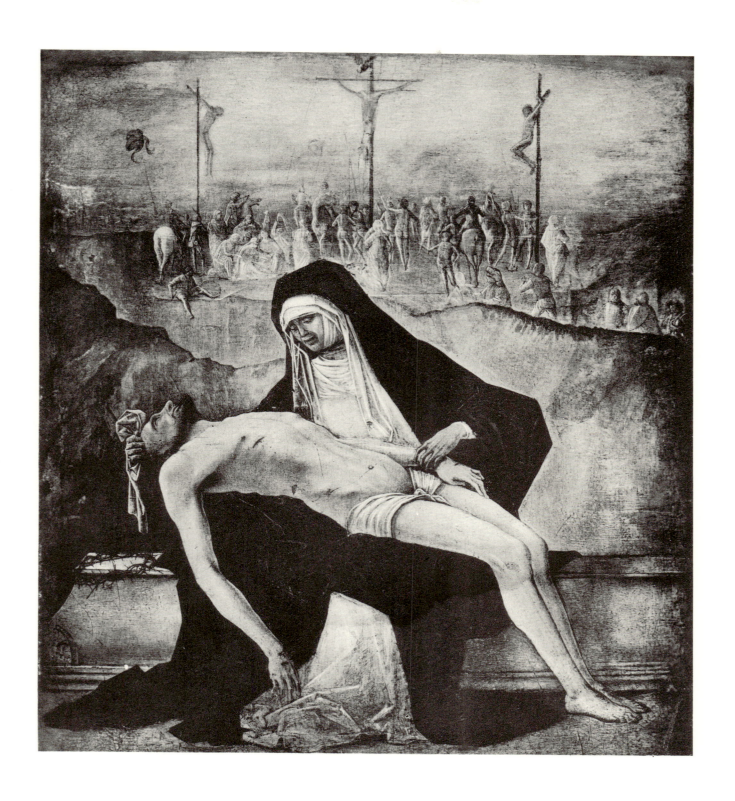

53

ERCOLE DE' ROBERTI

Pietà.

LIVERPOOL. ROSCOE MUSEUM

Photo Mansell

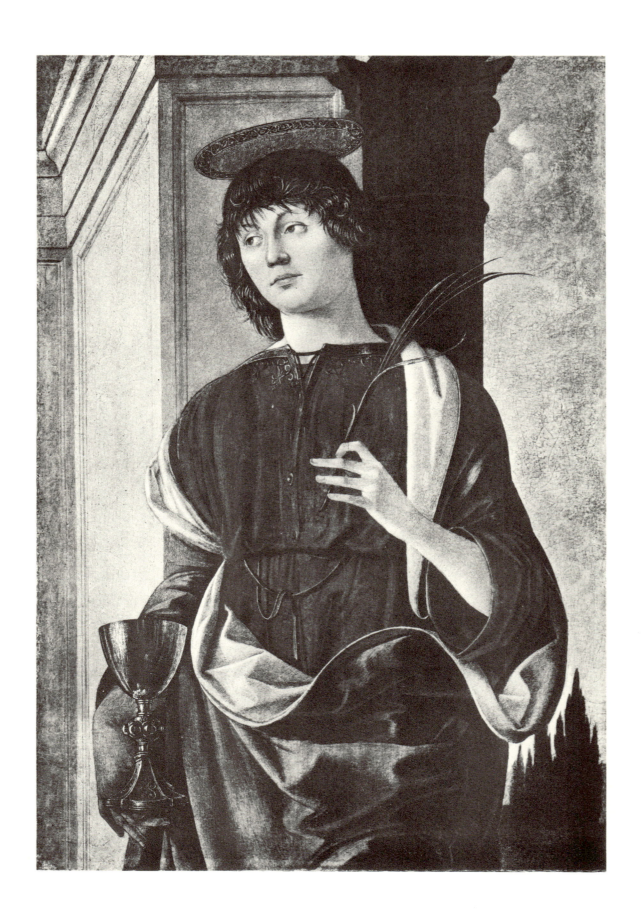

54

ERCOLE DE' ROBERTI
St. John the Evangelist.
BERGAMO. ACCADEMIA CARRARA

Photo Anderson

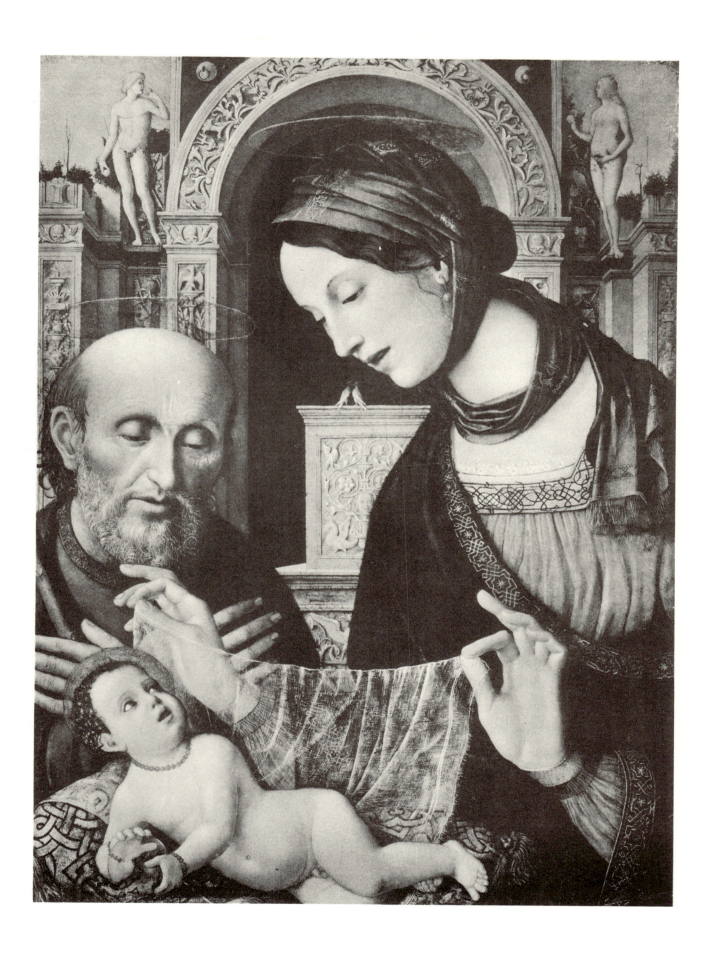

55

GIAN FRANCESCO DE' MAINERI
The Holy Family.
FERRARA. ETTORE TESTA COLLECTION

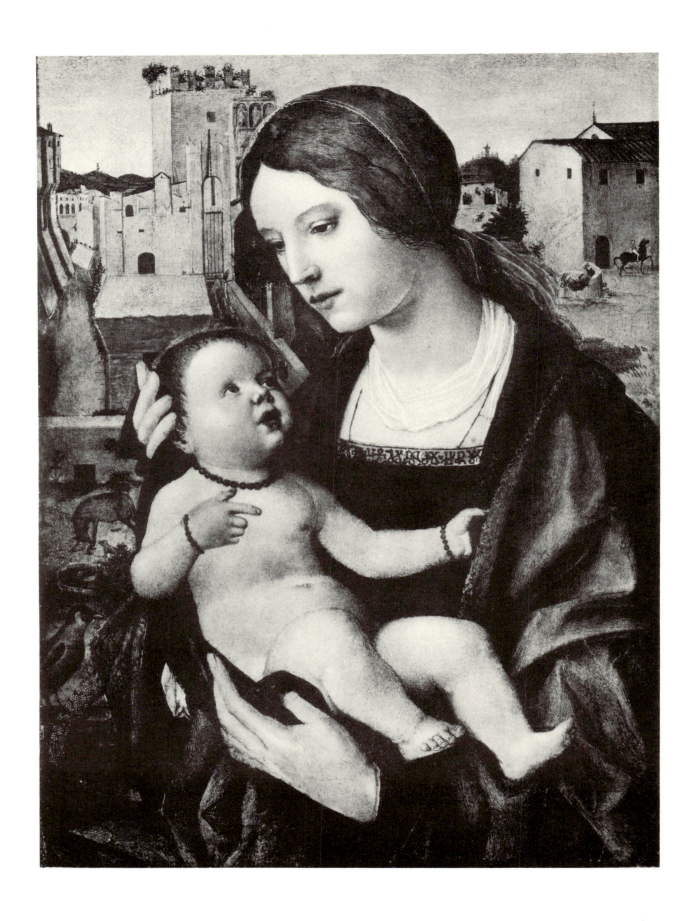

56
GIAN FRANCESCO DE' MAINERI
Madonna.
TURIN. ACCADEMIA ALBERTINA
Photo Dall'Armi

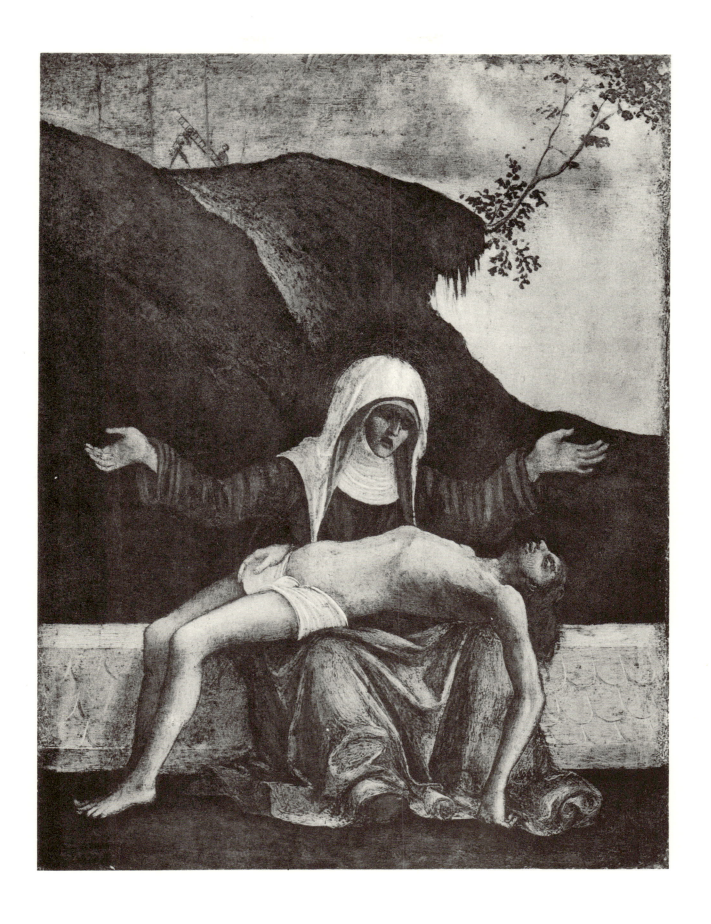

57

LUDOVICO MAZZOLINO
Pietà.

CASSEL. MUSEUM

Photo Hanfstaengl

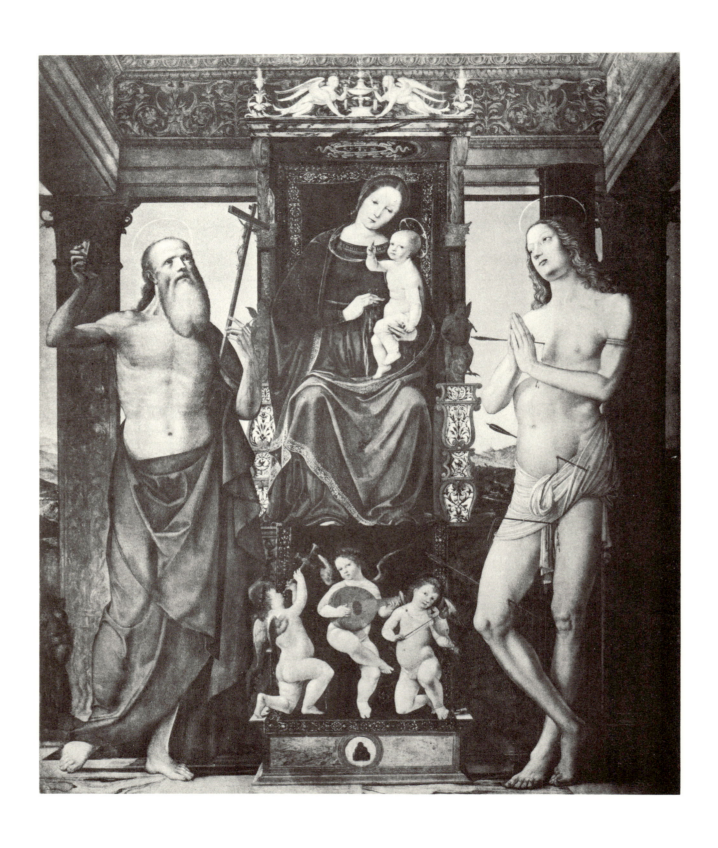

58

FRANCESCO BIANCHI FERRARI

Altar-piece.

MODENA. CHURCH OF SAN PIETRO

Photo Anderson

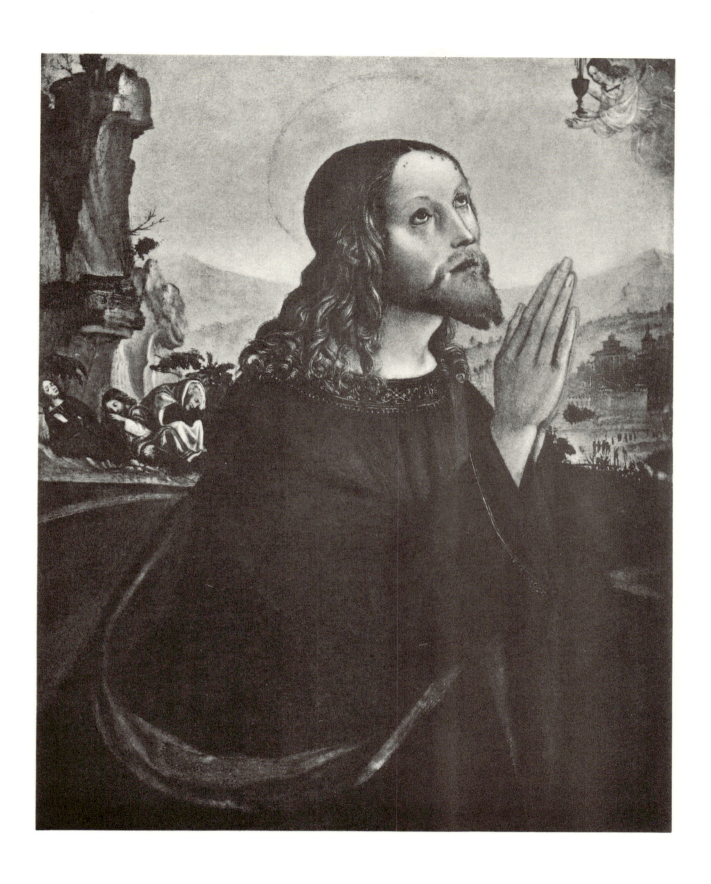

59

FRANCESCO BIANCHI FERRARI
Christ in the Garden of Gethsemane.
ROME. GALLERIA CORSINI
Photo Alinari

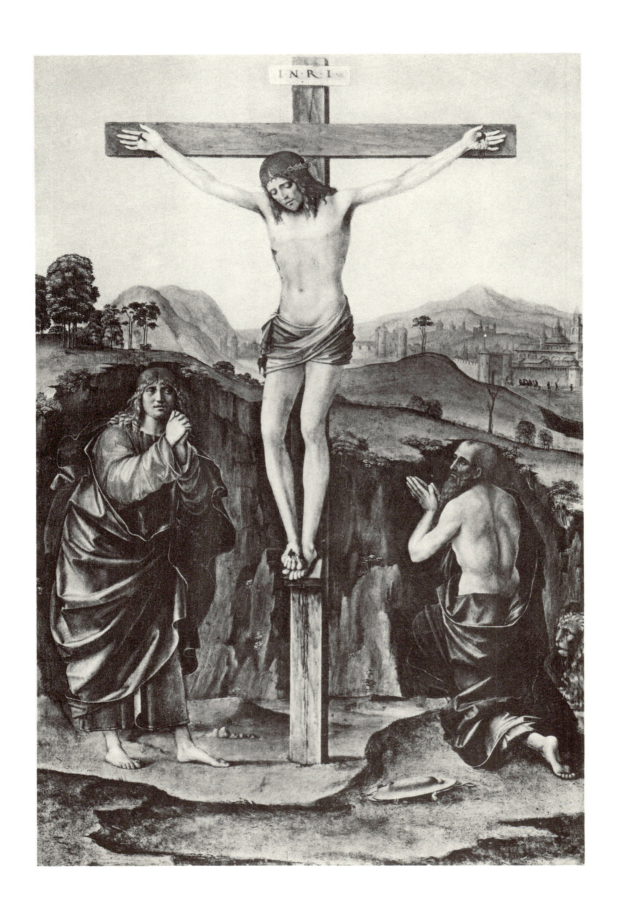

60

FRANCESCO RAIBOLINI called FRANCIA
The Crucifixion.
BOLOGNA. MUSEO CIVICO

Photo Anderson

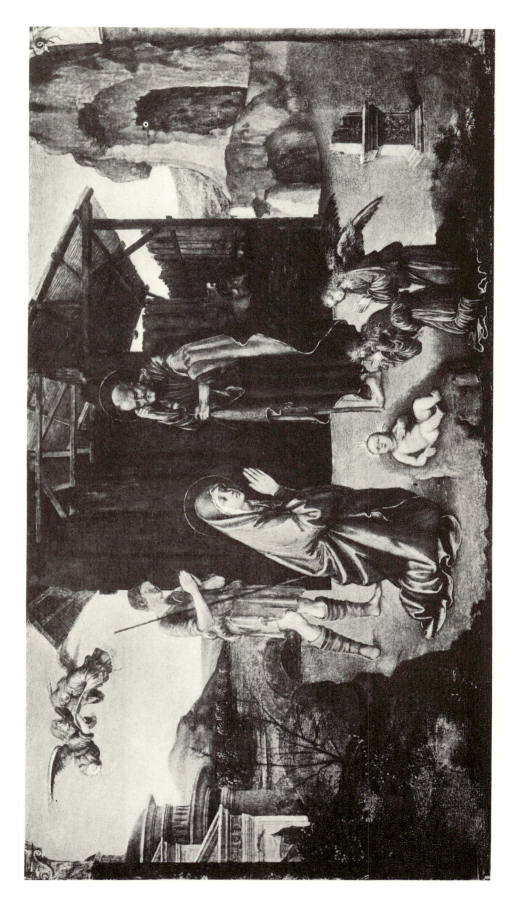

61

FRANCESCO RAIBOLINI called FRANCIA
The Nativity.
GLASGOW. CORPORATION GALLERY
Photo Hanfstaengl

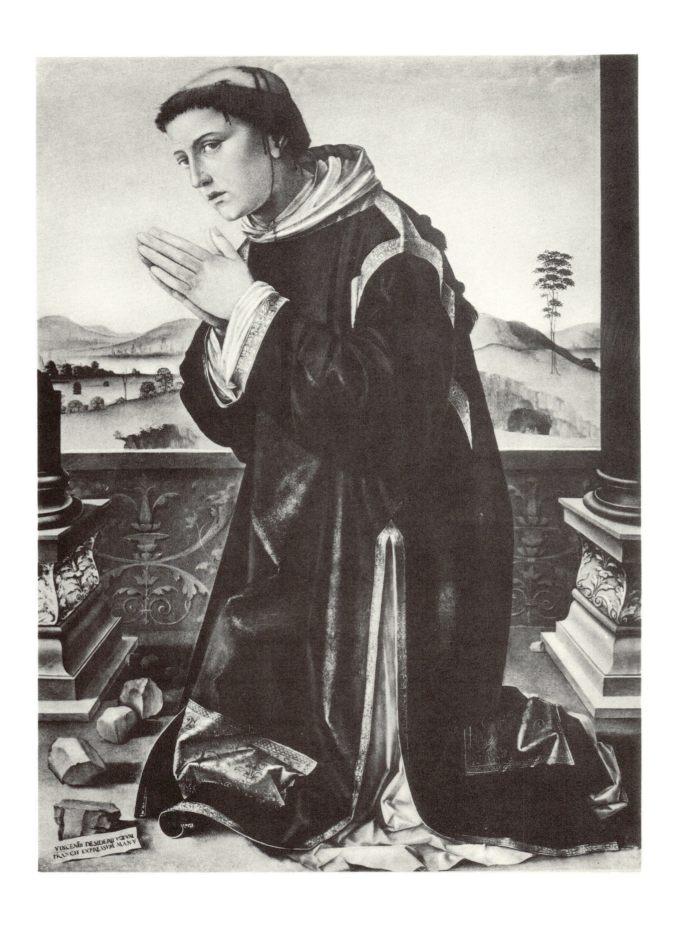

62

FRANCESCO RAIBOLINI called FRANCIA
St. Stephen.
ROME. GALLERIA BORGHESE
Photo Anderson

63

FRANCESCO RAIBOLINI called FRANCIA

Madonna and Angels.

MUNICH. ALTE PINAKOTHEK

Photo Hanfstaengl

64

FRANCESCO RAIBOLINI called FRANCIA

Altar-piece.

Bologna. Church of San Giacomo Maggiore

Photo Anderson

65

FRANCESCO RAIBOLINI called FRANCIA
Altar-piece.
LENINGRAD. HERMITAGE
Photo Hanfstaengl

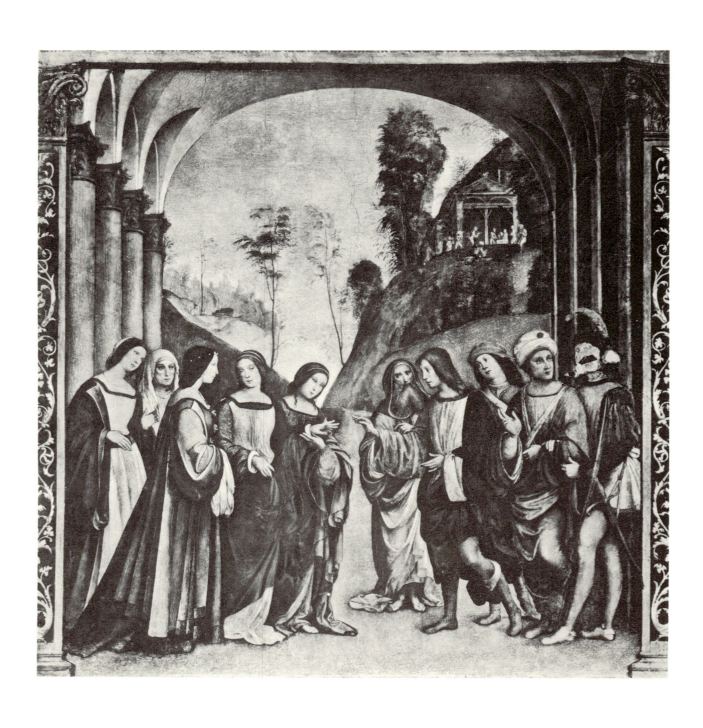

66

FRANCESCO RAIBOLINI called FRANCIA
The Nuptials of St. Cecilia.
BOLOGNA. CHURCH OF SANTA CECILIA

Photo Anderson

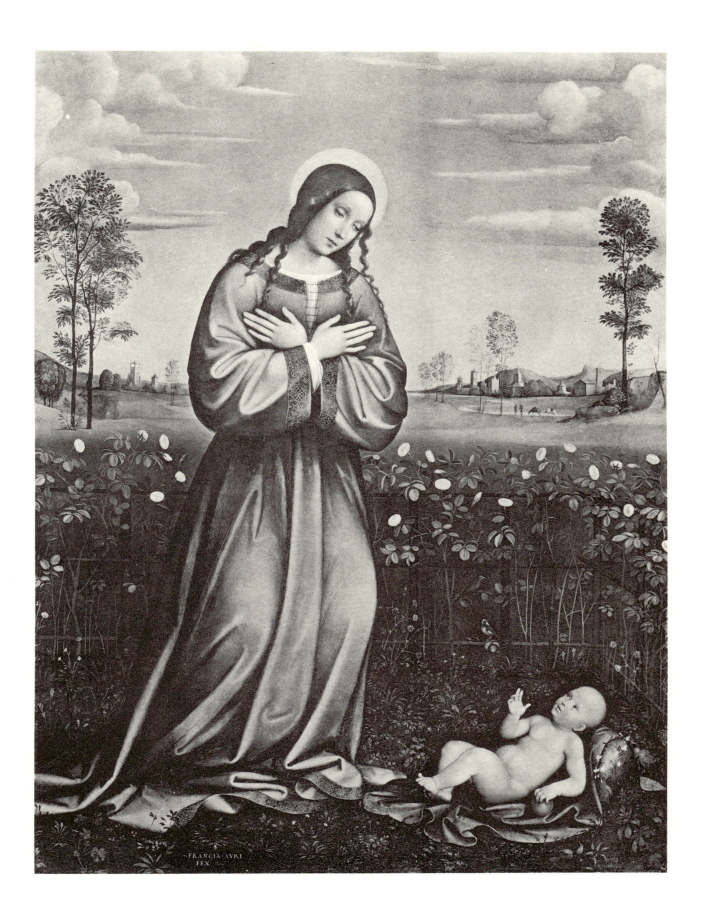

67

FRANCESCO RAIBOLINI called FRANCIA
The Madonna of the Rosebush.
MUNICH. ALTE PINAKOTHEK
Photo Bruckmann

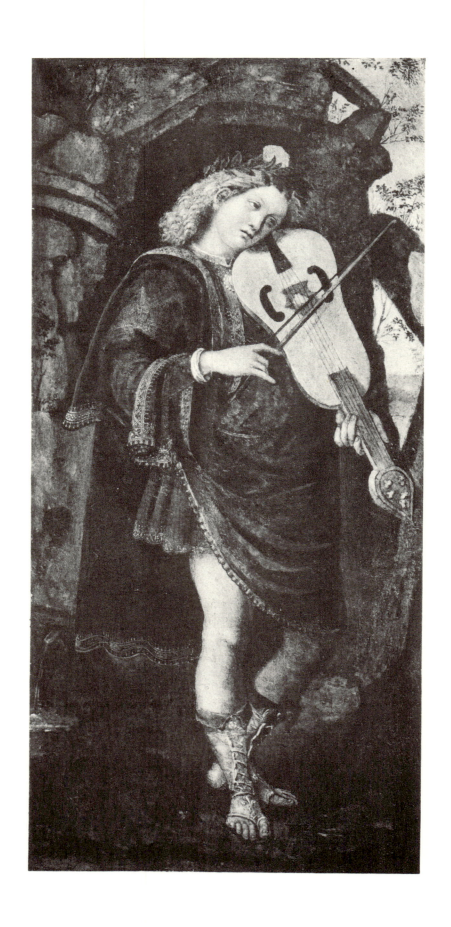

68

TIMOTEO DELLA VITE
Apollo.
FLORENCE. GALLERIA CORSINI
Photo Brogi

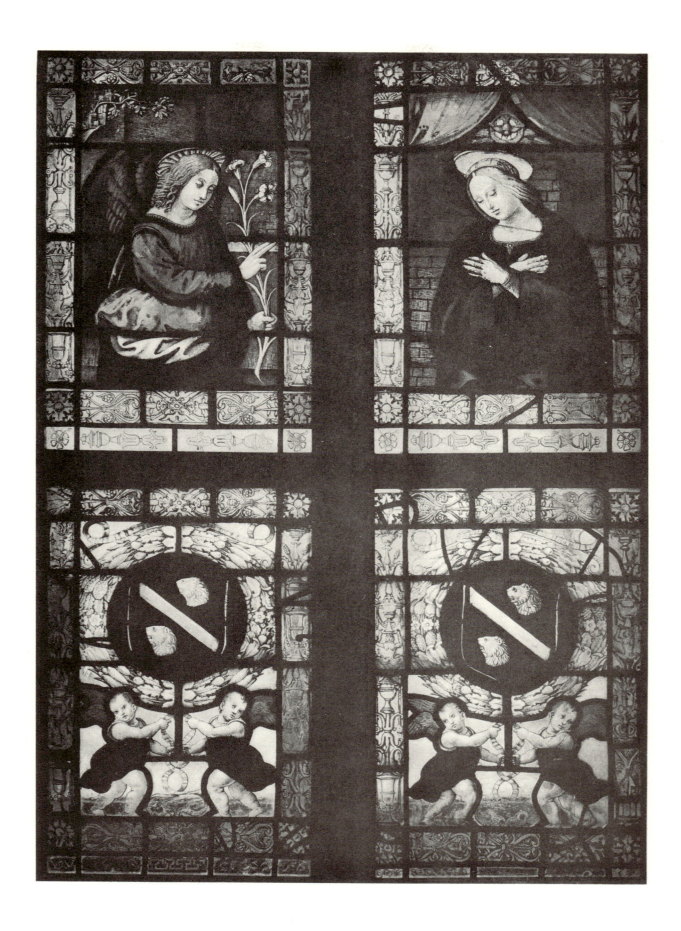

69

TIMOTEO DELLA VITE
Painting on glass: The Annunciation.
URBINO. PALAZZO DUCALE

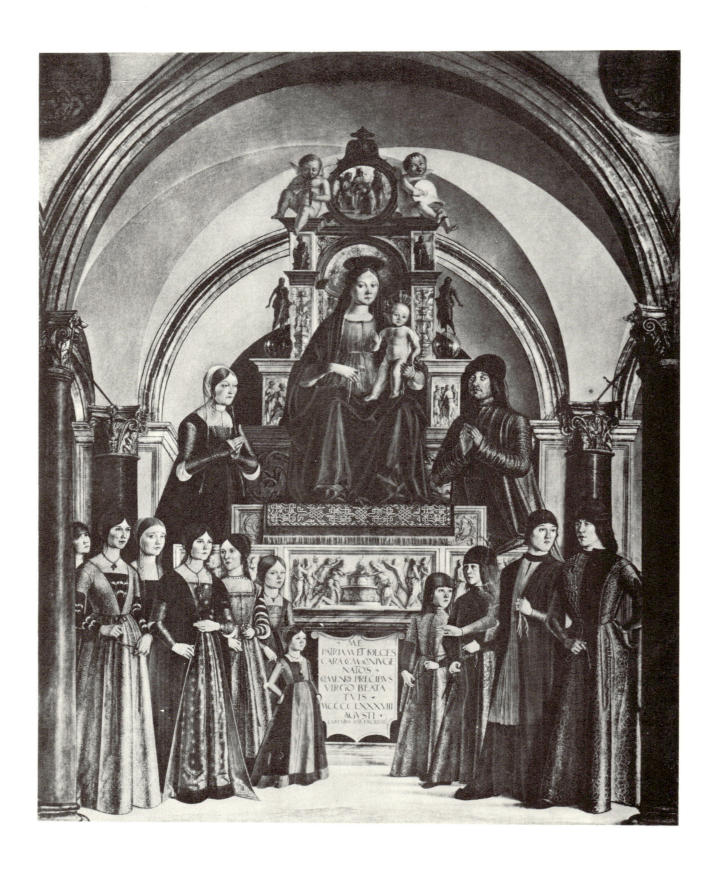

70

LORENZO COSTA

The Madonna adored by the Bentivoglio Family.

BOLOGNA. CHURCH OF SAN GIACOMO MAGGIORE

Photo Anderson

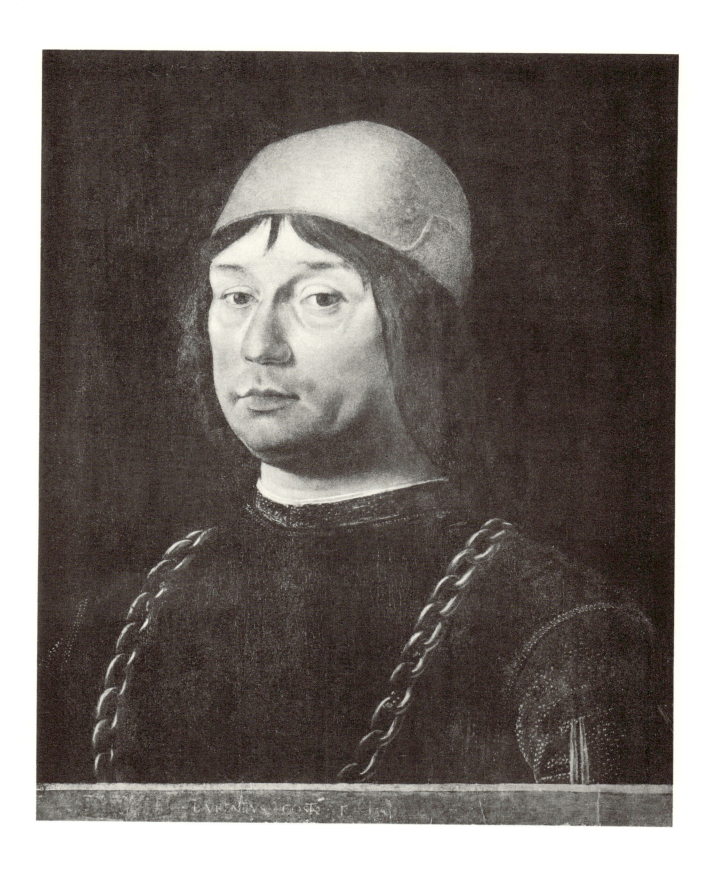

71

LORENZO COSTA
Portrait of Giovanni Bentivoglio.
FLORENCE. PALAZZO PITTI

Photo Anderson

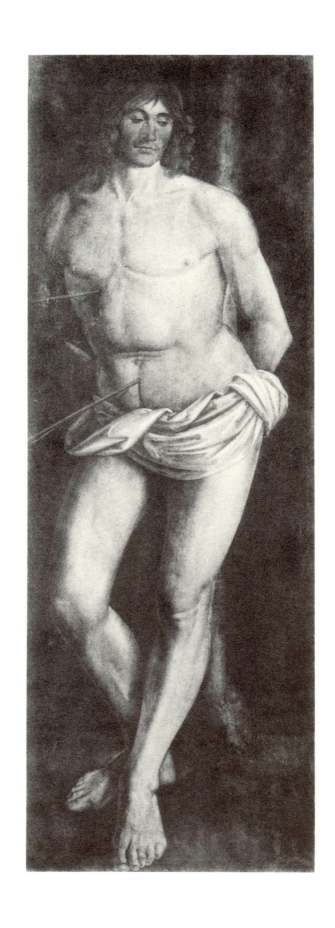

72

LORENZO COSTA
St. Sebastian.
REGGIO EMILIA. CASSOLI COLLECTION
Photo Orlandini, Modena

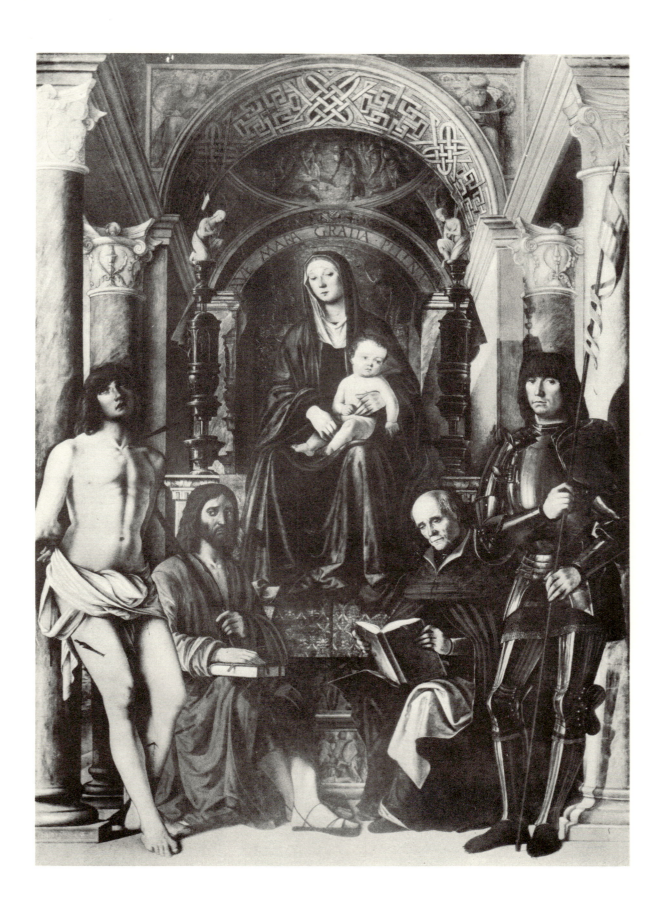

73

LORENZO COSTA

Altar-piece: The Madonna and four Saints.

BOLOGNA. CHURCH OF SAN PETRONIO

Photo Poppi, Bologna

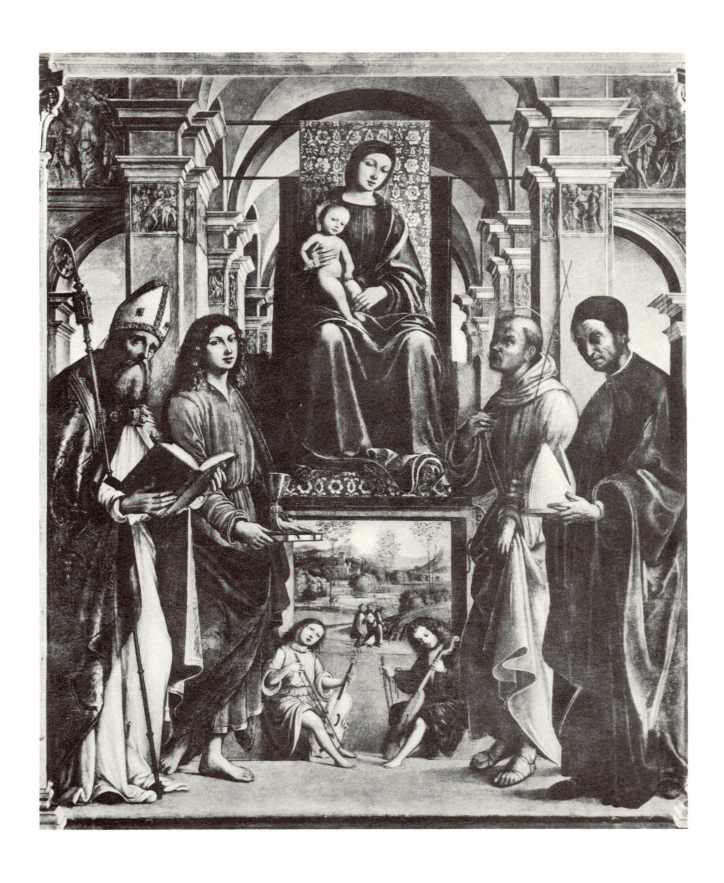

74

LORENZO COSTA
Altar-piece: The Madonna and four Saints.
BOLOGNA. CHURCH OF SAN GIOVANNI IN MONTE

Photo Anderson

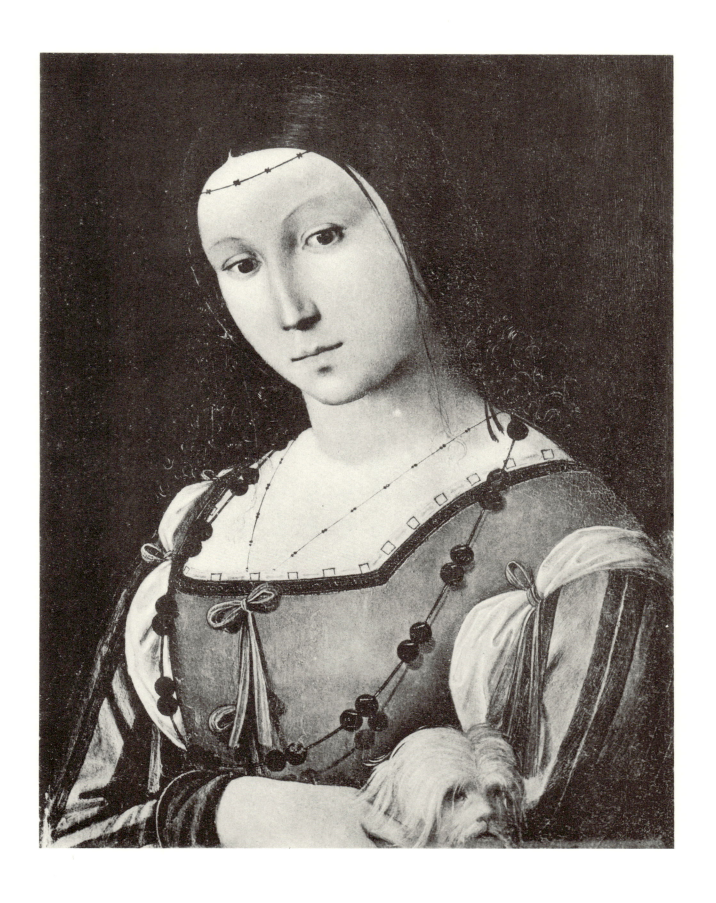

75

LORENZO COSTA
Portrait of a Lady.
HAMPTON COURT. ROYAL COLLECTION
Photo by permission of H. M. the King

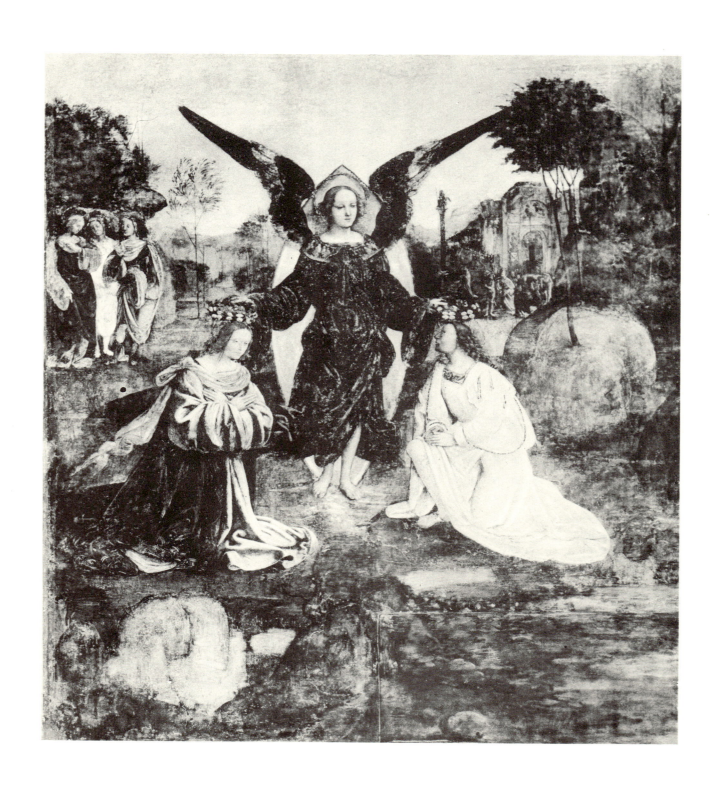

76

GIOVAN MARIA CHIODAROLO

St. Cecilia and St. Valerian crowned by an angel.

BOLOGNA. CHURCH OF SANTA CECILIA

Photo Alinari

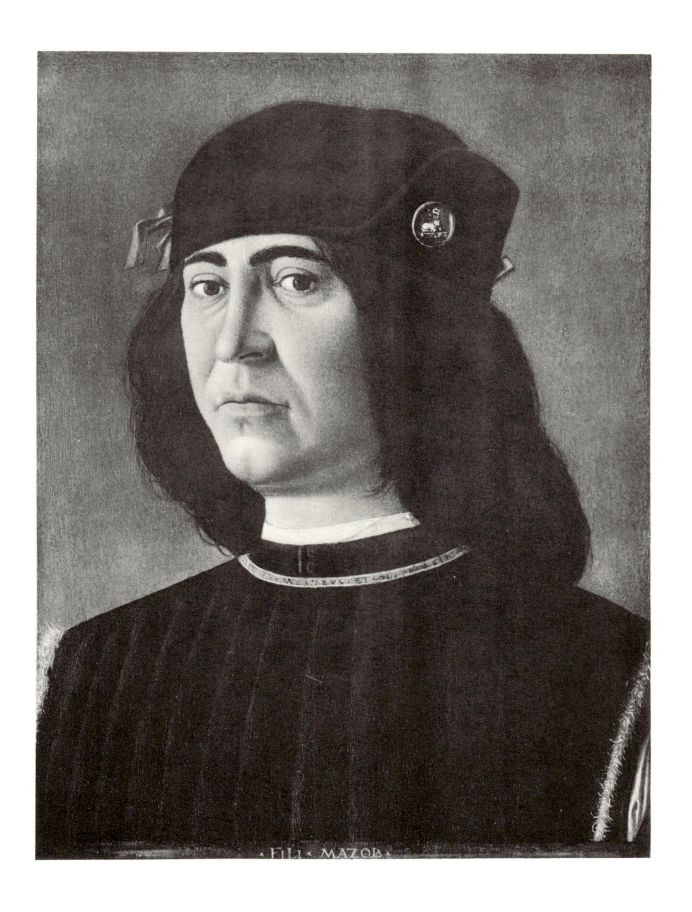

FILI · MAZOLA ·

77

FILIPPO MAZZOLA
Portrait of an unknown personage.
ROME. GALLERIA DORIA
Photo Alinari

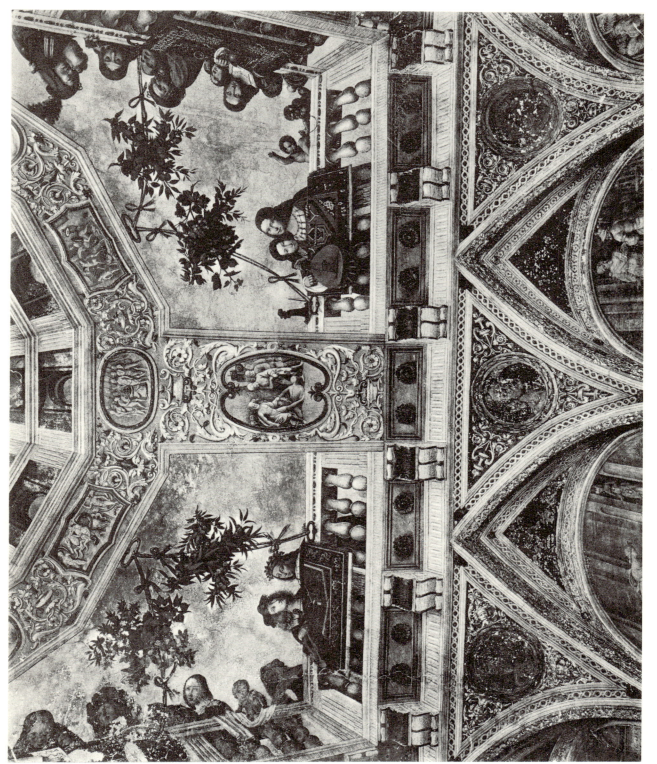

78

UNKNOWN DECORATOR

Decoration of the ceiling of a room in the palace.

FERRARA. PALAZZO COSTABILI

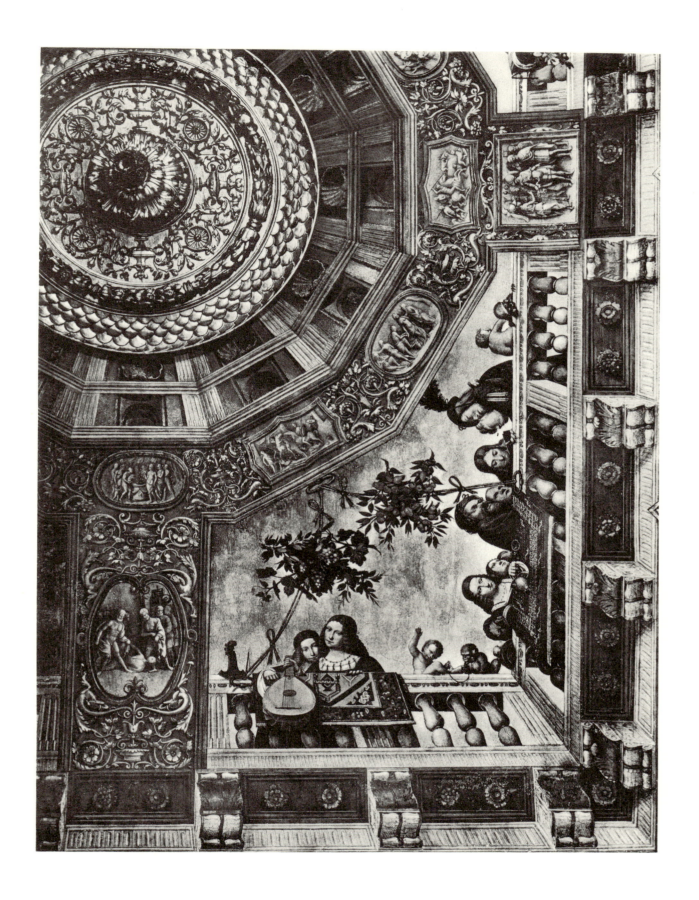

79

UNKNOWN DECORATOR
Decoration of the ceiling of a room in the palace.
FERRARA. PALAZZO COSTABILI
Photo Anderson

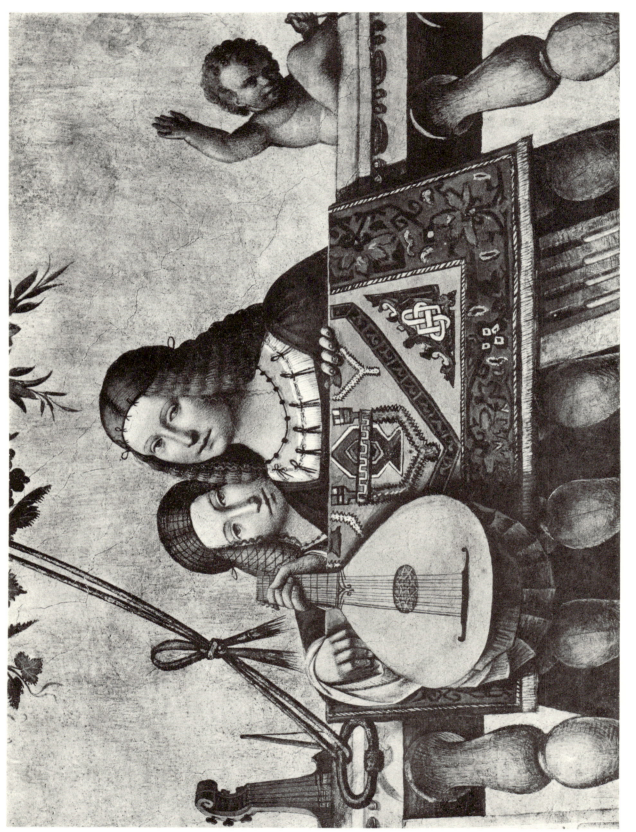

80

UNKNOWN DECORATOR

Detail of the decoration of the ceiling in a room of the palace.

FERRARA. PALAZZO COSTABILI

Photo Anderson

NORTH ITALIAN PAINTING OF THE QUATTROCENTO

LOMBARDY · PIEDMONT · LIGURIA

by

ADOLFO VENTURI

CONTENTS

LIST OF PLATES

SYNOPSIS

I

racteristics of the Lombard artist as contrasted with those of Renaissance painters in Tuscany; his indifference to and ignorance of perspective, his skill as a painter of impressionistic backgrounds, his well-rounded, and crisp forms; his efforts to obtain pictorial effects by the inter-play of light and shade. These characteristics self-evident in every work of this serious Brescian master, from the Madonna in the Garden of the Berenson collection — in which the charming idea underlying the composition has very little in common with Late Gothic — to the other Madonna in the same collection and the St. Jerome in the Accademia Carrara — in both of which every surface sparkles and derives animation from the play of light — and to the Davis Madonna — in which the Virgin, grave and thoughtful, as is the way of all Foppa's figures, clasps her Child to her bosom with a lyrical tenderness reminiscent of similar groups by Giambellino. Every work by Foppa imbued with the tendency to translate form into terms of light which, in a greater or less degree, underlies the whole of Lombard art during the fifteenth and sixteenth centuries, and at the beginning of the seventeenth becomes an outstanding feature in the work of the great master of later times, Michelangelo da Caravaggio. The colouring which is the basis of Venetian painting and the geometric constructive drawing of the Tuscans of but secondary importance in the art of Foppa, in whose backgrounds we sometimes find startling effects of impressionism. BERNARDINO BUTINONE and BERNARDO ZENALE DI MARTINO, contemporaries of Foppa, work together on the altar-piece at Treviglio: it is typical of their art and reflects the magnificence of Lombard decoration, being comparable as regards richness of effect and profuse and elegant accessories with the sculptural works of Omodeo. Differences between the methods of the two collaborators whether working together or apart. In contrast with the sumptuous colour schemes and decorations of these artists the work of AMBROGIO DA FOSSANO is cast in a more sombre mould: his ashen tints suggest the gentle monotony of the cloister, his figures are demure and timid, his visionary and somnolent landscapes are bathed in mist and exhale a wistful melancholy. In his work at Lodi he for once forsakes his pallid tints and imports a quality of richness into his accessories, as though in emulation of the sumptuously decorated building which contains them. A hitherto unknown Lombard master of outstanding merit: the author of the Louvre Annunciation. VINCENZO CIVERCHIO, a pupil of Butinone, who turns later to follow the teaching of Solario and the school of Leonardo. PIER FRANCESCO SACCHI, of Pavia, an artist whose contours are prominent and coarse, and whose figures are wooden and rectangular, resembling over-large carved and painted wood panels. Followers of Borgognone: AMBROGIO BEVILACQUA, GIOVANNI DELLA CHIESA, ALBERTINO and MARTINO PIAZZA. DONATO DA MONTORFANO, author of the antiquated Crucifixion which faces Leonardo's Last Supper.

BOCCACCIO BOCCACCINO shows influence of Ercole Roberti in his Journey to Cal-vary in the National Gallery, London, which is jewelled with colour and already exhib-its the tendency of this Cremonese artist to introduce refinement and elegance into his accessories. His transition from Lombardo-Emilian forms to those of the Venetians in the altar-piece for the church of San Giuliano in Venice. Boccaccino's elegance of style fully developed in the Sacra Conversazione in the Accademia at Venice, the Boncom-pagni Ludovisi Annunciation in Rome, and the Holy Family with St. Mary Magdalen in the church of Sant'Agata at Cremona. His last group of works: the frescoes in the cathedral at Cremona and the Adoration in the gallery at Budapest, in which the roun-ded figures and the tints warmed by the midday sun seem to be forerunners of the fervid art of Girolamo Romanino. ANDREA SOLARIO studies for three years in Venice. Tra-ces of Venetian influence, particularly of Iacopo de' Barbari and Alvise Vivarini, in his earliest works: the Madonna of the Carnation in the Brera, and a number of por-traits. Affinity with the earlier works of Lorenzo Lotto observable in the Portrait of a Venetian Senator in the National Gallery, London, and in other works, such as the Ecce Homo in London and the Holy Family with St. Jerome in the Brera, Milan. His series of Holy Families, culminating in his masterpiece, the Madonna of the Green Cushion in the Louvre, show that he vacillated between the influence of Leonardo da Vinci and that of Lorenzo Lotto during his Bergamasque period; the influence of the latter paramount in the Madonna and Child in the National Gallery, London, and in the Female Musician in the Hertz collection. AGOSTINO DA LODI, formerly known as the "Pseudo-Boccaccino", a pupil of Boccaccio Boccaccino, turns later to follow Bra-mante, Bartolomeo Suardi and the school of Leonardo.

He introduces into painting an unerring sense of constructive drawing, and works out architectural visions of vertical planes and high bare surfaces. In contrast with the ten-dencies of the local school, his art inclines in the direction of composition and abstrac-tions, striving to exclude mere ornament and to find full and clear expression in archi-tectural rhythms. The teaching of Leonardo, as interpreted by Bramantino, leads later to a general toning-down of colour; the skin becomes a diaphanous and translucent membrane illuminated by a ruddy glow kindled behind it; his human figures become swollen and elongated, increasing in vacuity of expression and roundness of form and set against architectural backgrounds that slope like the pylons of an Egyptian temple. The St. Sebastian in the Ventura collection the nearest approach made by Bartolomeo Suardi to the methods of the school of Leonardo.

3

Some of them to be regarded, for reasons of style, as really belonging to the sixteenth century. AMBROGIO DE PREDIS, a powerful portraitist, who frequently follows the Lombard tradition; a producer of masterpieces such as the Portrait of a Lady in the gallery at Amsterdam and the Litta Madonna in the Hermitage at Leningrad. G. A. BOLTRAFFIO draws much of his inspiration from the example of Leonardo, as may be seen from the Madonna and Child in the gallery at Budapest, but departs completely from his model in adopting a characteristic method of building up his compositions on vertical parallel lines, and colour-effects obtained as though by means of a network of small squares of coloured wood. BERNARDINO DE' CONTI, inexperienced and weak as regards form, but pleasing on account of the childish gravity of his figures and the brilliance of his colours. The miniaturist ANTONIO DA MONZA, author of the Sforza altar-piece in the Brera, sometimes confused with Bernardo Zenale. The rugged MARCO D'OGGIONO, a harsh colourist who loads his stereotyped Leonardesque masks with heavy shadow. FRANCESCO NAPOLETANO, one of the feeblest followers of Leonardo, author of an altar-piece in the museum at Zurich. CESARE MAGNI, a debased and coarse copyist of Leonardo. BERNAZZANO, a capable painter of landscapes, flowers and verdure, who sees with the eyes of a Flemish artist and puts in every detail with the most minute care; the unknown painter of the Madonna of the Scales in the Louvre, characterized by diminutive and rounded figures. FRANCESCO MELZI, wholly of the sixteenth century in his anxiety to give substance and size to his figures. GIAMPIETRINO, one of the greatest members of the school, produces delicate and tender groupings of the Virgin and Child, in which the tradition left in Lombardy by Borgognone seems to be revived in the charming but unhealthy children and in the delicacy of the gradations of tone. CESARE DA SESTO, whose figures tend to increase in size as though to keep pace with the Roman artists of the sixteenth century. BERNARDINO LUINI, a creator of Leonardesque types, although still guided by the traditional methods of Lombard art in his impressionistic treatment of glimpses of landscape and the quiet sameness of his facial expressions. He adopts Leonardo's delicate gradations of tone in order to give more softness to his rosy flesh-tints and even his backgrounds are suffused with a rose-coloured haze.

Examples of Late French Gothic art in San Pietro at Pianezza, the Castello at Manta and the castle of Fenis. The Journey to Calvary in the sacristy of Sant'Antonio di Ranverso one of the most virile and characteristic examples of Piedmontese art on account of the strong individuality of the types, the vigorous colouring and the

rhythm of the twisted and broken lines. Piedmontese artists whose principal work was done in Liguria: GIOVANNI MAZONE of Alessandria, a follower of Foppa; LUCA BAUDI of Novara, reminiscent of Borgognone and Sacchi; the priest GIOVANNI CA- NAVESIO of Pinerolo, a feeble and antiquated painter. MACRINO D'ALBA deserts the Piedmontese school in order to combine his own old-fashioned methods with Renais- sance forms from Tuscany and Umbria. MARTINO SPANZOTTI, the foremost artist of the Vercellese school, introduces Lombard elements into the art of Piedmont, such as the regularity of volume and constructive line of Bramantino and the realistic modelling and luminous relief of Foppa; even his earliest work, the Madonna in the gallery in Turin, reveals his grave, balanced and serious temperament. The understanding of plas- tic values and the admirable constructive skill exhibited in every one of the great cycle of frescoes in San Bernardino at Ivrea bear witness to the great ability of the artist. He leans sometimes towards the formal architectural construction of the Tuscans, sometimes towards the irresponsible drawing of the Provençal masters: the Adoration of the Magi in the Contini collection in Rome and the Christ disputing with the Doctors in the Museo Civico, Turin, indicate a change of method in the work of this great master, who migrated from Vercelli into western Piedmont and there turned towards northern types derived either from Germany or Flanders. DEFENDENTE FERRARI, pupil of Span- zotti, differs from his teacher in seeking to obtain effects of line and light and richness in his accessories. No other Piedmontese artist approaches so closely to the late fifteenth and early sixteenth-century work of the German school, from which is derived his pre- dilection for linear expression of light. IACOPINO LONGO, a feeble follower of Defen- dente. GIROLAMO GIOVENONE a painter with a tendency towards old-fashioned me- thods; his compositions suggest the work of Defendente but lack his aristocratic tastes. EUSEBIO FERRARI, in the triptych at Mainz, is more successful in reproducing the qual- ities of Defendente's Nativities, developing the volume of his figures in an effort to con- form to the canons of sixteenth-century painting, and tending sometimes towards the earlier works of Sodoma and sometimes towards GAUDENZIO FERRARI. In Gaudenzio's youthful works the evidences of his Lombard training almost obliterated by an inborn tendency to employ line and the effects of light as a means of imparting decorative rich- ness to his work. BERNARDINO LANINO reproduces Gaudenzio's types in a milder form but with subtle and delicate gradations of light and shade. The early years of G. A. BAZZI, called Sodoma, beginning with his frescoes in Sant'Anna in Camprena, in which characteristics derived from the school of Vercelli are already mixed with Um- brian characteristics derived from Pietro Perugino and Pinturicchio. Other works, in which the blending of Piedmontese and Umbrian elements is more fully expressive of the rare delicacy and grace of Sodoma's earlier works: the best examples the Crucifix-

ion at Cleveland, with its minute gradations of tone, and the Allegory of Love and Chastity in the Louvre, conceived with an almost Raphaelesque grace of rhythm. First clear indications of the influence of Leonardo on the work of Sodoma.

Mainly dominated by the influence exerted by the artists of southern France and Lombardy. The school of Nice: GIACOMO DURANDI, JEAN MIRAILLET, BARTOLOMEO BENSA. LUDOVICO BREA, his bold and precise modelling; the straightforward compositions of his earlier manner clearly inspired by the artists of southern France; his work confused and marred by heavy shadows when he comes under the influence of Foppa. Anachronisms of the Niçois painter. Brea's assistants and followers.

THE GOTHIC ELEMENT IN FIFTEENTH-CENTURY LOMBARD PAINTING

IN the first half of the fifteenth century Milan became the focus of art in Lombardy. The architects and sculptors who came from Germany to assist the local craftsmen in the erection of their cathedral brought in their train numerous examples of northern art; while the influence of French decorative methods is manifest in the illuminations done by Fra Pietro da Pavia for the copy of Pliny's *Naturalis Historia* now preserved in the Biblioteca Ambrosiana. The ornate Gothic of colder climes filtered through the Alps and helped to inspire the decorative borders of the Book of Hours of the Visconti, now in the possession of Baron Landau, as well as the margins of the Codex in the Bibliothèque Nationale in Paris mentioned by Toesca, and of that other delightful little Codex, by Giovannino de' Grassi, which lies in the City Library at Bergamo.[1]

Paintings representative of Milanese art in the first decades of the fifteenth century are few and far between, but among them there is a little altar-piece by Michelino da Besozzo, *Plate 1* who flourished between 1394 and 1442, in the galleries of the Accademia at Siena, in which the small, roundish figures are painted in pale tints something after the manner of Stefano da Zevio. The curvilinear features, the childish mouths, the Gothic arabesques adorning the draperies, and the ivory flesh tints are equally reminiscent of the same painter. The similarity, however, is one of manner only: it would perhaps be more correct to describe it as a similarity of artistic fashion, for it merely serves to accentuate the wide gulf which lay between the well-trained and well-equipped Veronese artist and the naive simplicity of a country painter of Lombardy, who sets cumbrous crowns all awry on the heads of the Madonna and St. Catherine, and models full-moon haloes of coloured plaster as a background for his saints; who breaks up the ornamentation of a throne and the folds of a garment as though they were pieces of Gothic panelling; and who, after giving his small round figures the appearance of having been modelled in wax with no definite contours, finishes them off with enormous hands and feet like paddles. But the work is nevertheless pleasing on account of its delicacy of restrained colouring, which blends well with the gold background; and for the artless striving to impart to the face of St. Catherine the expression of one who is both timid and anxious, and to represent St. Anthony and St. John as absorbed in earnest contemplation.[2]

Painting in Lombardy at that period followed a parallel path to that of Verona, even

if the Lombard artists were themselves inferior. The delight taken by the Veronese in the study of animal forms finds a counterpart in the work of the Lombards, and not only earned for Michelino the admiration of Decembrio but inspired some of the most beautiful pages in the little Giovannino de' Grassi Codex. Like the Veronese, the Lombards seem to have been impelled by a desire to populate the world around them and to cover it with green things, in order to compensate for the empty desolation left behind by their predecessors of the fourteenth century; and to this cause must be attributed their eager search for beauty in the plumage of a bird, in the richness of a fur mantle, or in the infinite diversity of animal forms.

Plate 2 Michelino's son, Leonardo, who was at work between 1428 and 1488, adopted the calling of his father. His frescoes in the Caracciolo chapel in San Giovanni a Carbonara at Naples, executed in 1428 — especially the archaic Coronation of the Virgin, where the angels form a multi-coloured oval framework round the three principal figures — present the same small features, the same roundish and infantile faces and the same indeterminate flesh tints that we find in the work of Michelino. Only one of the series, the Annunciation, betrays any attempt to apply Tuscan methods in the simplification of the drapery and a better distribution of the component parts. The architectural details are still Gothic in their complexity and slenderness, but they give a feeling of depth to the part of the picture where the Angel, full of grace and clad in robes which fall in regular and harmonious folds, delivers his sacred message with restrained gesture.[3]

The great majority of the Lombard paintings of the first half of the fifteenth century which have survived are the work of the brothers Zavattari and their descendants, all of whom were followers of Michelino da Besozzo. Cristoforo we know to have been painting from 1404 to 1417, Franceschino in 1417, Ambrogio between 1456 and 1459, Gregorio di Franceschino in 1479, and Francesco di Giovanni in the same year. The most

Plates 3, 4 important of their works are to be found in the chapel of Queen Theodolinda in the cathedral at Monza. The major part of the work dates from 1444. The series of frescoes opens with the mission sent by Autharis to the court of Garibold of Bavaria to seek the hand of the king's daughter in marriage. Then follow the visit of the ambassadors to Theodolinda, their return to Italy, the departure of the Bavarian emissaries and their arrival at the court of Autharis. The next scenes portray the journey of Autharis himself to Bavaria, the gifts laid at the feet of Theodolinda on his behalf, the announcement of his real name to the escort of Bavarians who accompany the bride-elect to the frontier, and the rejoicings connected with the betrothal.

The frescoes, arranged in three tiers, set out the whole life story of the queen from her

arrival and marriage in Italy to the funeral of Autharis, her subsequent marriage to Agilulph, the vision which gave rise to the building of the cathedral at Monza, the commencement of the actual building, and the arrival of gifts from Theodolinda and the Pope at the new church. This minutely-told story, which ends with the burial of the queen, is continued in another series of frescoes depicting the coming of the Byzantines to Italy.

It may be that these frescoes were executed by order of Filippo Maria Visconti and Francesco Sforza, whose badges figure in the decorative portions of the work. They form the most complete expression that has come down to us of the lordly northern conception of art as a thing of abounding ornamentation and the glitter of much gold. The artists have given free rein to their imagination in the matter of magnificent costumes, gorgeous tapestries, and delicate yet gay tints, so that the frescoes have the appearance of rich brocades hung about the walls of the chapel: yet the composition remains that of a number of persons who bear no closer relationship to each other than the rows of isolated heroic figures which adorn the walls of many a castle throughout Piedmont and Lombardy. The architectural backgrounds, broken up and piled piece on piece like a child's building blocks, reveal a mentality which has not yet shaken itself free of its fourteenth-century trammels, and the scenes follow each other as though we were witnessing a magic lantern show in which a picture is frequently thrown on the screen a second time but with the figures reversed. It seems as if these slender and graceful puppets with their rosy cheeks, their delicate colouring, their charming expressions, must assuredly be sustained by invisible wires lest they should be tripped up by the flowing robes that hamper their movements.[4]

The work of all the brothers bears a strong family resemblance, but careful examination reveals a difference in the way one of them handles his stiff figures and the reddish tones of his flesh tints, while another graduates the colouring of his faces with skill and carefully models their minute features. Yet a third hand can be distinguished in the frescoes on the front of the arch leading to the chapel and in the soffit of the arch itself, where the coarse and heavy workmanship is in strong contrast with the grace and childish simplicity of the other two. There is a very close affinity between these latter artists and the author of the frescoes, representing games played by groups of persons, in the Palazzo Borromeo in Milan. Here the vapid, unsubstantial figures derive a certain air of boyish grace from their long bodies, small heads and minute roundish features, whose pale and elusive tints remind us of the frescoes at Monza. The Gothic elegance of their beflowered robes and the slimness of the artless figures rivet our attention on these scenes from the daily life of the Lombard nobility towards the middle of the fifteenth century; for one cannot think of so typical an example of the picturesque Milanese style of architecture as the Palazzo

9

Borromeo without seeing in imagination that absurdly elongated personage who, in the picture representing a game of tennis, appears to be blown away by the breezes as his garments trail behind him in the rosy light; or the group of elegant lords and ladies intent upon a game of cards, half hidden in the wooded background. These works have an attractiveness peculiarly their own, compounded of charm, timidity and hesitation.

PAINTERS OF THE PERIOD OF TRANSITION BETWEEN LATE GOTHIC AND THE EARLY LOMBARD RENAISSANCE

ABOUT the middle of the century the Cremonese artist Cristoforo Moretti (at work from 1452 to 1485) painted the many-panelled picture formerly in the church of Sant'Aquilino in Milan, the central panel of which, representing the Virgin and Child, is now in the Museo Poldi-Pezzoli. The figures are devoid of vigour, the features ill-defined and weak, and the outlines blurred — characteristics to be found in the two pictures of Saints, from the Foresti collection, discovered and illustrated by Roberto Longhi.[5] The drapery hangs in the same ungraceful manner from the shoulders of the Virgin and of St. Stephen and follows the contours of their anaemic bodies. The Virgin is enclosed in a red and blue sheath patterned all over with Gothic profusion: St. Ginesius is decked out in a mantle adorned with fur; while St. Stephen wears a dalmatic which sits on his shoulders as though it were suspended from a coat-peg. All three figures, the saints outlined against their background of gold and the Virgin on her over-decorated and over-statued Gothic throne, have the same dull, cow-like, lustreless eyes, the same withered hands, the same huge elliptical haloes: the execution in each case is equally coarse and heavy. The picture, mentioned by Padre Allegranza,[6] is one of many examples scattered throughout Milan in which the Gothic tradition lingers on, tempered by some faint echo of the symmetry and rhythm of line characteristic of early fifteenth-century painting in Verona.

Although the Lombard school, as represented by Cristoforo Moretti, was insipid, there are in existence a number of smaller works by unknown artists which show that in other hands it was capable of better things. In the ex-Crespi picture representing the Madonna holding the Holy Child while a Carthusian monk kneels in adoration, the figures have a certain quality of plastic relief; the outlines are drawn more firmly and boldly — in some places even harshly — and the animated face of the monk is in a crude way a portrait drawn from life and full of character. The backwardness of Lombard art before the time of Foppa may be seen from the diptych, fraudulently bearing the signature of Michelino da Besozzo, in the Treasury of Milan Cathedral. The figures appear to be a patchwork made up from those of Michelino and the Zavattari, and the contours of the drapery (especially in the robe of the Virgin in the Presentation in the Temple) are still broken up according to Gothic tradition. The architectural accessories, a mixture of Gothic and Renaissance, are little more than screens, beyond which the starry decoration of the chapel

vault does not penetrate. The introduction of *grotteschi* into the ornamentation of the altar itself, however, leaves no room for doubt that this little picture was painted fairly late in the fifteenth century.

In the second half of the century the artistic centre of Lombardy shifted from Milan, Monza and Pavia towards Brescia and Cremona. Of the works of Benedetto Bembo,[7] probably a native of Brescia, of whom we have notices from 1465 to 1475, there remain a few fragments of a polyptych, now in the Museo Ala Ponzoni at Cremona. His methods recall in some degree the earlier works of the Paduan school, especially the all too scanty throne adorned with bas-reliefs, which seems to hold the Divine Group as in a vice, and the alternately metallic and glass-like lustre of the heavy robe of brocade worn by the Virgin. Not the least indication of Renaissance influence, however, is visible in the cusps and pinnacles of its architectural features. The artist strives to impart relief to his figures, and for this purpose emphasizes the shadows on the Virgin's face to such an extent that the whole face appears swollen, while at the same time he tucks her body away into a mantle of gold filigree as though it were a sword in its scabbard. The central group is flanked by St. George, a heroic figure modelled on Teutonic lines that might have come from the façade of some feudal castle, and by St. Anthony, in whose strong and rugged features, and the patient elaboration of the high-lights along the edge of his leathern belt and on the knots in the wood of the Cross, we seem to find a forerunner of the figures painted by Butinone. The drawing of the contours, especially in the case of the Virgin, the angels perched on the throne and the rugged St. George, is crude and stiff; the types are devoid of grace, with puffy cheeks, bulging foreheads and small features; the patterns on the brocades are put in with a sort of mechanical precision that might have been achieved with the point of a needle.

Plate 5 It may be that the picture formerly in the Castello di Torrechiara is of slightly earlier date than the work last mentioned. The subject in the central panel is the Madonna, four Saints occupying the lateral compartments. The predella, divided up into square panels in imitation of a sculptured plinth contains other saints, in rows. The Madonna is of a type we have already met in the picture in the Museo Civico at Cremona — haughty, bloated, with a small inquisitive nose and a mouth like a rosebud. The Holy Child in the latter picture resembles the one in the arms of the Madonna of Torrechiara as far as the shapelessness of the features and the flatness of the face is concerned; but the modelling of the Virgin's face is less exaggerated by shading and less inflated, while the youthful angels are grouped behind the throne in a semi-circle and take the place of the Gothic *motif* of garlands of roses. Despite the lingering traces of northern influence, this picture is one of the

most notable examples of the relationship existing between the art of Lombardy and the great school of Padua. The diminutive figures, indeed, balancing themselves uncertainly on feet that can scarcely support them, find a striking parallel in the Lazzara polyptych by Squarcione, while St. Anthony Abbot is a younger brother of Marco Zoppo's patriarchal saints. In the profusion of gold scattered over the pallid colouring of his figures and the lavish use of lustrous high-lights so that every little fretted fold in his draperies is flecked with light touched in with all the care of a penman, the Brescian painter proclaims the Paduan strain in his artistic pedigree. Only in the St. Peter Martyr does he attempt a sort of geometrical solution of the problem of representing volume.

To the same period as the Torrechiara Madonna and the decorative *putti* of the Sala d'Oro — who exhibit the same minute, contorted and puffy features as the Infant Christ sitting in the lap of the Virgin in the Torrechiara picture just mentioned — belongs the three-panelled picture of Angels bearing the Instruments of the Passion, in the Accademia at Bergamo, where we find a revival of the turned-up noses, the heavy eyes and little puckered mouths so much affected by Benedetto Bembo. Here, however, the execution is less clumsy, and is indeed almost pleasing on account of a certain whiteness of the flesh against the shadows thrown by the trees and its clean draughtsmanship, the lines being as sharp as though cut on a sheet of glass with a glazier's diamond. The incisive drawing, the concentration on essentials and the ivorine flesh tints render this work, which in some respects recalls the methods of Iacopo Bellini, a noteworthy example of the kinship that existed towards the end of the century between Venetia and Lombardy.

The work of the Brescian painter Bonifacio Bembo,[8] who was at work between 1447 and 1478, exhibits certain Tuscan-derived features hitherto not met with in Lombardy, but here blended with remnants of the methods first adopted by the Zavattari. Bonifacio was the creator of those lost frescoes in the Castello at Pavia which an old writer has described as "bespread with forests, and within them deer and wild boar and other beasts... and hounds painted so that they seemed to be alive". There was also a representation of "the noble Lord himself seated alone at table with Hieronimo de Becharia, the seneschal, standing by and pouring out wine and bearing a dish in his hand... and his Lordship supping from a plate of gold". A crowd of personages in gorgeous apparel completed the representation of ducal magnificence. These frescoes, had any portion of them survived to our day, would have revealed the mediocre personality of the author of the portraits of Francesco and Bianca Maria Sforza in Saint'Agostino at Cremona, whose rounded forms, severe outlines and simple yet regular draperies form so strong a contrast with the methods of Benedetto.

13

Another echo of Tuscan painting is to be found in the influence of Masolino's work on the author of the triptych recently reconstructed by Roberto Longhi[9] and attributed by him to Bonifacio Bembo. The painter has not entirely eschewed the use of Late Gothic embellishments, but he fails to give them harmony or continuity; and if the pinched and minute lineaments of his sacred characters betray a belated survival of Gothic traditions, those of the secular personages in the *cortège* display such marked diversity of features that they come near to being caricatures of the types portrayed. This superficial and somewhat overdone realism is, as it were, a Tuscan gloss superimposed on a non-Tuscan foundation. Yet the artist has failed to probe the Tuscan secret of giving depth to his work, and the landscape so crowds the upper part of his pictures that there is only room for a small patch of sky, fringed on the horizon with brilliant light. Fantastic castles, odd-looking avenues of trees, mountains out of which — without any interval of space to show how on earth they got there — the members of the various suites suddenly emerge, wearing immensely long conical hats that look like so many chimney-pots. Such are the accessories in the panel representing the Adoration of the Magi. In one place the profile of a young nobleman's face reminds us vaguely of Pisanello's portraits; in another there is a carefully-drawn figure of a youthful brawler with a snub nose; in the foreground one of the Kings stands before the Virgin immobile, sheepish, and rather like an inflated rubber doll.

In the panel representing the Coronation of the Virgin the garlands hanging from the ceiling are an honest attempt to imitate some Tuscan interior; the angels adorning the dais on which Christ and the Virgin are seated are pale reflections of the types painted by Fra Angelico. But the mere following of Tuscan models does not of itself suffice to give merit to this pretentious and miserable composition, for notwithstanding the magnificence of the costumes it will be noticed that the Eternal Father is standing on the dais clad in a long cope.

Plate 6 A triptych by Iacopino Cietario in *graffito* on a gold foundation, now in the Trivulzio collection at Milan, carries on the Late Gothic tradition. Paolo da Brescia, in his Madonna, now in the Pinacoteca at Turin, dated 1458, shows certain tendencies towards the school of Padua. This is especially noticeable in the arrangement of the Divine Group and the decoration of the throne; at the same time, however, the picture reveals the influence of an untutored Lombard style in the series of horizontal bands ornamented with small figures resembling antique gems, set in a background of dark stone. The complicated arrangement of the brocade, with its borders broken up and twisted after the manner of Gothic foliage, the pallid and evanescent colouring, and the feeble modelling, which characterize the decorative work of the Lombard artist Negroponte, mark a further stage in the development of local traditions.

14

The work of Donato Conte de' Bardi,[10] who is known to have died before 1451, is an improvement on that of all these second-rate Lombards, including even the Bembo of Brescia. His Crucifixion in San Giuliano d'Albaro at Genoa reveals the influence of the Renaissance in the sense of depth he has given to his work and the carefully-balanced composition. In no other work of the Lombard school prior to the advent of Foppa is so much attention paid to the modelling of accessories and features of the landscape — rocky mounds in the foreground, castles, houses and mountain ranges in the distance. One would say that the work reflects the style of Southern France rather than that of the Renaissance in Tuscany; and that Donato appears not so much to be a native of Lombardy as a student who acquired his artistic knowledge in Liguria. His work bears so close a family resemblance to that of the Brea that logically he must be regarded as belonging to the school that centred about Nice.

If we are to credit tradition, Zanetto Bugatto[11] of whom we have notices from the year 1468 to 1476, was a portrait-painter of distinction. He collaborated with the Bembo, and was sent by Bianca Maria Sforza to Brussels so that he might complete his artistic training there. But no authentic work from his hand is known to exist, and there is in consequence no material from which to reconstruct the individuality of a painter who "counterfeited nature with singular perfection". By another contemporary of the Bembo — Gottardo Scotti[12] whose notices cover the period 1457 to 1481 — there is a triptych in the Museo Poldi-Pezzoli at Milan representing Our Lady of Pity with Saints, the Annunciation, and the Adoration of the Magi. The colouring is slight and faded and obviously the work of a predecessor of the Bembo, who shows his attachment to the methods of the Zavattari in the minute and rounded features of the Virgin and in her dappled cheeks. Only the figures of the donors, thrown into relief by the use of heavy shading, have any affinity to the work of the Bembo.

Plate 7

Leonardo Vidolenghi,[13] who flourished from the middle of the fifteenth century until some time in the beginning of the next, is much more nearly akin to the two brothers. He is known to us through a fragment of a fresco in the church of the Carmine at Pavia, signed and dated 1463. His figures are coarse and the modelling is exaggerated both in the swollen muscles of the Holy Child and in the folds of the drapery.

Among the few Lombard names that can safely be identified with still existing pictures is that of Leonardo da Pavia,[14] the author of a very second-rate work, dated 1466, now in the Palazzo Bianco at Genoa; a work peopled with round and pallid-visaged figures and as boastful in form as it is timid in colour.

15

THE FIRST DEFINITE APPEARANCE OF THE RENAISSANCE
IN LOMBARDY

THE FIRST great herald of the Renaissance in Lombardy was the artist who painted the pictures in the Portinari chapel in Sant'Eustorgio in Milan. Lomazzo[15] attributes them to Vincenzo Civerchio, nicknamed "Il Vecchio" and Gaspare Bugatti says of them:[16] "They were the work of Vincenzo Vecchio, who in those days was a most rare artist... They were completed by the year '68". Modern criticism, however, has sought to account for the markedly Tuscan influence exhibited by the frescoes in this chapel by giving the credit to Bartolomeo da Prato, who flourished in the latter half of the fifteenth century and was greatly esteemed by Pigello Portinari.[17]

Similar tendencies towards Tuscan ideals are clearly noticeable in the group of somewhat tubular angels, reminiscent of those of Fra Angelico, in the scene representing the Assumption of the Virgin, and in the groups of Apostles in the same lunette. As the fresco is undoubtedly the work of a local artist, the "modern" inspiration was perhaps supplied by Michelozzo, the designer of the chapel. The decorative scheme appears at first sight to be almost entirely in two colours, this impression being due to the generous use of imitation black and white marble; but the profusion of the decorative *motifs* is emphatically Lombard in spirit, and does not conform to the rules of rhythmic spacing or geometric regularity. Even if the artist who decorated the Portinari chapel had seen reproductions of the works of the Florentines and had thus acquired some knowledge of the progress made by them in the study of perspective, he did not attempt to apply it. His complicated backgrounds are as ingenuously contrived from the point of view of perspective as they are carefully thought out in regard to the pictorial values of light and colour. Nowhere in Florentine art of the fifteenth century shall we find such a background as that employed in the St. Peter Martyr healing the wounds of a Young Man. It consists of a succession of loggias, of fortified bridges, of terraces and houses, scattered arbitrarily and picturesquely here and there, enlivened by reflections and shadows which fall on the fronts of the narrow houses and dapple the smooth surfaces of the archivolts, while the alternating bands of colour in the arches stand out boldly against the quiet polychromatic colouring of the buildings. There is no striving after dramatic effect in the sedate and very carefully modelled figures or in the quiet dignity of the setting: the complex scene is a network of squares and radiating lines which afford perpetual delight and continual surprise to the beholder.

In a similar manner the artist ignores the rules of perspective when he places small oval windows of Lombard type behind the Doctors of the Church; while in the two scenes representing St. Peter Martyr preaching and the Miracle of the Host, painted in a single lunette but separated by a window, the figures are arranged some within a series of slender arcades with vaulting supported on columns no stouter than a twig, some in pulpits, and some on flights of steps; and behind it all that is left of the background is covered with visions of trees and of streets lightly suggested by a few strokes of the brush.

That the artist visualized his artistic conceptions in terms of light and shade rather than through the Florentine medium of linear design is made abundantly clear by a study of the St. Peter Martyr preaching, where every strand of the wicker bench is kindled with light and the top of every step of the wooden staircase, every ledge of the pulpit, derives its form from the play of light, falling upon it like diaphanous layers of fresh-fallen snow. This use of light as an expression of form found its way into Lombard art through the example of Foppa, and is particularly noticeable in the impressionistic background of *Plates 8, 9* the Martyrdom of St. Peter. Taken in conjunction with the extreme roundness of the forms, this characteristic treatment goes far to support the theory that the frescoes attributed to "Vincenzo il Vecchio" are in fact one of the most important works of Foppa,[18] an artist who was born about 1427 and died about 1515, and lived to become the foremost artist of the Lombard school. Among all the painters of Lombardy only this native of Brescia can give us anything comparable to such examples of sane and placid naturalism as the two figures in conversation at the foot of the staircase, and that other truly marvellous figure of a woman sitting huddled up near the bench with her back to the spectator, and suggested entirely by the subtle play of light and shade among the folds of her coarse mantle.

The works of Foppa begin with the Madonna and Angels, formerly in the Noseda collection but now in the Berenson gallery at Settignano. In common with the Late Gothic compositions of the first half of the fifteenth century, the Virgin is seated in the open country with the Holy Child in her lap and surrounded by groups of cherubs. But the sober-minded Foppa replaces the joyous garden of flowers and singing birds by a simple field enclosed between hedges and dominated by a group of dark trees contrasted against a pale sky.

The whole composition is arranged on a single plane parallel to the frame of the picture; the figures of the Virgin, the Infant Christ, the angelic musicians, and particularly the group of three children busily turning the pages of a diminutive book, are all brought into harmony with the curve of the hedge; the hedge itself is interlaced with dark-toned tendrils and here and there flecked with light. Only in the *motif* of the hedge and the crescent form of the Virgin's robe do we find any echo of Gothic tradition: the heads are

beginning to acquire roundness, the clothing is becoming more substantial, the glistening feathers of the wings detach themselves from each other and lie in orderly layers. In the simply-contrasted figures set against the dark background of the hedge there is at the same time a hint of the employment of light as a means of expressing form.

Plate 10 This tendency is further developed in the admirable Crucifixion in the Accademia Carrara at Bergamo painted in 1456. Renaissance forms have here definitely taken a place in Foppa's work, and he places the three crosses behind a triumphal arch in the same way as Masaccio had done, against a background of rocky hills crowned by castles and houses. It bears a closer resemblance to one of Pisanello's landscapes than to the work of any member of the Tuscan school. This picturesque scene owes nothing to the science of geometry: the mountain peaks and the towers and walls of a totally fantastic Jerusalem lead up to a sky that is furrowed by bands of cloud not unlike flashes of lightning, while a little silvery road disengages itself like some tiny rivulet hurrying down the steep side of a declivity. Life is imparted to the whole composition by the lights burning on the three mounds on which the crosses stand, by the answering gleams lighting up the coralline shrubs and by the lurid bands which traverse the sombre sky. There is a row of trees that one might imagine to be some fantastic apparition of lighted torches: the three naked bodies hanging from the crosses stand out vividly against the sable cloak of night. More than in any example of the Tuscan school, there is in the sky a sense of depth that increases as we look into it, the eye being carried by gradual stages from shaft to shaft of light back towards the dark curtain of shadow, each successive shaft less bright as the background is approached.

Plate 11 His tendency towards high and even full relief led Foppa to conceive the figures in the group of the Virgin and Child, in the Trivulzio collection, as if they formed part of one of Donatello's sculptured panels, while those in the picture in the Castello Sforzesco in Milan are like some coloured terra-cotta group framed by a painted window. Both these works make us realize how great Foppa was as an artist, even in his younger days. In the first the tendency is all towards restraint; the expression on the Virgin's face is somewhat severe, the lineaments are sharp as though done in *repoussé* work on a metal plaque. In the second work the forms are more rounded, especially the austere countenance of the Madonna, and there is admirable balance and a sustained and gracious rhythm of gesture. There is a similar degree of modelling noticeable in the Brera altar-piece, formerly in Santa Maria delle Grazie at Bergamo, the subject of which is the Virgin enthroned between Angels, with eight saints in two tiers of panels. As in the Venetian altar-pieces, the angels are arranged as a frame round the Virgin, who sits in the apse of a stately chapel decorated with Lombard magnificence. The angels, confined within the narrow space around the Ma-

donna, have massive heads set on heavy bodies as in the primitive work in the Berenson collection, but the deep shadows in the hollows are in strong contrast with metallic high-lights, and accentuate the relief of the modelling. The Virgin, engrossed in thought, rests one hand as firmly on her book as she might have done had it been some support of stone; around her the angels pulsate with life; the Holy Child leans forward eagerly to touch the strings of a cithern held by a boyish musician, and smiles gently as he puts his head on one side to listen to the sound. Disposed within the ornate niches are SS. Jerome, Alexander, Vincent and Anthony of Padua, Clare and Bonaventura, Louis of Toulouse and Bernardino; St. Clare with luminous eyes and sculpturesque folds in her draperies; St. Louis of Toulouse placidly melancholy with soft and broadly-modelled face and hands plentifully dappled with shadow; St. Jerome monumental, leaning on the lion, so imposing of stature that he might well bear comparison with the St. Jerome painted by Francesco del Cossa; Alexander in the traditional guise of a fifteenth-century hero, stifled by his glittering armour, his corselet adorned with lilies copied from a pack of playing cards. Every figure is frankly representative of the grave and austere types to be found in the works of the great master of the Brescian school.

The predella contains deliciously homely scenes from the Life of the Virgin. The flesh tints are paler in tone and the whole colour scheme is exceptionally delicate and soft. The Flight into Egypt, in which the little Mother seems to be trying to warm her tiny Child with her breath as she clasps him protectively to her bosom, with the angel whose whole person, from his feet to the tips of his wings, lies within the shadow of a fantastic thicket of palm-trees, is among the most delicate works of the Lombard master.

The tendency to use light as a means of expressing form already exhibited by Foppa in the Crucifixion is reflected in two of his other masterpieces, the Berenson Madonna and *Plate 12* the St. Jerome in the Accademia Carrara. The group of the Virgin and Child stands out from a curtain in the background which is so picked out with gold that every strand in the weaving appears to be a spark of fire; the figure of the Infant Christ, seated sideways, is illuminated obliquely from a corner of the picture where the open country is not obscured by the curtain, so that every lock of the curly fair hair, each toe of the tiny restless feet, and every fold of the little crumpled vest, sparkles like ripples dancing in moonlight. This method of lighting imparts to the type and pose of the Child a vivacity not to be found in the mute and rigid infants clasped in the arms of Foppa's earlier Madonnas: the glance is full of intelligence, the baby hand that grasps one dainty foot is full of action. The Virgin's hand, as it clasps the Child to her breast is slender and nervous, the shape reminding us here, as in the Trivulzio picture, of some of the works of the primitive Giambellino. *Plate 13*

There is a tranquil, religious sense of maternity in this representation of the young Mother, set against the background of woven silver, absorbed in her Child and bending over him with maidenly gravity.

One of Foppa's most remarkable works as far as luministic effect is concerned is the St. Jerome in the gallery at Bergamo. The figure of the old man, broad-chested, vivid, and with a leonine head, emerges from the shadow of his cave. The colour is so slight as to approach monochrome, but the picture is instinct with a shimmering light that imparts its own rapid motion to every fold of the drapery, every fissure in the ground and every stratum of the sparkling schist. The Saint is praying apart in the light of the full moon, guarded by his faithful lion; around him moves all the mysterious life of the night. The ground under his knees appears to float away like a gurgling stream moving in whirlpools of light, while the crucifix, reflecting back the silvery brightness of the sky, shines in the moonlit night like a flaming torch. The governing factor in this work is the play and incidence of light. It is the light that gives life to things animate and inanimate and throws even the most insignificant detail into relief.

To this period also belongs the Madonna formerly in the Frizzoni collection. It is characterized by deep shadows out of which shine bejewelled borders of mantles, glittering folds of a veil and the flutings and other ornaments of a throne; on the window-sill the outline of a metal bowl stands out in contrast against the sky. Even the faces of the children seem to be blocked out in dull silver.

The spacious and solemn St. Bartholomew of the Sarasin-Warnery collection at Basle, in which the folds of the mantle are modelled to their full depth by means of bands of light, may be regarded as the immediate precursor of Savoldo's austere figures; while the upraised hands of the majestic St. Gregory, as he stands against the blue sky like some statue of oxidized silver enclosed in a reliquary, constitute a fragment of luministic representation that would be no disfigurement to any work of the seventeenth century, so exact is the representation of modelled relief, so perfectly are they brought into prominence by the concentration of light.

The Martyrdom of St. Sebastian, once in the Grandi collection at Milan, is worthy, on account of the impressionistic character of the wide and varied landscape bathed in atmosphere which constitutes its background, to be compared with the Martyrdom of San Pietro Monaco. The garments worn by the archers and the drapery of the martyred Saint appear to be made from spun glass falling into minute folds; the angel in white, with palm-branch and filmy raiment, seems to have been blown from the lips of a Muranese glass-worker and to float lightly in a puff of air. The less clearly defined portions of the background,

indicated sketchily by patches of light and shade, are to be regarded as among the most typical characteristics of the work of Foppa as well as of his successor Borgognone, for both of them adopted the practice of attempting no linear precision in their background and were content to adopt the Lombard habit of suggesting rather than actually constructing its details, thus tending towards a broad and picturesque impressionism. In his affection for lighting effects, Foppa interposes the head of a glistening-eyed negro between two of the bowmen, while the light and the breeze play hide-and-seek among the tiny, glassy folds of the Saint's loin-cloth.

We do not find these fantastic lighting effects repeated in the soft, concise and delicate colouring of the Brera fresco. The Brescian master drew his inspiration from the work of Donato Bramante alike in the architectural setting of his two kneeling saints, who resemble statues set in the interspaces between invisible columns, and in the archivolt of many-coloured marbles which surrounds the head of the Virgin. Christ, seated on the window-sill, opens his arms in blessing as though to gather the faithful in his embrace: the cushion on which he sits is placed on a rug woven of many bright hues and relieving the soft and pale tints of the remainder of the fresco with its gayness.

The background of the Brera St. Sebastian is also inspired in its general lines by the architecture of Bramante, though the strong reflected light on the soffit of the arch in this work is reminiscent of the Miracle of St. Peter Martyr in the Portinari chapel, while the summary rendering of the modelling by means of light and shade without any regard to geometric construction demonstrates very clearly the difference in point of view between the Tuscans and the native of Brescia. The effects which Foppa obtained at Bergamo by means of sparkling surfaces, every fibre of which is picked out in silvery light, is achieved here by variations of light and shade produced by alternations of hollow curved surfaces, by projecting mouldings and by the multiplicity of angles in the complex architectural background. Against this carefully-schemed obscurity the silvery nakedness of St. Sebastian stands out in striking contrast. We have here an unobtrusive alternation of shadow and gleams of light forming, as it were, a narrow corridor, at the bottom of which stands a small figure, clear-cut in vivid light.

In another St. Sebastian in the Castello Sforzesco, however, the place of martyrdom is *Plate 14* set in the open air, although the pilaster at the back of the victim supports two broken arches against a deep blue sky, while the intricate mouldings at the base of the pilaster afford scope for the display of those effects of light and shade so dear to the heart of this artist. Here, again, as in the Brera picture, the column of dark marble accentuates the contrast between the silvery whiteness of the saint's body and the alabastrine clarity of the other ar-

chitectural features. The subtle curve of an abacus impinging at one extremity on a shaft of light, the delicate gradations of tone between the ivory whiteness of the capital and the milky alabaster of the arches, cut off in the midst of their wing-like curves; the effulgent brightness of the angel's head and of the two translucent hands contrasted against a dark mass of clouds, such as we might find in one of Lorenzo Lotto's pictures: all these things are features that serve to reveal the greatness of Foppa as an artist. He delights in portraying the stooping, foreshortened bodies of the archers so that he may create an almost Bramantinesque procession of fleeting outlines; his network of sunlit houses interspersed with clusters of sombre trees reveals an impressionistic treatment which is astonishingly modern.

The two austere figures in the Castello Sforzesco representing St. Francis and St. John the Baptist in the inhospitable solitude of the desert — the latter resembling a stately tree growing amid the sand-dunes and spreading its branches against the pale sky — were painted about this time. To the same period must be attributed the two Savona altarpieces, one of which is still in Santa Maria del Castello and the other in the Pinacoteca. In both he accentuates the shading of his somewhat inflated figures, and in the biblical scenes in the predella once more indulges in the free play of sparkling high-lights. This is particularly noticeable in the Adoration of the Magi, where the gleaming figures and surfaces stand out in the shadow of overhanging mountains with an almost nocturnal effect.

The Madonna in the Johnson collection in Philadelphia, with its ample figures and heavy shadows against a curtained background of pale brocade, is also undoubtedly a late work by this artist. The great master of the Brescian school has here concentrated all that he knew of light and shade upon the delightful Infant Christ and the landscape; the latter an impressionistic fragment which, spurning every law of construction and of perspective, exhales the very essence of pictorial art as it was developed in Lombardy. The Madonna in the Davis collection at Newport is slightly earlier in date than the work just mentioned. As in a painting of the beginning of the fifteenth century, the Virgin, raised on high above a square of luminous sky and a thicket of roses, clasps her Child to her breast with such lyrical tenderness that we are at once reminded of similar groups from the brush of Giambellino. The background consists of one unbroken flat surface; a space of clear sky punctuated here and there by the dark leaves of the rose-bushes, and below it, between the branches of the thicket, a flaming light on the horizon in vivid contrast with its deep-toned embroidery of leaves.

The outstanding representative of painting in Lombardy before the arrival of Leonardo, Vincenzo Foppa from the very outset of his artistic career exhibits the same tendency to express all forms in terms of light and shade that swayed the Lombard school throughout

the sixteenth century. This tendency is particularly noticeable in the virile work of Gian Girolamo Savoldo, and was carried across the threshold of the succeeding century by the great master of the seventeenth century, Michelangelo da Caravaggio. The colour that was the foundation of Venetian painting, the exact and constructive draughtsmanship so earnestly cultivated in Tuscany, are of but secondary importance in the eyes of the Brescian painter, who achieves his modelling in the round entirely by means of shadow playing on light. In the Crucifixion at Bergamo the pallid corpses hanging from the trio of glowing crosses seem almost to approach the beholder out of the foreboding darkness of the sky, as though touched by a magician's wand. The greyish flesh tints subdue the effect of rich marbles and sumptuous apparel, checking their gaiety; the flat surfaces are burnished and lustrous; the figures emerge from their setting with a full measure of high relief and modelling; the distance, no longer a thing of precision, becomes a mere suggestion seen through a veil of hazy light. The backgrounds of Foppa and Ambrogio da Fossano reveal the art of Lombardy in its most perfect form.

Through this love of expressing form in terms of light Foppa gropes his way to his masterpieces; to the landscapes of his St. Peter Martyr and the St. Jerome at Bergamo, weaving a wondrous fabric from innumerable strands of shining gossamer and spreading it over rocks and earth. The effect of varying light upon fretted and fibrous surfaces, rather than the colouring of the Venetians, constituted the guiding principle of the school of Brescia in the sixteenth century, and this principle was first worked out by the painter of the St. Jerome at Bergamo and the St. Gregory at Basle, a sober and earnest craftsman who sometimes attains even to the very threshold of modern impressionist art.

TREVIGLIO has the distinction of having produced two artists of outstanding merit who were contemporary with Foppa. Bernardino Butinone[19] is known to have been active between the years 1454 and 1500 and Bernardo Zenale di Martino between 1484 and 1526. Both worked in a supremely rich and decorative style more nearly akin to the magnificence of the followers of Omodeo than to the austere simplicity of Foppa, and sometimes revealing forms more characteristic of the schools of Padua and Ferrara. In the early triptych in the Brera, Butinone sketches out a shallow Lombardesque niche behind the Virgin and SS. Bernardino and Vincent, and sets within it a narrow seat with curving sides and a shell-like apex resembling the thrones beloved by Cosmè and Crivelli. So, too, the sharp profile of St. Bernardino reminds us of Crivelli's ascetic visions, as do the cast-iron modelling and spasmodic contortions of the figures, twisting and turning against a background of cloudy sky like an elaborately crumpled ribbon, in the Berlin Pietà.

23

The same characteristics are to be found in the tondo of St. Jerome in the Gallery at Parma. As depicted, the Saint is a wooden figure with a fringe of shining hair and beard, malformed ears, protruding bones and a scowling face; yet the action expressed by the thin, withered and sinewy hands is eloquent in the extreme. The constrained and rigid attitude of the figure fits harmoniously into the dark background, while the metallic lustre of the drapery and the brownish flesh tints are thrown into added prominence by their dusky surroundings.[20]

Butinone appears before us in the guise of a Lombard Parentino in the Battle Scene in the Borromeo collection at Milan. The figures are angular and clothed in gauzy raiment sparkling with a filigree of points of light resembling spun glass, the whole work being carried out in a subdued and cadaverous colour scheme. The brightly-lit figure of a soldier with his back towards the spectator climbing a shadowed rock seems to be carved in the rock itself and is one of those fragments of modern impressionism which so often startle us in the works of the Lombard school of the fifteenth century.

The affinity already noted between this painter of good Lombard stock, the Paduans of the Mantegna period and the Ferrarese of the time of Cosmè is still more clearly marked *Plate 15* in the altar-piece at Isolabella signed *Bernardinus Betinonus de Trivilio pinxit,* where the metallic outlines of the lineaments, the laboured projection of the folds and the oval heads of Mary and St. Justiniana recall types familiar to us in the works of certain of Cosmè's followers — especially Cicognara. For all that, however, this little masterpiece, so much resembling the work of Omodeo, unmistakably expresses the personality of its author, especially in the delicacy of the clear, grey tones. It seems almost as if some stained-glass artist had been responsible for the design of this pellucid work, with its intricate friezes and capitals high over the heads of the attenuated figures, its lamp suspended above the Virgin after the manner of the Venetians, and its small metal discs in the spandrels where Mantegna or Bramante would have placed medallions. In his desire to break up the zones of reticulated light and to increase the splendour of his ornaments the painter besprinkles his work with a profusion of gold and jewels and enamel; and instead of covering his walls with marble, clothes them with a network of small tiles, some of them broken and others our of place, exactly as the Venetian, Carlo Crivelli, loves to show them to us. This over-rich but always light and delicate decoration serves as a setting for translucent figures of unusually gentle mien who seem to shine with unearthly internal light, and for graceful minstrels of the Omodeo type such as the two holding a music-book between them and whispering childish secrets in each other's ears.

The unpolished painter of the Brera triptych and the four Doctors reveals himself in a

still more gentle mood in the St. Louis and St. Bonaventura in the Galleria Ambrosiana at Milan. The small, slender figures in their copes of brocade are firmly balanced on their feet and outlined against a background of sky, like the St. Jerome in the medallion at Parma. The St. Bonaventura is a work of particular excellence; the Saint stands with his feet firmly planted on the ground like a statue on its pedestal, while the careful arrangement of the folded hands, the hat, book and monstrance, reveals the unerring judgement of the artist and is suggestive of the rhythm we find in the work of Antonello. Here, likewise, the flesh tints are of a greyish brown on a greenish background; but the colouring is denied its full brightness and the glitter of the gold is dimmed as if to prevent its disturbing the trance-like attitudes of the figures. Yet, for all that, the painter cannot refrain from giving us an example of his luministic impressionism in the tiny spots of light dancing on the golden-green brocade of St. Jerome's mantle.

Plate 16

There is, however, a radical transformation to be noted in the last works of Butinone — the altar-piece in the Scotti collection at Milan and the Madonna in the Brera Gallery. The latter is toned down to the gravity of aspect and firm, hard modelling of Foppa. In this Madonna he emulates that artist, accentuating the modelling of the lineaments, exaggerating the light in the eyes and on the eyelids, and over-emphasizing the shadows round the bony chin and coarse lips. Judging from the general similarity of action, it would appear that the two pictures were planned about the same time, for in the Brera Madonna the Infant Christ plucks at his mother's mantle, while in the Scotti panel he struggles to escape from her lap. Butinone, so frigidly composed in the Borromeo altar-piece and so precise in the St. Louis and the St. Bonaventura, here trifles with the youthful angels flitting about the throne of the Madonna like huge moths beating their wings against a lamp, and delights in disturbing the tranquil scene by thrusting sudden shafts of light among the shadows. The myriad points of light outlining every portion of the glittering predella beneath the Virgin's throne are delicate in the extreme, and the canal to the right, its placid waters immured between high walls, is a typical example of a picturesque Lombard landscape.

Bernardo Zenale's work bears a certain resemblance to that of Butinone, with whom he collaborated, in the primitive triptych in Sant' Ambrogio in Milan. The St. Jerome here is stunted and spindle-shaped and secured about the legs by a robe with cast-iron folds very much like the draperies Marco Zoppo and Cosmè Tura used to hammer out of their woven fabrics. The Virgin's throne, in comparison with those in Butinone's pictures, is simple in design, while the face of the Child Christ is no longer a mere flat disc, but is shapely, well-proportioned and gentle of aspect.

Zenale later painted the two panels of the polyptych in the Frizzoni Salis collection at

25

Bergamo, bestowing a still greater degree of decorative elegance on the sun-kissed architectural background and the somewhat wiry hair of the Archangel Michael. The colouring of the flesh, too, is clearer and more skilfully graded than in the works of Butinone; the modelling is more delicate, especially in the medal-like bas-relief of the head of the donor and the broad and simple folds of his white cloak. Neither the Sant'Ambrogio triptych nor the panels of the polyptych are equal in power of modelling or splendour of colour to the Treviglio altar-piece or to the fragmentary work in the Casa Treccani at Milan, representing Bona of Savoy before the Deity in company with one of the saints, which is truly worthy to be matched against the gem of Lombard art just mentioned. The treatment of the rich cloak of brocade is broad and majestic, the hand of the skilful craftsman who at Treviglio chiselled out the golden ornaments of the altar-picture appears here once more, busy among the lilies — ice-flowers floating on a sea of glass — that adorn the shining veil worn by Bona and the jewelled ornaments in the diadem of the saint.

Bernardino Butinone and Bernardo Zenale collaborated on the frescoes in San Pietro in Gessate, one of the most notable examples of fifteenth-century art in Lombardy. They also worked in company on the altar-piece at Treviglio which, from the point of view of richness and delicacy of effect, is to Lombard painting what the creations of Omodeo are to Lombard sculpture and architecture. Foppa's austere simplicity finds its antithesis in this luxuriant phantasy of gold and many-coloured marbles, and in the marvellously patient chiselling with which every part of the figures and their architectural setting is covered leaving only the turquoise velvet of the sky untouched. Every flat surface is draped with a fabric of closely woven ornamentation, the splendour of gleaming metals is reflected from every thread of this sumptuous composition. In the panels painted by Butinone — one with the Virgin between Angels, two with triple groups of saints, and the fourth with St. Martin and the Beggar — the leaden flesh tints are thrown into strong contrast by the dazzling colours of the backgrounds: the patterns of the brocades are broad and startling, the figures are more withered and wooden, and the intense shadows increase the effect of the high-lights, these characteristics being particularly noticeable in the shrivelled person of the beggar. The Virgin with her overgrown Child, the squat, Foppa-like angels, look as if they were cut out of brown cardboard and stuck on a sparkling background, while the disproportionately large horse which by itself fills the whole of the arch might well have been bought from a maker of wooden toys. As for the Saint himself, he is crushed into a narrow space, and is compelled to bend in harmony with the curve of the arch; but the face is that of a charming troubadour of Provence, and the uncouth posture of the arms only serves to set off this rare blossom growing among many dry twigs.

26

A born goldsmith, Bernardo Zenale[21] displays a better grasp of decorative treatment both in his figure subjects and in the architectural backgrounds of the two compartments, one of which contains a group of three male saints and the other three female saints. Comparing the work of the two collaborators one sees clearly the differences between them: Butinone detaches his figures of St. Anthony and St. Paul from the background with almost brutal force; Zenale, designing a panel similar in composition to that painted by his partner, allows the rigid figures of the sainted bishop and the equally sainted standard-bearer — guards of honour in apparel meet for a sacred ceremony — to rest against the pilasters of the loggia. He is careful to maintain the same quality of light both in his figures and their background, making of the two a single piece of lacework picked out with threads of gold. The same difference of temperament is apparent when we come to compare the shadowed glimpse of landscape behind Zenale's saints with the vivid, light-flecked back- *Plates 17, 18* ground chosen by Butinone; or the great golden flowers that flash out from the dalmatic of the St. Stephen painted by the latter with the silvery damascening on the corselet of Zenale's standard-bearer, who, with his elegant satin vesture, seems as if he might have been taken from some figure carved by Omodeo. We do not find in the work of Zenale the "modern" quality exhibited by Butinone when he sets the light dancing among the shadows in St. Bonaventura's cope; we are confronted instead with the patient craftsmanship of the goldsmith, an eye capable of understanding the relationship between figures and their decorative accessories. It is for this reason that in the *ancona* at Treviglio he eschews all that savours of fluttering robes or contorted bodies, except in the St. Peter standing against an open sky. He makes the keen-eyed bishop and the graceful young page stand erect and stiff so that they may better harmonize with the pilasters behind them, and he petrifies the magnificently robed holy women into monumental poses behind the graceful wrought- iron balustrade. These three statuesque figures are Queens, the natural inheritors of this *Plate 19* temple clothed in gold: the very impersonality of the type represented by them augments their decorative value, while the gorgeous colours of their vesture compete with the dazzling colours of the background.

IN CONTRAST with this richness of colour and crash of metallic tones, Ambrogio da Fossano, called Borgognone,[22] who was at work between 1481 and 1522, chooses rather to endow his work with ashen tints which savour of the monotony of the cloister. It is almost as if the sleepy mists that haunt the valley of the Po had cast their veil over his pictures. One of his earliest known works is the altar-piece in the Galleria Ambrosiana, reminiscent of Foppa in the shadowed modelling of the features and the large heads of the angels, and

of Butinone in the very rich decoration of the Lombardesque chapel. But he too is troubled by the problems of his art, seeking to establish a proper symmetry between the two rows of saints, elongating his meek figures, ironing their garments into thick and parallel folds with exemplary care, and suspending two little angels in the air in such a way as to suggest a pair of plaster cherubs hanging from the ceiling by invisible wires. And yet, for all his embarrassment, the personality of the artist has already begun to express itself in the carefully enlarged recumbent figures which are projected into the foreground of the picture by an ingenious succession of perspective planes. The tones of the flesh tints reflect the usual gamut of the Lombard master and the varied tones of the golden ornaments adorning the temple are all admirably in harmony.

Square forms, hard and regular folds and laboured grouping, are so many connecting links between the Ambrosiana altar-piece and the Christ carrying the Cross in the Scuola di Belle Arti at Pavia; while the view of the Certosa in course of construction in the background is a first example of Ambrogio's delicate sensibility as a landscape painter, in which all the veiled poetry of the Ticino valley is expressed by a few brief strokes of the brush. But among all the earlier works the one which most vividly reveals the personality of Ambrogio da Fossano, painter of Carthusian and Olivetan monks, is the picture in the National Gallery, London. A timid child, the Virgin takes St. Catherine of Siena by the hand, while the Infant Christ places the ring on the finger of St. Catherine of Alexandria. There is an expression of quiet melancholy on the faces of the Virgin and the Saint of Siena; they do not look at each other, but the sympathetic grasping of hands unites them well enough. This is not Mary the Mother of God, but Mary the sister of the dumb creatures about her throne. Her head is bent like one about to receive the Sacrament. The shadow of the cloister sits gently on the devout faces of the two women.

The Brera altar-piece, the Coronation of the Virgin, heralds a change in Borgognone's methods. The outlines of the undulating figures are less boldly indicated and are more in keeping with the thin and vaporous passages of light and shade in the greyish flesh. An equally careful toning down of the figures by means of shading is noticeable in the pictures in the church of the Incoronata at Lodi, particularly in the radiant Virgin of the Visitation and the Archangel Gabriel, who one would say was painted from a copy of the angel in the Virgin of the Rocks. The artist is entirely occupied in planning his work so that the richness of the temple is reflected in the crowded decoration of the accessories, in the minute needle-point ornamentation of the candelabra, mouldings, books and sacerdotal vestments: he sees to it that the brilliant colouring is repeated in the blue distance, in the golden friezes and in the vestments that seem to have caught fire from the golden reflec-

Plate 20

Plate 21

tions of the temple itself. The sumptuous background and delicate figures in Borgognone's pictures seem truly to be the offspring of the ecclesiastical magnificence of Lombardy, and to have been created by the genius of a single painter.

The brilliant colouring of the Lodi pictures is reflected in the St. Quirinus of the Accademia Carrara, in which the saint wears an oriental tunic woven with strands of gold, and in the Resurrection in the Nicholson collection in London, in which a delicate translucent substructure of colour becomes the vehicle for a succession of silvery reflections, and sparkles with a glitter as of new-fallen snow. Delicate half-tones of shadow play about the brown, clustering ringlets; but the remainder of the work presents a full scale of graduated whites on a grey foundation, fascinating in their purity and silvery in their transparency. Before long, however, the brilliant and complex colour scheme which had inspired the painter when elaborating his golden temple at Lodi began to lose its hold over him, and eventually ceased to have any power of attraction. Borgognone sets out again along a different path, suiting the soft monotony of his colouring to the gentle melancholy of his subjects and landscapes. The change is very noticeable in the three pictures of the Madonna, in the Vittadini collection, the Visconti Venosta collection and the Museum at Amsterdam respectively. They are the most delicate of all the flowers of art created by this painter. A comparison of the three Madonnas and the one in the National Gallery, London, in which two angels wearing sacerdotal vestments are worshipping the Virgin, shows how the artist had learnt to tone down his shining faces by the skilful use of shading, to soften the expression and to reduce the harshness of the flesh so as to bring it into harmony with a more delicate and flowing treatment of the draperies. In each of the three pictures the pallor of the figures is accentuated by the dark background provided by a curtain or a wall; in each case there is an opening which enables the eye to wander over distant and uncertain landscapes which are among the finest examples of the Lombard understanding of atmospheric effects. In the Vittadini picture we seem to be looking through a veil of mist at the Virgin, her Child and the impressionistic background, the latter consisting of roughly-suggested trees and grassy mounds contrasted with the dimmed brightness of the sky, or of uncertainly visible doors and windows in the wall. The country-side is mute, deserted, sad: the look of melancholy in the Virgin's eyes seems to impress the Child as he sadly turns away from her breast. In a similar manner the green of the curtain and mantle and the red of the clothing in the Amsterdam picture seem to fade in harmony with a landscape in which mists struggle for the mastery with the pale light of heaven.

There is more freedom and fluidity in the small picture in the Accademia Carrara at Bergamo representing the Meeting of St. Ambrose and the Emperor Theodosius, one of

Borgognone's last works. In it he reverts to the more usual methods of pictorial composition, interposing a low, dark-toned wall like some piece of drapery between the figures in their brilliant raiment and an impressionistic glimpse of a street. In the Bergamo picture the contrasts of light and shade are more intense than in any other of Borgognone's works; and while the composition of the scene, with the figures set laboriously in a line, is still archaic and primitive, there are certain details such as the hands of the Emperor which are made to appear almost as if modelled in clay by a few rapid touches of light distributed in the more modern manner.

Such masterly and rapid delineations of form are rare in the art of this painter, who usually prefers the leisurely ways of a placid stream flowing between its monotonous banks. Right up to the end he repeats the same type of figure, oval of face, mild of feature and slow of gesture, on backgrounds inspired by the mist-haunted banks of the Po; right up to the last the same sad and somnolescent music accompanies his little Madonnas with their faded claustral tints, his pallid children, his silent landscapes veiled in mist between wan skies and torpid streams. The charming homeliness of these fragments of the country-side as seen by the painter of Lombardy and translated into a few broad patches of colour is the most precious quality to be found in the works of Ambrogio da Fossano.

Plate 23 There is a certain degree of affinity with Foppa and Borgognone noticeable in a masterpiece of the Lombard school painted by an artist who has not as yet been identified. This is the Annunciation in the Louvre, a triptych commonly attributed to one or other of the schools of northern Italy.[23] The anonymous author of this work is a master of all the refinements of line and colour, and supremely gifted as a decorative artist. He appears before us as an adept interpreter of Omodeo's delicate ornaments, whether it be in the friezes adorning the terrace, or the Virgin's faldstool, or the bases supporting the slender columns with their flowery capitals, or the rich vase covered with scales and filled with long-stemmed white and red carnations rising among curling leaves. The angel, too, with his rosette-like ringlets, with a feather and three roses adorning his head, with silver quills in the feathers of his wings and velvet ribbons untied and twisted, is spiritually akin to the airy and ornate forms created by the sculptor. Bent like a bow above the yellow disc of the sun he floats towards the Virgin as some dolphin of the air might do, leaving behind him two patches of crystalline light such as are made by the dipping oars of a boat. But he is no Archangel Gabriel in the flower of youth: he is but a child, seemingly escaped from one of Borgognone's altar-pieces in order to present himself here, decked out by the hands of a cunning craftsman, in garments meet for some high festival; in gaily fluttering plumes and lilies and bands of ribbon. Before him there goes a limpid shadow — one might almost

call it the ghost of a shadow. The Virgin rises startled from her faldstool; yet her movement is so gentle that the rustle of her garments, light as the patter of leaves, is insufficient to disturb the silence of the landscape smiling sleepily in the pale midday light of the north. The two slender columns of marble, the clustered roses climbing the balustrade, the curving stems of the carnations weaving dainty arabesques against the open sky, and above all the subdued colouring of the landscape with its changing light and the mournful poetry of its rising ground-mists, together convert the drowsy softness of the tints into an atmosphere delicately and profoundly idyllic.

A poet of rare quality, this nameless painter knows how to infuse into his decorations the flowery grace and extraordinary lightness of Omodeo's modelling, and into his figures and landscapes a spirituality unique in Lombard art. The two saints in the panels approach each other with measured steps, standing out against a background consisting of drapery divided by lines of gold into horizontal bands which accentuate the rigid verticality of the figures themselves. Their natural contours concealed by the stiff smoothness of their garments like statues in some Romanesque portal of France, their faces elongated and lean, and their movements slow and dreamy, the four tall, seraphic figures advance with awed gaze, holding their breath as though spellbound. Everything about them is refined, lifted to a higher plane; the flower-strewn matting at their feet, the alabastrine folds of the draperies, St. Peter Martyr's knife, the small hands with their slow and stately gestures — especially the right hand of the saintly Bishop, which is partly modelled in shadow and partly emphasized with light in a way that reveals a true understanding of form. The saints listen in rapture to the Angelic Salutation, their rhythmic gestures crave silence on the part of the beholder.

This Lombard without a name is a wizard who conjures up spiritual visions and embodies them in figures and quiet shimmering landscapes; he is, too, an interpreter who tinges the effects of light and air with his own strong personality, as any may see who care to study the homely garments of the Virgin and the gauzy raiment of the Angel, with their deep channellings so reminiscent of Omodeo's massy draperies. The two figures seem to be enveloped in a quivering network of air and light.

Vincenzo Civerchio of Crema,[24] whose known works date from 1493 to 1524, succeeded Foppa on the work in the cathedral at Brescia. His earliest pictures show that he began as a follower of Butinone, for the St. Francis in the Accademia Carrara is an angular figure flecked with a network of high-lights where the darker wrinkles and veins cross and recross each other, and flattened out like some funeral effigy set in a shallow niche. In the rigidity of its wooden structure this figure, a fragment of a polyptych, is one of the best examples of this artist's methods.

31

Plate 24 It is still Butinone, but the Butinone of a later period, who inspires Civerchio's SS. Stephen and Anthony in the Museo Poldi-Pezzoli, with their squat and heavy figures, their polished surfaces and stiff and rigid contours.

The play of sparkling light is more intense, the colours are more vivid and the contrasts of light and shade more marked and more frequent in his Annunciation at Bergamo. Here the texture is that of painted glass. The folds of the drapery have developed into furrows, so that both the Angel and the Virgin seem to be clad in woven lattice made with glass-like strands. But when we turn to the *sportelli* in the Castello Sforzesco at Milan with their figures of saints, we find that the decorations inspired by the Butinone-Zenale polyptych at Treviglio and by Borgognone's altar-pieces are beginning to develop a certain heaviness; they no longer possess those delightful qualities that had their origin in the work of Omodeo. The abundant folds have been arranged carefully by a cunning hand in such a way as to intensify the effect produced by the delicate majolica-like decoration of the garments worn by St. Benedict and St. Clare.

Eclectic as a painter, Civerchio turns at one time to Butinone for inspiration and to Leonardo at another, as in the background to the Saints in the Museo Poldi-Pezzoli and the Madonna in the Brera. Yet when he paints such pictures as the Madonna and Child in the gallery at Bergamo it is from Solario that he draws his inspiration, with the result that this charming example of his earlier work was at one time attributed to that master.

Once again we find the hair of the Virgin and the delicate ringlets of the Child sparkling with threads of gold, as though they reflected some inner light shining through the transparent whiteness of the flesh. The soft skin, the smooth hand lightly caressed by a ray of light, the well-defined folds of the dress, and the gentle, pensive gaze of the Virgin together form the noblest production of a provincial artist who, as late as 1495, was still content to reproduce Butinone's inflated figures when painting the St. Anthony in the triptych at Brescia. The St. Sebastian in this work bears evidence of Leonardo's refreshing influence, while the Pietà in the upper panel, with dark figures on a network of gold, seems to indicate that Civerchio had had access to some of Giambellino's charming groups.

In such wise the little painter of Crema lived out his long life, standing still while around him better men than himself were moving forward towards fame, and Leonardo was ascending the heavens to become the brightest star in all the artistic firmament of Lombardy. Browsing now in one field, now in another — whether large or small mattered not — he sometimes succeeded, but even then only in his least pretentious works such as the Madonna in the Accademia Carrara and the little timid monk in the Castello at Milan, in producing a worthy reflection of the typical characteristics of Lombard art.

Pier Francesco Sacchi of Pavia,[25] known to have been active at least from 1512 to 1526, is represented in Berlin by a picture of the Crucifixion, dated 1515, which shows him to have been a careful draughtsman both as regards his figures and his backgrounds with their rocky eminences and gabled houses of a distinctively northern type. Similar characteristics are noticeable in a second picture in the same gallery, perhaps slightly earlier in date than the first, with SS. Jerome, Benedict and Martin, the last-named figure copied with a few slight variations from the Treviglio altar-piece. Having painted these two pictures as if they were great coloured images of wood, Sacchi painted the Louvre picture of the Four Doctors (1516). The shadows are more opaque, the figures stouter and more rectangular; their crudely natural attitudes are such as we might expect to find in the work of a fifteenth-century painter of the calibre of, say, Tommaso da Modena; and he steeps his northern country-side in beams of light which pick out the details of trees and grasses and houses, imbuing the whole landscape with a greater sense of atmosphere than in the pictures referred to above. That he came under the influence of Borgognone is evident from the Crucifixion and the Four Doctors, especially the latter where his usually dry and parchment-like flesh is veiled with shading, and the landscape is brighter and more pleasing.

Plate 25

But there are others among the artists of lesser note, such as Ambrogio Bevilacqua,[26] whose dependence on Borgognone is more clearly marked. Bevilacqua was a native of Milan and flourished between 1481 and 1512. There is a votive painting by him of 1502 in the Brera, in which he lavishes reds and yellows on a crowned saint resembling the king in a pack of cards. Mention must be made also of Giovanni della Chiesa[27] — alive in 1490 — a second-rate painter who, in two pictures at Lodi in the Incoronata, draws in his outlines with charcoal; and Albertino Piazza (born about 1450 and died before 1529) who, in partnership with his brother Martino,[28] painted a polyptych for the Incoronata, a picture for the church of Sant'Agnese at Lodi, and, later, the triptych formerly in the Crespi collection in Milan, in which he tried to introduce figures of the Leonardo type without disavowing his allegiance to Borgognone. But there was in addition a group of Lombard artists who remained uninfluenced by the example of Leonardo; among them Donato da Montorfano[29] who, in 1495, painted the fresco that faces Leonardo's Cenacolo in the Refectory of Santa Maria delle Grazie — an antiquated and rigid composition — and Agostino da Vaprio,[30] who three years later painted the little *ancona* in the church of SS. Primo and Feliciano at Pavia,[31] which is no more than a feeble imitation of Foppa's work. Left to the care of secondary painters such as these all that was good in Lombard art gradually disappeared; yet it had lived long enough to sow, in the person of Foppa, seeds that were destined to germinate later and, in the sixteenth century, to grow to full stature at Brescia.

IV

EARLY INFLUENCE OF VENETIAN ART

WHILE the older Lombard artists were content still to stamp their work with the impress of clearly-defined local tradition, Andrea Solario and Boccaccio Boccaccino[32] were already preaching the gospel of the Venetian school in Milan and Cremona.

Boccaccio Boccaccino was born about 1460 and is believed to have died in 1518. His earliest works suggest that he was trained in the Ferrarese school of Ercole de' Roberti. The *Plate 26* Christ on the way to Calvary in the National Gallery, London, is certainly inspired in its general lines by Ercole, without, however, possessing the delightful rhythm of the original. Even at the outset of his career there are indications of those subtleties of manner which were peculiarly his own; the careful distribution of well-chosen decorative features, the studied illumination, the elegant raiment strewn with rich embroideries; borders bright with flowers, rocky fragments scintillating with points of light, clusters of shining curls and translucent amber eyes. His colours rival the delicious tints of the Modenese painter, Bianchi Ferrari; his flesh is conceived in darkish tones touched here and there with white: he sees the distant landscape through smoked glasses. Boccaccino was still under the influence of the Emilian school when he painted the Adoration of the Magi now in the École des Beaux-Arts at Nice, in which the contrasts of light and shade are more studied and violent, and the grouping of the figures against the spacious background more fully worked out. The venerable figure of St. Joseph in this work is very much in the manner of Bramantino.

The transition from Lombard-Emilian characteristics to those of the Venetian school is marked in Boccaccino's work by the altar-picture in the church of San Giuliano at Venice, in which figures similar to those of the picture in the National Gallery, London, appear side by side with others directly traceable to the influence of Vicenza; while the background consists of a chapel adorned with mosaics of a type that we are accustomed to associate with works of the Venetian school. His paintings, however, lack the exquisite delicacy we look for in Boccaccino and find in the polyptych[33] in the Museo Ala Ponzoni at Cremona, formerly ascribed to Diana. The Cremona picture is equally Venetian in its general conception, and recalls Cima's work in the two full-length figures of saints; while the half-length figure of St. Catherine, sheathed in a silky mantle of the kind worn by Iacopo de' Barbari's women, is an excellent example of the elegance so characteristic of Boccaccio Boccaccino. This elegance is displayed triumphantly in the Sacra Conversazione, a masterpiece now in the Accademia at Venice, and is particularly noticeable in the figure of

34

St. Catherine, who appears before us as a shining elf in the starry brightness of her mantle and brocaded bodice.

Akin to this gem are the same artist's Gipsy Girl in the Pitti at Florence, and the Annunciation in the Boncompagni Ludovisi di Piombino collection in Rome. The back- *Plate 27* ground of the latter work is a temple which, for delicate treatment, smooth and gleaming surfaces, and the scrupulous care with which every detail of the ornaments is drawn, is comparable to the dainty Renaissance works of Rossetti at Ferrara rather than to the architectural pomp of the Lombards and Venetians. But it reflects also the same vision of elegance that gave birth to the figure of St. Catherine in the Venice picture. Every detail appears as if it were the work of a goldsmith; the small hands of the Virgin, the silken border of her sleeves, the almost imperceptible thread of gold keeping her hair in place, the gemlike flowers of the vesture of the angel, his diadem of metallic leaves, and the altogether lovely lamp of crystal with sprays of laurel intertwined in the wire from which it hangs. The colours in the vestments are those of precious stones, with here and there a note of rare delicacy, such as the subtle blending of tones in the wings, both of which shade from blue to chestnut, while the right wing in addition throws back a reddish reflection of the dawning day.

The fourth of this series of works in the style of Boccaccino — somewhat later in date, however, and a copy made by one of his disciples — is the Holy Family with St. Mary *Plate 28* Magdalen in Sant'Agata at Cremona, in which the dreamy figures and the landscape bursting into life at the first kiss of spring are not only eloquent of Boccaccino but possess an idyllic grace rare in the works of this Cremonese who was not only an artist but an individualistic and refined poet to boot.

In 1506 Boccaccio Boccaccino painted his first fresco in the cathedral at Cremona — the Christ with four Saints in the apse, and in 1518 he painted his last, the Disputation in the Temple — thus completing a series of pictures which must be regarded as the most important of all his works. From first to last his manner remains steadfast, unvarying; he is ever careful of his sparkling accessories, his subtle elegances. In his search for magnificence he sometimes lapses into exaggerations of form, but they are so overlaid with crystalline light and flowery patterns, and so gemmed with gold, as to be scarcely discernible. His colouring shows a predilection for cold and silvery tones, but in some of his pictures, such as the Madonna with SS. Anthony of Padua and Lawrence (1518), in the Museo Ala Ponzoni at Cremona, and the Adoration from Count Palffy's collection at Budapest, we have abundant evidence that in his maturity Boccaccino acquired greater warmth and fervour; his personages, having lived on into the summer of his art, are scorched by the

heat of the sun. If some of the raiment and some of the mantles are still softly blue there are others full of sparkle — red with the redness of glowing embers, yellow with the glitter of gold. His greens become more intense, his reds begin to kindle; the yellows in his shadows grow warmer, his figures broader. The purple autumn of Romanino is at hand.

ANDREA SOLARIO,[34] who was born about 1460 and died before 1530, spent the three years from 1490 to 1493 in Venice in company with his brother Cristoforo, who was at that time employed by the Doge as a sculptor. Leaving Venice with the recollection of Iacopo de' Barbari's work still fresh in his memory, he painted on his return a little picture, now in the Brera. It is a small, oblong figure of the Virgin wearing a mantle broken into slender linear folds, and painted with a dainty timidity of colour, clear, soft and translucent. The sky is so serenely blue, the pottery gleams so white; the carnations are so lovely in their rosy freshness, and the Child itself is but another, rosier carnation. Some recollection of this primitive Madonna appears in the slightly later picture in the Johnson collection at Philadelphia, in which the figures are placed against a wall pierced by circular-headed windows, as in the picture by Alvise in the church of the Redentore in Venice. It exhibits a delicate uniformity of colour without shadows to assist the modelling, while the folds of the drapery, the arched eyebrows thin as *antennae,* and the flattened-out locks on the smooth forehead of the Virgin are clearly and carefully drawn. The faces of all the four donors, seen in profile, are very much alike, and all the figures are lacking in animation, owing to the gentle sleepiness of their movements and the too close resemblance to porcelain of the flesh tints.

The portraits painted by Solario in his earlier years show that he had already acquired considerable power in the handling of shading and modelling in relief — witness the *Plate 29* Portrait of an Old Man in the Boston gallery and the Venetian Senator in the National Gallery, London. It is to be inferred that the latter was painted in Venice, not only from the nature of the subject but also because of all Andrea's works this one most faithfully reflects the mannerisms of Alvise.

The Senator stands squarely before us as though placed behind an invisible parapet, holding a carnation between two fingers in the manner affected by the Flemish school, and towering above the simple Lombard landscape dotted here and there with starveling bushes. The folds of the tunic are small and drawn in profile without the frequent breaks of continuity which are so usual a feature in the work of Alvise's greatest disciple, Lorenzo Lotto, but the angular outlines of the face, the delicate and deeply-lined features, the crystalline transparency of the eye, the fluidity of the flesh tints, and the lifelike, facile hands,

36

definitely recall the earlier methods of that great master. We do not, however, find the intense vitality of Lotto's earliest portraits in this austere personage who gazes with scornful superiority, chin in air and stiff-necked, as at a distant rabble.

The portrait in the Boston gallery, on the other hand, was painted about the same time as the Philadelphia Madonna, and consequently belongs to his first sojourn in Milan. It represents the head and shoulders of an old man seen against a wall pierced by a small, circular-headed window. The face has the same angular structure, but the modelling is more superficial. The light is manipulated so as to keep the modelling from too great prominence, and the shadows are reduced to a border of festoons. The construction of the wrinkles in the neck and on the face, and the careful arrangement of the silky locks show that the tendencies inherited by the painter from his native land were slowly gaining the upper hand over his recently acquired Venetian manner.

Solario still had Lorenzo Lotto in mind when he painted the Ecce Homo now in London, with its flowing colour and abundant Lombard curls; and, at a slightly earlier period, the Holy Family with St. Jerome in the Brera, in which the well-rounded Child, so reminiscent of Alvise, attracts the questioning gaze of all the bystanders. The St. Jerome is reminiscent of Albrecht Dürer's venerable Magi: the skin is smoothed over the angular projection of the bony skeleton and tucked into the furrows of his face in a series of silky wrinkles, much as in Lotto's work: the left hand of the saint, bathed in silvery light and transparent shadow, is wholly in Lotto's style. But the background is a pure product of the Lombard school and resembles those of Boltraffio, with vertically stratified rocks and green bushes behind figures set scrupulously in a symmetrical row.

In a picture in the Museo Poldi-Pezzoli the Virgin still inclines her head towards her shoulder and turns her gaze downwards as she gently enfolds her Child in her arms. The baby Christ looks at her questioningly, as if asking an explanation of some passage just read in the half-closed book. But a film of shadow has now begun to spread over the brilliant colouring and to dim the brightness of the eyes, recalling the sweet gentleness of the school of Ambrogio da Fossano: only the Child, whose whole soul goes out in that questioning look, reflects the vivacity usually to be found in Andrea's *putti*.

In one other picture — the beautiful and boldly-drawn portrait in the National Gallery, London — Andrea adopts the severely bilateral symmetry of figures and landscape already noticed in the Brera Holy Family and even intensifies it. But at this point there comes a change. He chooses a single subject, the Virgin suckling her Infant, and paints it over and over again in a series of pictures, some of which are to be numbered among his best and most significant works. The first of these is the one formerly in the Crespi collection. In

it appear for the first time those serpentine or spiral folds which are, as it were, a graphic commentary on the entirely new flexibility imparted by Leonardo to his figures, and an inevitable consequence of the softer treatment of the human body itself. And it is from Leonardo also that the curly-headed Child seems to have derived his well-modelled little body, his softly-moulded limbs and baby dimples. The fingers of the Mother's left hand sink into the soft flesh, just as in the seventeenth century those of Pluto were to sink into the marble limbs of the Bernini Proserpine, while her right hand caresses the plump flesh with a delicacy of feeling that reminds us irresistibly of the masterly example of Leonardo's draughtsmanship preserved in the library of Windsor Castle, representing a naked child supported by two hands with interlocked fingers. The little hand, too, with its fat and chubby fingers resting lightly on the Virgin's bosom, comes very close to its Vincian prototypes. And yet, even when Andrea most closely follows the precepts of Leonardo there flows through his work an undercurrent derived from his early Venetian training; for the transparent shadows playing about the left wrist of the Virgin, and the sleeve with its soft folds radiating like the petals of some luminous flower, still call to mind Lorenzo Lotto, the Venetian painter who came nearest in spirit to the Lombards.

In charm and homeliness the Crespi picture falls short of Andrea's other variants of the same subject. In each he strives to increase the sense of movement by intensifying the contrast between light and shade and accentuating the vivacity of pose and gesture. Whether we examine the weak and ill-balanced compositions of the Accademia Carrara and the Museo Poldi-Pezzoli or the masterful example in the Louvre, we shall find that in each *Plate 30* he has introduced a whirlpool of curves attuned to the drooping posture of the Child as he stands against a curtain of dark trees. In this group of pictures the artist elaborates the general lines of his earlier compositions; the Virgin bends nearer and nearer to her Son, while the Holy Child and the cushion on which he is placed grow more and more curved, until at last there is an indefinite suggestion of an imaginary circle knitting the whole group together. The momentary movement of the Child, who, with remarkable fidelity to nature, is represented as bending down to grasp one tiny foot in an equally tiny hand, gives the keynote to the composition and is the starting-point for voluptuous curves worthy of Correggio himself. They help to bring the lights and shadows falling on the two figures into harmony with the sense of earthly enjoyment visible on the faces of the Child and the Mother who watches over him so tenderly; while the sombre clump of trees invades nearly every part of the picture, scarcely allowing the pale waters and fields and sky of the background to peep through the narrow interstices of their closely interwoven branches. Yet while Leonardo would have hollowed out his green background so as to make

the figures appear to be further away from the spectator, Andrea Solario, as a faithful follower of Lombard tradition, flattens out his trees into a wide and level screen of dark hues, so that his figures may stand out against them in the fullest relief and bathed in quivering light.

It is, in our opinion, to this period and not to his earlier Venetian days that the Brera portrait of a young man should be attributed. The modelling is obtained by a similar play of shadows on undulating surfaces. In the portrait of Charles d'Amboise, in the Louvre, on the other hand, painted about the year 1507, the face is flattened down to a monotonous and even half-tone. It is as though the artist had used plaster instead of pigment in fashioning the head and had cut the garments out of cow-hide, sprinkling them with minute patterns of northern origin.[35] His lordship is so weighed down by his pompous apparel — golden cuffs, necklet of shells, cameo, jewelled border, pearls, filigree and the rest — that he seems to be quite in keeping with the damp and mist in which both sky and landscape are shrouded.

Although it may have been no more than a superficial resemblance, the affinity between his work and that of Lorenzo Lotto is still recognizable even when he approaches most nearly to Leonardo's technique. It becomes still more marked in such of his works as were produced during the second decade of the sixteenth century. The Virgin and Child in the National Gallery and the female musician in the Hertz collection, for example, are so directly inspired by Lotto as to make one believe that Andrea had been to Bergamo; for it cannot be doubted that the drooping Madonna in the National Gallery, with the harmonious yet vigorous spiral folds of her drapery, the unusually elongated oval face, the shadows flitting across the landscape and the lightly-sketched group standing in an open glade, are directly descended from Lotto's work during his stay in Bergamo. So, too, the horizontality of the Hertz portrait, in which the musician sits obliquely in the middle of the picture in an attitude that carries the eye across the scene from one side to the other, the hands pierced with light and the puffy folds of the rustling silken sleeves can only be explained by assuming that Andrea had quite recently had access to the works of Lotto. *Plate 31*

The Milanese artist still endeavours to follow in the footprints of the great Venetian when painting the portrait of Domenico Morone, now in the Gallarati Scotti collection and one of the best productions of Andrea's decadence. Even in his latest years — that is to say, in 1515 when he was planning the Sojourn in Egypt in the Museo Poldi-Pezzoli — he seems still to be haunted by memories of Iacopo de' Barbari, for the long folds into which the garments of the several figures fall are reminiscent of that master, though it may be that in this case the reminiscence is due not directly to Iacopo but to Boccaccino's interpretation of Iacopo's methods. The landscape rises high into the sky but has no depth; the

39

source of illumination, low down on the right of the picture helps to interrupt the harmony of the composition. In the laboured interlacing of restless hands there is not a trace of the vitality which animates the "Madonna of the Green Cushion". The folds of the drapery, no longer arranged in graceful spirals, are thick and coarse and overcrowded. Solario descends to still lower depths when he paints his Christ carrying the Cross in the Borghese Gallery, for the composition is full of inferior imitations of the ugly soldiery to be found in Flemish and German pictures, and his energies are frittered away in imitating with painstaking exactitude the very fibre and substance of the Cross, the suffering flesh of the Christ, the cords, the crown of thorns, and even the finger-nails of one of the executioners and the great white teeth of another. These characteristics, by the way, are also to be found in the St. Joseph in the Sojourn in Egypt.

In the Assumption of the Virgin, in the Certosa di Pavia, the heads of the Apostles are over-refined and lacking in character, albeit formed on the Vincian model; and the whole work only serves to show that the artist who throughout his life was content to follow the lead of one master after another found himself at the end exhausted, and incapable of producing anything worthy to rank with his earlier achievements.

The smooth transition from the warm tints of the figures to the silvery grey tones of the background marks out the Senator in the National Gallery, London, the Crespi Madonna, the Portrait of a Young Man in the Brera, the Annunciation of the Fairfax Murray collection and the somewhat later Musician of the Hertz collection as the most notable productions of a Milanese who received his artistic training in Venice; who was subsequently attracted by the example of Leonardo, but not always with happy results; and who, through Leonardo, found his way along tortuous paths that led him back to the Venetian school and to the feet of Lorenzo Lotto. As a general rule he moves slowly along his appointed path. He is aware that his figures are heavy and oafish, and in his endeavour to imbue them with grace and delicacy twists them this way and that and bends them almost double under the curving folds of his ample draperies. He wavers between Venice and Lombardy; he falls back periodically on his own resources or seeks inspiration in the works of a bygone century. For that reason he cannot be regarded as really representative of his native region, or comparable with artists of pure Lombard stock such as Vincenzo Foppa, Butinone, Zenale and the gentle Ambrogio da Fossano.[36]

Agostino da Lodi, formerly known as the "Pseudo Boccaccino"[37] trod the same early path as Solario by choosing Iacopo de' Barbari as his model, although it is true that his actual knowledge of Venetian methods was acquired at second hand through the paintings *Plate 32* of the Cremonese Boccaccio Boccaccino. Agostino's picture in the Albertini collection

40

in Milan is peopled with figures that lack solidity but are delicate and graceful, clothed in soft raiment falling in clusters of tiny folds picked out with high-lights. Lacking the instinctive refinement of his preceptor Boccaccino, he strives to emulate his always delight-ful rendering of waving curls, his softly-falling veils, and his delicate marbled surfaces. He sets a turban on the head of the Madonna and embellishes the little shirt of the Child with corals and ribbons: the fingers of the hands are short, and his figures are softened down by the greyness of the atmosphere.

In the Holy Family in the Fontana collection at Turin the outlines of the faces become more rounded and begin to approach the circularity of form which later became the distin-guishing mark of this mediocre artist. He seems to revert through Boccaccino to some earlier Emilian composition such as Costa might have produced, while the head of St. Joseph in particular is Emilian to the extent of being almost Correggesque. The Holy Child, full of the restless grace of infancy, is daintily drawn, while the clear colouring is still derived from Boccaccio Boccaccino; but the drapery is beginning to increase in volume and to re-volve in spirals, just as it does in the works of Solario, Bramantino, Gaudenzio Ferrari, Romanino and most of the early sixteenth-century painters of northern Italy.

The distinctive refinement and delicacy of his earlier works is less apparent in the force-ful St. Sebastian in the Galleria Estense at Modena, where the mountain against which the martyred Saint is outlined fades from one tone of blue to another in a way that clearly indicates its Leonardesque origin. The same is true of the Virgin and Child with two Saints in the Accademia at Venice, in which the several heads are copied from the works of other artists. In the altar-piece in San Pietro Martire, at Murano, we find his individuality once more expressing itself: the little figures are clearly drawn; their flesh is like pink porcelain; they stand between white marble sparkling in sunlight and a banner furled so that its folds may repeat the curving outlines of the heads and childish bodies. His tendency to resolve all forms into a series of concentric curves, coupled with the freshness of his colouring and the delicate gradation of his flesh tints, reminds one not a little of a Lorenzo Lotto unable to shake himself free from the mannerisms of the Quattrocento.

The Christ washing the feet of his Disciples, painted in 1500 and now in the Accade-mia at Venice, must be slightly earlier in date than the Virgin and Child just mentioned. In the case of some of the figures — that of St. Peter, for instance — the stiffness of the atti-tudes, the rigidity of the outlines and the metallic high-lights on the draperies are taken bodily from Boccaccino; while the influence of Bramantino has already begun to make itself felt in the figure of the young man, seen in profile, behind the Saviour. The heads of some of the old men, such as the third Apostle from the right with a bald head, form an

41

interesting prelude to the types painted by Pordenone in his earlier years. But Agostino da Lodi is a painter who treads the narrow path without deviation to one side or the other. He reviews his Apostles, and is careful that they shall all be of equal height and stand perfectly upright; the proportions of his small rounded figures are always the same; he draws each ringlet of a head of hair, each fold in a piece of cloth, with all the assiduity of a penman; the blue ornaments on the bowl of water are finished with the delicate solicitude of a Bramantino.

There is a figure by Donato Bramante which Agostino probably had in mind while he was painting the picture now in the Brera, in which St. John appears before us with an over-large head crowned with luminous curls. It is a type which forms the basis of inspiration for a whole group of pictures ascribed to him, while the types evolved by Leonardo stood as sponsors for the *ex-voto* panel in the Museo Nazionale at Naples and the Marriage of St. Catherine in the church of Santo Stefano at Venice. The first of these consists of a clumsily constructed pyramidal group against a background of greenery, but the second ranks among his best achievements, and is the only picture in which the influence of the sixteenth century is apparent. With this picture and the Jesus disputing with the Doctors, also in Venice, the works of Agostino da Lodi come to an end. He finishes much as he began; for the last-named picture is composed of half-length figures such as one finds in the Concerts and Ages painted by the earlier disciples of Giorgione, and up to the very end he repeats the round faces, the shining annular curls and the small curved features of his first Madonnas. Having perceived the elegance that marks the work of Boccaccino he tries to emulate him by arranging his drapery in tight-drawn folds, by putting in the highlights with meticulous care on every curl and by imparting a doll-like charm to diminutive and over-dressed figures who look down modestly through half-closed eyes. His old men are all of one invariable type, with bushy beards, aquiline noses and beetling brows; his young men have small round faces and minute features. He is particularly industrious in polishing his surfaces and laying his clean and vivid tints, but he never at any time rises to be more than a second-rate artist with a gift for taking pains.

V

THE ISOLATION OF BRAMANTINO DURING
THE DOMINATION OF LEONARDO

BARTOLOMEO SUARDI[38] was born about the year 1480. There is equal uncertainty as to
the date of his death, but he is known to have been still alive in 1511. There is a similarity
between his methods and those of Ercole da Ferrara, but it does not necessarily follow that
he was Ercole's pupil; it is more likely that the two artists were followers of Mantegna and
developed simultaneously along the same lines. Be that as it may, Suardi was the only
Lombard who, beginning his artistic career in the opening years of the sixteenth century
maintained his own personality despite the dominating presence of Leonardo. His earliest
work is at the same time perhaps his best achievement from the point of view of animation
and originality of treatment. It is the Ecce Homo formerly in the Del Majno collection, *Plate 33*
and represents the Redeemer as a spectral figure of grief, made visible among the shadows
by a beam of moonlight. The stereotyped figure that Venetians, Umbrians and Tuscans
alike selected as fitting for such a subject is in this case rejected without ceremony, and we
are given instead a composition that seems to be created out of the limitless ice and dark‑
ness of the far North; the sky a swelling dome of silvery green pierced by harsh slabs of
rock that may be likened to mysterious inlets at the edge of a polar sea, and the figure gleam‑
ing in the darkness like some Alpine crag illuminated by the full moon. The tendency
to adopt striking effects of light already noted as characteristic of the Lombard school
breaks out again in this fantastic conception, and seems almost to have been born of some
pre‑Rembrandtesque composition, notwithstanding the completeness of every detail. Wi‑
thered and lean, the whole figure breathes the spirit of Bramantino's architecture; the wide
expanse of the breast is impressive on account of its emaciation, while the latent strength
of the neck is expressed in the tendons sharply outlined in light. The left hand presses
against the chest and is thus kept in the same uncompromisingly vertical plane as the body,
and the broad flat surfaces of the folds between shoulder and arm reveal the innate skill
of the modeller who thus allows the light to search out every anatomical detail. The folds
of the drapery, too, seemingly hammered out on the anvil of the Ferrarese school, expand
into the broad swathes of which this artist is so fond; while a fragment of cloth falling along
the hand of the Sufferer as though it were water turned to ice by the bitter night, seems al‑
most to be the sign‑manual of Bramantino in his younger days. Foppa lives once again in
the contrast between the dark rocks and the figure obliquely lit by the moon as it moves

43

across the sky and is about to disappear behind the gloomy rampart of rocks; and it is of Foppa we are reminded by the further contrast between these self-same rocks and the light from the full moon diffused over the sky. But the supreme quality of his genius lies in the majestic conception that gave birth to this work. It compels him to record almost imperceptible variations of surface and a multitude of veins and tendons, wrinkles and angles; he traces the individual hairs of the beard, the teeth revealed by the half-open lips; and all this so that he may pile splendour on splendour. At one and the same time he broadens out the surfaces of the draperies and of the naked torso; he penetrates to the heart of things and looks through opaque draperies as through a crystal; he transforms the tiny moon into a minute bubble and the eyes into tears. Extreme complexity is mixed with extreme simplicity. The composition with its vertical planes is as far removed from ordinary things as is the subject it portrays. It is a lamp lit with embers dropped by the fires of sorrow.

Plate 34

At much the same time that the youthful Bramantino reached the acme of achievement in this marvellous nocturne he painted another picture, now in the Ambrosiana at Milan. This is a Nativity, in which groups of angular figures are arranged with architectural precision against the low walls of a building and the sky. Three saintly monks and the youthful St. John Baptist mingle their voices with those of the Virgin and St. Joseph in devout prayer. From a raised marble plinth emerges a group of musicians who hymn the coming of Christendom and seem as it were to form one with the cluster of pilasters and the arch. Augustus and the Sibyl look on in contemplation from the lateral margins of the picture. Instead of a ruined hut the scene is laid within a triumphal arch, the arch itself set against a marbled sky and panelled with shadow, and the pilaster outlined in light. It is more vivid, daintier, and more refined than any of the arches erected by Ercole da Ferrara behind the thrones of his Madonnas. The poses of the figures have been worked out scientifically; for example, that of the Dominican saint is regulated in accordance with a vertical axis passing through the bowed head and the point where the hands join, in exact agreement with the principles adopted by Bramantino in his architecture. We have here the application to the human body of the laws governing the profiles of architectural mouldings.

There is no beauty of feature in Bramantino's grave and enigmatic faces: he is content that the skin shall appear as a diaphanous membrane. And yet he is not above adding touches of idyllic grace, such as the light kiss of a ray of sunlight on the head of the Baptist, or lighting up with a nobility more than human the alabastrine form of the Sibyl as she sits within the shadows. She wears a plain circlet of gold about the delicate draperies that enfold her; her clothing is a pedestal, open at the neck like a chalice, and, secure within her alcove of shadows, she rises with dreamy eyes in the semblance of a statue of Meditation.

44

On the other hand, all the crude archaism of Bramantino's earliest manner marks the group of four musicians. They stand upon narrow bases with rhythmic and easy movement of limb, and draperies curled by the wind into folds; their feet are placed too close together, but by this means their shining bodies are made to rise more abruptly against the gleam of alabaster and sky. The delicate colouring, the silvery grey of the flesh, the yellowish green of the Madonna's robe, the reds and whites of the angel on the right, the vermilion of the angel on the left, the sky dappled with clouds, give to this work the final touch of beauty, delicate but at the same time inflexible, which marks every one of Bramantino's earlier paintings.

The austerity of the facial expression degenerates into a harshness which is almost caricature in a composition dealing with the days of pagan Rome — the Philemon and Baucis in the museum at Cologne. It is constructed on still more rigid architectonic lines and is more precise than the extremely beautiful Nativity in the Ambrosiana. In the centre are figures seated round a table. the wide-spreading tree and the hut; at the sides two other groups are set somewhat further back than the central one, but balanced as truly as the two sides of a pair of scales. To emphasize the perfect equipoise there are at the sides of the hut two exactly similar pinnacles of rock, sharp-pointed as arrows, each set on the same axis as the single erect figure dominating each of the two groups. The pointed gable of the hut is counterbalanced by an enormous drooping fold contrived in the border of the tablecloth. The position and arrangement of everything in this fundamentally architectural composition is calculated with mathematical precision, from the broad base of human beings, rectangular and flattened out until they resemble pilasters or vertical bands, to the marble cornice marking the level of the heads in the background and to the tree with its branches extending over the whole of the central group and its upper part cut off by the top margin of the picture. And just as Bramantino, when designing actual or painted structures, prefers large and restful bare spaces above all others, so in the Jupiter he gives us a flat, sharply-outlined figure and boldly-cut folds. The very tree towering in the centre of the picture seems to expand its skeleton form to right and left, and every branch, every twig and every leaf conforms to rule by keeping strictly parallel with the main lines of the hut and the table. Disorder is banished to the skies, for only the clouds are permitted freedom of movement. All the rest, beings animate and inanimate, keep to their allotted places in a way that is as foreign to the normal methods of the painters of Lombardy as the majestic simplicity and bare walls of the burial vault in SS. Nazaro e Celso are to the wealth of colour and delicate tracery we are accustomed to look for in the architecture of Lombardy.

The draperies fall in complex folds, with every prominence accentuated by light in ac-

45

cordance with the usage of the Lombard school. Light defines every lock of hair, every finger, every wrinkle and each joint in the brickwork. The contrasts between light and shadow are more intense than in the Nativity, and give life to the composition. It is particularly noticeable in the tree, where the sombre mass is relieved by zones of powdered light resembling fresh-fallen snow. Every figure is rigid, every movement arrested: the living beings no longer live as the barbarous figure of Jupiter emerges from the forest with tangled hair and savage features. The stiffness of the whole work is so marked that it appears to be a deliberate and calculated reversion to archaic forms, painted during or after his visit to Rome. It undoubtedly presents novel features, such as greater expansion of form and a truer grasp of statics, and equilibrium worthy of Piero della Francesca. Nor are classical elements entirely absent, such as we might expect to find in the work of an arch-stylist who aimed at the perfection of ancient Greece. We feel their presence, for instance, in the group of oxen and the servant standing erect on the right with upraised hand, the latter a striking figure of such masculine beauty that he might be compared with a bronze by Lysippus.

The group of oxen and the sturdy henchman recall one of the greatest achievements of Bramantino's genius, a drawing in the Musée Bonnat at Bayonne representing Hercules overcoming the Cretan bull. The hero does not struggle with his savage antagonist but is content to lean on his huge and ponderous club. Immovable as a column of stone he stands there, all his thoughts and energies concentrated in the arm that is extended to keep the infuriated monster at a distance. When Bramantino designed this superb cartoon he was unquestionably still under the spell of the ancient monuments he had studied at the beginning of the sixteenth century and included in a book of drawings of the ruins of ancient Rome. His Hercules is a marvellous reincarnation of classic feeling. While the figure of the kingly spectator is of the stiff and elongated type familiar to us in his earlier works, there is a freedom, a breadth of treatment in the grouping of Hercules and the bull to be found nowhere else in the work of this Lombard master. Let us forget the presence of the king who watches the combat, and concentrate for a moment on the two combatants. Before our eyes there passes a vision of the innumerable curves of a Roman arena. The invincible conqueror stands his ground like a mighty pivot rooted in the soil; the bull, with foaming jaws and lashing tail, charges at him from all points. But the watchful arm of the heroic figure is the radius of a circle within which the bull may not penetrate; it is the measure of the inviolable distance set between the athlete and the wild beast. Thus Bramantino settles the main characteristics of his composition and turns to the details. He endows the torso of Hercules with passive strength expressed in the tense and eloquent gesture of resistance, and then falls to on the bull, raining hammer blows of shadow on the huge volume of the

46

monster, and producing effects of light and shade that neither Titian nor Tintoretto would have scorned to acknowledge as their own.

The paintings in the Carafa chapel in San Domenico at Naples must be attributed to this epoch, being intermediate between the Cologne picture and the Layard Adoration. Instead of minute stucco friezes of grotesques the paintings in the vaults and spandrels obey the fundamental laws of construction, and boast no ornamentation but the startling purity of the surfaces — spread out like lengths of silk in the angles of the imaginary spandrels and along the ornate soffits of the arches — and the unadorned elegance of the balustrade encircling the eye of the dome, where graceful cherubs fly in and out as in the centre of the ceiling of the Stanza della Segnatura in the Vatican. The four figures bearing lettered scrolls and placed aslant behind the balustrade are conceived on a heroic scale and treated as though they were large areas mottled with inlays. With the copings of the parapets in the niches and the voluminous scroll-work covering the various surfaces they are made to play their part in the architectural illusion created by this gifted Lombard artist. The length-wise presentation of every detail which is the guiding principle of the Cologne picture is here replaced by a scheme in which everything is foreshortened; everything is brought into harmony with the swaying curves of the festoons of fruit and the marble panels set obli-quely to the plane of vision and parallel to the axis of the figures. Few of Bramantino's works so fully demonstrate the greatness of his genius, for the slender figures, the flowing streamers and the ornamentation of the arches are all interrelated in such a way as to form a perfect and complete expression of architectural unity.

In the Layard Adoration of the Magi he reaches the same high level of excellence and *Plate 35* shows himself supreme in the art of balancing masses. The pivot is formed by the Virgin and Child, thrown into prominence by a zone of dark marble between broad mouldings of pale alabaster. With the exception of Luca Signorelli's Birth of St. John in the Louvre and certain parts of his frescoes at Orvieto, there is no other work by Bramantino or, speak-ing generally, by any of the artists who lived to see the fifteenth century give way to the sixteenth, which presents so perfect an example of cubism. It permeates even the gestures of the figures and invests St. Joseph and one of the three Kings near the throne with an almost Egyptian formalism: it is so complete that the marble block on the steps and the broad pedestal on which the Virgin is sitting develop before our eyes into key-types of the form on which the whole composition is based. As Antonello reduced all his forms to spheres, so here Bramantino interprets everything in terms of cubes. The effect produced is one of regal splendour. The blocks of Parian marble of which the throne is composed, the three stone sarcophagi with their shallow ogee mouldings, the bowl placed on the steps

as some offering before an altar — arches and bowl and plinth all duly related to the height of the marble steps — form with the cubical throne a progressive chain of harmonious incidents beginning with the internal and external walls of the ruined palace and counter-balanced by the steep dolomitic rock standing like an ancient tower on the right. The empty spaces of the building seem to be measured against the serrated edge of the rocky spire, and the bending figures of the Virgin and the Moorish king on the left set against the upright St. Joseph and a servitor on the right. The spacious horizontal movement is worked out with mathematical accuracy so that it shall fit exactly to the scale of a composition in which every movement is suspended as though petrified into eternal immobility. Every light and every shadow that falls on the smooth surfaces of this supernatural world helps to emphasize their spotless purity.

What little hint there is of Bramante's influence in the Layard Adoration is concealed by the intensely individual mannerisms of its author Bramantino, but this influence is so much more marked in the Argus in the Castello Sforzesco at Milan that the work is still attributed to Bramante,[39] the artist who painted the Men-at-Arms, now in the Brera. The Men-at-Arms, however, are very different from the Argus. They are grandiose, material; Argus is a giant form, cast, as it were, in a foundry and smooth as bronze, with one leg crossed over the other in leisurely fashion. The warriors are painted in boldly with dashing strokes; but much care and thought has gone to the limning of Argus, and every detail of form and lighting is rendered with the characteristic touch of Bramantino. Not only the figure itself but the architectural background in which it is set bears the sign-manual of the Lombard master. The heroic figures of the Casa Panigarola are placed in huge alcoves bordered by friezes of rayed discs like those under the cupola of Santa Maria delle Grazie; Argus is framed in marble prisms square of base and set upon a pair of marvellous brackets; his figure is kept almost rigidly within vertical planes so that parallel lines would touch his body at most points. The high smooth walls always to be found in Suardi's back-grounds and in the architecture of the Trivulzio chapel in SS. Nazaro e Celso are present here in all their purity. The figure of the hero is an integral part of the structure itself, erect in a tall niche adorned with bosses and slender shields and the silhouettes of a pair of pea-cocks set with old-fashioned elegance at the ends of a cornice.

The principles of slenderness and verticality are employed with still greater emphasis in the architectural background of the great medallion adorning the niche where Argus stands; for here the seat is raised to a considerable height and attached to the bare smooth walls of a building broken up by horizontal bands typical of Bramantino's compositions. The out-lined figure of the youth with the *amphora* is as crisp and alert as an Assyrian statuette, and

may be regarded as the ultimate development of the elaborate and characteristic elegance so noticeable in the group of musicians in the Ambrosiana Nativity.

The two smaller medallions contain other scenes from the story of Argus. In the first he lies sleeping while Mercury plays the flute; in the other he lies dead beneath the gaze of the victorious god. The figures in each are notable examples of Bramantino's treatment; the small undraped characters of the story, with their slender legs and agile bodies, are sharply defined, and as smooth as if they were cast in bronze.

The tradition that ascribes the fresco in the Castello at Milan to Bramante is responsible for the belief that he also painted the Christ formerly in the abbey of Chiaravalle but now preserved in the Brera. It is a work which recalls the figure of the Apostle St. John in the half-destroyed but very beautiful fresco of the Pietà in San Sepolcro at Milan; while it also bears a certain resemblance to the Cologne picture. The Ecce Homo of Chiaravalle, somewhat later in date, has its roots in the soil of Lombardy. Its colouring is warm and intense, the lighting is worked out in the minutest detail, whether we examine the slow spirals of each lock of hair, the richly-chased uprights of the candelabra, or the folds of the ivory-white linen cloth. The landscape in the background, broad and variegated, is enclosed by peaked mountains with strata of alabaster here and there, similar in character to the more elaborate ones of the Adoration of the Magi in the Brera. There is the same ele-gantly-modelled chalice resting on a sun-lit pedestal mirroring the canons of Bramantino's art, and the majestic rigidity of architectural outline so dear to this master is displayed in the slender columns of the candelabra, which thread their way through a sheath of stiff foliage, each leaf pointed like a lance or twisted into a volute behind the head of the Christ. There are ornamentations, too, similar to those in the pilasters of the sacristy of San Satiro carved by Lombard sculptors in completion of Bramante's design, indicated with a gentle hand and curling in graceful spirals. The body of the spectral Christ from the Del Majno collection has grown more ample, the glass has become stone; but the teeth gleaming from the shadows about the mouth, the eyes clear as crystal — very different from the opaque eyes of the figures of Bramante — are still those of the earlier Christ. In this Ecce Homo, planned on traditional lines and lacking the fantastic originality of that from the Del Majno collection, the symbolical chalice placed on the window-ledge between the Victim and the landscape, as on some altar, is eloquent of the singular lack of poetical insight which is so characteristic of Bramantino's compositions.

The figures so broadly but solidly constructed in the Chiaravalle Christ begin to grow shallow and to swell out of shape in the Madonna and Child from the Simon collection in Berlin. The picture has, however, suffered much through the repainting of the Child. The

49

crystalline structure of Bramantino's earlier work has little place in the figure of the Virgin, who is enclosed within a broad ellipse formed by the fall of her mantle, in accordance with a type of composition which is one of the distinguishing marks of his later period. But even here the projection of the figures is kept within bounds, and the movement of the hand holding a citron is entirely justified both from the constructive and symbolical point of view. The background, a world of limpid and fragile crystal, is among Bramantino's most beautiful conceptions: the walls have no substance, and the spaces are distributed in accordance with an immutable law. The Virgin is full of youthful gravity. The movement of her head is balanced by that of her hand and her whole person is enveloped in a great ellipse of blue cloak, such as Bramantino in his later years delighted to contrast with the soaring verticalism of his architecture.

Plate 36 In the admirable Lucretia of the Sola Cabiati collection in Milan the composition is more spacious and the harmony more complete. The Egyptian tendency noted in Bramantino's methods here produces a remarkable rhythmic relationship between the flattened figures, the draperies with their small, thick and clearly-defined folds, and the vertical lines of the colonnade; and between the impulsive movement of Lucretia and the gesture of the woman whose outstretched arms seem to have been suddenly petrified into the semblance of a cross. There are details here reminiscent of the work of Piero della Francesca at Arezzo. The thorny bush bears in its upper branches an echo of a former *motif*, branch after branch above the whole length of the building presenting a bristling confusion of spikes. A dark curtain isolates the figure of Lucretia from the ancient buildings forming the somewhat unusual background, and serves to moderate the marked and solemn effect of a succession of endless vertical lines broken only by a few mouldings. There are but few patches of shadow. The curtain of velvet and the clothing of the woman watching the scene break through the gentle gradation of the tones of light, but the only accentuated point of light in a composition full of suffused brightness is a tender flower of shining silver — a veil of lace standing out against the white face and the curtain of velvet.

In the triptych in the Ambrosiana we may detect the influence of Leonardo's example, for the figures are rounder and have somewhat the appearance of inflated bladders. But the stamp of Bramantino's unmistakable genius is visible in the clearly-defined lines of the composition. Alternate masses of architecture and groups of figures complement each other, beginning with the polygonal temple between two large towers and ending in the divine group between two angels, two holy persons and two other foreshortened figures. The composition is balanced in the same way as in the group of the Virgin and Child, diverging from the centre but towards the opposite side. The landscape, which in the hands of Foppa

50

and his successors was a medium for pictorial effects obtained by a method in which light and shade played the principal parts, becomes in the art of Bramantino a means of presenting clearly-defined architectural themes. In this picture he displays before our eyes the buildings of fifteenth-century Milan, transformed and glorified in such wise that every detail assumes a definite value as part of the composition. Indeed, although the passing years have deformed the figures and dulled their tones, the architectural elements still preserve intact the mark of their creator's power. But although the Ambrosiana triptych is composed of inflated figures that have no substance, it still remains one of the most striking evidences of the painter's ability, for he here adopts a method of lighting in which the figures are illuminated from below by a flame-coloured light which accentuates their rotundity.

He employs similar effects when painting a St. Sebastian now in the Ventura collection in Rome. This work, more than any other, reveals the fact that even Bartolomeo Suardi, the independent Lombard painter, was to some extent influenced by the example of Leonardo. Within the sombre shadow of a tree — a substitute for the grotto in the Virgin of the Rocks — lies the saint, his face afire with fervour. The full light of day illuminates his naked flesh. The well-proportioned body is painted softly and with refinement, in a scale of tones graded from grey to ivory. The pose, too, in which the curve of the body is counterbalanced by that of the head, also in all probability owes its graceful sinuosity to some original from the hand of Leonardo. Not only is the cluster of trees with its perforated screen of interlacing foliage rustling and sparkling in the light a free translation from the same master, but the landscape itself, reduced to a narrow band at the sides of the picture, contains a hint of Leonardo in the hazy rocks afar off and the lake nestling between melancholy strips of land painted in dull bluish tones. Towards the foreground, however, the rustling green leaves are rendered by means of a manipulation of light which is wholly Bramantino's own, as are the vessels mirrored on the glassy blue lake and the knot of gauzy material at the side of the martyr. The last-named detail is a bubble of glass blown by a skilful craftsman within a frail but marvellously rigid mould.

In the Holy Family in the Brera the figures are still more distended and unsubstantial, *Plate 37* and the tones of the colouring merge into each other more perfectly. The Virgin, an oval figure enveloped in a voluminous mantle, fills the whole height of the picture, and is contrasted with the tall arcades and pointed cypresses of the background. Bramantino's newer formula, in which the figures, while retaining something of their former arrangement, tend to increase in size and to evaporate, begins to offend the eye on account of their exaggerated rotundity and lightness: the Virgin becomes a great incandescent balloon, ready to be wafted away in the direction indicated by the gesture of her Child. A red turban envelops the

51

head of this somewhat artificial figure, and the face, in which there are no eyebrows, is of a vaporous colour illuminated from below. All trace of the bony structure has now disappeared for ever from his faces. Henceforth they are round and vacuous — inflated bladders as it were, shining with an internal light.

And yet in this picture the scarcely-broken vertical lines of the buildings, the jewelled and sparkling colour and, in particular, the remarkably modern impressionism of the three figures in the middle distance, all bear witness still to the greatness of Bramantino as an artist; a greatness the decline of which can be traced in the Madonna between Angels in the Brera, and the Crucifixion in the same collection, where the statuesque beauty of the saint in a vesture of golden-green velvet recalling the tones of Savoldo does not make up for the stifling abundance of flabby draperies hung on inflated forms.

Having abandoned the precise and succinct methods of his younger days, he is tempted into new paths by the elusive and subtle figures of the frigid but sublimely intellectual Leonardo. Bramantino takes to increasing the roundness of his characters at the expense of solidity; and, in the hope of imparting to them something of the grand manner of the sixteenth century, introduces draperies of immense thickness with folds arranged in soft clusters, thereby at the same time missing the accustomed charm of his earlier forms. The strong contrasts of light and shade become less strong; the flesh degenerates until it is merely soft and diaphanous, lit over its unbroken surface by a sort of machine-made light; his earlier enigmatic figures grow imperious and fall into listless attitudes.

Thus Bramantino, the artist of grandiose ideas and an outstanding, solitary figure in the Lombardy that produced Foppa and Borgognone and the followers of Leonardo; Bramantino, the schemer of compositions planned with a mathematical precision worthy of Piero, ends his career on a note that is as artificial as it is deliberate.

THE LOMBARD FOLLOWERS OF LEONARDO

THE WORK of those of Leonardo's followers who forsook the artistic traditions of Lombardy is entirely outside the scope of the present volume, because it would carry us into the sixteenth century and involve a study of sixteenth-century forms. In the work of Bramantino, however, although late in point of time, the characteristics of the earlier period are still present in the architectonic nature of his compositions. It will therefore only be necessary to pass in brief review the work of Leonardo's Lombard disciples. The contamination of local forms by the admixture of elements imported from elsewhere was certainly not entirely beneficial to an art that had already given signs of immeasurable promise in the stupendous performances of Foppa and Bramantino.

The first of the Lombards to be fascinated by the genius of Leonardo da Vinci was Ambrogio de Predis,[40] who was at work between 1482 and 1506. He collaborated with the famous Florentine, and duplicated the Virgin of the Rocks in his London triptych. The central portion, a copy of the version in the Louvre, derives from its prototype a certain charm that is absent from the two angels in the wing panels. In the latter the shadows are heavy, the garments inflated and twisted into exaggerated flapping folds, as if they had been cut out with a pair of scissors. Here the example of Leonardo seems positively to have been harmful to the Lombard painter, who could draw in the profile of a portrait with all the precision of a medallist. But when, instead of moulding his own forms, he has merely to copy a figure already created by the Master, it may be that he alters the proportions of the over-large heads, and clouds the spiritual beauty in the face of Jesus, and adds a touch of heaviness to the gentle undulations of the original: but he shows himself capable of producing illusions of bronzed flesh and sad-hued garments seen through a veil of greenish-gold atmosphere, as through a film of water — not, it is true, as smooth and full of movement as those of Leonardo, but for all that profoundly poetical on account of the grave and melancholy note which seems to have quenched the colours.

But the personal equation in Ambrogio's work is not so much evident in his sacred pictures — which are definitely Leonardesque in character — as in his portraits, some of which are entirely free, or nearly so, from the influence of da Vinci. The medal-like profile in the Museo Poldi-Pezzoli at Milan is a case in point, in which the effect is that of a *Plate 38* chiselled plaque of bronze.

In the portrait at Bergamo the face is no longer presented in profile, while the drawing

recalls the methods of some of the lesser Florentines who came after Leonardo — Ridolfo Ghirlandaio, for instance; but the distribution of the planes of light and shade, which re‐ semble an inlay made from pieces of light and dark wood, and the clearly‐defined outlines such as Leonardo would studiously have avoided, show that the tradition left in Lombardy by Civerchio and Sacchi was strong enough to exercise considerable influence over Leo‐ nardo's sometime partner. The blackish, carbonized shadows so typical of Ambrogio de Predis are a mistaken interpretation of Leonardo's elusiveness, the exaggerated folds of the mantle and their unusual depth reveal a determined attempt to probe the secret of his flexile draperies. But the very intensity of his desire to imitate the example set shows how insurmountable was the barrier between them: between the wooden figures with their hard outlines and blackish tones, and Leonardo's figures steeped in atmosphere and softened by graduated tones that tend to obliterate the outlines.

Plate 39 There is rather more affinity with Leonardo in the very beautiful profile portrait of a lady recently acquired by the gallery at Amsterdam. The outlines are less strongly delinea‐ ted, and along the neck and shoulders appear as a thread of vitreous light. There is a Flo‐ rentine air of smiling grace about the profile, and the mass of hair which the velvet ribbon scarcely suffices to keep in place falls back lightly on the neck. And if the accent on the shadow is still a thought too strong it has shed its former heaviness.

The tones are intense and luminous, especially in the red velvet bodice; but the flesh tints, as is always the case in Ambrogio's work, tend towards monochrome, even the lips having a blackish tone mingled with their natural red. But even here the insistent Lom‐ bard tradition finds an outlet in the thickness of the ribbons holding the hair in place, in the adherence of the clothing to the bosom and the prominence of the outlines which, al‐ though much thinner, emerge boldly from the shadowy background.

The silky sheen noticeable in this female portrait is still more prominent in the Litta Madonna in the Hermitage at Leningrad, which is either a faithful copy of a picture by da Vinci or painted from one of his cartoons. The original, beyond all possibility of doubt, belongs to Leonardo's Florentine period, as may be judged from the two circular‐headed windows opening on to a sky veiled in clouds and an evanescent landscape, the profile of the Virgin (with the same arched lips and heavy eyelids as in the cartoon for an An‐ nunciation by Leonardo in the Gabinetto di Stampe e Disegni at Florence), and the atti‐ tude of the Child, which recalls his early studies of infantile forms. The pensive Virgin cradles the Child in her arms and turns on him a look of ineffable love. Her attitude is that of one of Filippino's Madonnas, and the light which reaches her obliquely through one of the windows throws the flesh into prominence, relieving with its colour the heavy

54

shadows usual in the work of Ambrogio de Predis. There are none of Leonardo's serpen/
tine coils in the smooth hair drawn back over the temples; but to compensate for their ab/
sence and to give a touch of animation to their uniform mass he covers the silken scarf
with sparkling points of light.

The body of the Child is deformed by foreshortening, and the hydrocephalous head
with its immense eyes encircled by livid lines is of a type common to Leonardo's Lombard
following, and particularly noticeable in Giampietrino's waxen figures. The outlines are
defined in a way Leonardo would not have approved — witness the hard line of the lock
of hair on the forehead and the harsh fold cutting across the foot of the Child. But such
as it is, the beautiful Leningrad picture with its magnificent colouring and intense illumi/
nation bears very clearly the marks of its inspirer's genius.

It was not until after Ambrogio de Predis had painted this copy of Leonardo that he was
able to produce the series of portraits possessing the intense silky brilliance of surface of the
Litta picture. The Musician of the Ambrosiana, which belongs to this series, seems to have
been produced by mixing the methods of Leonardo with those of Antonello, if we may
judge from the contrast between the robust structure of the head and the shadows softening
the flesh, and between the clinging draperies and the luminous locks with their bold curls.

The Portrait of a Young Man in the National Gallery, London, is somewhat later in
date, and has the appearance of being made of plaster covered with a luminous skin. It
has the fork/like fingers peculiar to this artist and hair consisting of curled tow. The flame
of animation that shone in the eyes and smile of the young woman in Amsterdam is un/
kindled in these round, clear eyes that seem barricaded by weariness, and in the mouth
with its pouting negro lips. In the portrait of an unknown person who looks out with clear
eyes from a picture in the Brera we find a similar mouth with the same thick and discolour/
ed lips. Seneca's dictum, *Vita si scias uti longa est,* inscribed in a corner of the picture after
the Lombard fashion which, as we shall see, was adopted later by Giambattista Moroni,
seems truly to define the resolute and honest spirit lying behind the steadfast gaze. Here,
more than in any of his other works, the two external influences struggling for precedence
in the art of Ambrogio are clearly visible: the inflexibility of the attitudes, the mass of cy/
lindrical curls on the forehead, the smooth but thick clothing and collar seemingly mo/
delled in clay, are culled from the teaching of Antonello, while the phosphorescent light in
the eyes and the curls light as a puff of air are as evidently due to the influence of Leonardo.

With extraordinary delicacy the painter allows the shadow of the silky, flexible eyelashes
to fall on the transparent irises; he marks the contour of the nasal bone by introducing a
softly/defined shadow; the nostrils are full of sensitiveness. Both the beautiful profile of the

lady at Amsterdam and the two copies of Leonardo indicate the highest point reached by this forceful and rugged Lombard master, who at times knew better than any of his contemporaries how to reflect the light shed by Leonardo while he was yet alive. When, however, Ambrogio comes to paint the portraits of Massimiliano I and Bianca Maria Sforza after the death of Leonardo, he seems as if completely deprived of his source of inspiration, yet unable to find his way back to the straight Lombard path from which he had strayed.

THE TYPES affected by Civerchio — but somewhat taller and more rotund — reappear in the figures, seemingly made of pink stucco or light-coloured wood, of the six devout persons and four saints who fill the wings of a triptych, now in the Castello Sforzesco at Milan, by Gentile Boltraffio,[41] an artist who is known to have been at work between 1467 and 1516. The only portions of this work which show clearly that he endeavoured to follow in the footsteps of Bramantino are the eyes full of ecstasy and the transparency of the skin of some of the figures, such as the youth with brown hair and the St. Sebastian holding an arrow; though it may be that the rigid perpendicularity so characteristic of Boltraffio when not directly under the influence of Leonardo or influenced by him at second hand through the works of Solario, is also a naive and elementary translation of Bramantino's architectonic equipoise. When, however, he paints the two somewhat similar Madonnas of the Crespi and Loeser collections, he turns aside from Bramantino and shows in the exaggerated curvature of their bodies and their dramatic gestures that he is striving to follow Vincian models of the same period as those copied by Ambrogio de Predis when painting the Virgin of the Litta collection.

The Leonardesque type followed in the two Madonnas reappears once more in the equally unnatural head of Narcissus, looking out from a background similar to that of the Virgin of the Rocks but darkened in accordance with the Lombard fashion in order to give greater prominence to the pallid tones of the flesh. The badly-proportioned profile is smoother than that of either of the two Madonnas, and the more gently curved lips and characteristic heaviness of the eyelids are reminiscent rather of Leonardo's prototypes. The colouring is still smooth and laid on thinly, modulated just a little by the touch of shading on the eyes and lip, and relieved by the dainty blossoms sparkling like dew among the silken locks. The desire to imitate Leonardo is also clearly visible in the Portrait of a Woman in the Castello Sforzesco at Milan, but the difference in outlook between the teacher and the scholar is equally observable; for the latter endows his forms with a general quality of roundness not to be found in Leonardo; he models his flesh in plaster, so to speak, and spreads his tints in broad patches of vivid polychrome. He is more nearly

akin here to some Ridolfo Ghirlandaio of Raphael's time than to the Leonardo who painted "La Belle Ferronnière".

Equally constructed out of coloured plaster is the smiling mask of the St. Louis from the Stroganoff collection, with its great mane of curls made of iron wire. In the small head of a Youth — with the usual vacant expression — in the Duke of Devonshire's collection at Chatsworth, and the head of a Woman, loaded with trifling ornaments, in the Metropolitan Museum in New York he has done his best to imitate Leonardo's gentle gradations of tone. In the vivacity of movement displayed in the Virgin and Child of the National Gallery at Budapest he comes a little nearer to the Vincian model, for here the flexibility of the Child, the complex folds of the drapery and the sudden contrasts of light and shadow give the composition an animation entirely lacking in his vacuous portraits and his earlier Madonnas. The figures start into life out of the shadows, clothed in Boltraffio's clean colouring, with features marked by the shadows of Solario. In a similar way the group in the Poldi-Pezzoli Museum combines the spiral movement of Leonardo's work with the clean modelling and sparkling colour of Andrea Solario. But even in this beautiful composition the laboured manner in which the Virgin's arms are crossed reveals the same rigidity that pervades every one of Boltraffio's most characteristic works, such as the Casio Madonna in the Louvre, the tondo in the Accademia Carrara at Bergamo and the votive picture belonging to Count Palffy, planned on parallel vertical lines and displaying all the modernity of the nineteenth century in its powerful drawing. *Plate 40*

The greatest of all this Lombard painter's achievements, and the one in which his personality is most clearly expressed is the series of pictures in the Monastero Maggiore at Milan, consisting of the Annunciation and figures of saints in circular panels. [42] The lesson learnt from da Vinci is reflected in the softness of the drapery, in the curving lips and in the delicate distribution of light and shade over the eyes: yet the sedateness of the figures themselves shows how strong is the strain of Lombardy within them. Bramantino speaks to us softly in the St. Barbara and in one of the female martyrs, whose swollen and transparent figure is bent to an arc by a bunched-up mass of drapery resembling a ball of variegated wool. In the case of nearly all the other figures the glass-like quality of the outlines, the soft monotony of the light and the oblong form of the faces recall the placid creations of Borgognone. Nowhere in this beautiful series of frescoes do we find the sparkling, polished surfaces of the Palffy Madonna or of the young girl in the New York Museum, or the Madonna in the Poldi-Pezzoli; the light is diffused into a delicate and uniform transparency which imbues the faces, standing out against the blue of the background, with the softness of satin. In harmony with this peaceful, claustral illumination the attitudes of the figures

57

sometimes lose so much of their accustomed stiffness that they seem to conform, with a sort of graceful rhythm, to the curving margins of the roundels in which they are set.

Looking at Boltraffio's work as a whole one feels certain that the supposed creator of "La Belle Ferronnière" in the Louvre — clearly the work of Leonardo — is one of the least faithful of his followers. His taste is for rectangular compositions, rigid outlines and square divisions. It is true that in the exceptional case of the "Madonna del Fiore" at Budapest he chances to give his figures a pliant and lifelike appearance; but when in painting the Madonna of the Poldi-Pezzoli Museum he tries to develop a scheme of ra-diating spirals amid the metallic gleam of fabrics and floral designs, we find that the carefully arranged series of intersecting lines entirely fails to produce any sense of movement. Then, too, Boltraffio's peculiar method of colouring is a clear violation of the practice adopted by Leonardo, for the former seems to build up his surfaces by means of a network of minute squares of vivid colours in harmony with the rectangular structure of the design itself.

Plate 41

IN THE work of Bernardino de' Conti,[43] who flourished between the years 1496 and 1522, we meet once again the familiar inflated figures with their quilt-like clothing, enormous bulging foreheads, round eyes and equally round faces. His diminutive figures have hands and faces made of wax and gay clothing in which a lustrous canary yellow and a joyous, sparkling red predominate. He does not know how to foreshorten the padded figures that move with such impulsive gestures; he has an odd conventional way of drawing the muscles of his naked children, deluding himself into the belief that he has caught Leonardo's soft-ness. And when, in his free translation, now in the Brera, of the Virgin of the Rocks, he sets out to reproduce the grotto of the original, he piles up a mound of wooden cylinders and prisms like a child playing with a box of building-bricks, cuts off every outline square-ly, and transforms Leonardo's stalactites into bundles of skittles or small tubes. Features outlined with black, swollen hands, heads covered with tow; eyes round, owlish and con-trasting with the light-hearted gaiety in the colour of the garments: such are the characte-ristics by which this little master may readily be recognized. The infantile gravity of some of his female portraits is occasionally pleasing by reason of a resemblance to children play-ing at being grown-up; and there is often charm in the picturesque variety of his scraps of landscape — for example, the view of a shining lake peeping out from between dark banks in the background of the gentle Carrara Madonnina.

Plate 42

A miniature-painter, Antonio da Monza,[44] used frequently to be confused with Ber-nardino de' Conti, and, in the Sforza altar-picture now in the Brera, recalls the methods of Borgognone and Sacchi. The resemblance is more particularly noticeable in the wooden

figures with their prominent outlines and the overloaded architectural details, while the faces of the Virgin and the Child are flattened masks based on Leonardo. The handiwork of this trite and commonplace maker of masks appears again in one of the pictures in the Cora collection at Turin, where the anatomical structure consists of a bagful of rounded stones, the clothing is made of rough-hewn granite and every detail of the costumes is put in with the utmost industry.

It was among such painters as these that Marco d'Oggiono[45] — born about 1470 and died about 1530 — struggled with fiery red flesh tints and overdone colouring in an endeavour to follow the new Lombard fashion, and to reproduce Leonardo's types by throwing livid shadows on the flesh and around the eyes, by giving his figures round faces with enormous foreheads, and supplying each one with a mouth curved in a perpetual smile and stopped at both ends by a patch of shadow. In the Brera there is a picture by this artist in which three somewhat effeminate archangels are placed against a sky made of striped wood. One of the three, dressed like a pretty mannequin, is an adaptation of Leonardo's angel in the Louvre Madonna — the same figure that we have seen, deformed and insipid, doing duty as the Virgin of the Rocks in the Ambrosiana picture, and holding a monstrous-headed Child in her arms. The painter is still more at sea after the death of Leonardo and endeavours to produce an exaggerated sense of movement when painting the Apostles in the Brera Assumption. The draperies are flecked with light and the heads are *Plate 43* almost detached from the bodies in their intense anxiety to gaze up into the sky where the Madonna floats away supported by a swarm of angels — a human ball among balls of cloud. In the group of Apostles we find caricatures of the figures around the table in Leonardo's Last Supper, but the linear quality of the light as it plays about the metallic folds is an echo of Lombard tradition, and may be traced more particularly to Solario, whose methods it most nearly resembles. Such is the nature of Marco d'Oggiono's work: superficially he appears to imitate Leonardo, striving to gain effectiveness by means of a display of energy; and succeeding in dissipating the melancholy poetry of the older Lombard backgrounds by translating them into a mass of broken lines clothed in tints that are much too vivid.

Francesco Napoletano[46] is to be numbered among the minor representatives of the Lombard school founded by Leonardo. There is an altar-picture by him in the museum at Zurich, in which the figures are ill-balanced, the thin draperies are outlined in light, and the architecture is a series of boxes studded with shining glass-like enrichments; the whole being executed in the tiny brush-strokes of a miniaturist. The crooked St. John, broken in two by the angle to which he is bent, seems to be a tardy survival of Filippino's types,

while the stiff St. Sebastian, whose whole figure is contained within an elongated rectangle, is undoubtedly derived from Boltraffio.

It cannot be said, either, that Cesare Magni,[47] one of the last of Leonardo's devotees, rises to a much higher level in the Madonna from the Vittadini collection, or the Holy Family in the Brera. With the exception of the St. Joseph — who is a bad copy of Bramantino — the figures in the latter picture have smooth, round faces resembling those painted by Agostino da Lodi. When foreshortening the faces he deforms them hideously; when painting the flabby draperies he digs great pits of shadow in an attempt to copy Leonardo; when modelling his naked children he gives them enormous, shapeless heads, forgets to provide them with necks, but sees to it that their muscles are monstrously swollen. Legs and arms are dislocated where they should be attached to the body; round heads are pushed down between spherical shoulders. Cesare Magni walks among the mannerisms of the Lombard school with leaden feet.

Bernazzano,[48] a painter of delicate landscapes and flowers, was likewise a follower of Leonardo. In our opinion, it was he who supplied the background to the Bacchus in the Louvre, after a drawing by Leonardo himself. There is also, in a private collection in London, a vitreous St. John the Baptist which bears traces of the Master's influence. While in Leonardo's Virgin of the Rocks the light and the breeze float together across the field, blending grass and flowers into a hazy mass, the artist of the Louvre picture gives us isolated tufts of flowers and shrubs lifting their heads out of the shadows into the light of day, each plant rendered with the minute care of a Flemish painter; and, further, the clear sky and undefined landscape are contrasted with the rocks and leafy trees.

The joyous artist who painted the Madonna of the Scales,[49] now in the Louvre, seems almost as though he were playing with a couple of children, for the work is notable on account of its rounded baby forms and pleasing infantile grace. Francesco Melzi[50] is wholly of the sixteenth century. He studies statuesque elegance, and uses Leonardo's cartoon of St. Anne as a model for the figure of Pomona in a somewhat confused picture now in the Kaiser Friedrich Museum. Leonardo's favourite pupil gives us an exhibition of studied grace in the portrait in the same museum of a woman holding a sprig of jasmine.

GIAMPIETRINO,[51] in whose life we know but a single date, 1521 — was an indefatigable producer of Madonnas and Children and sighing Magdalens during the period of his greatest approximation to Leonardo. A very beautiful copy by him of the Leda is in the collection of the Prince of Wied, and he also painted a Madonna, formerly in the possession of the Holford family, in which the supple figure bends in a gracious curve, while the dra-

peries are less deeply furrowed so that the shadows may lurk within their cavities with the same animated play of light and shade as in the Crespi Madonna — another work which bears the influence of the Leda writ large upon the swan-like neck of the Virgin. The sinuous curves of the Holford picture become as ample and as solid as in the Borghese picture, which represents Giampietrino's most successful attempt to express the combined movement of a group, as well as intense — almost violent — contrast of illuminated figures opposed to backgrounds full of shadow, and brilliantly lighted clouds floating in a turquoise sky. But little by little the painter shows how slender is his stock of ideas by repeating the same groups and the same situations. The Borghese Virgin reappears in the Virgin of Olden- *Plate 44* burg, but she has grown a little weaker; her head droops towards her right shoulder and the Child is doubled up in her arms. The Madonnas of the Murray collection in London and the Castello Sforzesco at Milan turn the major part of their backs on the spectator and their heads in the opposite direction, just as Palma or Pordenone might have portrayed them in order to obtain effects of colour instead of line and shadow. The gigantic and lan-guid Magdalens are portraits of each other. But when, as in the Murray Madonna, he is not trying to follow Leonardo too closely and attempts to evolve something original, Giam-pietrino reveals a personality tender and delicate; he shows us that he can combine the tones of waxen flesh and the gentle melancholy of sickly children with dark-ringed eyes, and can shed over it all a tranquil light which recalls some of Borgognone's skies.

THERE is a world of difference between the hesitating gentleness of Giampietrino and the broad and pliant figures of the da Vinci period painted by Cesare da Sesto, [52] who was born about 1480 and died about 1521. The quality of his work may be judged from two copies of Leonardo's St. Anne, one of them in the Prado and the other in the Museo Poldi-Pezzoli. The latter work is particularly characteristic with its lacework of shining houses and rocks in the background. The breadth and suppleness of his figures is equally notice-able in the grandiose productions of his maturer years, from the pyramidal group of the *Plate 45* Virgin and Child in the Brera to the colossal Holy Family in the Louvre, in which the influence of Raphael is already strongly marked. His ambition appears to have been to paint larger and yet larger figures, and to identify himself with the Roman school. With the Holy Family of the Louvre he passes completely into the Cinquecento and its methods.

WE HAVE given but a short notice of Giampietrino and Cesare da Sesto, and in a similar way only a few words need be devoted to the work of the sixteenth-century artist, Bernar-dino Luini, [53] who was born about 1490 and died about 1532.

61

His Lombard mind was stored with the remembrance of all that Solario and Borgo-gnone had done for native art, and he drew inspiration from both. Solario supplied the impulse for the beautiful Madonna in the Hage collection at Nivaagaard, while the art of Borgognone seems to survive and expand in certain impressionist details of landscape and in the soft delicacy of the figures in the Scotti picture and in the Berenson predella. He is incapable of finding Leonardo's secret recipe for imparting a sense of movement to a mass of figures, and the persons in his Saronno frescoes as a consequence stand about in dis-united groups.

He is a stranger to violent gesture; a delicate colourist who builds up his work on an airy foundation of grey and rose. The movements of his figures are slow and charming. As late as 1521 Bernardino Luini adopted one of Borgognone's old-fashioned groupings *Plate 46* when designing the Brera altar-piece, but he moulded the figures themselves on Leonardo's slender and graceful types, and then dressed them in the rosy veil of his own colouring.

62

VII

QUATTROCENTO PAINTING IN PIEDMONT

IN THE left aisle of the church of San Pietro at Pianezza in Piedmont there is a singular example of Late Gothic art, French in character, which reveals a sense of realism so in‑ *Plate 47* tense that it borders on caricature. Nor must we forget to mention the admirable decora‑ tions in the ceiling of Sant'Antonio di Ranverso, melodious in the rhythm of their simple and graceful lines, joyous in the variegated colouring of their miniature‑like ornaments and peopled with holy Bishops, set about the walls, each in his own niche, and each with *Plate 48* a head rough‑hewn, severe, and modelled with a kind of brutal force. One of the most re‑ markable examples of Gothic art in Piedmont is the collection of Heroes painted on the walls of the Castello at Manta and grouped under a flimsy porch in which tree‑trunks take the place of columns, leafy boughs are substituted for rafters, and grass and flowers serve as a floor. In the several divisions of this airy structure are heroes in the full panoply of war, kings in magnificent robes, and richly‑clad ladies. Their apparel, with its profuse feathery ornaments, and their mantles trimmed with fur produce a series of harmonious curves, while their bowed heads are adorned with wreaths of flowers and foliage, or jewel‑ led crowns and tiaras, or filmy veils as the case may be. The outlines do not develop into *Plate 49* spirals, nor do they become flamboyant, as in the Late Gothic of Venice and the Tyrol; they have a pleasing flexibility of line which approaches closely to the work of the French artists who decorated the castle at Fenis and, together with the paintings in the Castello at Manta, are the most conspicuous examples of Gothic painting to be found in Piedmont.

Moreover, elements which had their origin in France played a considerable part in Pied‑ montese art in the beginning of the fifteenth century. We need here only mention such exam‑ ples as the paintings on one side of the cloisters in Santa Maria in Vezzolano, those in the vault of San Magno at Castelmagno, and the Madonna in San Clemente at Occhieppo Inferiore near Biella. In the parish church at Manta there are some scenes from the Life of Christ which show a certain affinity with the Flemish school, a tendency equally to be noted in the decorations of the chapel in the Castello at Manta.

Other examples of the early Piedmontese school are to be found in the ceiling of a cha‑ pel in San Sebastiano at Monterosso and in a chapel in Sant'Antonio at Villar San Cos‑ *Plate 50* tanzo, in both of which there is plenty of animation of a Gothic sort in the figures, the ar‑ chitecture and in the gaily‑coloured borders. Then, too, there are the little church of San Fiorenzo at Bastia and the oratory of the Missione at Villafranca, where some skilled artist

who had studied the elegant figures in the Castello of Manta has depicted a cavalcade of the Vices approaching the mouth of Hell. They differ somewhat from those mentioned by Scolastica, and are chained together beneath the Virtues. Pride, with sceptre and crown, rides on a lion; Avarice, advanced in years, is seated on a monkey; Luxury is mounted on a wild boar and looks in her glass; Envy, on a dog, gnaws a little stick, while the dog gnaws a bone; Greed bestrides a wild beast and carries a supply of food and a large jar; Wrath, accommodated on the back of a bear, is in the act of impaling herself; Sloth rides on a young foal. The primitive character of this work only serves to show how little Pied-mont was affected by the artistic progress of other parts of Italy.

Plate 51 In the sacristy of Sant'Antonio di Ranverso there is a large lunette representing Christ carrying the Cross, accompanied by a mighty concourse of people. It is a composition full of decorative effects, and one might almost consider it in the light of a forerunner of Gaudenzio's earlier works, except that there is in it an exaggeration of type amounting al-most to caricature, a sparkle as of many-hued mosaic, and, over the heads of the surging throng, a fantastic profusion of spears and halberds, of richly-engraved swords and flowing banners. The keynote of this typical work of the Piedmontese school of the early fifteenth century is supplied by the vivacious colouring and the combination of broken and twisted lines. Like the earliest works of Gaudenzio, it seems to be composed of enamels, and multi-coloured woods, and gilt and chiselled metals. It is impossible to write down as second-rate the unknown artist who drew the violently contorted figures of the two rob-bers and the evil-visaged soldier bent over his shield as though he were part of a wheel.

No one has so far been able to discover who painted these frescoes, and the only names revealed to us at present are those of a minor craftsman, Giovanni Beltrano of Pinerolo[54] — who signs his work and adds the date 1414 — and Domenico della Marca d'Ancona, a stranger to Piedmont, who worked in the apse of Santa Maria di Spinerano, near Ciriè, and in San Sebastiano at Fontanetto.

A glance at such works as these, representative of the artistic development of Piedmont from the beginning of the fifteenth century up to about 1470, is sufficient to prove that Go-thic methods of handling line and colour still held the field against all comers, even after the full flood of the Renaissance had swept over other parts of Italy. Line and colour con-tinue to be the fundamental principles of art in Piedmont throughout the fifteenth century with the single exception of the works of Martino Spanzotti.[55]

Names become more plentiful as the century draws to a close and we are therefore better able to distinguish the different currents in the Piedmontese stream. An outstanding fig-ure is that of Giovanni Mazone of Alessandria,[56] whose name crops up in 1490 and 1497,

and who worked principally in Liguria. The harsh and wooden triptych, with its black-ish shadows, now in the Louvre, shows him to have been a follower of Foppa. There is a polyptych in the gallery at Savona, however, in which the clear and smooth flesh tints with their plaster-like surfaces for once in a way do not look as if they had been dug out of the shadows; the reduction to a minimum of the contrasting light and shade as between figures and background, and the harsh notes of crimson and gold, are all of them elements which are not to be found in works of the Lombard school. Moreover, in the Santa Maria del Castello picture the angel in priestly vestments and the over-elegant St. George chosen as models by Foppa find no place, but give way to others that might have come from one of Brea's altar-pictures. Similarly, the architecture, with its narrow and tall arches raised on pilasters not much thicker than stilts, has little in common with that of the Lombards.

Luca Baudi of Novara worked in Liguria, and is the author of a picture representing St. Ambrose enthroned between St. Monica and St. Augustine, in which the over-large figures, cut out of wood and clothed in metallic garments, are derived from Borgognone and Sacchi. There was also a painter-priest, Giovanni Canavesio of Pinerolo,[57] whose known activity extends from 1450 to 1499, and who repeats flat figures on gold backgrounds without so much as attempting to introduce the absurdly emaciated scraps of architecture to be found in the works of Giovanni Mazone and Macrino d'Alba. The polyptych by him, painted in 1491 and now in the gallery at Turin, again shows that his draughtsman-ship was faulty and crude and that he cared little so long as his dark-toned figures stood out prominently against their golden backgrounds.

MACRINO D'ALBA,[58] a prolific artist whose activities cover a period extending from 1494 to 1507, introduced a number of Tuscan and Umbrian elements into the art of Piedmont, but he seems to have lost all sense of proportion in his endeavour to develop a treatment of line and colour wholly foreign to local tradition. His earliest known work, a Madonna between two Saints in the Capitoline Museum, reflects the result of an attempt to graft Umbro-Tuscan elements on to Piedmontese stock — figures modelled with a cer-tain breadth of treatment, as by an artist accustomed to work in fresco, but from types de-rived from Perugino and Signorelli enclosed in garments with angular and wooden folds. The background consists of an Umbrian dolmen, with trees whose graceful trunks are equally imported from Umbria; and his draperies fall into rectangular furrows of Um-brian stamp. Everything is done wholesale, competently; as by a provincial artist who works industriously, making his variegated pavements and the throne look like planed logs or a festoon of clouds from some Byzantine painting. The metallic colouring of this altar-piece

is more obviously the work of an artist trained in Central Italy than is the triptych in the Wilstach collection at Philadelphia, in which the delicate architectural background, almost hidden behind the figures, recalls the wooden canopies of Giovanni Mazone in the Santa Maria del Castello triptych. But if the figures were removed the remaining architecture could not be made to fit together; while in the altar-picture in the Turin gallery he sets out to emulate the spacious compositions of the sixteenth century by introducing a portico with a heavy cornice and bold vaulting adorned with rosettes and recessed panels. The timid figure of the venerable St. Jerome is drawn from the work of Luca Signorelli, to whom is also due the idea of representing the Divine Group as outlined against the clouds and float-ing clear of the ground beneath; but he exhibits his curious want of logic by showing his figures as detached from the earth but not similarly detached from the sky, as in Signorelli's work, although they are safely housed under the shelter of a substantial canopy. Nor can this little master of Piedmont refrain from showing us the empty throne. On the contrary, he sets out to invent a most remarkable one, with a footstool made of clouds and grotesque cherubs, and a seat which two other cherubs hold up for all the world as if they were car-rying a board between them. Inside the building there are the usual angelic musicians — also inspired by Signorelli — at the highly-decorated base of the vanished throne, and the four saints within the chapel walls still stand in symmetrical couples about the throne, without, apparently, realizing that it has disappeared and that the Virgin is floating away on a temporary throne of clouds. We are here assisting at a village performance of some scene originally produced in a theatre of the metropolis. This want of logic in the details of composition is not rendered any the less noticeable by the painstaking attention to sym-metry, and is present in nearly all the works of this artist: in the altar-pieces in the Muni-cipio at Alba and the Santuario di Crea, as well as in the Nativity in the church of San Giovanni at Alba; in the St. Francis receiving the Stigmata in the Turin gallery as well as in the triptych in the gallery at Frankfort — the latter a late work in which the figures are of larger size but painted according to the same archaic principles, perpetuating the customary Umbrianesque square-edged folds in the plaster draperies, the heavy shadows, and the incoherent but careful landscape. As usual, it is built up of a mosaic of bits of co-loured wood; the colours themselves are metallic, the golden reds and golden greens are those of the tin-foil that chocolates are sometimes wrapped in. The toy-maker who sup-plied the quaint throne for the Madonna in the Turin altar-piece must also have supplied the grotesque figure which does duty as the Eternal Father, swimming manfully through a sea of clouds to propel a diminutive doll of a St. John towards Joachim and Anna. It is as a painter of such things as these that Macrino d'Alba closes his career, despite the fact

Plate 52

66

that he had left his quiet country home in order to study art in Central Italy, and had re-
turned to Piedmont armed with an empty show of Renaissance forms.

Martino Spanzotti, whose activities are known to have extended from 1481 to 1528,
was the chief of the school of Vercelli, and an artist of very different calibre. Simply and
almost humbly he appears before us for the first time in the signed Madonna in the gallery
at Turin. The Virgin is seated on a throne adorned with rectangular marble panels sur-
rounded by clear-cut mouldings. The upper part of the throne is narrowed down in har-
mony with the slender human form, surrounded, with admirable simplicity, by the heavy
mantle and a mass of fair hair. The mantle clings closely to the shape of the body and swells
out to enfold the matronly figure like a bell of blue fabric; drawn in gradually along the
curves of the arms and shoulders until it reaches the neck. The artist's single thought has
been to avoid interrupting the geometric regularity of the outline by any movement of the
arms or hair. A native of Lombardy, Spanzotti carried some of the traditions of his birth-
place with him into Piedmont, such as Bramantino's sense of balance and constructive
draughtsmanship, and Foppa's convincing modelling and method of employing light to
emphasize any feature of a composition. Out of these ingredients he produces something
entirely his own, and reveals himself as an artist of grave, thoughtful and well-balanced
temperament. In the Turin Madonna there is a full appreciation of the value of line and a
general sobriety of colour, with accents of rare delicacy in the pallor of the face and hair
in opposition to the deep tones of the draperies and marble.

The St. Sebastian in the gallery at Turin once formed part of a polyptych. It represents *Plate 54*
a knightly figure in armour, placed against a background of flowered brocade. The slender
form, the pale oval face and the sharply-outlined features approach much more closely to
the elegance of the French school than does the Madonna. But even here the excellence of
Spanzotti's constructive work is reflected in the conical form of the folds in the velvet and
in the ovoid shape of the cuirass with horizontal striations put in in minute brush-strokes.
Both decorative and constructive effect are combined through the medium of light, with
the result that the sharp edges of the greaves are toned down, the conical folds of the short
jacket are softened, and the hand resting on the hip is so modelled as to stand out with
the requisite degree of prominence. This charming representation of a cavalieresque lady-
killer, with one hand on his hip, a bunch of arrows held aloft in the other like long-stem-
med lilies, and the glistening greaves on his legs standing out against a parapet of smooth
marble, becomes a part of the brocaded background, as though he were some hero wor-
ked into a French tapestry.

Plate 53 In a later work, the Madonna in the Accademia Albertina, some element of the old Go-
thic tradition of Piedmont seems to have crept back into Spanzotti's work. Here he gives
us a Madonna wearing a mantle sinuous in outline, and contrasts the two cherubs perched
on the throne against a background of lighter tone. The lines of the Madonna are long and
drooping; compared with the beautiful and grave figure who in the earlier picture regulated
the turn of her body and the inclination of her head according to a set rule, she seems to
have grown a little weary and careless. The thin hand, emerging timidly from beneath her
cloak, the feverish flush on her cheek and the harmonious S-shaped curves, make her appear
at first sight a tardy sister of the earlier florid Gothic figures; but if we look down from her
hand to her lap we perceive at once that the lower half of the body is constructed with ar-
chitectonic exactitude, and forms a cube more clearly defined than in the earlier picture.
And if we raise our eyes to the back of the throne we see that the drapery is hollowed to
receive the Virgin in a white niche, as it were, between sculptured ornaments of fully-
developed Renaissance character.

In both pictures, and especially in the former of the two, which is not disturbed by ser-
pentine lines, Spanzotti's object is the same as in the group of the Madonna and Child in
the Adoration of the Magi at Turin; that is to say, he endeavours to delineate ample and
regular forms. The same tendencies are to be seen in a more definite form in others of his
works, particularly in the frescoes in the church of San Bernardino at Ivrea and in the Bap-
tism in the sacristy of the cathedral at Turin.

Plates 55-57 Although in some of the earlier panels of the series of frescoes at Ivrea — more particu-
larly the Raising of Lazarus and Christ entering Jerusalem — we have to admit that the
artist is evidently unfamiliar with the special technique required for painting in fresco, and
unaccustomed to composing scenes containing large numbers of persons, he is so much
an adept in balancing his compositions that the work as a whole shows very clearly the
great ability of this artist who came out of Lombardy and brought with him the meditative
seriousness of Foppa. Foreign elements, imported from the South of France, appear in the
first of the series — the Annunciation — such as the sharply-defined folds of the drapery,
the wings resembling hatchets, and the poor and bare interior. But the poorness is by no
means squalid; it is rather of the type that moves us to compassion. Through a window we
look out upon a clear sky; a partly-open door allows us no more than a glimpse of one
corner of Mary's bed and a wall on which the light of the sun is falling. It is like one of
Pieter de Hooch's Dutch interiors. The humble, ill-furnished room is full of light, and
even the vase of lilies adheres to the faldstool so that nothing shall disturb the illusion of
an uninterrupted cubic space. An expert constructive draughtsman, thrust by force of cir-

68

cumstances into the midst of an imitative Piedmontese school, Spanzotti makes a single architectural background, divided by the mouldings of each compartment, do duty for the scene of the Nativity as well as for the Adoration of the Magi. The former includes a group of angels of the conventional Piedmontese form of the day, but the latter reflects his delight in the geometric forms of solid bodies, for he breaks up the wall near the cubical group of the Virgin and Child into a series of alternate raised and sunk panels, as though rectangles and such things were the symbol of himself; and when he works out the details of the log of wood which props up a crumbling wall, he employs methods such as a stone-mason would use in shaping a column, and cuts it smooth and round in an imaginary lathe. The principal tools used by this master-modeller are light and shade: with their aid he hews out in the Agony in the Garden the many-facetted rocks of the background and the sleeping figure of St. John, whose brown cloak seems almost a part of the rocky ground on which he reposes. Line and light together are the bases of his polyhedrous forms, just as they are in a number of works by Provençal artists of the early sixteenth century: he relies on line and light for all his effects of receding and advancing planes and for all his modelling.

In the episode of Christ before Herod, the Redeemer, clad all in white, stands out vividly against the crowd in the background, his shining garments having the effect of increasing the apparent depth behind him and adding new length to the long range of columns, slender as the pipes of an organ. The white figure at the same time seems to be impelled forward by an illusionistic arrangement of rays of light falling athwart the pavement, converging on the sacred figure and, as it were, following it. The net result is that two different spatial effects are produced: the modelling is thrown forward and the depth of the background is enhanced, while the composition acquires in addition a spiritual grandeur comparable only to that achieved a hundred years later by Tinto-retto. Tintoretto, it is true, took greater pictorial liberties, but he obtained his results by the same use of light as Spanzotti, isolating the figure of Christ from the surrounding crowd by emphasizing the whiteness of the garments and impregnating them with a radiance so splendid that the shadows are put to flight and the body of the Redeemer is made to shine with unearthly light.

As the work progresses, the erstwhile painter of small, sleek figures becomes more sure of himself and more accustomed to his medium. When the time comes for him to portray the procession to Calvary and he finds himself obliged once more to deal with a multitude of figures, he disposes of them in perfectly-balanced groups, weighs the open space in the fore-ground against the width of the archway in the background, and the two assemblages of

onlookers at either side of the central group against each other. The Maries at one extreme flank of the picture are satisfactorily counterpoised by the figures, worthy of Masaccio, of the two mounted trumpeters on the other flank. Throughout the whole of this composition there is a sense of volume, which finds expression as much in the details of a piece of walling in full sunlight as in the two trumpeters so knit to their horses that they might be mistaken for centaurs; and there is at the same time a thorough appreciation of constructional details everywhere apparent, even in such minor features as the joints and structure of the three crosses. The intersection of the two beams of the Cross borne by Christ in the centre of the picture forms a yoke about his neck and puts the finishing touch to this stupendous composition. The impressive and serene conceptions of the Piedmontese artist find their highest expression in a clear understanding of plastic values; of which an example may be noted in the standard-bearer, whose body is half lit and half shadowed in sympathy with the light and shadow on a wall in the background.

The Deposition from the Cross is equally admirable. The figure of the Magdalen, shrouded within her mantle, is illuminated so that we can see her features, while the light plays in the crumpled folds of her clothing, as in a picture by one of the grand old Avignon masters who were such excellent modellers. We see the body of the Victim sinking to the ground, overcome by its own weight, while there loom up the figures of two men bending down to lift the stone from the sepulchre, the flexure of their bodies approximating so closely to spiral curves that we are inevitably reminded of Luca Signorelli and certain details of the frescoes at Orvieto.

In the Crucifixion, which is equally one of Martino Spanzotti's masterpieces, there is no striving after depth of perspective. On the contrary, he seeks to avoid it by introducing immense conical masses of rock with curvilinear sides formed into petrified waves and eddies. The rocks that were so formless in the Raising of Lazarus now bristle with jagged points, and seem to jostle the procession of women, pressing forward towards the crosses whose summits are outlined against the sky. The scene may be said to derive its whole character from the rocks, for their massive forms are echoed back by the imposing group of horses in the foreground.

This silent teacher, whose pensive serenity of mind finds an outlet in these thoughtful and crystalline compositions, builds up his Bible story with barbarous and repellent force, and prepares the way for the Stations of the Cross, which, with their painted wooden figures, became so common a feature in Piedmont during the sixteenth century.

Certain of Spanzotti's works belong definitely to his latest years — that is to say, they were painted after he had left Vercelli and settled in the western parts of Piedmont. The

Baptism in the sacristy of the cathedral at Turin and the frescoes at Ivrea belong to this period; and there are yet others of his works painted in a manner so different from those already mentioned that not a few may be said to bear a considerable resemblance to the work of Defendente Ferrari. It is as if some new source of inspiration, either Flemish or German, had intervened to divert him from calm and simple architectural forms and from luministic interpretations of scenes in themselves profoundly dramatic, such as the Christ before Herod in the frescoes at Ivrea; and to turn his thoughts to the possibilities presented by the play of light on draperies and woven fabrics, and the crystalline and metallic effects that might be obtained by a proper concentration on such features.

The most striking examples of this change in Spanzotti's artistic outlook are to be seen in the Adoration of the Magi in the Contini collection in Rome and the Christ disputing *Plate 58* with the Doctors in the Museo Civico at Turin. The first of these is set in spacious surroundings, with a sunlit arcade sparkling in the brilliant atmosphere. The constructive ability of the artist is revealed in the fanciful succession of patches of open sky as well as in the geometrical outlines of some of the figures. The latter quality is particularly noticeable in the figure of the Madonna, whose cloak conforms to an imaginary cube, and in that of the king kneeling to the right of the picture with his mantle falling about him in folds of crystal. There is also a notable figure of a man standing on the threshold of the door with his back turned and his cloak broken up into great wide folds resembling the swinging succession of ribs in the vaulting of a church. The Virgin's head inclines towards her right shoulder and the Child bends in the same direction to gaze intently at the aged king who stretches forwards towards the Infant Saviour in a diagonal line, this line being prolonged intermittently by the zig-zag pattern on the border of his robe, and finding a counterpart in the line traced by the metallic cloak of the second king kneeling on the other side of the central group. The central portion of the composition is thus dominated by two transverse parallel lines breaking up the continuity which otherwise would link up the two mutually-balanced figures at the sides of the throne. It is a linear construction quite new in the work of this artist.

The Virgin herself, with her chaste and solemn grace, is come of ancient and noble Flemish stock. Everything surrounding her sparkles with life, from the unobtrusive arabesques adorning the rug draped over the throne and seen as through an impalpable cloud of gold dust, the sumptuous brocade of one of the mantles, and the heavily-gemmed borders of the cloaks worn by the courtiers, to the velvet mantles of the kings. That of the youthful king on his knees is particularly admirable on account of its glass-like folds and the filmy light in which it is veiled. The figure of this king is at the same time one of Spanzotti's

71

most remarkable geometrical creations, cut almost like a square pillar and channelled out into narrow flutings by the regular folds of the mantle and the more shallow corrugations of the sleeve. The wizard modeller of the frescoes at Ivrea here regards the source of illumination no longer merely as an aid towards construction and imaginative work, but as an excuse for introducing dazzling patches of illusive colouring where, in the upper portion of the composition, the suites of the three kings pass behind the throne in a region of shadow broken by shafts of light.

Plate 59 Characters of a similar but rather more ample type figure in the Christ disputing with the Doctors, where the Virgin, enveloped in a mantle which falls in elaborately superimposed folds, foreshadows the Annunciation in the Museo Civico at Turin painted by Defendente Ferrari. Here, too, the two stupendous figures with their backs turned to the spectator and their loose garments conforming to the straightness of their backs yet twisted into folds of extreme complexity, show how the sense of balance possessed by this painter has contrived to solve the problems by this bold and novel composition. All these acutely twisted folds and rigid forms give the impression of being a free translation by Spanzotti, tinged with his own very strong personality, from some Flemish original by Rogier van der Weyden or one of his kind, while the metallic sparkle of the carpet and of the cloak worn by the oriental figure to the left can only be compared to the German paintings which inspired the work of Marco Marziale at Venice. The jewelled bands worn by another eastern figure to the right of the picture, the brocaded garments of his companion and the bepatterned hangings of the throne combine to produce an effect which, for richness and sparkling brilliance, has no equal anywhere else in the works of Martino Spanzotti.

He is the most profound thinker among all the painters of the Renaissance period in Piedmont — not even excluding Gaudenzio Ferrari. He is also, perhaps, the greatest of them all, whether we consider his work from the point of view of the distribution of masses within definite limits of width and depth, or the manipulation of light and shade for the purpose of depicting supernatural events, as in his Agony in the Garden and Christ before

Plate 60 Herod. The background of the Baptism in the sacristy of Turin Cathedral is undoubtedly one of the finest examples of landscape produced in the early part of the sixteenth century in any region of Italy (with the exception of Venice) as regards the balance and harmony of the sky-line, the delightful variation of the lights and shadows — sometimes intense, at other times soft — with the dark trees rising tall and mysterious against the blanched sky, the figure of the Christ gleaming wanly against the dark masses of the background; and, lastly, the melancholy group of figures awaiting they know not what, surrounded by the vast silence of the night. Martino Spanzotti, calm and self-controlled even in his most

72

exalted moments, seems to have arisen as by some miracle in the midst of the Gothic world of Piedmont that was unconsciously preparing the way for the flamboyant mural decorations of a later period and for the sonorous harmonies of Gaudenzio. He is like some flower from the gardens of Provence grafted on to the older stock of Italian art.

DEFENDENTE FERRARI [59] is known to have been active from 1510 to 1535. His earliest dated work is the Nativity in the Kaiser Friedrich Museum in Berlin, and belongs to the year 1511. His latest work, the triptych with SS. Crispin and Crispinian in the cathedral at Avigliana, bears the date 1535. Chronologically, therefore, his most productive period belongs to the sixteenth century; but the spirit of archaism which still dominates his work at a time when so much progress had been made by the artists of other parts of Italy, not excluding such of the Piedmontese painters as had hastened to follow in the steps of Leonardo, marks him out as virtually belonging to the fifteenth century. From Spanzotti's methods as expressed in his Vercellese period, Defendente learnt to balance his compositions with greater success than his contemporaries; but he remains indifferent to that master's plastic conceptions although ready enough to learn from him all he could of line and colour. Indeed, his attempts at modelling are nearly always introduced as decorative features, to the great detriment of his work.

In the beautiful Nativity of the Kaiser Friedrich Museum in Berlin he sets out to obtain *Plate 61* constructive and mass effects in the composition of his architectural background, and with great care works out the salient features of his figures, and the regular and geometrical folds of the draperies of the Virgin and of one of the onlookers. Their heads are small and clear-cut. In the Assumption belonging to the Confraternita del Santo Sudario at Ciriè he is all at sea: torn between Spanzotti's plastic methods and his own inclination towards line; between the desire to portray distant landscapes and the attractiveness of broad and simple flat surfaces. The same may be said of the oval panel representing Our Lady of Pity in the parish church at Ciriè, painted in 1519.

That Defendente was inclined in his younger days to seek effects in the play of light and shadow is much more clearly revealed in the Adoration of the Infant Christ in the cathedral at Ivrea, where the few remaining beams of the roof appear to be outlined in powdered moonlight. In the far-off light the little bodies and round curly heads of the cherubs acquire the same quality of softness that we find in the children of Dürer and Cranach. They are always small, all of one size and exactly alike, differing only in the deliciously droll variety of their sorrowful gestures.

In the Berlin Nativity the shadows on the diminutive bodies are strengthened in order

to emphasize the modelling, but in this work — in which the figure of St. Clara and the nun who commissioned the artist to paint it are still constructed in a few broad board-like planes — they exhibit the soft and luminous tones in which Defendente clothed his later renderings of the same subject. The same soft and smooth tones, but softer and yet more *Plate 62* smooth, appear in the picture in the cathedral at Susa like flakes of golden light falling about the Infant Jesus. The light in this case is derived from three sources; it is reflected from the sunlit street behind the group of angels on the left of the picture, it penetrates through the small and narrow window high up in the wall, as well as through the open door of the hut. Blended of all three, the light permeates every part of the interior, resting on the feathery garments of the seraphim, accentuating the sharp angle formed by the clasped hands of St. Joseph, and glorifying the Virgin's robe. There is no longer the faintest trace of the constructive folds which were a feature of the cloak of the Berlin Madonna, but instead the zones of colour are spread wide and smoothly between flowery margins. In the border of the mantle, where it falls in a gentle curve between the two outstretched arms, the golden thread at its edge that in former works had sparkled in the sun at the touch of the Piedmontese goldsmith is already beginning to dissolve, and no longer marks the outline with the sharpness of earlier days.

There is another masterpiece by Defendente in which the still broader forms, the somewhat angular modelling of the powerful head of the donor, and the deep conical folds in the ermine mantle suggest a rather earlier date than that of the work last mentioned. It is a Holy Family, with a bishop-saint and the donor, in the cathedral at Ivrea, painted in 1521. It is a triumph of goldsmith's work and elegant linear composition. Here, also, a street in perspective opens out behind the Virgin's seat, but in this case it leads up to a distant temple. It is, however, something of a fabulous street, in which Piedmontese Renaissance forms are produced entirely by means of outlines picked out in strong light, growing less marked and more sparkling as they recede towards the little gilded cage of a temple, and towards the white streaks of cloud, the last eddying waves dying out in a sky of green. Everything affords him a pretext for lighting effects, obtained not by means of colour but of line; the jewelled lacework of the Bishop's robe and mitre, the drops of golden dew distilled by the fringe of the linen cloth on which the Holy Child lies, the extremely beautiful candelabra of the pilasters, the coverings of the wall with streaks of gold that convert them into pieces of shining matting, the veil encircling the Virgin's brow like a diadem of crystal, and the marvellous architectural mosaic. The very hands of the Virgin, crossed on her breast, flicker like flames against the shadow of her mantle.

The purely-ornamental luministic effects of the Ivrea picture become the governing idea

74

in a small panel of the Crucifixion in the Museo Civico in Turin, in which the refractions *Plate 63*
of light are more liberally scattered over the shadows of a mountain gorge surrounded by
a semi-circle of rocky walls. Stratified clouds with minute parallel fringes of light illumi-
nate the sky. The carefully executed figure of the Christ is still reminiscent of Spanzotti;
but the almond-shaped group of the Maries clearly bears the marks of Germanic influence.
The slender hands tremble like leaves against the dark splendour of the clothing; the little
face of the Virgin cries aloud, reaching out to the cold green light of heaven.

The Nativity in the Museo Civico in Turin is a perfect nocturne, in which the light *Plate 64*
once more is derived from three separate sources: the Holy Child, a candle held by St. Jo-
seph and a radiance from the sky. The light from the Christ illuminates his mother and
accentuates portions of her outline; the candle, protected from the wind by St. Joseph's
hand, lights up his face from below and marks out his features with effects such as one
sees in a photographic negative, then lightly touches a delicate feminine head that floats
out of the shadows like a flower. The wall, too, is illumined by minute threads of gold, re-
minding one of nothing so much as the tiny veins of moisture shining on the face of a
humid rock. The three figures imprisoned as it were in a network of light are more like a
group from some old northern Saga than those of the nocturnes of the Italian Renaissance.

There are two other pictures in the Museo Civico in Turin — depicting the Annuncia- *Plate 65*
tion — in which, instead of the customary lines broken up so as to present a series of points
of light, the artist has substituted a slight and delicate tracery of harmonious lines surround-
ing the figures, and broader colour-spaces on which the light falls in subtle gradations to
produce an effect of unbroken and brilliant transparency. Nowhere has Defendente the
goldsmith bestowed so much loving care on his surfaces, putting in the pattern of his bro-
cade thread by thread, and bestowing equal care on the fretted, luminous margins of the
feathers and the outlines of the wing, the curls on the head of the angel and the crystalline
aureoles. The faces have all the purity of the lily, the hands of the angel are as transparent
as if they were leaves woven of threads of light; the shadows nestling in the hollow of the
wing are of such a kind that, contrasted with them, the jewelled margins sparkle in the
sun like the strings of a cithern. A diagonal line of light links the dove to the delicate fig-
ure of the Virgin as though it were the thin edge of an imaginary ray of light.

The several tendencies we have noticed in Defendente's work are all blended together
in the series of panels for the choir-stalls of the ex-Convent of San Girolamo at Biella.
Among the most beautiful of these is the Nativity, with small figures half lost to view
within a narrow hut which cuts the top margin of the picture. The background is a street
enclosed by high walls, with a glimpse of cloisters and churches painted in tones of ivory

against a blue and serene sky — pale tints on pale tints. In the foreground, by way of contrast, there are details emphasized by shadow, and impressionistic patches of light here and there in the group of graceful women, the meadows, the sombre-leaved tree, and the cloisters outlined in light. Wherever there is an ordinary decorative *motif* Defendente seizes upon it as a means of displaying his instinct for beauty of line and colour.

In the composition of his altar-pieces he rarely rises to the height of perfection reached in these fanciful works, or, generally speaking, in his small pictures or predellas; perhaps because he was obliged to adopt groupings stereotyped by tradition, or because his efforts to bring his methods into line with the all-triumphant forms introduced by the Renaissance led him to enlarge his figures or to intensify the contrasted light and shade of his faces. An unnatural effort of this kind is in every case detrimental to the delicate artistic constitution of this Piedmontese Crivelli, author of the Madonna and Child in the Museo d'Arte Moderna in Turin; attracted by sparkle and elegance, but without the passionate vigour and pathetic expression of the Venetian; indifferent to dramatic situations, but with every fibre responsive to the superficial charm of glittering line. Indeed, in designing the background of the Nativity for the polyptych in the church of Sant'Antonio at Buttigliera Alta he loses the archaic grace of his earlier compositions by emphasizing the mouldings of his architecture and deepening the shadows on the faces of the cherubic angels. Yet, when all is said and done, several of the productions of his later years are to be numbered among his master-

Plate 66 pieces. We need only mention the St. Jerome in the Museo Civico in Turin, in which there is a breath of real romanticism pervading the sombre setting, and in which every ounce of his exceptional freedom of touch is employed to give prominence to the figure of the saint against a background of warm shadow, and in a still greater degree to emphasize the crucifix and the skull by illuminating them from below, as if the rays from some invisible lantern were falling on them. The triptych in the gallery in Turin is a jewel among jewels in the work of this artist. The fact that it is Renaissance in form does not in any way detract from the elegance and vivacity of the composition, or the charm of the flat, clear-cut figures set amid the golden reflections of the colours.

The art of Defendente was thus subject insensibly to changes throughout the whole of his career; and at the beginning of the sixteenth century finally shook itself free of the Gothic tendencies of the lesser Piedmontese artists. He attained at last, with the help of German examples, to the mode of expression most in consonance with his own ideals — a line of light fraught with eloquence. He strives after slenderness of line; he sets free sparkling points of light from his intermittent outlines and plants them in the shadows by means of minute strokes of gold. His faces are thin and oval and refined; his hangings resemble thin sheets of

76

metal, and the ornamental borders of his robes, and his open-work crowns are of metal too: light irradiates his fabrics and the curling locks on his heads. He is, perhaps, happiest when working as a miniaturist or a goldsmith. When, in 1540 or thereabouts, he is called upon to design an altar-piece — now in the Municipio at Caselle Torinese — he transforms the walls of a Renaissance chapel, with a sort of archaic elegance, into a screen on which there are delicate landscapes divided up like panels of silk embroidery, and harmonizing with the languid, lily-white face of the Virgin. At the same time that he was painting the altar-piece at Caselle Torinese with all the care and refinement of an artist of old time, Gaudenzio Ferrari was already covering the interiors of Lombard domes and the walls about them with the broad outlines of his sunlit figures.

DEFENDENTE had many assistants but only one follower — and a feeble one at that — Iacobino Longo, who is represented in the gallery in Turin by a picture copied from one of Defendente's Nativities, in which he tries to imbue the Virgin's pasty face with refinement, and squeezes the figures of St. Joseph, the Virgin, the extraordinary-looking children, houses and a round-topped mountain into a narrow gap beside the hut.

Girolamo Giovenone,[60] who flourished between 1516 and 1555, painted a Nativity, now in the Istituto di Belle Arti at Vercelli, composed on the same lines. Although in point of time he belongs to the sixteenth century, his old-fashioned methods are those of the fifteenth, and possess none of the exquisite taste characteristic of Defendente Ferrari.[61]

The same arrangement reappears in the triptych at Mainz, in which the subjects are the Nativity,[62] St. Jerome and the Archangel Raphael, all three of them based on the work of Defendente. The artist in this case is Eusebio Ferrari, who was born about 1470 and died in 1533. The large and heavy figures, however, show something of the influence exerted by the sixteenth century, and are somewhat more voluminous than those of Defendente, while at the same time exhibiting a definite tendency towards the earlier types of Gaudenzio and Sodoma. In the Nativity there is an open street enclosed between high walls, as in Defendente's work; but it has changed in character, and is no longer a crooked and narrow corridor introduced merely as an excuse for the display of light and shade. It has become a broad open space behind the figures, and is full of character and incident. White marble sparkles under a brilliant sky, dark shadows slant across the walls; tufts of grass grow abundantly wherever they can gain a footing, fringing the mouldings with green, outlining the crumbling masonry, clinging to every jagged splinter and hanging from every cranny in delicious and picturesque profusion. The angels, too, owe their origin to Defendente's Nativities, only here each of the three diminutive forms is set in opposition to the larger figures

of St. Joseph and the Virgin, and resembles the cherubs in Gaudenzio's pictures rather than the flock of featherless birds created by Defendente out of the materials supplied by the painters of the North, whose example he endeavoured to follow. The whole composition of the group is artificial and forced, and as though Defendente's own freedom of treatment had been banished from his work and replaced by a laborious regularity of construction.

The wooden figure of St. Jerome, with its harsh, strongly-marked features and sharply cut furrows, betrays more than any other part of the triptych a striving after large and unnatural forms. The head of the archangel Raphael exhibits the florid grace of Sodoma's earlier works, and the gaiety of the landscape is reminiscent of the same master. Eusebio adorns his swollen figures with vestures covered with lacework patterns, curling locks, wings spangled with light: he even gets so far as to transform the head of the little Tobias into a mass of ringlets outlined in gold, so great is his thirst for unnatural embellishments. But the little dog sniffing the air with its pointed muzzle is so full of animation, so on the tip-toe of excitement, that Eusebio seems once again to have captured the spirit of freshness and life which makes the background of his Nativity so remarkably attractive.

THERE IS not much that need be said about the earliest works of Gaudenzio Ferrari.[63] He was born about the year 1480, and died either in 1549 or the year after. At a very early stage in his artistic career the full current of the sixteenth century claimed him for its own and enticed him away from the unprogressive atmosphere of his birthplace. According to Lomazzo, he was a fellow pupil with Bernardino Luini in the studio of Stefano Scotti; and there are certainly traces of a Lombard education observable in his earliest works, such as the small panels in the gallery in Turin of Joachim driven from the Temple and the

Plate 67 Visitation, in both of which the draperies are arranged in ellipsoidal curves in the manner of Bramantino, and the landscapes vague and veiled in atmosphere. Yet for all that, these first two pictures clearly reveal the Piedmontese origin of the painter by reminding us insistently of types employed by Spanzotti in his latest phase. But the erstwhile polygonal corrugations of the draperies dissolve into sharp, acute-angled bends of shining filament, and the hard outlines melt into melodious curves. He tries, too, to improve the modelling of the heads, and employs broad, flat surfaces of colour to impart an appearance of breadth to the bodies beneath the draperies. With exemplary care he covers candelabra, borders, spiral tufts of beard blown by the wind, curls tangled until they look like polished straw, walls of buildings and the folds of a veil, with a delicate filigree of strands of light. These forms, expanding in the sunlight of the Renaissance, we recognize as the traditional forms of Piedmontese art, in which line and the effects of light were regarded as no more than

ornamental adjuncts. In these two pictures, however, we can already detect that rhythmic development of linear effect which is still further elaborated in another picture in the same collection, representing the Madonna and Child with St. Anne, and in several of the compartments of the dividing wall in Santa Maria delle Grazie at Varallo, where the linear rhythm is sometimes complicated and sometimes simple, sometimes broad and sometimes severely restricted. In the Deposition, the most beautiful of all the series, the several *Plate 68* figures are combined in a group, the dominant lines of which intertwine like the tendrils of some climbing plant and converge on the body of Christ in a series of spiral curves. The deep hollow of the cavern with its great slabs of stone, its huge rough steps, and broken, irregular opening fissured and crumbling away between jagged points of rock, seems to shimmer in a close-woven network of points of light.

The dominant note in the Agony in the Garden, is not so much rhythm of line as concentration of light as a means of emphasis. The white figure of Christ stands out from the shadows of a dark and gloomy cave, hollowed out among time-worn massy rocks that have the appearance of the boulders lying at the bottom of a shallow stream. Both line and light are employed to give life to the mountainous landscape, outlining every detail of the structure of the rocks; while the rounded curves of the garments worn by the Apostles are eloquent of the dejection felt by the watchers. In the figures one can detect the influence of both Spanzotti and Defendente, but the modelling of the heads reveals a tendency in the direction of the Lombard school.

Gaudenzio more often than not takes up the role of a decorative artist. In his Christ before *Plate 69* Pilate the background resembles some exquisitely woven tapestry covered with lanceolate leaves of beaten gold; and in the scene of the Betrayal the halberds are transformed into lilies of fire between flaming faces and incandescent bodies, the light-encrusted helmet of the soldier whose ear St. Peter smote off and the draping of a sleeve — suggested solely by a few broad and resplendent strokes — are fragments of unadulterated impressionism. In his earlier works Gaudenzio occasionally strays from the magic path that was leading him through a world filled with decorative effects of light and line. The Nativity in the church of Santa Maria at Arona, for instance, is full of homely grace, for he has introduced features which have much in common with the methods of Perugino, differing from them in that they are transfigured by the mobility of the lighting; and he has achieved a delicate gradation of soft tints, from the whiteness of the flesh at one end of the scale to the rosy hues in the sky at the other. The sparkling contrasts of colour in the small pictures in Turin and the larger paintings in Santa Maria delle Grazie at Varallo give way to a rhapsody of warm, soft and dreamy tones lit by quiet high-lights in perfect harmony with the Umbrian gentleness of the attitudes.

Gaudenzio was a provincial artist, and for that reason we are unable to trace any clear and definite line of development in his work. His art wavers between the assertiveness of an original thinker and the blind obedience of a copyist hide-bound by tradition; between the gentle harmonies of the altar-piece at Arona and the resounding contrasts of the Crucifixion at Varallo; and between the grandiose modelling of the two figures in the Arrival of the Magdalen at Marseilles (in the church of San Cristoforo at Vercelli) and the vast coloured pageant of the Journey to Calvary at Varallo. In his later years Bramantino sacrificed the crystalline purity of his forms in order to obtain effects of volume; and Gaudenzio in a similar manner, when tempted by his passion for spectacular display and for brilliant colouring, falls to painting flat figures, broad surfaces, whirlpools of curves with a medley of *motifs* and jumbled high-lights; and, to finish up, entwines a bank of prickly acanthus with the angels of the cupola at Saronno. And yet the qualities that go to make a master-piece are present whenever decorative effect is justly balanced against modelling and re-lief. They are present, for instance, in the Crucifixion in the church of San Cristoforo at Vercelli, where the multi-coloured crowd thronging about the base of the Cross is bal-anced in a masterly way against a cloud of angels in the sky.

Bernardo Lanino painted a great number of altar-pictures, following as closely as he could in the footsteps of Gaudenzio, whose figures he took as models. His copies lack the vigour of the originals and are generally milder in character, but possess much delicacy in the play of light and shade. The example of his work selected for illustration in this vo-

Plate 70 lume is the Nativity in the church of San Cristoforo at Vercelli.

GIOVAN ANTONIO BAZZI[64] was born at Vercelli in 1477 and died in 1549. From 1490 to 1497 he worked under Spanzotti; but in spite of that, even his earliest dated works — the paintings in the Monastery of Sant'Anna in Camprena — show that, in addition to a tendency towards the plasticism of his teacher and the indelible traces of his Piedmontese origin, he was very clearly biassed by a recollection of much that he had seen during a visit to Siena and the adjacent towns; and was particularly impressed by the Umbrian school as represented by Perugino and Pinturicchio. The fresco of the Virgin and Child, with two attendant monks in adoration, has a throne geometrical in form with shining surfaces of dark polished marble surrounded by light-toned mouldings, recalling Spanzotti's ear-liest Madonna in the gallery in Turin: and the whole structural unity between the figures and the building in which they are placed seems to derive its admirably calculated equi-librium from the master of Vercelli. The cloister, with its extremely high central arcade and its lateral colonnades, introduced here as a counterpoise to the figures, reminds us of

the general arrangement of Spanzotti's group; St. Anne, aloft in the sky, being counter-balanced by the very sturdy and strongly-characterized nuns. The small trees with their slender stems already bear something of the impress of Siena or Umbria, but the careful, painstaking execution still remains faithful to Piedmontese practice.

Another fresco in the monastery of Sant'Anna, representing St. Benedict consigning the Rule of the Benedictine Order to his followers, is painted in a vein of gentle irony. It has a larger sense of space, and the architectural background, consisting of a triple arcade, is bathed in softly-diffused light such as Perugino employed to illuminate his *ancone*. The two monks in the foreground are placed in positions that suggest the flanking figures met with in the compositions of the Umbrian school; but the solid folds of the drapery are those of Spanzotti, only somewhat more ample; and the columns support an arcade ador-ned with rosettes such as Bramante might have designed, and are peopled with the playful cherubs so much in favour with the Lombards.

As his frescoes progress, so the influence of the Umbro-Sienese school over Sodoma grows more and more pronounced. In the fresco of the Blessing of Bread the flowing lines of the grouping evoke memories of the Umbrian compositions on the walls of the Sistine Chapel; and only the landscape — inlaid of many pieces, meticulous, enlivened by con-trasts of light and shadow which diffuse over earth and sky an atmosphere of romantic melancholy — tells us that Sodoma is, after all, a son of Piedmont.

And when we come at last to the Pietà we find ourselves face to face with Peruginesque figures that have suffered grievously at the hands of their Piedmontese admirer; for Sodoma takes whole figures and masses of rock from Perugino's creations and then, because like his Lombard neighbours he loves dark backgrounds, transfers them bodily to the centre of the scene and tucks them away behind the group carrying the body of the Crucified. The counterfeiting of Umbrian forms is particularly obvious in the coarse figure of St. John, who lounges in an attitude aping those of the Saints who stand near the Cross in the pictures of Perugino, but is unable to obtain any support in his lounging from the well-balanced figure of the Virgin.

Similar vagaries of style appear in the series of frescoes in the Convent of Monteoliveto near Siena, where, in the Coronation of the Virgin, we are reminded of Lombardo-Pied-montese forms by the round face and flat head of the Madonna, painted in the manner of Lanino; while all the mystic sweetness of Umbria shines from the lineaments of the Christ.

Sodoma's work on the cloister walls is in continuation of that of Luca Signorelli. The result is that he has somebody new to copy; somebody who is just a little too athletic for his languid and effeminate soul. And the further result is that from this new source of

inspiration he acquires a new idea or two for his figures, or some attitude expressive of more than the usual amount of energy, or some particularly angular type of humanity — and in the acquisition he loses much of his skill in massing men and animals against Piedmontese backgrounds of flimsy character. Thus it is that in another fresco in the cloisters at Monteoliveto we find him producing a remarkable example of mannerism, in which the deliberate lack of proportion between the sizes of the several figures and the constant introduction of false harmonies of colour show how hard he tried to adapt the linear rigidity of a Lombardo-Piedmontese composition to the soft cadences of the Umbrian school. Two of his works, however, show Sodoma's efforts in a far better light. The first of these *Plate 71* represents the monk Romano lowering food to St. Benedict by means of a rope, and the second is a view of the Tiber with the Castel Sant'Angelo. Although in the first of these the cavern hollowed out of a monolithic mass of stone, the ecstatic devotion on the face of the praying Saint and the background in the manner of Pinturicchio are clear indications of Umbrian influence, we are compelled to recognize as fragments of his birthright the laborious and careful construction of the mound of stones with its straight bands of light and shadow, as well as the figure of the Saint, who seems to be a piece broken from the rock behind him, so broad and smooth and solid are the folds of his cloak. The narrow cavern is in the form of a niche, within which the figure is so blended with the rocks behind him that it seems to be a part of them. Another feature which is unmistakably Piedmontese is the view of Rome seen through two Renaissance arches bathed in shadow, with minute variations of light on the angles of the stone-work and on the battlements, and the impressionistic contrast between the darkness shrouding both houses and river bank and the light gleaming on the water and broken here and there by the black silhouettes of boats and figures. It is a vision conjured up out of many fragments taken from the landscapes of Defendente Ferrari.[65]

Belonging to the same period as these frescoes are a number of small paintings, in which vacillation between the traditional forms of his native land and the exotic forms that were so constantly before his eyes produced less unsatisfactory results. In the St. George of the Cook collection at Richmond, contemporary with the Monteoliveto frescoes, it is still too much trouble for him to impart an adequate sense of movement to his work; and we detect here the first signs of that artificial elegance which appears all to clearly in the Lucretia of the museum at Hanover. In the last-named work there is a mass of brilliant light shining on the hair, the veil, the little teeth; the borders of the robe are slashed and loaded with festoons: Lucretia herself is a bedizened doll set in a bedizened landscape. But the *Plate 72* delicate figure of Charity in the museum in Berlin, standing upright against a clear back-

ground of almost wintry aspect and holding a Peruginesque child in her arms, appears to advance towards the spectator full of grace and pensiveness. The Judith at Siena bends gracefully to the left as though in obedience to the inclination of the head, and the curve of the dagger harmonizes with the graceful flexure of the whole pose.

Groups of figures, clusters of trees and mountain passes are blended together in one broad harmonious scheme of shadow and reflected light in the spacious landscape of the Siena Deposition. The inspiration here is drawn from Umbro-Tuscan originals; as is that of *Plate 73* the Cleveland Crucifixion, in which the figures are built up by laying film on film, and the landscape is slight and full of atmospheric effects. Of all the early works of Sodoma this is the most charming, both on account of the soft and gentle grace of the figures and the delicate poetry of every part. Another early work of rare merit is the allegorical painting of Love and Chastity, in the Louvre, with its exquisitely painted nudes, its pure and limpid *Plate 74* colouring, its landscape filled with refreshing blues and greens, and the almost Raphaeles-que eurythmic beauty of a linear composition which achieves complete harmony between the poses of the figures and the curved margin of the tondo.

The earliest sign of any leaning towards Leonardesque types appears in the well-arranged circular panel of the Holy Family in the Borgogna collection at Vercelli; and the same source of inspiration is traceable in the altar-piece in the gallery in Turin, where the delicate, softly-rendered figure of the Evangelist is derived from the angel in the Virgin of the Rocks. It is only, however, in the Adoration of the Magi in the church of Sant'Agostino at Siena that the influence of Leonardo leads the painter to study large masses of figures in movement amid constant variations of light.

The suave and voluptuous Sodoma, like the more fiery Gaudenzio, remains throughout the whole of his artistic career under the spell of home traditions; so much so that even after he had produced one of the finest examples of post-Leonardesque Lombard art in the St. Sebastian in the Pitti at Florence, with its imposing grouping of the human body against the trunk of the tree, he reverts in a later work — the Madonna with Saints in the Museo Civico at Pisa — to the old-fashioned parallelism of his native land; while in his famous Christ in Limbo he gives us once again a series of figures all on the same plane but of different sizes. His field of vision is sometimes very wide, at others extremely narrow: he lacks stability, and has none of the clearness of outlook which marks the work of the greatest masters. In all the exuberance of sixteenth-century art he remains, in spite of his rare gifts, a figure in the background; working in conventional colour schemes and grat-ifying our eyes with his soft blue atmosphere, his sentimental grace, and the beauty of his gentle and delicate types.

83

VIII

THE PAINTERS OF LIGURIA

LIGURIA was dominated by the school of Nice throughout the fifteenth century, and was thus indirectly influenced by the masters of Southern France. It was at the same time affected to some extent by the work of Vincenzo Foppa at Savona, where he collaborated with Ludovico Brea, chief of the Niçois school. But Foppa was not the only Lombard who carried Lombard forms into Liguria, for Donato de' Bardi of Pavia, Lorenzo and Bernardino Fasolo and Pier Francesco Sacchi, all worked in places bordering on the Mediterranean; while the school of Piedmont was represented in the same regions by such men as the priest, Giovanni Canavesio of Pinerolo, and Giovanni Mazone of Alessandria.

In 1451 Justus d'Allemagna painted and signed an Annunciation in the cloisters of the church of Santa Maria di Castello at Genoa in which the Late Gothic tradition endeavours with much ingenuity to adapt itself to the forms of the Renaissance. A fellow-countryman of his, Conrad by name, painted some Sibyls and Prophets in the same church.

It is also probable that the Spanish artist Rubeus visited Genoa, leaving a picture at Acqui on his way, while the Lomellini brought a picture by Jan van Eyck from Flanders which passed into the possession of Alfonso of Aragon. But Genoa, open to every artistic wind that blew from France, Spain, Germany or Holland, endeavoured — not always, it is true, with advantage to herself — to follow the example of the Lombard masters, whose plastic methods necessarily came into contact with those of Provence at Nice, a city which in the fifteenth century was the artistic capital of Liguria.

Giacomo Durandi,[66] a native of Nice of whom we have notices extending from 1410 *Plate 76* to 1468, was a painter of presses for Doge Raffaele Adorno at Taggia: Jean Miraillet,[67] born at Montpellier but living at Nice, worked both at Marseilles and Toulon, and is thought by some to have been the real founder of the school of the Brea. Another Niçois, Bartolomeo Bensa, put his signature in 1466 to an altar-picture in the castle of Lucéram.

Plate 75 There is a signed work by Durandi in the cathedral at Fréjus representing, in the central panel, St. Margaret, with saints in two tiers of Gothic niches in the side panels. The faces are pointed, the glassy eyes look out askance, and the lips are tight-drawn. Although the whole work is archaic in character, it derives individuality from the clean and rigid drawing of the outlines and the gay colouring of the clothing, contrasting with the yellowish tints of the flesh and the fresh complexion of the Saint. Her neat but angular figure is enfolded in a flowered mantle that closes round her like the two halves of the shell of an almond.

84

Among all the fifteenth-century painters of Liguria the personality of Ludovico Brea[68] is the one that stands out most clearly. His notices extend from 1475 to 1515. Belonging to the former date there is a signed Pietà in the church at Cimiez, an impressive example *Plate 77* of modelling, especially as regards the group of the Virgin with the body of her crucified Son, and the equestrian figure of St. Martin towering up into the calm sky. Tones of black and gold alternate in the draperies, white and blue in the background; yet the restrained colour scheme is in keeping with the slow movements of the living figures and the silence of the inanimate objects projected against the sky. The composition of the central group resembles that of the Pietà in the Louvre painted by some Avignon master, but it must be admitted that Brea has failed to produce the same harmony of intermittent line or of facetted planes. Many years later — that is to say, in 1488 — he painted and signed the altar-picture of St. Catherine at Taggia in which careful balancing of figures painted on a *Plate 78* background of golden diaper marks very clearly that sense of proportion which is one of the fundamental characteristics of Ludovico's work. Often, too, there is a certain similarity to the methods of the Siculo-Catalan painters of the school of Antonello.

Under an arcade on the right St. Lucy, wearing a mantle which indicates with charming simplicity the lines of her flat little figure, appears entirely absorbed in standing before us in a pose of impeccable balance, holding her cloak and the stem of her palm-branch in one hand as a counterpoise to the little dish in the other. Even the glance of her eyes is perpendicular to their half-closed lids and conforms to the rigidly vertical composition. St. Agatha, on the right of St. Catherine, is equally absorbed in the same endeavour. St. Catherine herself stands in the centre, four-square to the beholder, scapulary in one hand and crucifix in the other, rising with neo-Byzantine rigidity from a pedestal of small devotees towards a triangular group composed of the Eternal Father and two angels.

In the Annunciation individuality is obtained chiefly by the employment of light and shade, used most successfully in the slender figure of St. Michael, clad in golden armour that has not yet shed the spikes of its Gothic ancestors. Ludovico employs similar effects when painting the saints, where the contrast is between the uniform clarity of the flesh tones and the browns of the garments, and between the latter and the diapered background of gold. Inert and solemn, the two saints in the smaller panels are among the most beautiful of Ludovico's feminine types: they are simple, flower-like examples of virginal grace. The refined, pensive figure of St. Lucy, her forehead smooth as a piece of marble, and her hair falling in ringlets about her shoulders, arouses in us a far-away vision of the Virgins Jan van Eyck and Gerard David used to paint; but translated into a noble, Latinized figure made of polished stucco or smoothest marble; while St. Catherine presents herself before

our eyes with all the vacant fixity of gaze of a doll, intent on nothing beyond holding tight to the symbols of her sainthood.

Ludovico Brea therefore appears as a painter of the older dispensation who is sometimes capable of expressing noble thoughts, as in the St. Lucy; sometimes unimaginative, as in the rectangularly divided background; yet in his greatest moments a draughtsman of power and precision. There is none of the Lombard endeavour to give individuality to each figure; they are all of one type, grave and silent, and not a little suggestive at times of a reversion to the majestic types of the old Byzantines.

Plate 79 The Crucifixion in the Palazzo Bianco at Genoa was in all probability painted before Brea collaborated with Foppa and before he did the paintings at Taggia. Its composition is Flemish in character, with weeping angels of archaic form and a vast landscape which is indefinite as regards the foregound but grows clearer as it recedes into the distance. The slow, sad gesture of the Virgin is contrasted with the violent movement of the Magdalen, whose cloak seems to impel her towards the Cross, while we are left to imagine the heart-rending cry that must have broken on the silent air. The piled-up folds of the drapery are channelled deeply in accordance with the practice of the French school.

The beautifully-executed and gentle figures of the St. Catherine polyptych are repeated in another polyptych — an Annunciation — also painted for the Dominicans at Taggia. The Angel in this case fails to conceal his lack of modelling by wearing a robe inlaid with chiselled gold, and his folded hands are pressed as close to his body as those of a recumbent effigy. The brow of the Virgin is framed by a circlet of curls. Behind the pair there is an ornate chapel of Lombard Renaissance type, but neither figure is in any way related to it, and might just as well have been painted on a background of gold. Brea had already

Plate 80 worked in partnership with Foppa at Savona in 1490; but if some trace of the Lombard master's influence is observable in the grandiose half-length figure of St. Dominic and in the full-length figure of St. Sebastian, the models are transformed by the uniformity of the lighting, the marble smoothness of the figures and the striking tallness of the naked youth. St. Pantaleon is clearly a recollection of French methods; the Virgin, with her half-clenched hands close to her sides, seems to bring the whole composition into harmony. The Bishop-Saint, slowly turning on one foot as carefully as if he were guided by a plummet, is, as regards pure statics, reminiscent of the St. Lucy in the St. Catherine polyptych.

Scarcely more freedom of movement is noticeable in the Assumption painted in 1495 — five years after Brea's collaboration with Foppa. It exhibits a fresh outcrop of French *motifs* in the lily-like group of the Betrothal of St. Catherine, in the types chosen for the Virgin and St. Joseph in adoration before the Holy Child, and in the figure of the Virgin,

86

borne up by a swarm of cherubs through a sky made of golden fabric. The arrangement is the same as that of the six small figures in Ambrogio da Fossano's Assumption in the Brera, but a tender blue, broken by light clouds, surrounds Borgognone's figures with an atmospheric ellipse, the movement is quiet and gentle, the figures soft and free: in Brea's work, on the other hand, the scene is set in front of a sheet of gold, and every fold of the mantle which encloses the Virgin as in a sheath is governed by the most rigid rules of symmetry.

The group of the Apostles and the obscured figures of SS. Peter and Francis alone reflect any of the characteristics of the Lombard school. It does not seem, however, as if their adoption was of any benefit to the artist, for in the result they tend to obscure the grace of his types, which depend for their effect on their bright colours, their precise and subtle lines and charming placidity. Indeed, it is not easy to believe that Ludovico painted the two saints with big heads and shadows so heavy that they over-accentuate the modelling.

The frame of the central panel of a polyptych in the parish church at Lieuche bears the date 1499. The Crucifixion in the curved panel at the top with a spacious landscape full of luminous relief, and the central panel of the Annunciation[69] are notable exhibitions of Ludovico's powers. In the less important panels he was possibly assisted by a very commonplace artist, who painted great golden fleurs-de-lys all over Ludovico's cope. It would appear that here, also, some breath of the pensive virginal grace of the Madonnas of Hans Memling and Gerard David has touched lightly on the white forehead of this Virgin, and left behind it an expression of rapt absorption. Through a transomed window there is a view of a somewhat mechanical landscape sparkling in the sun and carrying the silent homeliness of the scene beyond the narrow walls of the building away towards the misty horizon. When composing the Madonna del Rosario in 1513 for the Dominicans at Taggia the artist appears to have been somewhat thrown off his balance by endeavouring to adapt himself to new ideas. He replaces the golden background and severely simple throne of his earlier Madonnas by a sombre landscape and an ornate Lombard throne; but he only succeeds in superimposing one over-elongated feature on another without interrelating them, with the result that a plaster Virgin and a Child modelled after the manner of Foppa find themselves confined within a narrow sentry-box. Shadows envelop the beautiful surfaces of his earlier works; the figures tend to repeat themselves as though they were turned out in sets by some factory; and in the process of mechanical reproduction all the simplicity and nobility which Ludovico Brea infused into the St. Martin at Cimiez and the St. Lucy at Taggia disappear.

Both his son Francesco,[70] whose notices extend from 1538 to 1547, and his brother Antonio (1504 to 1516) made feeble copies of Ludovico's forms without varying them to

any great extent. Francesco's figures are angular, and have small heads that seem to be modelled in plaster. Antonio is part-author of a picture in the Palazzo Bianco at Genoa, which he painted in collaboration with a kinsman from Nice, and of an Archangel Gabriel between Saints at Diano Bosello. Other artists there were also, whose names are unknown to us, such as the author of the Ecce Homo in the church at Biot; who of them all most nearly approached to the excellence of Ludovico himself in warmth of golden tones. Another nameless artist painted an Annunciation in the church at Utelle with coarse and heavy figures; and yet another Annunciation, by some unknown hand, is in the chapel of the Penitents at Villars-du-Var, in which the rough and disjointed workmanship falls far below the standard set by Brea, although there are three admirable little panels in the upper row with effects of light and line which approximate to the work of the masters of Piedmont.

With the passing of the Brea family, together with Ludovico's anonymous followers and a few others whose works are somewhat nearer in character to the French schools — such as the unknown painter of the St. Stephen in the church at Gréolières — the influence of the older Niçois school in Liguria comes to an end. In the sixteenth century Genoa rises into prominence with Pierin del Vaga and Cambiaso, two artists who prepared the way for all the brilliant galaxy of painters which in the seventeenth century was so bright a jewel in the crown of Genova la Superba.

NOTES

1] MONGERI, *L'Arte del minio nel ducato di Milano*, in *Archivio storico lombardo*, 1885, p. 530. MOIRAGHI, P., *Sui pittori pavesi*, Pavia, 1880, p. 109; *A proposito di Giovannino de' Grassi* in *L'Arte*, 1906. TOESCA, P., *Di alcuni miniatori lombardi della fine del '300*, in *L'Arte*, 1907, pp. 184-196. VENTURI, A., *Storia dell'Arte Italiana*, Vol. VII, pp. 271 and 274, Hoepli, Milan. TOESCA, P., *La pittura e la miniatura nella Lombardia dai più antichi monumenti alla metà del '400*, pp. 325 et seq., 517 et seq., 334 et seq., and 435, Hoepli, Milan, 1912. TOESCA, P., *Michelino da Besozzo e Giovannino de' Grassi*, in *L'Arte*, 1905.

2] Sources: LOMAZZO, *Trattato dell'arte della pittura, scultura ed architettura sec. XVI*, Vol. II 222, 341, Del Monte, Rome, 1844. Recent bibliography: CALVI, G. L., *Notizie dei principali Architetti, Scultori e Pittori che fiorirono in Milano durante il governo degli Sforza*, Milan, 1859-65. D'ADDA, G., *Une famille d'artistes lombards du XIV au XV siècle: les Besozzo*, in *L'Art*, Paris, 1882, pp. 81 et seq. MONGERI, G., *L'Arte in Milano, op. cit.*, 1885. MAGENTA, *La Certosa di Pavia*, p. 32, Milan, 1897. MONTI, *Storia ed Arte nella Provincia di Como*, p. 253, 1902. MALAGUZZI-VALERI, *Pittori lombardi del '400*, Milan, 1902; see also *Rassegna d'Arte*, 1902, p. 189. SUIDA, W., *Neue Studien zur Gesch. der lombard. Malerei*, in *Repert. f. Kunstw.*, 1902, p. 343. TOESCA, P., *Michelino da Besozzo e Giovannino de' Grassi*, in *L'Arte*, 1905, p. 335. ZAPPA, *Michelino da Besozzo miniatore*, in *L'Arte*, 1910. VENTURI, A., *op. cit.*, VII, I, pp. 271-277 and 291.

3] For Leonardo di Michelino see: D'ADDA, *L'Arte del minio nel ducato di Milano, Archivio storico lombardo*, Anno XII, and *L'Art*, 1882, Vol. II, pp. 81-99. BROCKHAUS, *Leonardo da Bisuccio (Festgabe für A. Springer)*, Leipzig, 1885. MALAGUZZI, F., *Pittori lombardi del '400*, Milan, 1902. VENTURI, *op. cit.*, VII, I, pp. 214-275. TOESCA, *La Pittura e la miniatura, cit.*

4] For the Zavattari family see: CROWE and CAVALCASELLE, *A History of Painting in Northern Italy*, Vol. II, p. 63, London, 1871. COLOMBO, GIUSEPPE, *Tavola descrittiva degli affreschi che adornano la parete della cappella del Rosario, nella basilica di Monza*, Turin, 1882. CASATI, CARLO, *Dipinti a fresco della cappella della Regina Teodolinda nella basilica di Monza ed il loro restauro*, Milan, 1888. FUMAGALLI-BELTRAMI, *Di alcuni dipinti dei fratelli Zavattari e di Giacomo Vismara in San Vincenzo in Prato di Milano. Rivista di Scienze storiche*, Pavia, 1908. VENTURI, A., *op. cit.*, VII, I, pp. 277-288. TOESCA, P., *op. cit.*, pp. 492 et seq., 513, 532, 538, 550, 555, 576. SALMI, M., in *L'Arte*, 1923, p. 149.

5] See *Pinacoteca*, Year I, No. 2, September-October, 1928.

6] *Storia pittorica dell'Italia*, Bassano edition, 1809, Vol. IV, p. 121.

7] For Benedetto Bembo see: BOHL, *Storia della Svizzera italiana*, p. 119, 1885. RICCI, C., in *Arte italiana decorativa e industriale*, Vol. III, 1894; also in *Archivio storico lombardo*, Vol. III, p. 420, 1895. MALAGUZZI, F., *op. cit.*, pp. 102, 120. VENTURI A., *op. cit.*, pp. 288/289 and 291. TOESCA, P., *op. cit.*, pp. 572 *et seq.* and 582.

8] For Bonifacio Bembo see: VASARI-MILANESI, IV, p. 583. LOMAZZO, *op. cit.*, II, p. 321. Recent bibliography: ZAIST, G. B., *Notizie storiche di pittori, scultori ed architetti cremonesi*, Cremona, 1774. GRASSELLI, G., *Abecedario biografico dei pittori, scultori ed architetti cremonesi*, Milan, 1827. CAFFI, M., *Di alcuni maestri d'arte nel secolo XV in Milano poco noti o male indicati, Archivio stor. lombardo*, Year V, p. 82. SACCHI, J., *Notizie di pittori cremonesi*, 1872. MALAGUZZI, F., *Pittori lombardi, op. cit.*, pp. 97/122. VENTURI, A., *op. cit.*, pp. 288/291. TOESCA, P., *op. cit.*, pp. 573/576.

9] LONGHI, R., *Bonifacio Bembo*, in *Pinacoteca*, I, No. 2.

10] SUIDA, W., *Studien der lombardischen Malerei*, in *Monatsh. f. Kunstw.*, 1909. Id., *Donato de' Bardi*, in Thieme-Becker, *Künstlerlexikon*.

11] For notices of Bugatto see: BELTRAMI, L., *Il Castello di Milano*, pp. 338/339. MALAGUZZI, F., *op. cit.*, pp. 123/136. VENTURI, A., *op. cit.*, VII, 4, 1905, pp. 5, 824 and 828. TOESCA, *op. cit.*, p. 576.

12] For Gottardo Scotti see: VENTURI, *op. cit.*, VII, 4, pp. 828/829. TOESCA, *op. cit.*, p. 558.

13] For Leonardo Vidolenghi see: FFOULKES-MAIOCCHI, *Vincenzo Foppa*, London, p. 22, 1909. VENTURI, A., *op. cit.*, VII, 4, p. 829. TOESCA, P., *op. cit.*, p. 563. MALAGUZZI-VALERI, F., *Maestri minori lombardi del '400*, in *Rassegna d'Arte*, 1911, and in *Pittori lombardi*.

14] For Leonardo da Pavia and Leonardo Vidolenghi see: FFOULKES-MAIOCCHI, *Vincenzo Foppa*, p. 22, London, 1909. MALAGUZZI, *Maestri minori lombardi*, in *Rassegna d'Arte*, 1911.

15] LOMAZZO, *Trattato della pittura*, 1584.

16] See the manuscript chronicle in the Monastery of Sant'Eustorgio. Gaspare Bugatti died in 1583.

17] See: CAFFI, in *Arch. stor. lombardo*, XIII, 1886. BELTRAMI, in *Arch. stor. dell'Arte*, 1892. MALAGUZZI, *I pittori lombardi, op. cit.*

18] For Vincenzo Foppa see: VASARI-MILANESI, Vol. II, pp. 448 and 457. LOMAZZO, *op. cit.*, Vol. I, pp. 165, 387; Vol. II, pp. 39, 139, 321. *Burlington Fine Arts Club Exhibition, Milanese Schools*, London, 1899, p. 26. VENTURI, A., *Galleria Crespi*, 1900, p. 223. MALAGUZZI-VALERI, *Pittori lombardi del '400*, 1902, passim, and *Catalogo del-*

la R. Pinacoteca di Brera, Bergamo, 1908, *passim.* BERENSON, *North Italian Painters,* 1907, p. 218. FFOULKES-MAIOCCHI, *Vincenzo Foppa of Brescia, Founder of the Lombard Schools, his Life and Work,* London and New York, 1909. FRIZZONI, in *L'Arte,* 1909, p. 249. MALAGUZZI-VALERI, in *Rassegna d'Arte,* IX, 1909. SUIDA, in *Monatshefte für Kunstwissenschaft,* II, 1909, p. 477. COOK, H., *Due figure del Foppa,* in *Rassegna d'Arte,* 1908. HENNIKER-HEATON, R., *An unpublished picture by Foppa,* in *Art in America,* 1925. POGGI, *Arte e Storia,* 1909, p. 294. CATALOGUES: *Kaiser Friedrich Museum,* Berlin, 1912; *National Gallery,* London, 1913; *Wallace Collection,* London, 1909. TOESCA, P., *op. cit.,* pp. 567, 576 *et seq.* BREK, in *Rassegna d'Arte,* XI, 1911, p. 113. VENTURI, A., *op. cit.,* VII, 1, pp. 288-291; and VII, 4, pp. 824-826 and 837-862. SALMI, M., in *L'Arte,* 1923, pp. 150-151. SUIDA, *The unknown pictures by V. Foppa, Burlington Magazine,* XLV, 1924.

19] For Bernardino Butinone see: VASARI-MILANESI, IV, pp. 151, 152. LOMAZZO, *op. cit.,* II, p. 49. TORRE, *Ritratto di Milano,* 1674, pp. 162, 319. PASSAVANT, in *Kunstblatt,* 1888, No. 66. CALVI, G., *Notizie dei principali architetti,* 1865, Vol. II, p. 103. LOCA-TELLI, P., *Illustri Bergamaschi,* 1867, Vol. I, p. 407. MONGERI, G., *L'Arte in Milano,* 1872. CROWE and CAVALCASELLE, *History of Italian Painting,* 1876, Vol. VI. LER-MOLIEFF (MORELLI), *Die Werke,* etc., 1880, p. 459, and *Gal. zu Berlin,* 1893, p. 129. SEIDLITZ, in *Gesch. Stud. z. Kunstgesch, Festgabe für Ant. Springer,* Leipzig, 1885, p. 64. COOK, H., in *Cat. d. Mail. Ausst. des Burlington Club,* XXIII, 1898. MALAGUZZI, F., in *Rassegna d'Arte,* I, 1901, p. 99. SUIDA, in *Repert. f. Kunstw,* XXV, 1902, p. 332. SEID-LITZ, in *L'Arte,* 1903, p. 31. MALAGUZZI, F., *op. cit.,* pp. 3-58. BELTRAMI, L., *Perseveranza,* 26-27 May, 1901. MALAGUZZI, F., in *Rassegna d'Arte,* IV, 1904, p. 38; VII, 1907, p. 145. COOK, H., in *Burlington Magazine,* IV, 1904, 84. BERENSON, B., *North Italian Painters,* 1901, Vol. I, p. 180. SUIDA, W., in *Monatsh. f. Kunstwiss,* II, 1909, p. 486. FFOULKES-MAIOCCHI, *op. cit.,* 1909, pp. 82 and 249. VENTURI, *op. cit.,* VII, 3, p. 475. MALAGUZZI, F., *Nuovi affreschi lombardi del '400,* in *Rassegna d'Arte,* 1914. SALMI, M., *Il trittico del Butinone nella Pinacoteca di Brera,* in *Arch. stor. lombardo,* 1925, p. 411.

20] The tondo at Parma is unquestionably part of a polyptych to which the two other roundels in the Noseda collection, representing St. Augustine and St. Ambrose, also belonged.

21] For Bernardo Zenale see: VASARI-MILANESI, Vol. IV, p. 151 and Vol. VI, p. 513. LOMAZZO, *op. cit.,* Vol. I, p. 165; Vol. II, pp. 39, 47, 54, 55 and 209. MALAGUZZI-VALERI, *op. cit.,* pp. 24 *et seqq.* and 58-78, and *passim.* SEIDLITZ, W. VON, in *Gesam-melte Studien zur Kunstgeschichte, Festgabe für Anton Springer,* Leipzig, 1885, pp. 64-85.

CALVI, *op. cit.,* 1865, p. 115. FFOULKES, in *Rassegna d'Arte,* 1904. SEIDLITZ, *Zenale e Butinone,* in *L'Arte,* 1903. VENTURI, A., *op. cit.,* VII, 3, pp. 475, 722; see also *Studi dal vero attraverso le raccolte artistiche d'Europa,* Milan, Hoepli, 1927, pp. 35-36.

22] For Borgognone see: LOMAZZO, *op. cit.* CROWE and CAVALCASELLE, *op. cit.,* VI, pp. 45 *et seq.* GAMBA, F., *L'Arte antica in Piemonte,* 1882, pp. 22 *et seq.* GRUYER, G., in *Gazette des Beaux-Arts,* 1893, I, 484 *et seq.* SANT'AMBROGIO, DIEGO, in *La Lega Lombarda* for 26th May, 1895. BELTRAMI, L., in *Emporium,* I, 1895, p. 339; and *Arch. stor. dell'Arte,* VI, p. 25. BORIA, *Ambrogio da Fossano,* Fossano, 1897. ABLA, in *La Perseveranza* for 15th Feb. 1897. FRIZZONI, in *L'Arte,* 1900, p. 323; 1902, p. 65; also *Le Gallerie dell'Accademia Carrara in Bergamo,* 1907, *passim.* RICCI, C., *Mostra d'arte ant. senese,* Cat. gen., Siena, 1904, and in *Boll. d'Arte,* 1909, p. 252. *Archivio storico lombardo,* Vol. XI, pp. 138-149; XX, pp. 997-1001; XXXII, pp. 140-151. *Rassegna Bibliografica,* Vol. II, p. 144. MALAGUZZI, F., in *Rassegna Bibliografica,* Vol. II, 1899, p. 253; *Catalogo della Pinacoteca di Brera, Pittori lombardi, op. cit.,* p. 166. ZAPPA, G., in *L'Arte,* 1909, pp. 51 and 108. FFOULKES-MAIOCCHI, *op. cit.,* p. 248; also in *L'Arte,* 1909, p. 203. BERENSON, B., *The North Italian Painters of the Renaissance.* VENTURI, *op. cit.,* VII, 4, pp. 883-912 and *passim.* ZAPPA, G., *Note sul Borgognone* in *Verso Emmaus, Scritti d'Arte e di Storia,* Milan, Alfieri and Lacroix, 1921. SALMI, M., *Una mostra di antica pittura lombarda,* in *L'Arte,* 1923, pp. 152-153. VENTURI, L., *Catalogo della Raccolta Gualino,* Milan, Bestetti and Tumminelli, 1926. VENTURI, A., *Studi dal vero, op. cit.,* pp. 336-340. CALDERARA BRASCHI, A., *Amb. Borg. et les peintres primitifs de Lombardie,* in *Revue de l'Art,* XXXVII, 1920.

23] For notices of this triptych see: LOGAN, M., *Le triptique attribué a Juste d'Allemagne au Musée du Louvre,* in *Gazette des Beaux-Arts,* XVI, 1896. VENTURI, *op. cit.,* VII, 4, p. 1091.

24] For Vincenzo Civerchio see: VASARI-MILANESI, Vol. III, p. 953. LOMAZZO, *op. cit.,* Vol. II, p. 49, n. 131 and 321. RIDOLFI, *Le meraviglie dell'arte,* 1648, Vol. I, p. 401, Vol. II, p. 163. CALVI, G. L., *Vincenzo Civerchio,* 1861. CROWE and CAVALCASELLE, Vol. VI, p. 82. MONGERI, *Arte in Milano,* 1872, pp. 61, 62, 63, 64, 187, 188. FENAROLI, *Art. Bresc.,* 1877, p. 307. *Gazette des Beaux-Arts,* 1879, I, pp. 238-239. *Jahrbuch d. Kgl. preuss. Kstsamml.,* Vol. XVII, p. 22; Vol. II, p. 265; Vol. IV, p. 182. CAFFI, M., *Di Vincenzo Civerchio,* 1883. *Archivio storico dell'Arte,* 1887, p. 487. *Archivio storico Italiano,* 4th Series, Vol. XI, p. 328. *Arte e Storia,* 1890, p. 252. MORELLI, *Gal. zu Berlin,* 1893. *Archivio storico di Lodi,* 1896, p. 170. *Anonimo Morelliano,* Frimmel edition of 1888, p. 74. BERENSON, *op. cit.,* p. 195. MALAGUZZI, *Pittori Lombardi, op. cit.,* pp. 157-240. *L'Arte,* 1905, p. 50; 1909, p. 258. GRECO, N. P., *Vincenzo Civerchio,* Crema, 1906. FFOULKES-MAIOCCHI, *op. cit., passim. Rassegna d'Arte,* 1909, p. 140,

and 1911, p. 149. REINACH, *Rep. d. peint.*, cfr. Reg. in Vol. III, 1910. LONGHI, R., *Cose Bresciane*, in *L'Arte*, 1918.

25] For notices of Sacchi see: VENTURI, *op. cit.*, VII, 4, pp. 921, 922, 1078, 1096, 1102.

26] For Ambrogio Bevilacqua see: LOMAZZO, *op. cit.*, II, p. 321. BRUN, C., in *Meyers Künstlerlex.*, XI, p. 775. MORELLI, *Gallerie di Monaco e Dresda*, II, 334; and *Gallerie di Berlino*, 122. *Burlington Fine Arts Club, Illustrated Catalogue of Pictures by Milanese Masters*, London, 1899, p. 39. MALAGUZZI, F., *Pittori Lombardi, op. cit.*, p. 165 et seq.; *Rassegna d'Arte*, 1905, p. 88; *Catalogo della R. Pinacoteca di Brera*, Bergamo, 1908, pp. 148, 190. VENTURI, A., *op. cit.*, VII, 4, pp. 122-125.

27] For Giovanni della Chiesa see: CAVALCASELLE, *op. cit.*, pp. 94 et seq. *Illustrazione Italiana*, 1888, Vol. I, p. 126. *Archivio storico di Lodi*, 1892, p. 114. *La Patria*, Florence, 1894, p. 406. MALAGUZZI, F., *Pittori Lombardi, op. cit.*, p. 243. VENTURI, A., *op. cit.*, VII, 4, pp. 925-927.

28] For Albertino and Martino Piazza of Lodi see: VASARI-MILANESI, IV, p. 148, n. 1. VENTURI, A., *op. cit.*, VII, 4, pp. 927-928. FERRARI, E., *Albertino e Martino Piazza da Lodi*, in *L'Arte*, 1917, pp. 140-158.

29] For Donato Montorfano see: VASARI-MILANESI, IV, p. 33. MALAGUZZI-VALERI, *Pittori Lombardi, op. cit.*, pp. 7, 15, 16. VENTURI, *op. cit.*, VII, 4, pp. 928-929. SALMI, M., *Gli affreschi in Santa Maria delle Grazie in Milano*, in *Boll. d'Arte*, July 1928.

30] For Agostino da Vaprio see: MALAGUZZI-VALERI, *Pittori Lombardi, op. cit.*, pp. 200, 201. VENTURI, *op. cit.*, VII, 4, p. 928.

31] No authenticated works by Costantino da Vaprio, the most notable member of the Zenoni family, or by Agostino's second brother, Gabriele, are known to exist.

32] For Boccaccio Boccaccino see: VASARI-MILANESI, IV, pp. 581-585, and VI, pp. 459-492. LOMAZZO, *op. cit.*, I, pp. 308-338, 390; II, p. 411. GRANELLI, *Abecedario biografico dei pittori cremonesi*, 1827, pp. 53 et seq. BARUFFALDI, *Vite de' pittori ferraresi*, 1844, I, p. 315. BALDINUCCI, *Note dei professori del disegno*, 1847, II, p. 69. CITTADELLA, *Doc. ed illustraz.*, Ferrara, 1868, pp. 156 and 178. FIORENTINI, *Guida di Ferrara*, p. 108. ALIZERI, *Notizie dei professori del disegno in Liguria*, 1870, I, p. 178. SACCHI, *Not. pitt. cremonesi*, 1872, pp. 38-48, 180, 186, 223, 227, 349. CROWE and CAVALCASELLE, *op. cit.*, 1876, VI, pp. 508-515. *Catalogo dell'Accademia Carrara in Bergamo*, 1881, n. 209. VENTURI, A., *La R. Galleria Estense in Modena*, 1883; *Arch. stor. dell'Arte*, 1894, p. 55; *Arch. stor. lomb.*, 1895; *Catalogo della Galleria Crespi in Milano*, 1900. p. 244. BODE, in *Arch. stor. dell'Arte*, 1890, p. 193. CAMPORI, G., *I Pittori degli Estensi*, 1886, p. 51.

MORELLI, *Le gallerie Borghese e Doria Panfili in Roma,* 1890, pp. 261 and 365 *et seq.*
BURCKHARDT, *Cicerone,* 1909, pp. 795 *et seq.* FRIZZONI, in *Arte e Storia,* 1890, p. 249;
1907, p. 25; also in *Arch. stor. ital,* Fourth Series, col. IV⁄V. CAFFI, in *Arte e Storia,*
1892, p. 199. LUCCHINI, *Il Duomo di Cremona,* 1894, I, p. 145; II, pp. 29, 37, 47⁄60.
SPINAZZOLA, in *Napoli Nobilissima,* 1895, p. 7. *Catalogo dell'Esposizione d'Arte Sacra
in Cremona,* 1899, p. 35. *Catalogo del Museo Civico e Raccolta Correr in Venezia,* 1899,
p. 68. SCHWEITZER, in *L'Arte,* 1900, pp. 41⁄46. LUDWIG, in *Jahrb. der Kgl. preuss.
Kstsamml.,* 1905, p. 10. *Rassegna d'Arte,* 1908, p. 115. *Atti e memorie per le provincie di
Modena e Parma,* Third Series, Vol. III, part II, pp. 525⁄604; for *Romagna,* Third Series,
Vol. VI, pp. 91, 350, 422; Vol. VII, pp. 368, 412. MONTEVERDI, *Su la vita di Maria
dipinta a fresco dal Boccaccino nel Duomo di Cremona,* Cremona, 1910. GRAFF, *Über zwei
Zeichnungen in der graphischen Sammlung in München,* in *Jahrb. der bildend. Kunst,* 1911,
p. 61. VENTURI, A., *op. cit.,* VII, 4, pp. 594⁄595 and 671⁄676; *Un capolavoro del Boc⁄
caccino in Roma,* in *L'Arte,* 1925, pp. 148⁄150; *Studi dal vero, op. cit.,* pp. 174⁄178.

33] This charming work has lost much of its delicacy of colour as a result of retouching
and varnishing. The photograph, taken in its dilapidated condition before the restor⁄
ers touched it, gives a far better idea of its real quality.

34] For Andrea Solario see: SCHLEGEL, in *Rassegna d'Arte,* 1913. BADT K., *Andrea So⁄
lario, sein Leben und seine Werke,* Leipzig, 1914. VENTURI, A., VII, 4, pp. 945⁄978 and
passim. SALMI, A., in *L'Arte,* 1923, p. 157.

35] The Louvre picture of the Head of the Baptist on a Charger also approaches very
closely, as regards the shadowed undulations of the modelling, to the Madonna of the
Green Cushion. In it we find Andrea Solario as intent as any of the old Flemings
on rendering the reflection of the bedizened head in the burnished metal dish which
is placed on a screen with as much solemnity as if it had been set on an altar. Although
morbid and unpleasant details are elaborated with unnecessary care, this singular com⁄
position is worthy to rank among the productions of the artist's best period.

36] Among the followers of Solario was Bernardo Fasolo, who worked in Liguria in the
Santuario del Monte near Genoa (1518). He also worked in San Biagio at Finale
(1520) and San Massimo near Rapallo. The ill⁄drawn and harsh Holy Family in
Berlin, with Joseph and Mary intently reading out of the same book while the Child
lies asleep in his Mother's lap, is very much in Solario's manner, but there is none of
his vivacity in the grave and preoccupied faces.
For Bernardino Fasolo see: VARNI SANTO, *Appunti artistici sopra Levanto,* 1870. ALI⁄
ZERI, *Notizie dei professori del disegno in Liguria,* 1870⁄80, Vol. II, pp. 225, 271; Vol. III,
p. 246. CROWE and CAVALCASELLE, *op. cit.,* VI, p. 89. MORELLI, *La Galleria di*

Berlino, 1893, p. 23. BERNARDINI, in *Rassegna d'Arte,* I, 1901, p. 151. MALAGUZZI, in *Rassegna d'Arte,* 1905, p. 90. SUIDA, *Genua,* 1906, p. 81. FFOULKES-MAIOCCHI, *op. cit.* VENTURI, A., *op. cit.,* VII, 4, pp. 1090-1096.

37] For Agostino da Lodi (the "Pseudo Boccaccino") see: BODE, *Archivio storico d'Arte,* 1890, p. 192. BURCKHARDT, *Der Cicerone,* p. 748. FRIZZONI in *Arte e Storia,* 1890, p. 249; and *Arch. stor. d'Arte,* 1909, p. 127. PAOLETTI and LUDWIG, in *Repert. f. Kstw.,* 1899, p. 456. SCHWEITZER, E., in *L'Arte,* 1900, p. 43. BERENSON, *op. cit.,* pp. 168-169. GEROLA, G., in *L'Arte,* 1908, p. 330. FOGOLARI, G., in *Bollettino d'Arte,* 1908, p. 173; and *Rassegna d'Arte,* 1909, p. 61. MALAGUZZI, F., *Catalogo della R. Pinacoteca di Brera,* 1908, p. 192; also in *Rassegna d'Arte,* 1912. VENTURI, A., *op. cit.,* VII, 4, pp. 978 and 988.

38] For Bartolomeo Suardi (Bramantino) see: VASARI-MILANESI, VI, p. 511. LOMAZZO, *op. cit.,* I, p. 320, and II, pp. 48, 50 and 133. ANONIMO MORELLIANO, *Notizie di opere del disegno,* Frimmel edition, Vienna, 1888. MORIGGIA, *La nobiltà di Milano,* 1595. TORRE, *Il ritratto di Milano,* 1674. DON VENANZO DE PAGAVE, *Biographie Suardis,* Milan. CALVI, *Notizie delle opere del disegno,* Milan, 1865. MONGERI, *L'Arte in Milano,* 1872; *Bramantino e le rovine di Roma al principio del secolo* XVI, Milan 1825. LAYARD, *Handbook of Painting,* London, 1887. MORELLI, *Le Gallerie di Monaco e Dresda, op. cit.,* p. 12. COOK, *Catalogue of the Exhibition of Lombard Paintings, Burlington Fine Arts Club,* London, 1899. MOTTA, E., *Nozze principesche nel '400,* Milan, 1894. FRIZZONI, G., in *L'Arte,* 1901, 1908. LUDWIG, *Jahrb. d. Kunstsamml. d. Allerh. Kaiserh.,* 1901, II, pp. XIV, XXXI. SUIDA, *Die Jugendwerke des B. S.,* in *Jahrb. d. Kunstsamml. d. allerh. Kaiserh.,* Vienna, XXV, 1904, and *Die Spätwerke des B. S.,* id., XXVII, 1905. BERENSON, *op. cit.,* p. 176. FIOCCO, *Il periodo romano di B. S. detto il Bramantino,* in *L'Arte,* 1914. KOOP, *The Bramantino portraits from San Martino di Gugnago,* in *Burl. Mag.,* VIII. VENTURI, A., *op. cit.,* VII, 4, pp. 988-1006 and *passim.* FRIZZONI, G., *Intorno al Bramantino e alle sue presenti relazioni col Luini,* in *Rassegna d'Arte,* July 1915. BERNARDINI, G., *Due disegni di B. S.,* in *Boll. d'Arte,* No. 1, 1915. BORENIUS, *Adoration of the Magi by Bramantino,* in *Burl. Mag.,* July 1916. SALMI, M., in *L'Arte,* 1923, pp. 155-156. VENTURI, A., *Il Bramantino,* in *L'Arte,* 1924, pp. 180-186; *Scelta di rari disegni nei musei d'Europa,* in *L'Arte,* 1926, pp. 5-9; and *Studi dal vero, op. cit.,* pp. 361-364. SUIDA, W., *Bramantino,* in *Cicerone,* XX, 1928, p. 549.

39] Roberto Longhi believes that the Argus was painted by Bramantino. See *L'Arte,* 1916.

40] For Ambrogio de Predis and his kinsman Cristoforo see: BELTRAMI, *Il Libro d'oro Borromeo alla Biblioteca Ambrosiana miniato da Cristoforo Preda,* Milan, Hoepli, 1896; and *Miniature sforzesche di Cristoforo Preda nella Galleria Nazionale di Londra,* in *Rassegna*

d'Arte, I, 1901, p. 28. LOESER, *Un'opera di Ambrogio de Predis* in *Rassegna d'Arte*, 1901. MALAGUZZI, *Ambrogio Preda e un ritratto di B. M. Sforza*, in *Rassegna d'Arte*, 1902, p. 93; and *Pittori Lombardi, op. cit.*, p. 69; *La Corte di Ludovico il Moro*, III. VENTURI, A., *La Galleria Crespi in Milano*, Milan, 1900; *Storia dell'Arte, op. cit.*, VII, 4, pp. 1009′1024; *Per Leonardo da Vinci*, in *L'Arte*, 1919, pp. 1′7; *Studi dal vero, op. cit.*, p. 340. SIRÉN, O., *Leonardo da Vinci*, Brussels, 1928.

41] For Boltraffio see: VASARI′MILANESI, IV, p. 51. LOMAZZO, *op. cit.*, II, p. 382. MO′RELLI, *Le Gallerie Borghese e Doria Panfili*, Leipzig, 1890, p. 207; also *La Galleria di Berlino*, 1893, p. 137. CAROTTI, G., *Le Gallerie nazionali italiane*, IV, 1899, pp. 298 *et seq.* FRIZZONI, G., *Catalogo della Gall. Morelli*, 1892, p. 22; and *La Galleria dell'Ac′cademia Carrara a Bergamo*, 1907, pp. 168, 202, 203; also in *L'Arte*, IV, p. 108. VENTURI, A., *La Galleria Crespi a Milano, op. cit.*,_ p. 23. *Burlington Fine Arts Club, Catalogue of Pictures of the Milanese School*, London, 1899. BERENSON, *op. cit.*, p. 170. VIT′TADINI, in *Arch. storico dell'Arte*, 2nd Series, I, p. 210. RICCI, *Illustrazione italiana*, 1903, I, p. 103. SEIDLITZ, *Leonardo da Vinci*, I, p. 273. MALAGUZZI, F., *Catalogo della R. Pinacoteca di Brera*, Milan, 1908, p. 165; *Il Ritratto femminile del Boltraffio lasciato dal Senatore d'Adda al Comune di Milano*, in *Rassegna d'Arte*, 1912, p. 9. VENTURI, A., *Sto′ria dell'Arte, op. cit.*, VII, 4, pp. 1024, 1041 and IX, 1, 1925, pp. 100′102; *La quadreria di Ludwig Mond*, in *L'Arte*, 1924, p. 204; and *Studi dal vero, op. cit.*, pp. 341′358.

42] See VENTURI, A., *Studi dal vero attraverso le raccolte artistiche d'Europa*, Milan, Hoepli, 1927.

43] For Bernardino de' Conti see: CROWE and CAVALCASELLE, *op. cit.*, p. 80. BODE, in *Jahrb. d. preuss. Kunstsamml.*, 1886; and *Gazette des Beaux′Arts*, 1889. MORELLI, *Gallerie di Berlino*, 1893, p. 136; and *Le Gallerie Borghese e Doria*, Milan, 1897, p. 188. FRIZZONI, in *Arch. stor. dell'Arte*, 2nd Series, III, 1897, 83; and *Gall. Carrara di Ber′gamo*, 1907, p. 51. DELL'ACQUA and CARAGNA SANGIULIANI, *Guida di Pavia*, 1897, p. 105. *Burlington Fine Arts Club, Catalogue of the Milanese Schools*, London 1899. VENTURI, *Gall. Crespi*, Milan, 1900, p. 255; and in *L'Arte*, 1900, p. 438. CA′GNOLA, in *Rassegna d'Arte*, 1905, p. 61. SUIDA, in *Jahrb. d. Kunstsamml. d. Allerh. Kai′serh.*, XXVI, 1903, p. 293. BERENSON, *op. cit.*, 1901, p. 197. SEIDLITZ, *Leonardo da Vinci*, Berlin, 1909, p. 271. NATALI, *Pavia, Guida Artistica*, 1911, p. 145. VENTURI, A., *op. cit.*, VII, 4, pp. 1041′1043.

44] For the author of the Sforza altar′piece in the Brera see: VENTURI, A., in *Arch. stor. dell'Arte*, 1898. LOESER, in *Rassegna d'Arte*, May 1901. MALAGUZZI, in *Rassegna d'Arte*, 1905, p. 44. JACOBSEN, in *Rassegna d'Arte*, 1910, p. 53, note 4. SALMI, M., in *Cronache d'Arte*, Bologna, 1927: *Il Pittore della Pala Sforzesca*.

45] For Marco d'Oggiono see: VASARI-MILANESI, IV, p. 52. BERENSON, *op. cit.* VENTURI, A., *La Galleria Crespi, op. cit.* FRIZZONI, *La Pala di Marco d'Oggiono nella chiesa parrocchiale di Besate,* in *L'Arte,* 1904. VENTURI, A., *op. cit.,* VII, 4, pp. 1054-1057.

46] For Francesco Napoletano see: JUSTI, *Die Leonardischen Altargemälde in Valencia,* in *Rep. f. Kstw.,* 1893. VENTURI, A., *op. cit.,* VII, 4, pp. 1057-1059. CAGNOLA, *Intorno a F. N.,* in *Rassegna d'Arte,* June 1905.

47] For Cesare Magni see: VENTURI, A., *op. cit.,* VII, 4, p. 1060. SALMI M., in *L'Arte,* 1923, p. 158.

48] For Bernazzano see: LOMAZZO, I, p. 320; and II, pp. 425, 444. VASARI-MILANESI, V, pp. 101, 102 (note 1); *Archivio storico dell'Arte,* 1894, p. 266. VENTURI, A., *op. cit.,* VII, 4, pp. 390 and 1072.

49] For the painter of the Madonna of the Scales in the Louvre, see: VENTURI, VII, 4, p. 1070 and IX, 2, p. 243.

50] For Francesco Melzi see: LOMAZZO, *op. cit.,* I, pp. 174 (note 2) and 175. VENTURI, A., *op. cit.,* VII, 4, pp. 1061-1063.

51] For Giampietrino see: VENTURI, A., *La Galleria Crespi, op. cit.* MALAGUZZI, *Catalogo di Brera.* VENTURI, A., *op. cit.,* VII, pp. 1044-1053; and IX, 1, p. 210; *Studi dal vero, op. cit.,* pp. 340-341. SIRÉN, O., *Leonardo,* Brussels, 1928.

52] For Cesare da Sesto see: VASARI-MILANESI, V, 102 (note 1). LOMAZZO, I, 338, 390, 405; II, 71, 181, 412. REYMOND, M., *Cesare da Sesto,* in *Gazette des Beaux-Arts,* April, 1892. PHILIPS, C., *St. John the Baptist, by Cesare da Sesto,* in *Burlington Magazine,* XIII, 1908, p. 34. MALAGUZZI, F., *Cesare da Sesto e un nuovo acquisto alla Pinacoteca di Brera,* in *Rassegna d'Arte,* 1908. FRIZZONI, in *Rassegna d'Arte,* 1901, p. 43. VENTURI, A., VII, 4, pp. 1063-1068. DE LIPHART, E., *Cesare da Sesto allievo nello studio di Lorenzo di Credi,* in *Rassegna d'Arte antica e moderna,* No. 12, December 1921. SALMI, in *L'Arte,* 1923, p. 151.

53] For Bernardino Luini see: VASARI-MILANESI, IV, 59, 585; and VI, 519, 520. LOMAZZO, I, 16, 275, 416; and II, 69, 412, 460. WILLIAMSON, *Bernardino Luini,* in *Great Masters Series,* London, 1899. GORAN, *Masterpieces of Luini.* MALAGUZZI, F., *Pittori Lombardi, op. cit.,* 181, 182. BELTRAMI, L., *Luini, materiale di studio raccolto a cura di L. B.,* Milan, 1911. VENTURI, A., *op. cit.,* VII, 4, pp. 1069 *et seq.* MALAGUZZI, F., *La Carità Romana del Luini,* in *Rassegna d'Arte,* 1916. VENTURI, A., *La quadreria Ludwig Mond,* in *Rassegna d'Arte,* 1924, p. 204; *Storia dell'Arte,* IX, 2, 1926, pp. 742-768; and *Studi dal vero, op. cit.,* p. 364.

54] For Giovanni Beltrano of Pinerolo see: VASARI-MILANESI, V, p. 552 (note 2); and VI, pp. 487 *et seq.* LOMAZZO, II, p. 373.

55] For Martino Spanzotti see: VASARI-MILANESI, VI, p. 403. BREZZA, L., *Miscellanea di Storia Italiana,* I, Turin, 1862. VESME, A., *Martino Spanzotti, maestro del Sodoma,* in *Arch. storico dell'Arte,* 1889, p. 42. MOTTA CIACCIO, L., *Gian Martino Spanzotti,* in *L'Arte,* 1904, p. 441. VENTURI, A., *op. cit.,* VII, 4, pp. 1110-1118. COOK, H., *A note on Spanzotti, the Master of Sodoma,* in *Burlington Magazine,* December 1918. BAUDI DI VESME, *Nuove informazioni intorno a Martino Spanzotti;* and *I principali discepoli di Martino Spanzotti,* Turin, 1918.

56] For Giovanni Mazone of Alessandria see: VENTURI, A., *op. cit.,* VII, 4, pp. 1096-1101.

57] For Giovanni Canavesio of Pinerolo see: ALIZERI, *Notizie dei prof. del disegno in Liguria,* 1870, I, p. 232; II, appendix. BERTEA, E., *Pinerolo,* 1897, pp. 17 *et seq.* TARAMELLI, in *L'Arte,* 1900, p. 168. SUIDA, W., *Genua,* Leipzig, 1906, p. 77. VENTURI, A., *op. cit.,* VII, 4, p. 1096.

58] For Macrino d'Alba see: FLERES, *Macrino d'Alba,* in *Le gall. naz. it.,* Rome, 1897. CIACCIO, L., *Macrino d'Alba,* in *Rassegna d'Arte,* October 1906. FABRICZY, *Macrino d'Alba* (for the triptych at Tortona), in *Repert. f. Kstw.,* XXVIII. ROSSI, G. B., *Macrino d'Allodio (Macrino d'Alba),* in *Burlington Magazine,* May 1909. SANT'AMBROGIO, D., *Il trittico di Macrino nella cappella episcopale di Tortona,* in *Boll. di Storia Partia,* No. V. BISTOLFI, *Macrino d'Alba,* Turin, 1900. WEBER, *Die Begründer der Piemonteser Malerschule im XV. Jah. zum Beginn des XVI. Jahrhunderts,* Strasburg, 1911 (in the series: *Zur Kunstgeschichte des Auslands,* No. 91). VENTURI, A., *op. cit.,* VII, 4, pp. 1103-1110.

59] For Defendente Ferrari see: GAMBA, F., *L'Abbazia di Ranverso e Defendente Ferrari da Chivasso,* in *Atti della Società d'Arch. e Belle Arti,* 1875. BARBARARA, G. C., *Brevi notizie su Defendente de Ferraris e Gandolfino,* Turin, 1898. VENTURI, A., *op. cit.,* VII, 4, pp. 1119-1126. FORATTI, A., *Un'opera sconosciuta di Defendente Ferrari,* in *Rassegna d'Arte,* 1917. BRIZIO, A. M., in *L'Arte,* 1924, pp. 211, 246.

60] For Girolamo Giovenone see: RUSCONI, *Monogr. novaresi,* 1877, p. 161. GAMBA, *L'Arte antica in Piemonte,* 1882, p. 25. COLOMBO, *Artisti vercellesi,* 1883, pp. 269-328. ROCCAVILLA, *L'Arte nel Biellese,* 1905, pp. 43, 46, 137 *et seq.* BERENSON, *North Italian Painters, op. cit.* VENTURI, VII, p. 1126. For detailed biography see THIEME-BECKER, XIV, p. 154.

61] Another Piedmontese artist, Gandolfino d'Asti, painted a polyptych dated 1493, now in the gallery in Turin. It approximates to the work of the late fifteenth-century painters of Liguria. Recollections of Leonardesque Lombard forms may be noted in the

large cartoon by this artist in the Turin gallery representing the Virgin and Child with angelic musicians. Giovanni Perosino painted a St. John Baptist in 1520 — with a doll's face surrounded by a frame of metallic curls.

62] See the reproduction by Rieffel, in *Studien aus der Mainzer Gemäldegalerie*, in *Rep. für Kunstwissenschaft*, 1891.

63] For Gaudenzio Ferrari see: VASARI-MILANESI, VI, p. 518; III, p. 538; and IV, p. 654. CIACCIO, *Il Sacro Monte*, Novara, 1565. LOMAZZO, *op. cit., passim*. BORDIGA, G., *Notizie intorno alle opere di Gaudenzio Ferrari*, Milan, 1821; and *Guida al Sacro Monte di Varallo*, 1851. PERPENTI, A., *Elogio di Gaudenzio Ferrari*, Milan, 1843. COLOMBO, G., *Vita ed opere di Gaudenzio Ferrari*, Turin, 1881. MORELLI, *Die Gal. zu München*, 1891, p. 369; *Die Gal. zu Berlin*, 1893, p. 147; and *Della pittura italiana*, Milan, 1897, p. 177. MOTTA, in *Arch. stor. lombardo*, 1891, p. 260. FRIZZONI, in *Arch. stor. dell'Arte*, 1891, pp. 280-284, 215 et seq. MELANI, *Arte italiana decorativa e industriale*, II, 1891, p. 71. WARSBERG, *Auf den Spuren des G. F., Nachgel. Schriften*, Vienna, 1892, p. 173. MA-RAZZA, in *Arch. stor. dell'Arte*, 1892, p. 145. DAMIANI, in *Arch. stor. dell'Arte*, 1895, pp. 212, 214; 1896, pp. 306-313. LOESER, in *Arch. stor. dell'Arte*, 1897, p. 356. MEYER, in *Repert. für Kunstw.*, XX, 1897, pp. 147-150. ARIENTA, G., *Arte e Storia*, VIII, 1899, p. 234 et seq. VENTURI, A., *La Galleria Crespi*, Milan, 1900, p. 267. FRIZ-ZONI, G., *La Galleria Carrara in Bergamo*, 1907, pp. 22, 52. MONTI, G., *La Cattedrale di Como*, 1896; and *Storia ed Arte nella pianura di Como*, 1901. MALAGUZZI, F., in *Rassegna d'Arte*, 1902, p. 181, and 1904, pp. 63, 73. FRIZZONI, in *L'Arte*, 1901, pp. 103-108. MANARA, A., *Intorno a Gaudenzio Ferrari*, Novara, 1903. OUROUSSOW, *Gaudenzio Ferrari a Varallo e Saronno*, Paris, 1904. HALSEY, *Gaudenzio Ferrari (Great Masters Series)*, London, 1904. CIACCIO, in *L'Arte*, 1905, pp. 232 et seq. TOESCA, in *Rassegna d'Arte*, 1906, p. 42. FRIZZONI, in *Rassegna d'Arte*, 1908, p. 185. COLOMBO, in *Rassegna d'Arte*, 1911, pp. 140-143; and *Gaudenzio Ferrari e la Scuola vigevanese*, Vigevano, 1911. LOMAZZO, G., *Arte Cristiana*, II, 1914, pp. 98 et seq. BRIZIO, A. M., *Studi su Gaudenzio Ferrari*, in *L'Arte*, 1926, pp. 102-120 and 158-178. VENTURI, *La Quadreria Ludwig Mond*, in *L'Arte*, 1924, p. 204; *Madonne del Correggio e di Gaudenzio Ferrari nella Raccolta Borromeo all'Isola Bella*, in *L'Arte*, 1925, pp. 1-4; *Studi dal vero, op. cit.*, p. 358.

64] For Giovanni Antonio Bazzi ("Il Sodoma") see: LOMAZZO, II, p. 220 (note). AR-MELLINI, G. B., *Dei veri precetti della pittura*, Ravenna, Telalami, 1587. UGURGIERI, P., *Pompe sanesi*, Pistoia, printed by Pier Antonio Fortunati, 1649. DELLA VALLE, PA-DRE GUGLIELMO, *Lettere sanesi*, Rome, Lempel, 1736. BOTTARI, *Rome Edition of Va-sari (Life of Sodoma)*, Rome, 1759. BALDINUCCI, *Decennali*, Florence, 1769. MILANESI, *Documenti per la storia dell'arte senese*, Siena, Porri, 1856. BRUZZA, L. *Notizie intorno*

alla patria e ai primi studi del pittore Giovanni Antonio detto il Sodoma, in *Miscellanea di storia italiana*, Vol. I, 1862. FRIZZONI, G., *Nuova Antologia*, August, 1871, Vol. XVII. BOTTARI, *Racc. di lett. sulla pittura, scultura ed architettura scritte dai più celebri personaggi dei sec. XV, XVI e XVII*, Milan, Silvestri, 1872. FRIZZONI, *Intorno alla dimora del Sodoma a Roma nel 1514*, in *Giorn. di erud. d'arte*, Vol. I, No. VII, July 1892. MILANESI, *Storia dell'Arte toscana* (sub *Giovanni Antonio Bazzi e i suoi scolari*) Siena, 1813. VASARI-MILANESI, VI, pp. 579 *et seq*. BAUDI DI VESME, *Martino Spanzotti, maestro del Sodoma*, in *Arch. stor. dell'Arte*, 1889. VENTURI, *La Farnesina*, Collection Edelweiss, Rome, 1890. FRIZZONI, *Arte italiana del Rinascimento*, Milan, 1891. TANFANI and CENTOFANTI, *Notizie d'artisti tratte dai documenti pisani*, Pisa, 1893. SUPINO, I. B., *I pittori e gli scultori del Rinascimento nella Primaziale di Pisa*, Rome, 1894; also in *Arch. stor. dell'Arte*, VI, No. II. MORELLI, G., *Della pittura italiana*, Milan, 1897. BORGHESI and BIANCHI, *Nuovi documenti per la storia dell'Arte senese*. FACCIO, C., *Giovanni Antonio Bazzi*, Vercelli, 1902. LUGANO, P., *Il Sodoma e i suoi affreschi in S. Anna in Camprena presso Pienza*, in *Bull. Senese di Storia patria*, 1902. PEREGO, *Guida illustrata di Monteoliveto Maggiore*, 1903. CUST, L., *Giovanni Antonio Bazzi*, London, 1906. GALLY, *Le Sodoma*, in *Revue de l'Art ancien et moderne*, 1910. VENTURI, A., *op. cit., La pittura del '400*, IV, 1915, pp. 1126-1140; and *La pittura del '500*, II, 1926, pp. 768-809. TOZZI, *La volta della Stanza della Segnatura*, in *L'Arte*, 1927.

65] Some of his other frescoes, such for instance as the Absolution of the two Nuns in the Piccolomini Library, are similarly derived directly from the work of another painter, Pinturicchio, as is also the picture representing St. Benedict laying the Holy Sacrament on the breast of a dead man.

66] For Giacomo Durandi see: ALIZERI, *Notizie dei professori del disegno*, 1870, Vol. II, p. 278. BENSA, *Peinture en Basse Provence*, 1909, pp. 18, 24 *et seq*. BRED, *Brevi notizie inedite*, Nice, 1906, p. 28, and *Questioni d'Arte regionali*, 1911, pp. 26, 81 *et seq*. LALANDE, L. H., in *Gazette des Beaux-Arts*, 1912, I, pp. 291-297, 416, n. I, II, 151; and *Catal. esp. retrosp.*, Nice, 1912, p. 112.

67] There is a polyptych by this artist, representing Our Lady of Pity with Saints, in the Mont-de-Piété at Nice (pl. 76), which displays his better qualities and reveals him as a creator of delicate forms of the Late Gothic type usually met with north of the Alps. The Virgin in the central panel was probably repainted by Brea, whose regularity of form and smooth flesh tints are suggested by the workmanship.

68] For Ludovico Brea see: VASARI-MILANESI, II, p. 448, note 3. SOPRANI-RATTI, *Vite dei pittori genovesi*, 1768, p. 21 *et seq*. LAGRANDE, L., in *Gazette des Beaux-Arts*, XXIII, 1867, p. 188. ALIZERI, *Notizie dei professori del disegno in Liguria*, 1870-80, Vol. II,

pp. 272-287 and 291-331. SCHÄFFER, E., *Giov. Mirallieti e Lodovico Brea*, Nice, 1881.
CAROTTI, in *Archivio storico dell'Arte*, 1895, pp. 462 *et seq.* JACOBSEN, in *Arch. stor. dell'Arte*, 1896, pp. 124 *et seq.* LOGAN, M., in *Gazette des Beaux-Arts*, 1896, II, pp. 491-496.
SUIDA, W., *Genua*, Leipzig, 1906, pp. 78-80. FFOULKES-MAIOCCHI, *Foppa, op. cit.*
MALAGUZZI, F., in *Rassegna d'Arte*, 1909, pp. 86 *et seq*; and 1910, p. 111. POGGI, V.,
in *Arte e Storia*, 1909, pp. 294 *et seq.* FRIZZONI, G., in *L'Arte*, 1909, pp. 255, 259 *et seq.*
VENTURI, A., *op. cit.*, VII, 4, pp. 859, 1078, 1081, 1090, 1093, 1096. LALANDE, L. H.,
Les peintres niçois des XV et XVI siècles, in *Gazette des Beaux-Arts*, May 1912. BORENIUS,
An Annunciation by Lodovico Brea, in *Burlington Magazine*, Vol. XL, No. 231, June 1922.
ROSSI, G., in *Arte e Storia*, 1896, pp. 83 *et seq.*; 1902, p. 60.

69] There is a picture in the Harris collection in which the plan is similar to the Lieuche
Annunciation. It is, however, superior to it as regards the powerful modelling of the
drapery the thick folds of the boldly-drawn features of the Virgin, and the striking
high relief. Its simplicity of form is very attractive. The plan is one imported from
Flanders, with the Angel of the Annunciation visualized as a pedagogue and wearing
priestly vestments; but it seems probable that the painter had already seen the work of
Foppa and had learnt from him how to increase the relief by intensifying the shadows.

70] For Francesco Brea (son of Ludovico) and Antonio (brother of L.) see: ALIZERI,
op cit., II, pp. 287, 289-291; and Appendix, p. XIX. ROSSI, G., *op. cit.*, pp. 83 *et seq.*
SUIDA, *op. cit.*, p. 89. VENTURI, A., *op. cit.*, VII, 4, p. 1090. For Antonio: ALIZERI,
op. cit., pp. 287, 289; and Appendix, pp. XIX *et seq.* ROSSI, G., *op. cit.*, pp. 83 *et seq.*
FRIZZONI, in *L'Arte*, 1909, pp. 259 *et seq.* VENTURI A., *op. cit.*, VII, 4, pp. 1090-1091.

GEOGRAPHICAL INDEX

VIENNA
 Kunsthistorisches Museum: Ambrogio de Predis, *Portraits of Massimiliano I and Bianca Maria Sforza, 56.*

VILLAFRANCA
 Oratory of the Mission: *Piedmontese paintings, 63-64.*

VILLARS-DU-VAR
 Chapel of the Penitents: Unknown artist, *Annunciation, 88.*

VINCOLIA VILLAR SAN COSTANZO
 Sant'Antonio: Unknown Piedmontese Master, *Pictorial decoration, 63;* plate 50.

ZURICH
 Museum: Francesco Napoletano, *Altar-piece, 59-60.*

INDEX OF ARTISTS

PLATES I-80

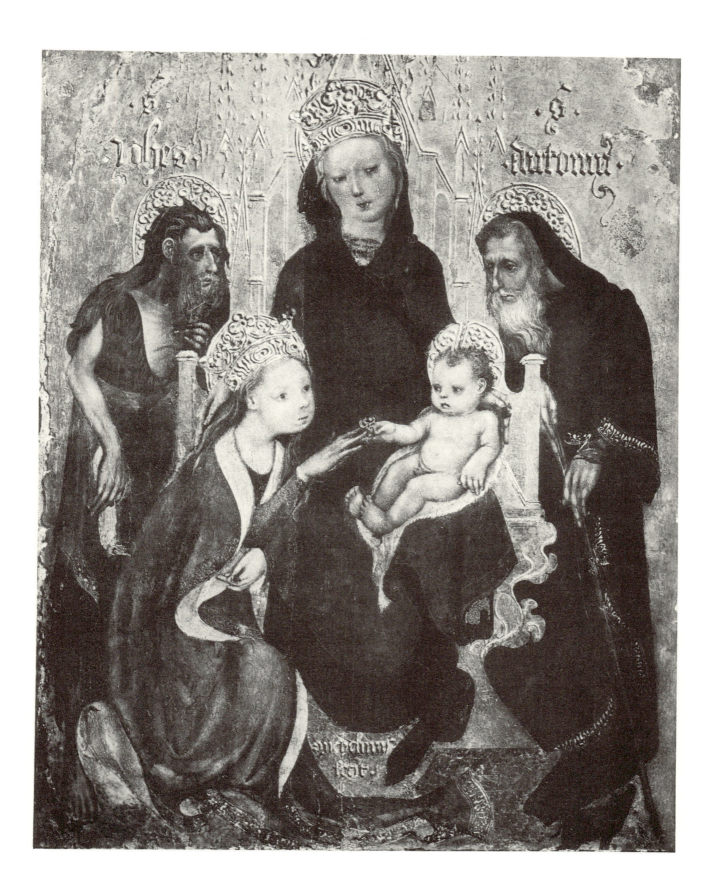

1

MICHELINO DA BESOZZO
Altar-piece: The Madonna and Child, St. Catherine,
St. Anthony and St. John.
Siena. Accademia di Belle Arti

Photo Alinari

2

LEONARDO DA BESOZZO
The Eternal Father and the Coronation of the Virgin.
NAPLES. SAN GIOVANNI A CARBONARA
Photo Anderson

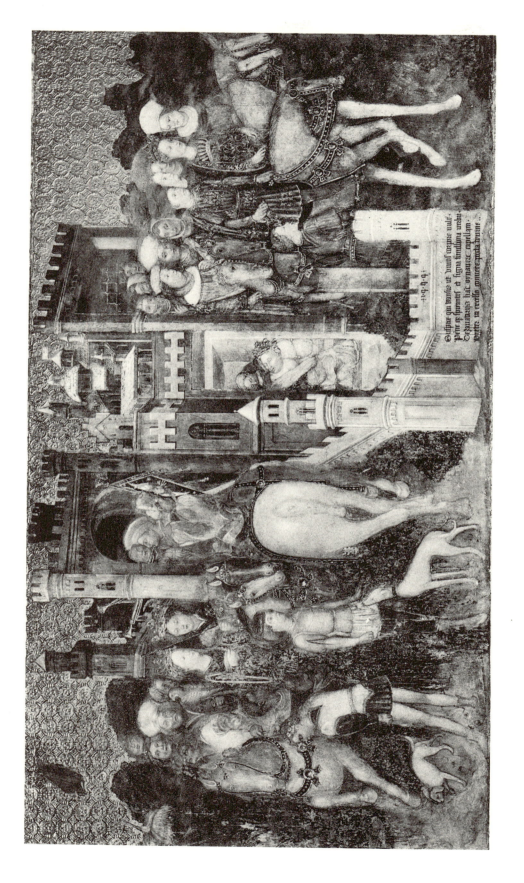

THE BROTHERS ZAVATTARI

Episodes from the story of Theodolinda.

Monza. Cathedral

Photo Alinari

3

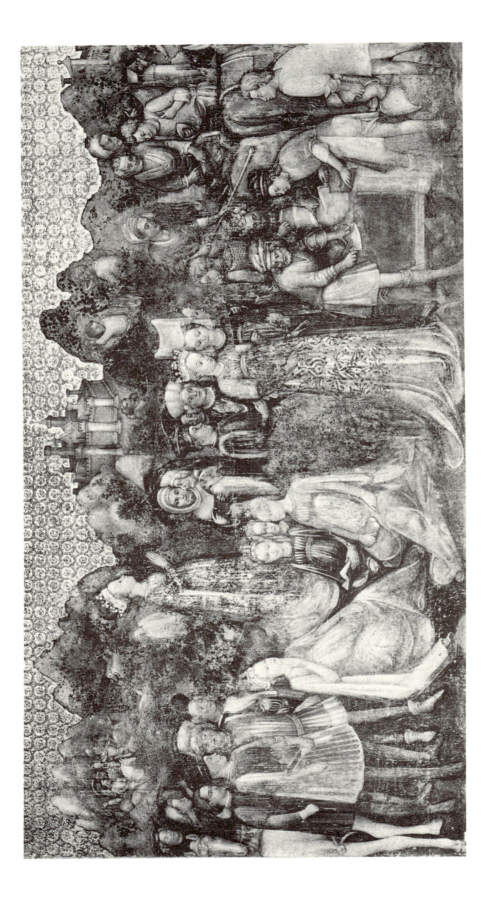

4

THE BROTHERS ZAVATTARI
Episodes from the story of Theodolinda.
MONZA. CATHEDRAL
Photo Alinari

5

BENEDETTO BEMBO
Polyptych.
Formerly in the Castle of Torrechiara

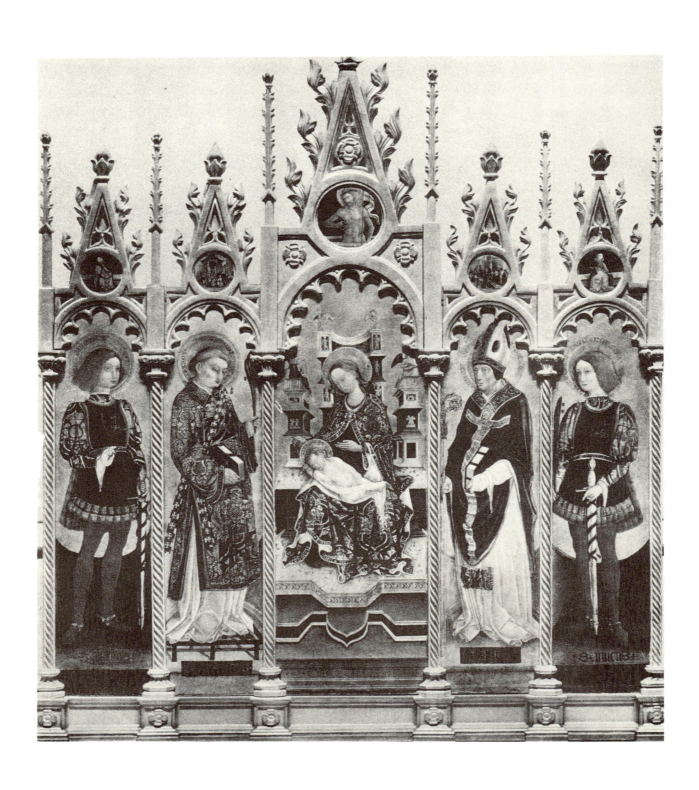

6

PAOLO DA BRESCIA

Polyptych.

TURIN. PINACOTECA

Photo Anderson

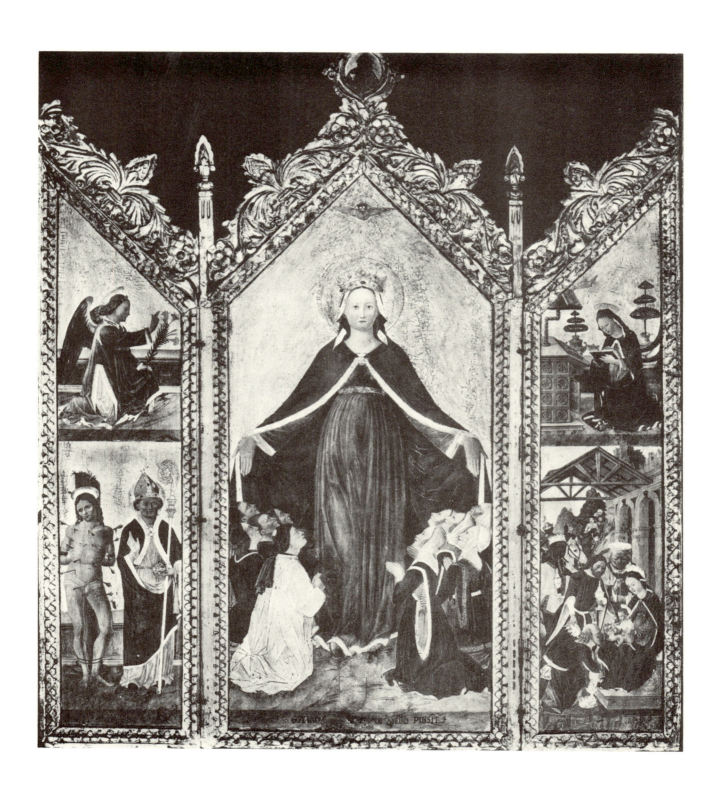

GOTTARDO SCOTTI
Our Lady of Pity.
MILAN. MUSEO POLDI-PEZZOLI
Photo Alinari

8

VINCENZO FOPPA
St. Peter Martyr healing a Young Man.
MILAN. CHURCH OF SANT'EUSTORGIO
Photo Bonomi

9

VINCENZO FOPPA
Death of St. Peter Martyr.
MILAN. CHURCH OF SANT'EUSTORGIO
Photo Bonomi

10

VINCENZO FOPPA
The Crucifixion.
BERGAMO. ACCADEMIA CARRARA
Photo Anderson

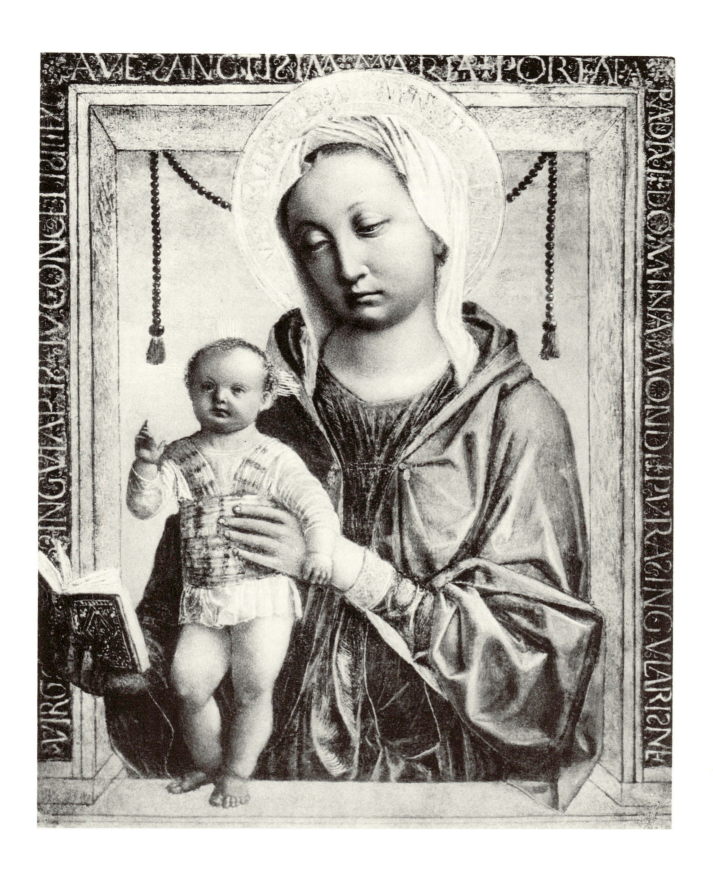

11

VINCENZO FOPPA
Madonna and Child.
MILAN. CASTELLO SFORZESCO

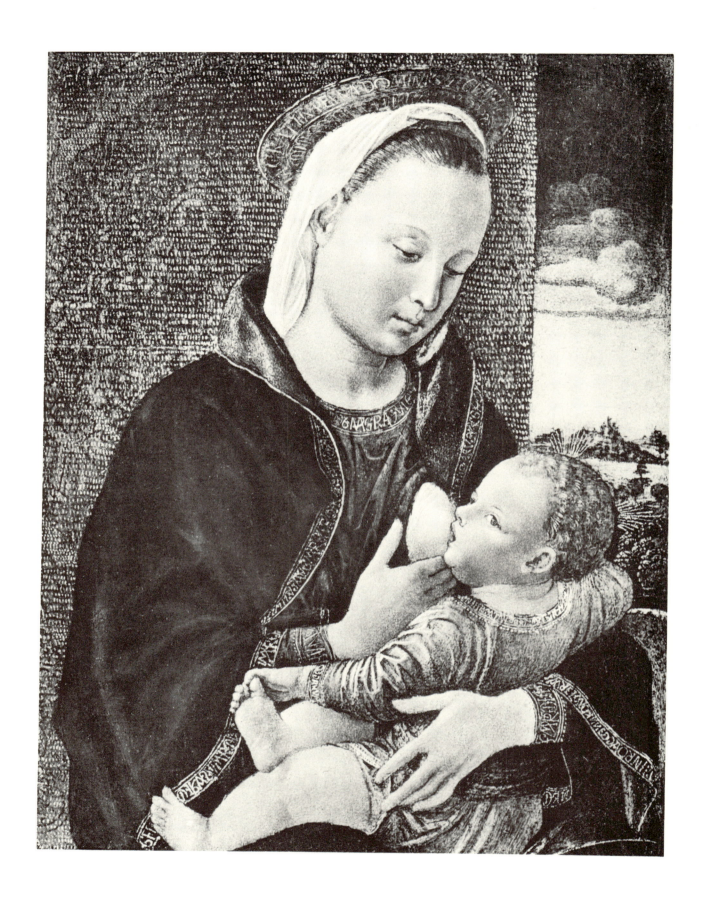

12

VINCENZO FOPPA
Madonna and Child.
Settignano. Berenson Collection

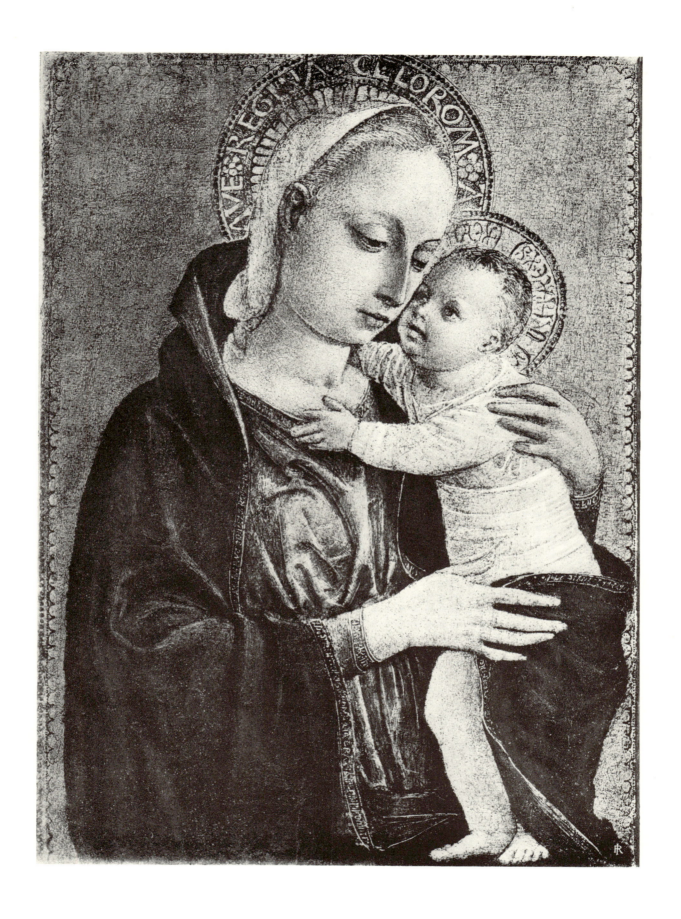

13

VINCENZO FOPPA
Madonna and Child.
MILAN. TRIVULZIO COLLECTION
Photo Anderson

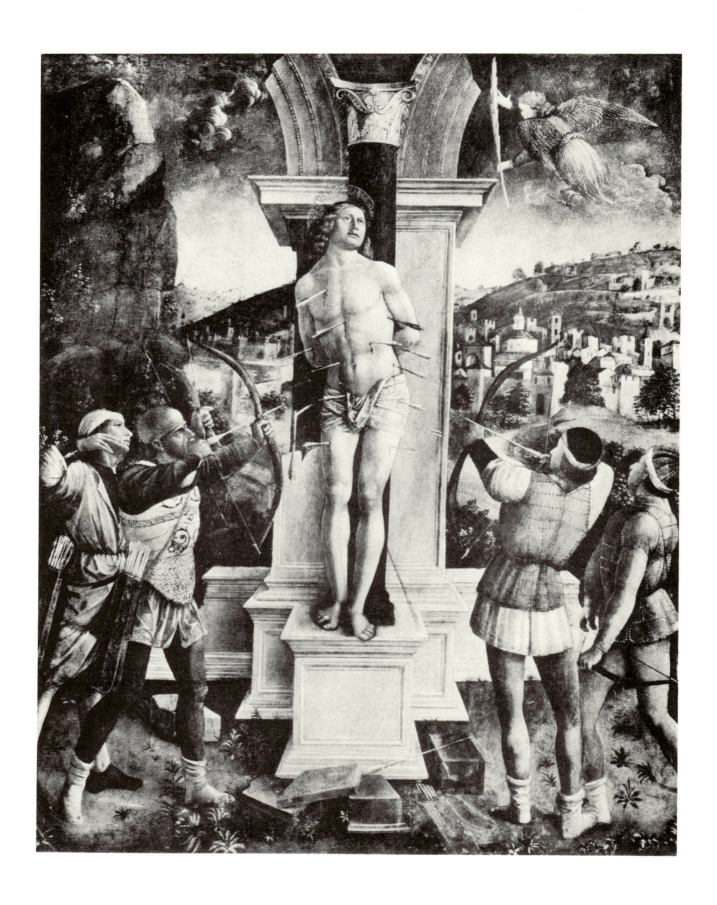

14

VINCENZO FOPPA
The Martyrdom of St. Sebastian.
MILAN. CASTELLO SFORZESCO
Photo Anderson

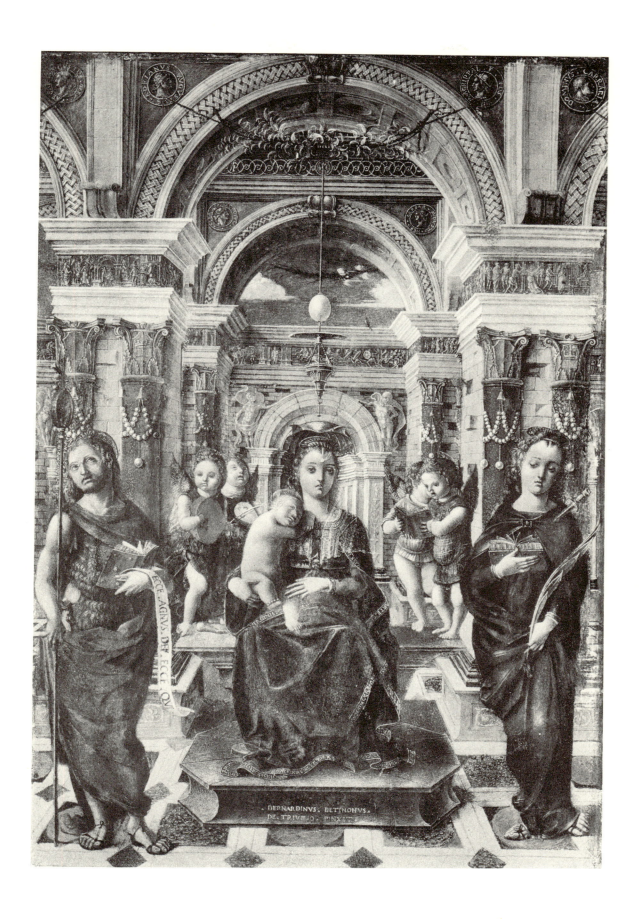

15

BERNARDINO BUTINONE
Altar-piece.
ISOLABELLA. PALAZZO BORROMEO
Photo Alinari

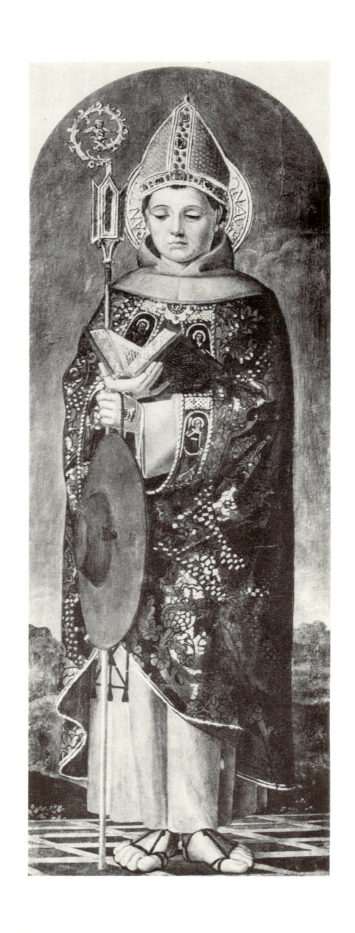

16

BERNARDINO BUTINONE

St. Bonaventura.

MILAN. GALLERIA AMBROSIANA

Photo Dino Zani & Co.

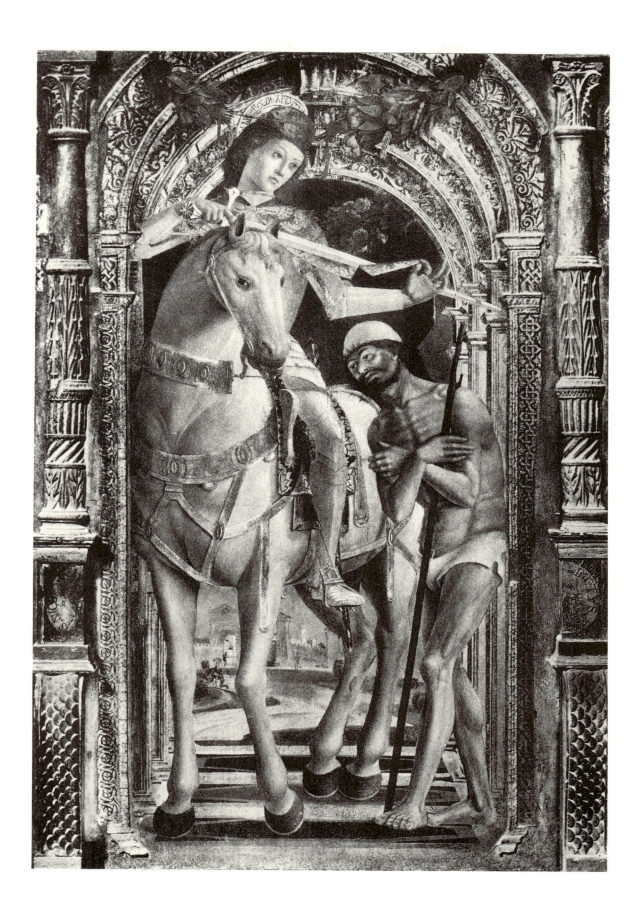

17

BERNARDINO BUTINONE
Panel from the altar-piece.
TREVIGLIO. CATHEDRAL
Photo Anderson

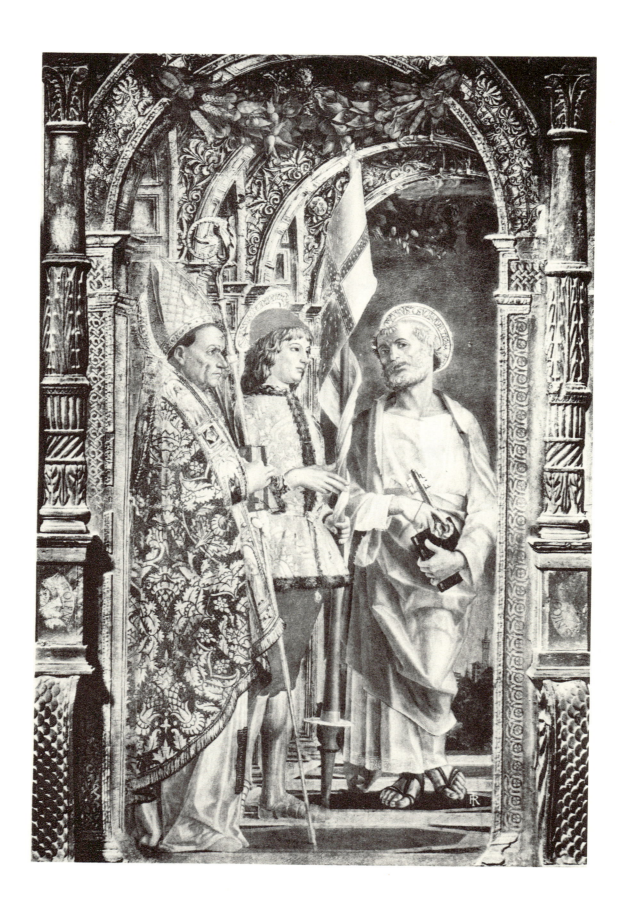

18

BERNARDO ZENALE
Panel from the altar-piece.
TREVIGLIO. CATHEDRAL

Photo Anderson

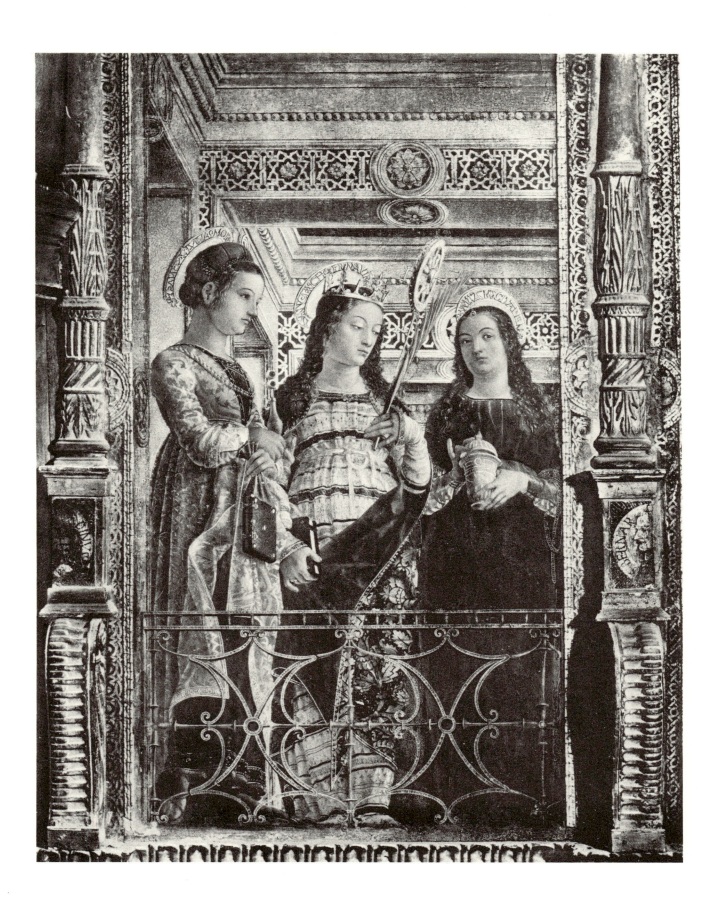

19

BERNARDO ZENALE
Panel from the altar-piece.
TREVIGLIO. CATHEDRAL
Photo Anderson

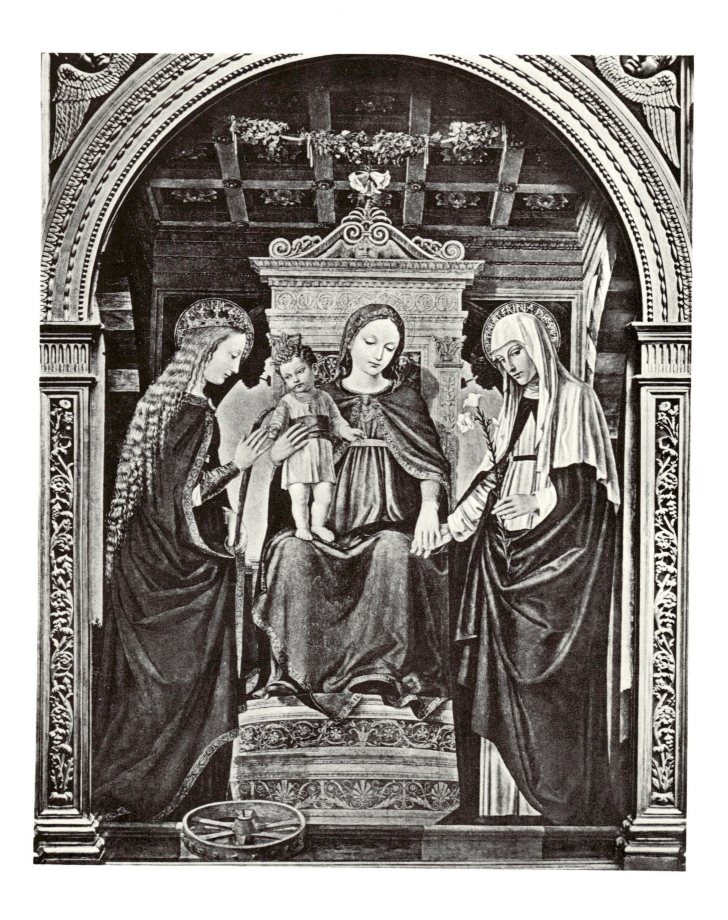

20

AMBROGIO DA FOSSANO called BORGOGNONE
Madonna and Child, with St. Catherine of Alexandria and
St. Catherine of Siena.
LONDON. NATIONAL GALLERY
Photo Hanfstaengl

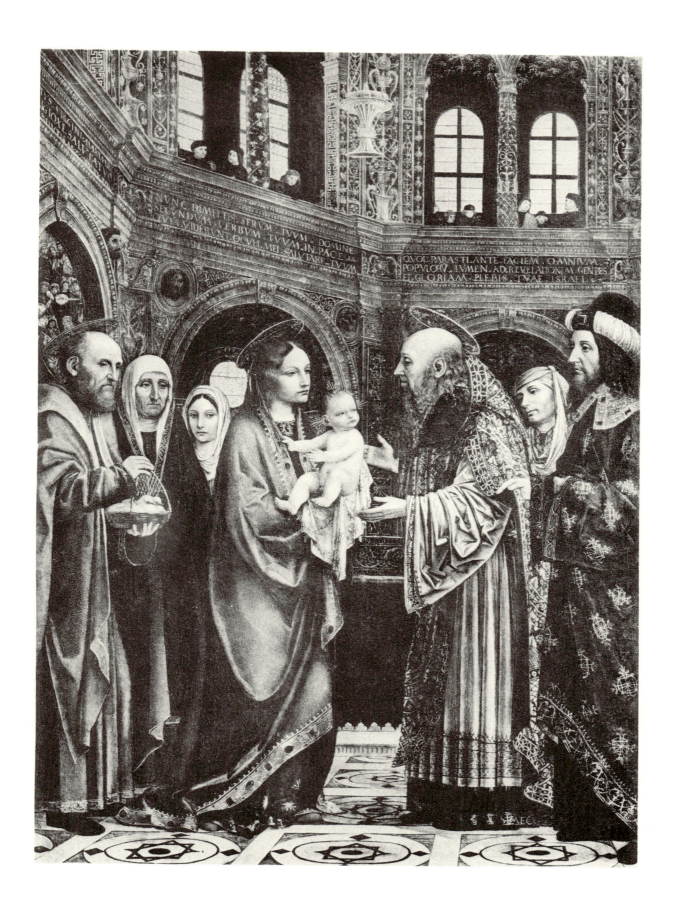

21

AMBROGIO DA FOSSANO called BORGOGNONE
The Presentation of Jesus in the Temple.
LODI. CHURCH OF THE INCORONATA
Photo Anderson

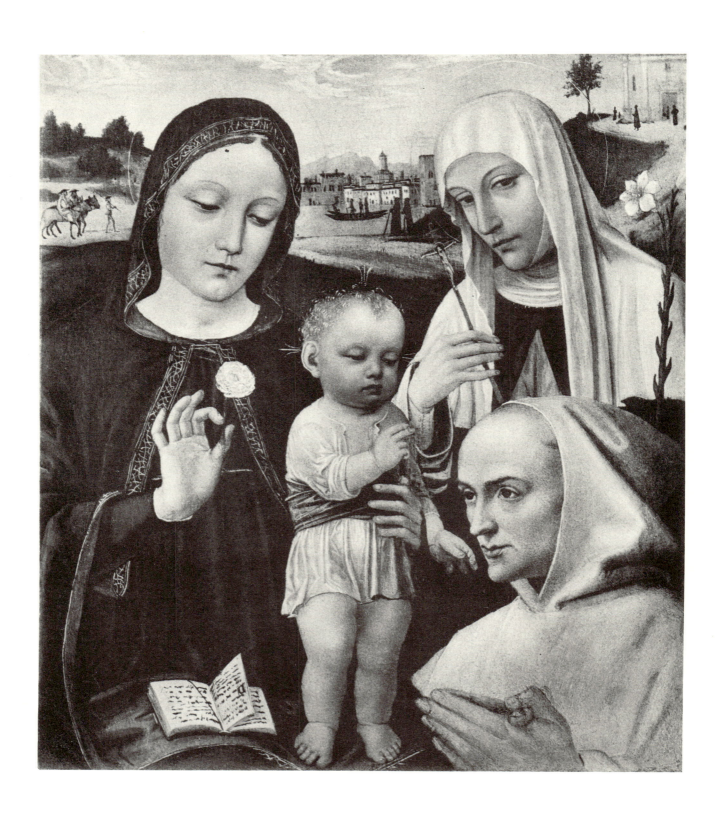

22

AMBROGIO DA FOSSANO called BORGOGNONE
Madonna and Child, with St. Catherine of Siena and a
Carthusian monk.
MILAN. BRERA
Photo Anderson

23

UNKNOWN LOMBARD MASTER
The Annunciation.
PARIS. MUSÉE DU LOUVRE

Photo Alinari

24

VINCENZO CIVERCHIO
St. Stephen and St. Anthony.
MILAN. MUSEO POLDI-PEZZOLI
Photo Bassani

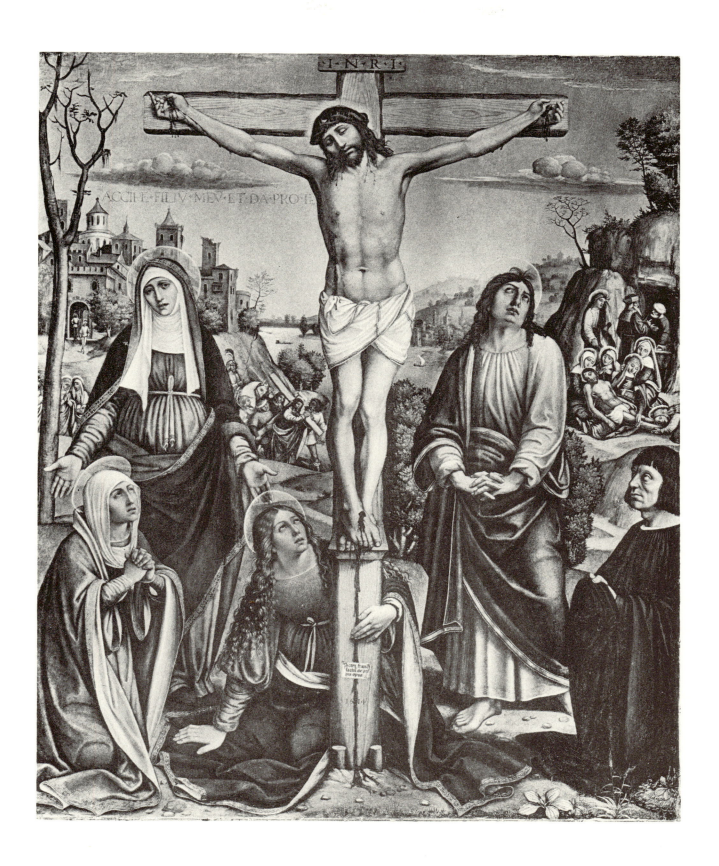

25

PIER FRANCESCO SACCHI
The Crucifixion.
BERLIN. KAISER FRIEDRICH MUSEUM
Photo Hanfstaengl

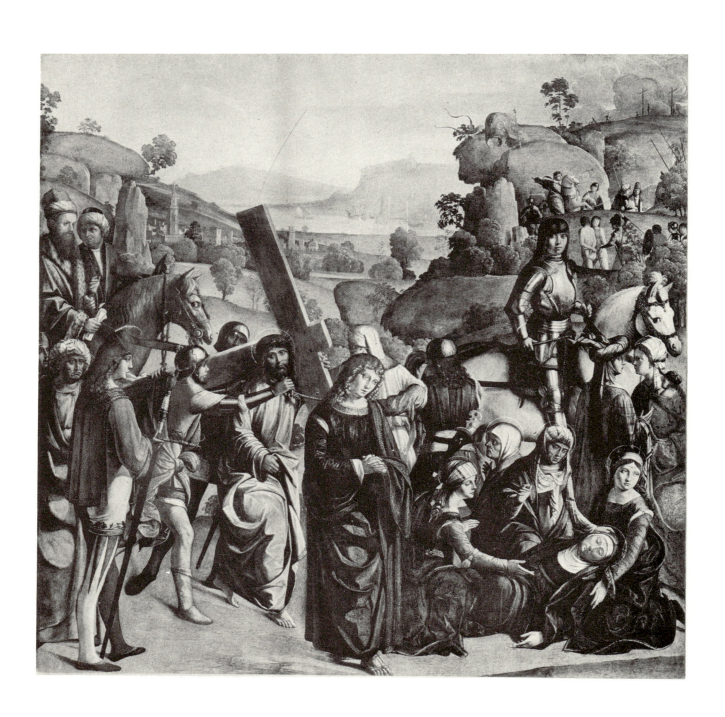

26

BOCCACCIO BOCCACCINO
Christ on the way to Calvary.
LONDON. NATIONAL GALLERY
Photo Hanfstaengl

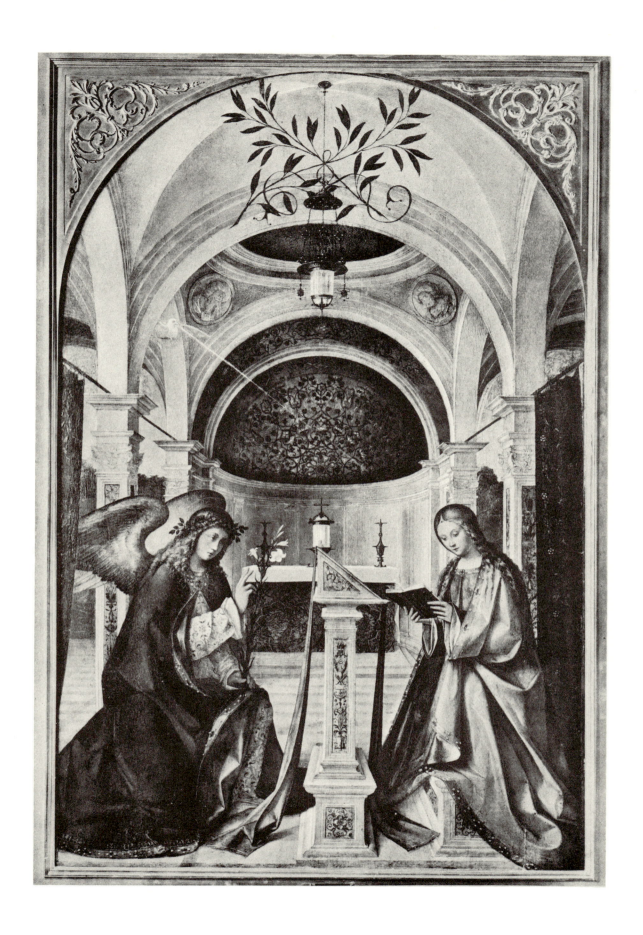

27

BOCCACCIO BOCCACCINO
The Annunciation.
ROME. BONCOMPAGNI COLLECTION
Photo Anderson

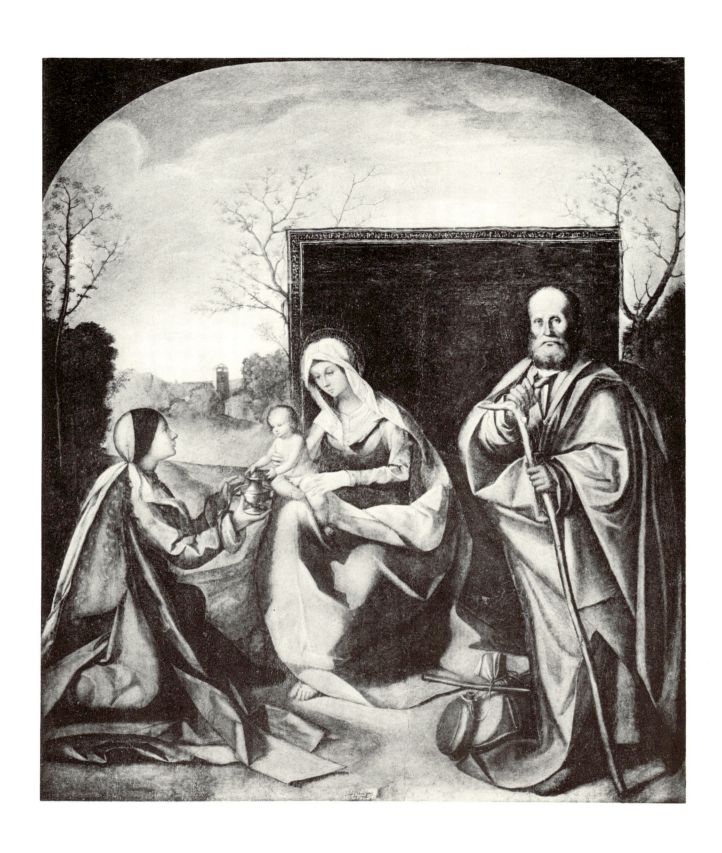

28

SCHOOL OF BOCCACCIO BOCCACCINO
The Holy Family with St. Mary Magdalen.
CREMONA. SANT'AGATA

Photo Alinari

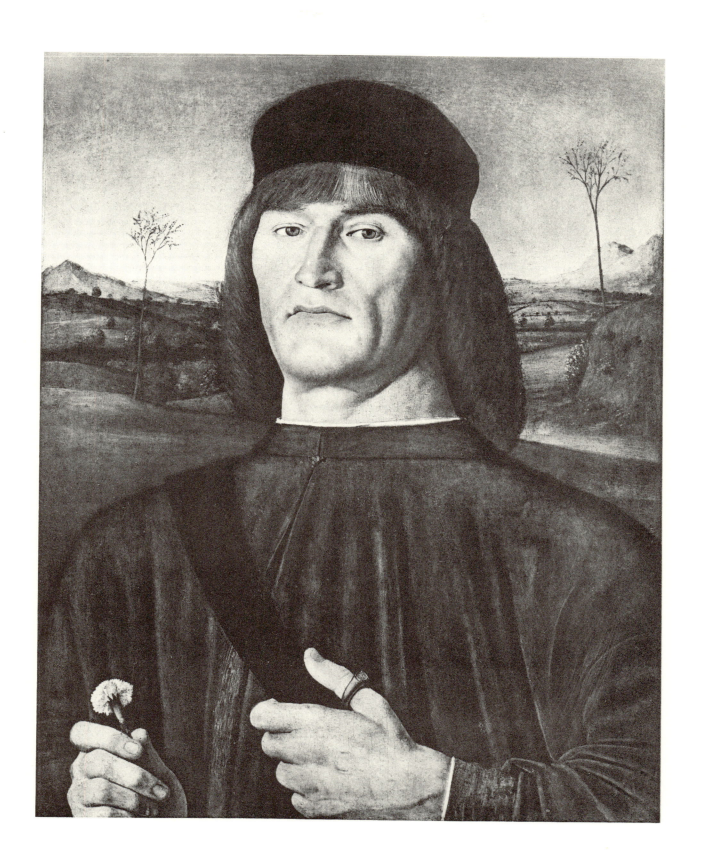

29

ANDREA SOLARIO
Portrait of a Venetian Senator.
LONDON. NATIONAL GALLERY
Photo Anderson

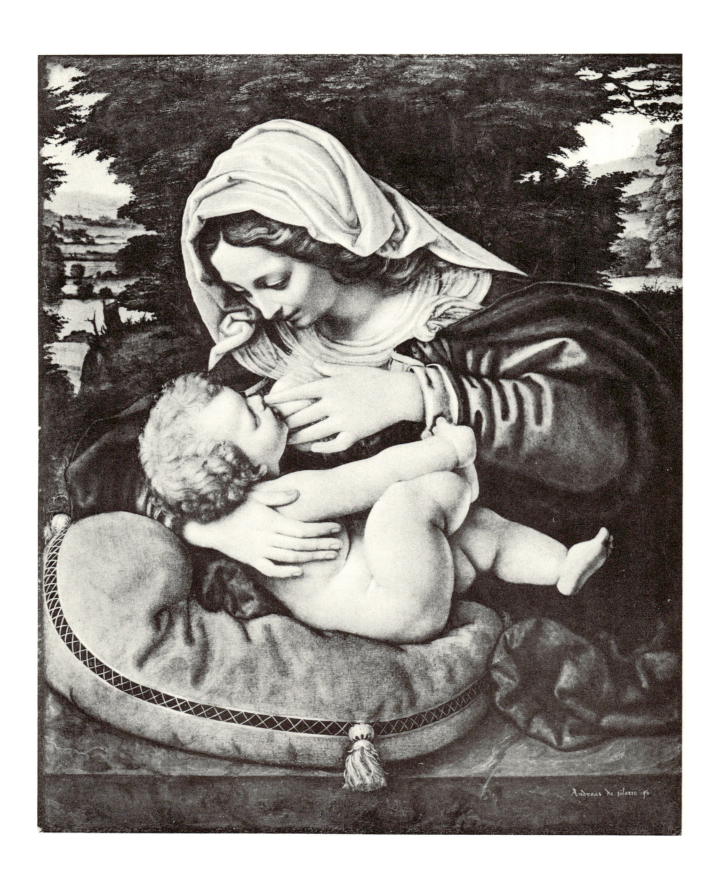

30

ANDREA SOLARIO
The Madonna of the green cushion.
PARIS. MUSÉE DU LOUVRE
Photo Alinari

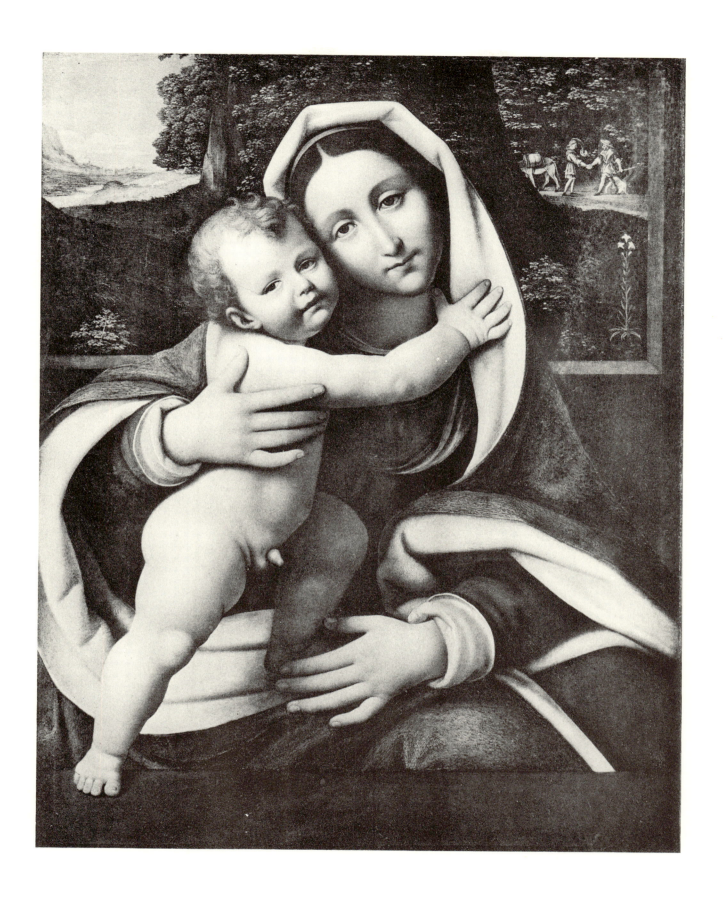

31

ANDREA SOLARIO
Madonna and Child.
LONDON. NATIONAL GALLERY
Photo Anderson

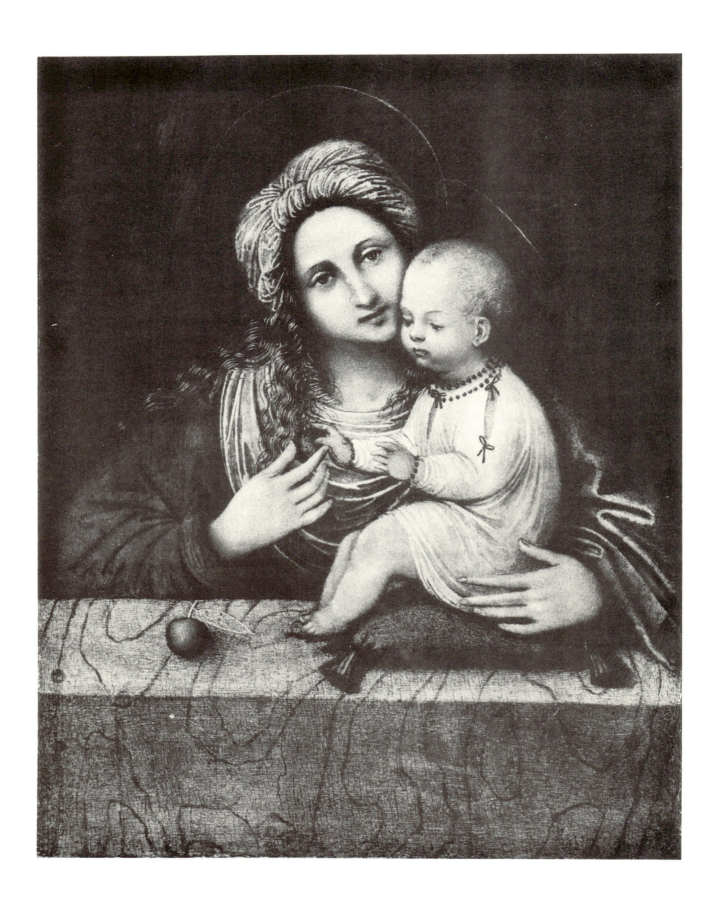

32

AGOSTINO DA LODI
Madonna and Child.
MILAN. ALBERTINI COLLECTION
Photo Anderson

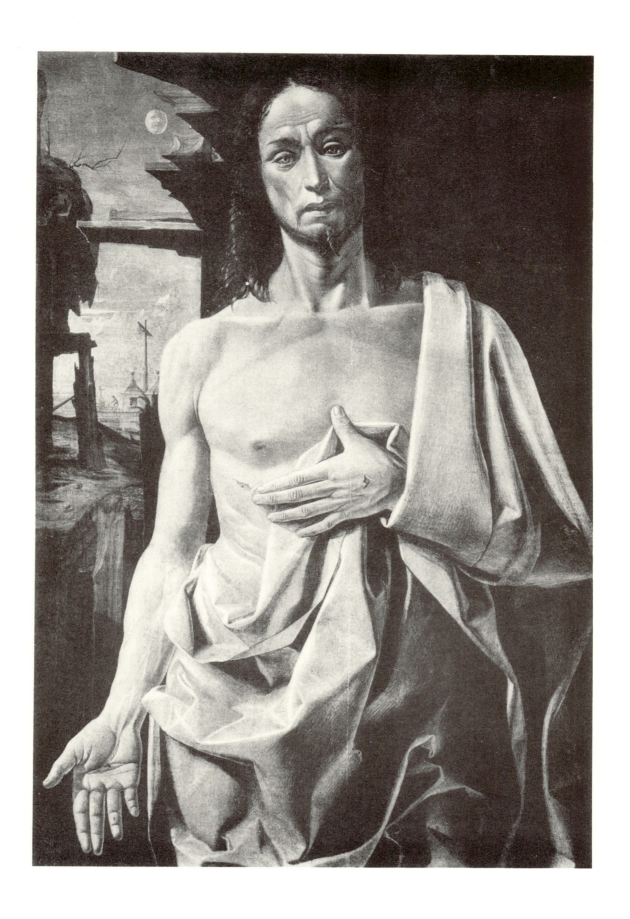

33

BRAMANTINO
Ecce Homo.
MILAN. SORANZO COLLECTION
Photo Zani

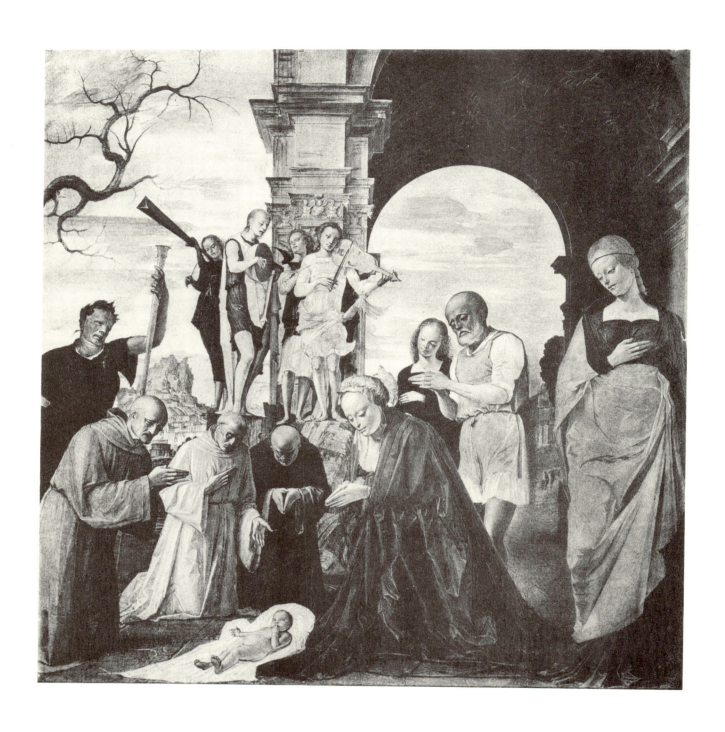

34

BRAMANTINO
Nativity.
Milan. Galleria Ambrosiana
Photo Anderson

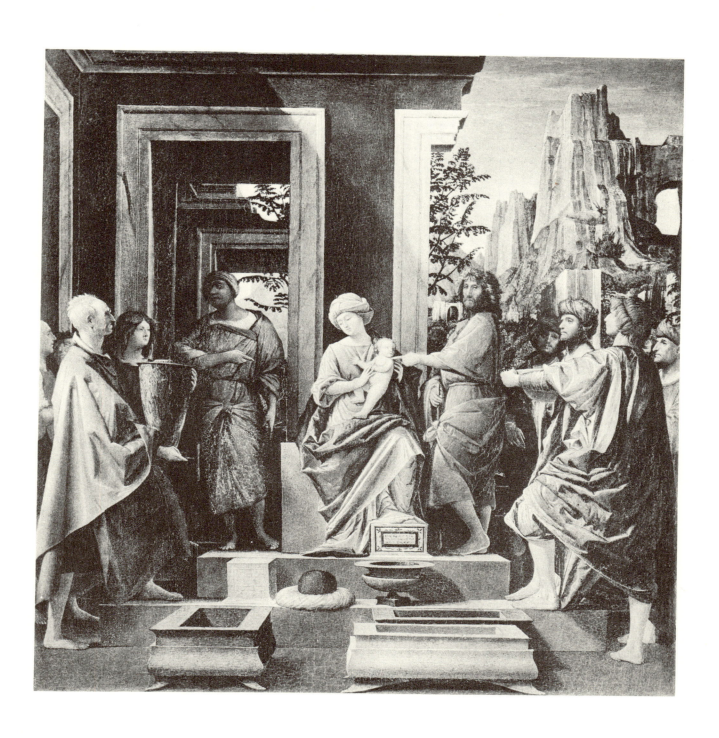

35

BRAMANTINO
The Adoration of the Magi.
LONDON. NATIONAL GALLERY

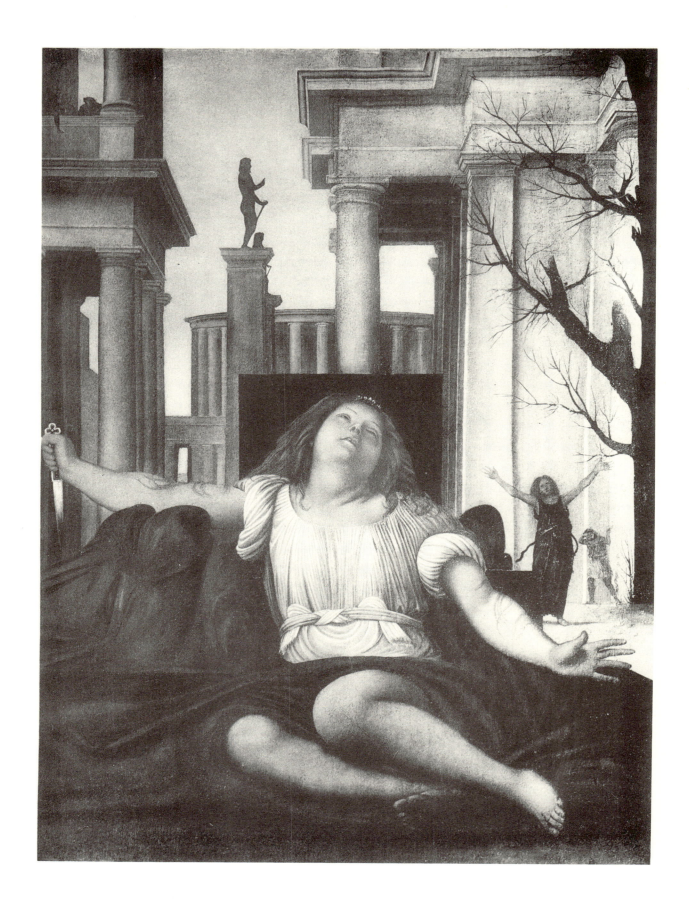

36

BRAMANTINO
Lucretia.
MILAN. SOLA CABIATI COLLECTION
Photo Zani

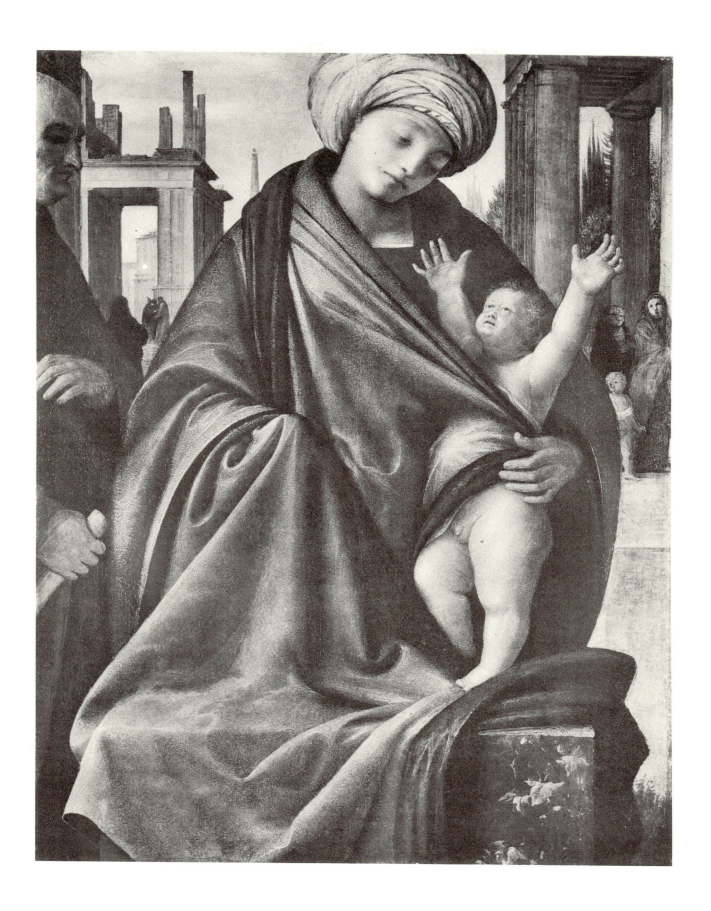

37

BRAMANTINO
The Holy Family.
MILAN. BRERA
Photo Anderson

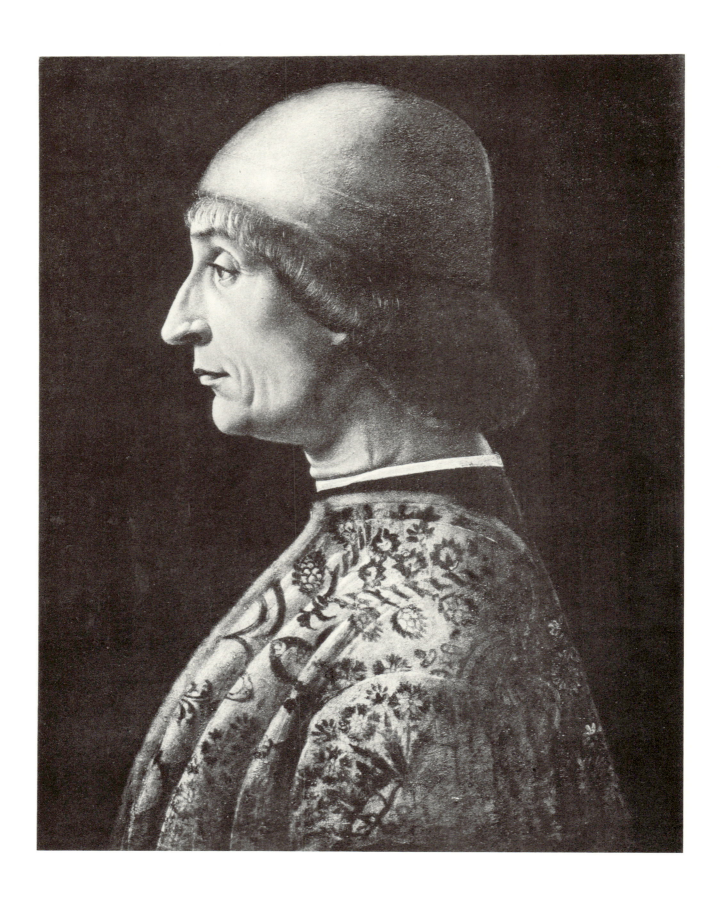

38

AMBROGIO DE PREDIS
Portrait.
MILAN. MUSEO POLDI-PEZZOLI
Photo Anderson

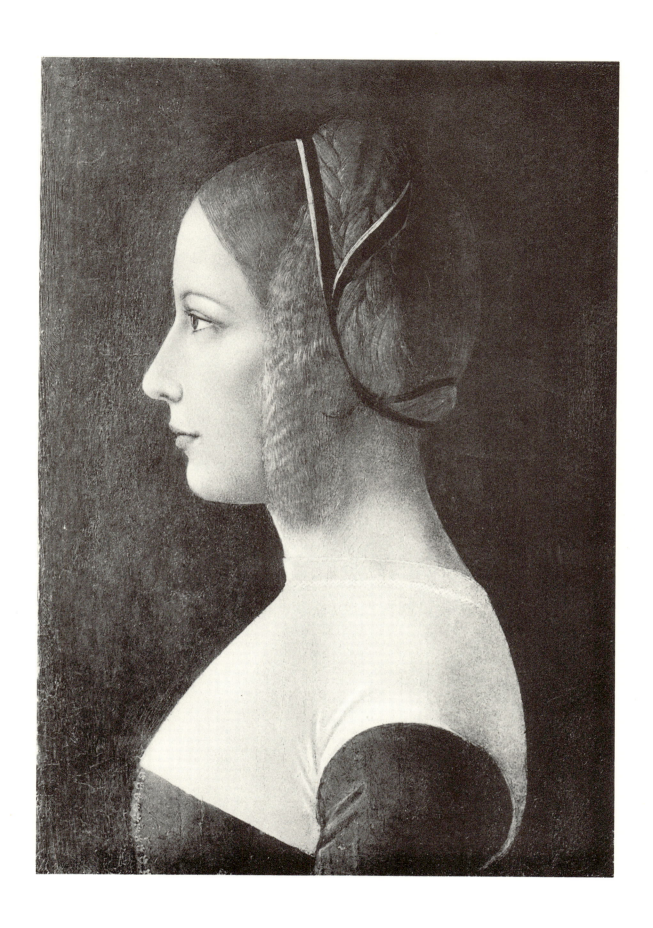

39

AMBROGIO DE PREDIS
Portrait of a Lady.
AMSTERDAM. RIJKSMUSEUM

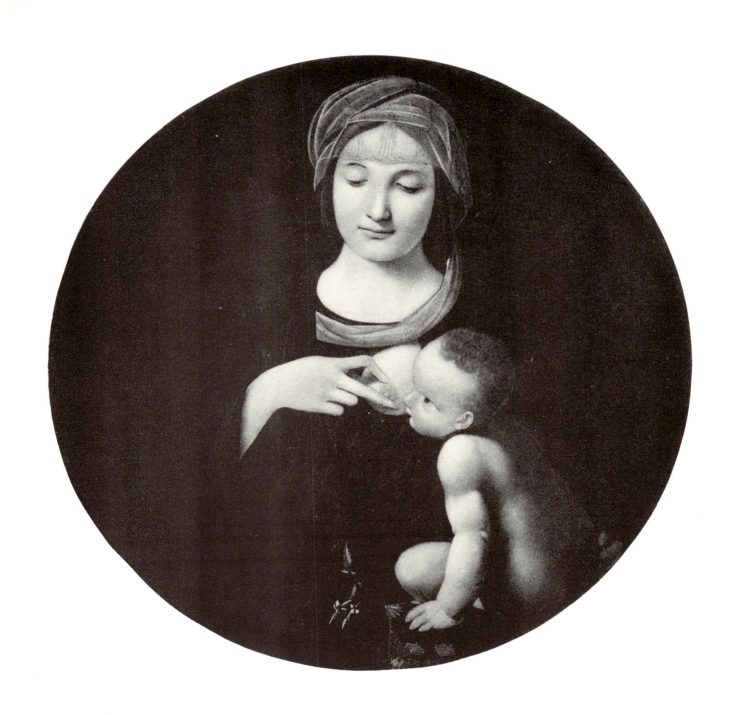

40

G. A. BOLTRAFFIO
Madonna and Child.

BERGAMO. ACCADEMIA CARRARA

Photo Anderson

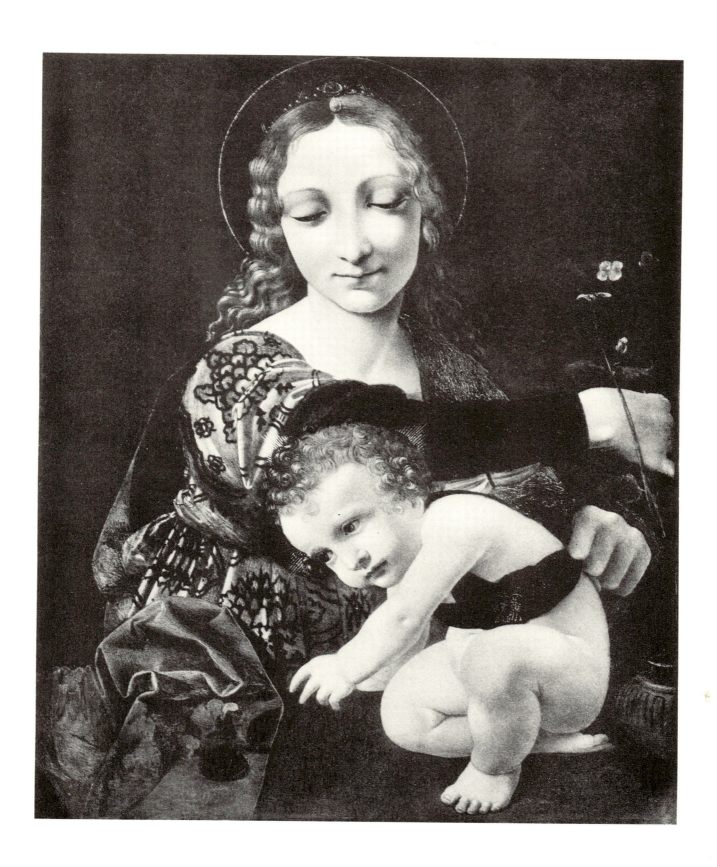

41

G. A. BOLTRAFFIO
Madonna and Child.
MILAN. MUSEO POLDI-PEZZOLI
Photo Anderson

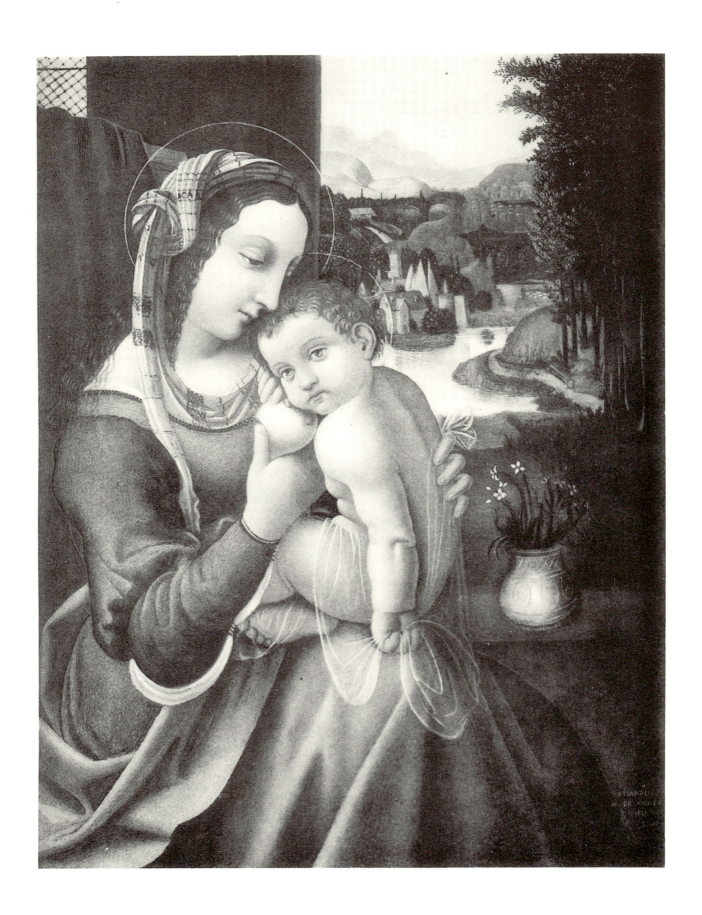

42

BERNARDINO DE' CONTI
Madonna.
BERGAMO. ACCADEMIA CARRARA
Photo Anderson

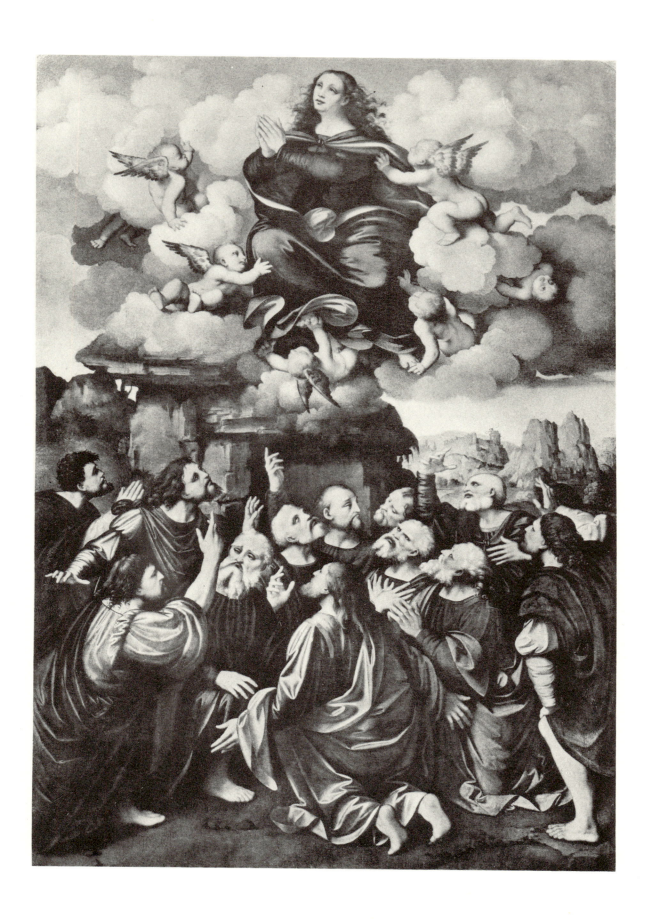

43

MARCO D'OGGIONO
The Assumption of the Virgin.
MILAN. BRERA
Photo Alinari

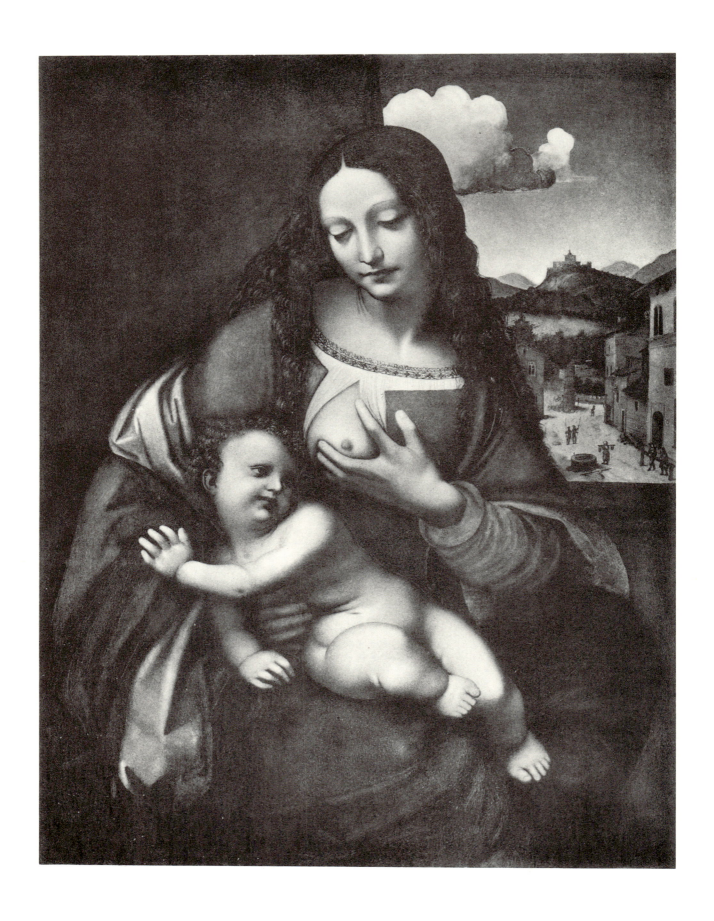

44

GIAMPIETRINO
Madonna.
ROME. GALLERIA BORGHESE

Photo Anderson

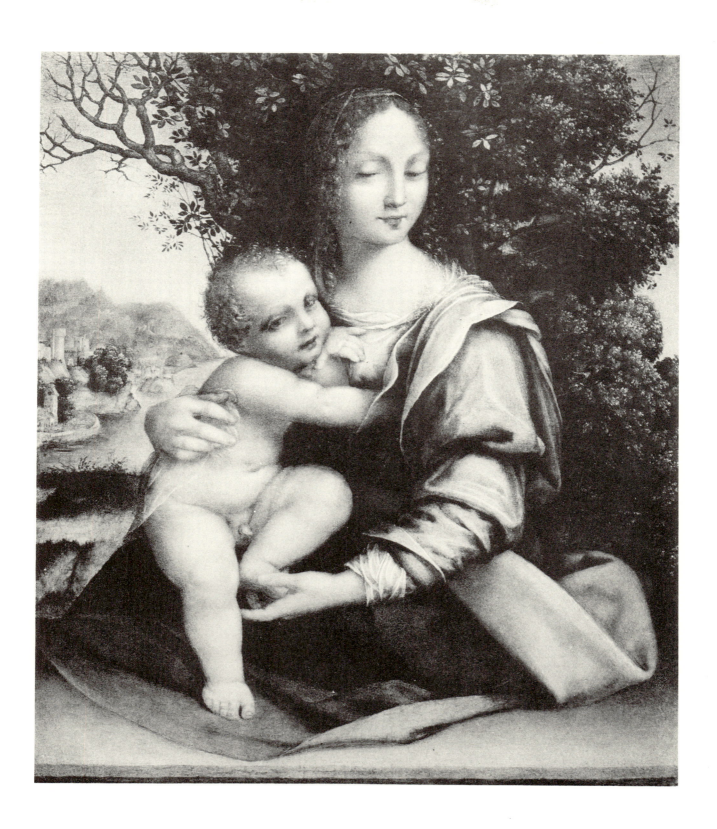

45

CESARE DA SESTO
Madonna and Child.
MILAN. BRERA
Photo Anderson

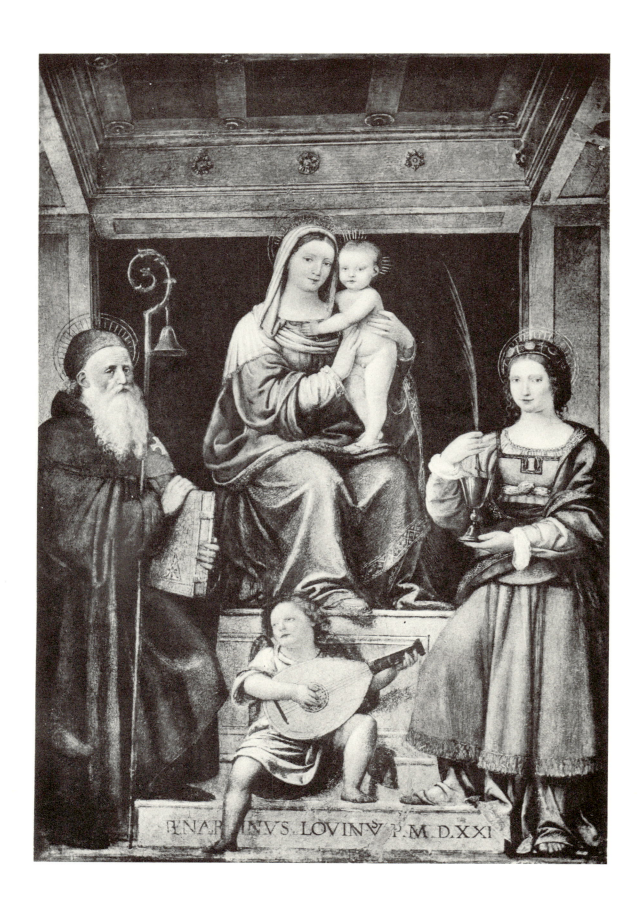

46

BERNARDINO LUINI
Altar-piece.
MILAN. BRERA
Photo Alinari

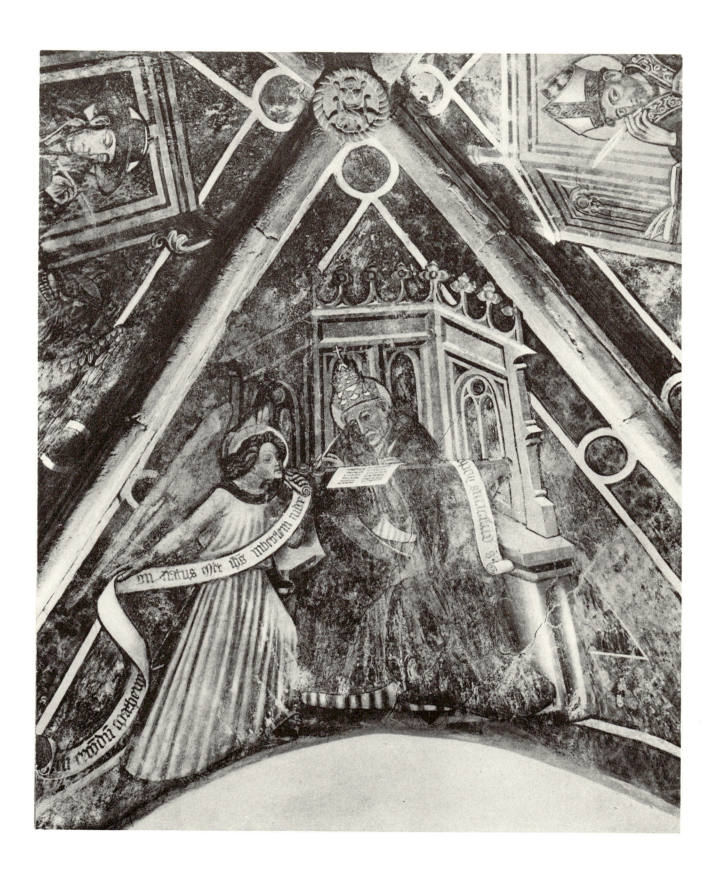

47

UNKNOWN PIEDMONTESE MASTER
Frescoes.
PIANEZZA. CHURCH OF SAN PIETRO

Photo Ist. It. d'Arti Grafiche, Bergamo

48

UNKNOWN PIEDMONTESE MASTER
A Bishop-Saint.
BUTTIGLIERA ALTA. CHURCH OF SANT'ANTONIO DI RANVERSO
Photo Ist. It. d'Arti Grafiche, Bergamo

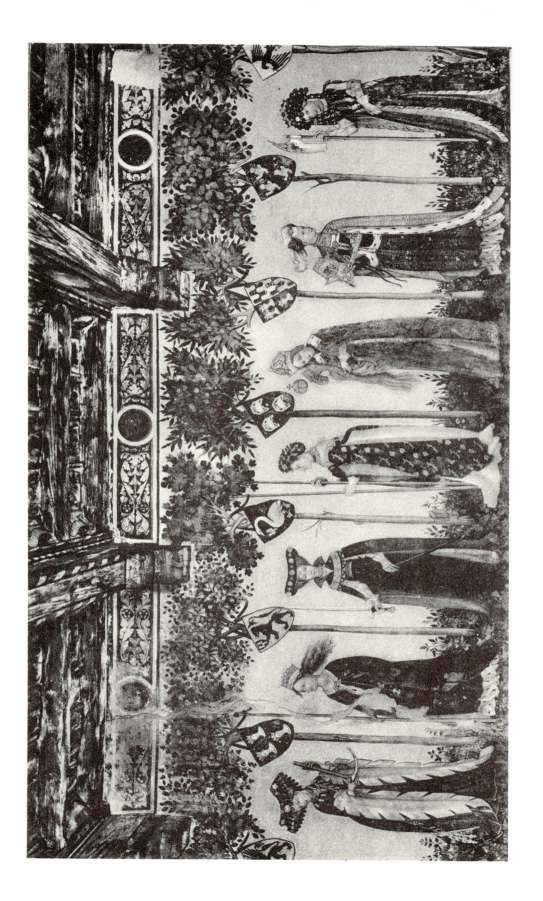

UNKNOWN PIEDMONTESE MASTER
Heroines. Details from the decoration of a room.
MANTA NEAR SALUZZO. CASTLE
Photo Alinari

49

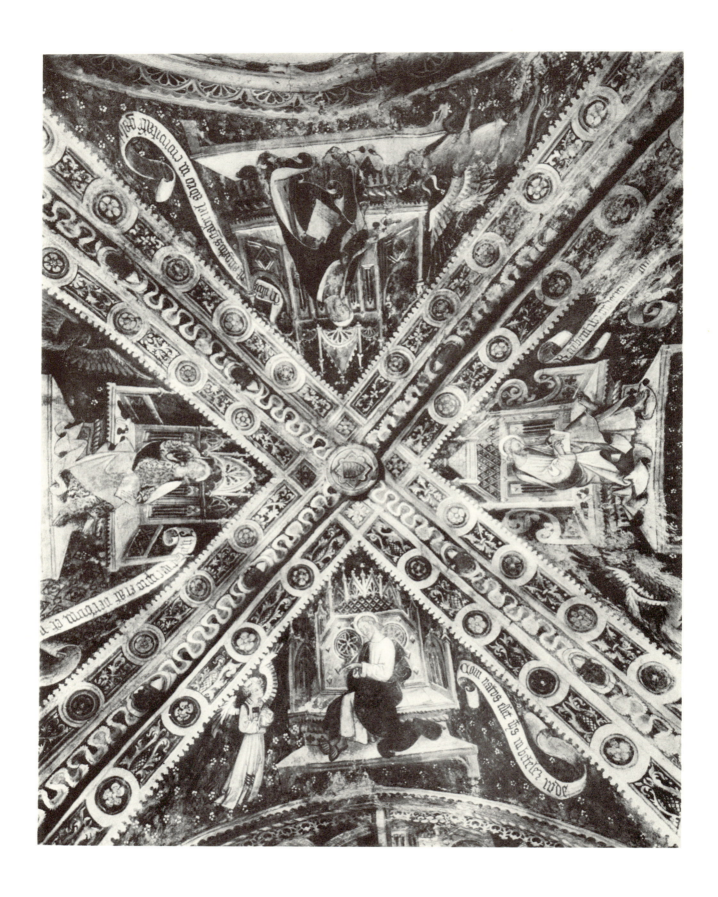

50

UNKNOWN PIEDMONTESE MASTER
Frescoes from a ceiling.
Vincolia Villar San Costanzo. Church of San Pietro
Photo Ist. It. d' Arti Grafiche, Bergamo

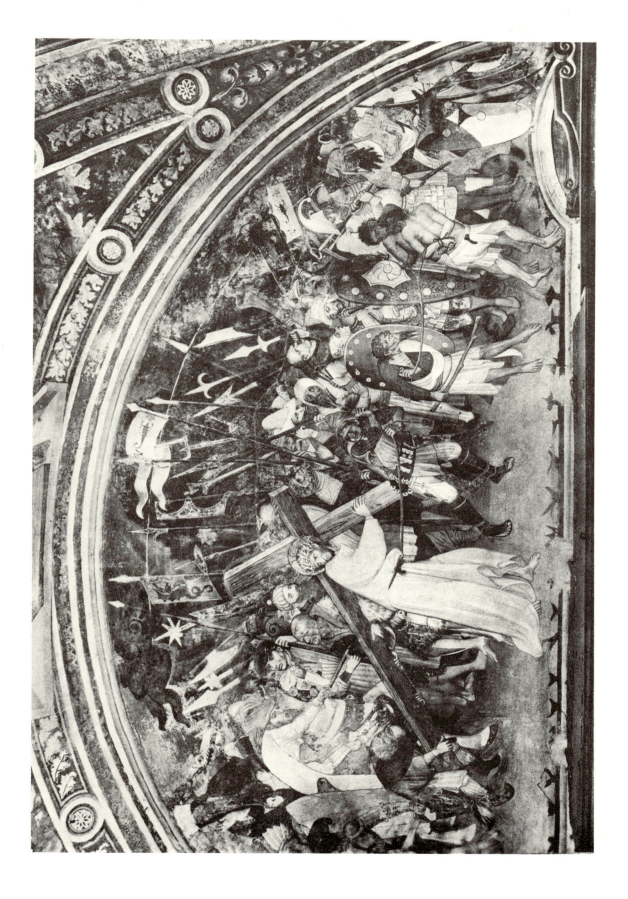

51

UNKNOWN PIEDMONTESE MASTER
Christ carrying the Cross.
BUTTIGLIERA ALTA. CHURCH OF SANT'ANTONIO DI RANVERSO

Photo Ist. It. d'Arti Grafiche, Bergamo

52

MACRINO D'ALBA
Altar-piece.
TURIN. PINACOTECA
Photo Anderson

53

MARTINO SPANZOTTI
Madonna.
TURIN. ACCADEMIA ALBERTINA

54

MARTINO SPANZOTTI
St. Sebastian.
TURIN. PINACOTECA
Photo Pedrini

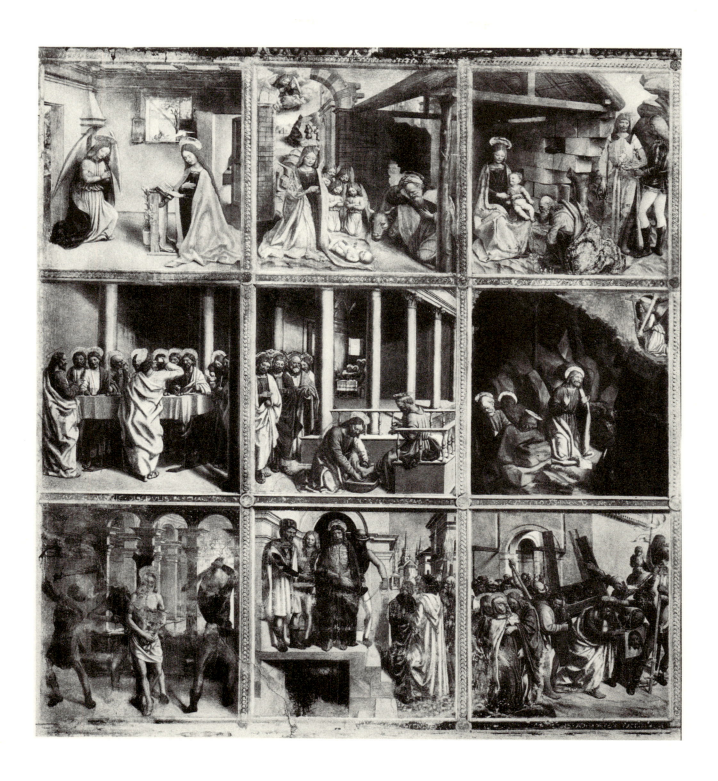

55

MARTINO SPANZOTTI

Scenes from the Life of Christ.

IVREA. FORMER CONVENT OF SAN BERNARDINO

Photo Ist. It. d' Arti Grafiche, Bergamo

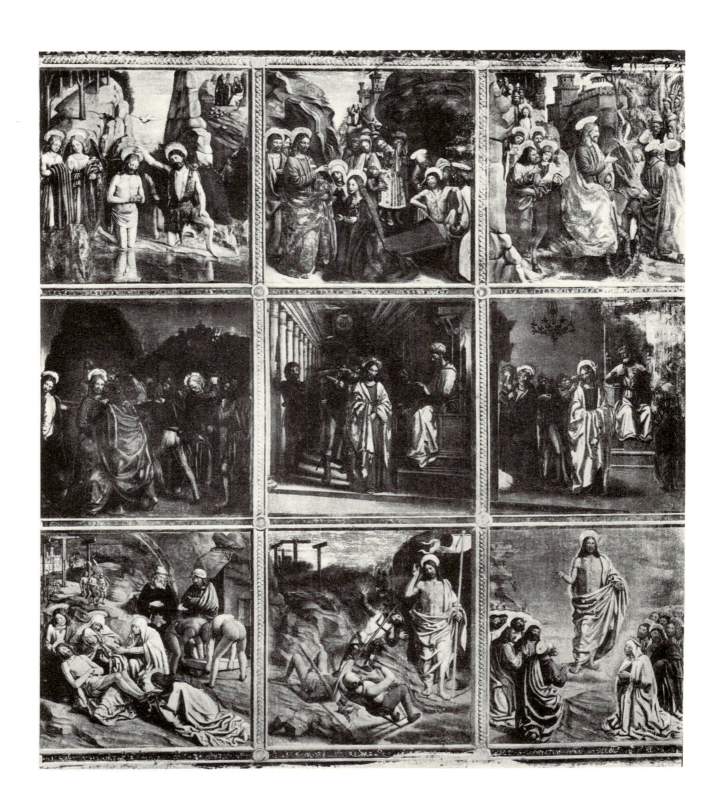

MARTINO SPANZOTTI
Scenes from the Life of Christ.
IVREA. CHURCH OF SAN BERNARDINO
Photo Ist. It. d'Arti Grafiche, Bergamo

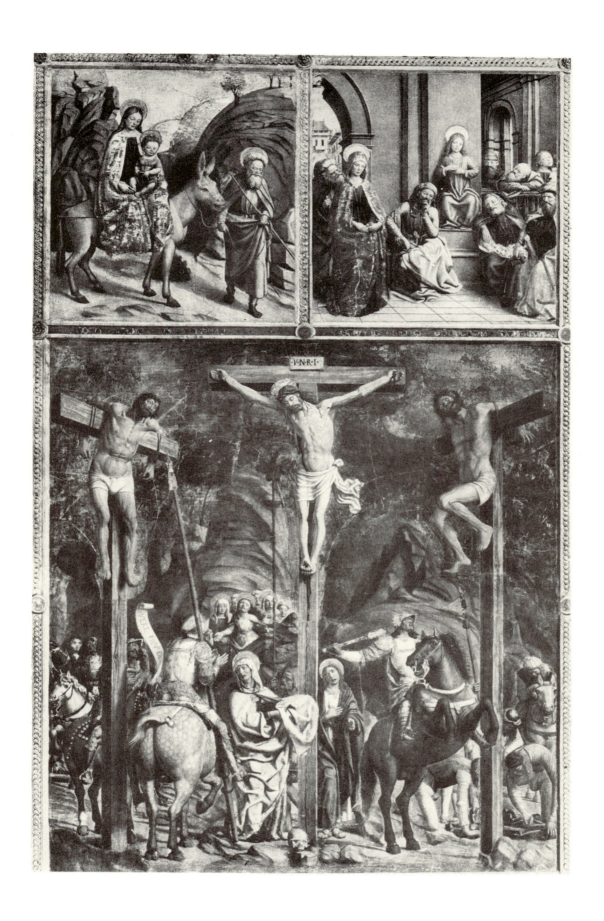

57

MARTINO SPANZOTTI
Scenes from the Life of Christ.
IVREA. CHURCH OF SAN BERNARDINO

Photo Ist. It. d' Arti Grafiche, Bergamo

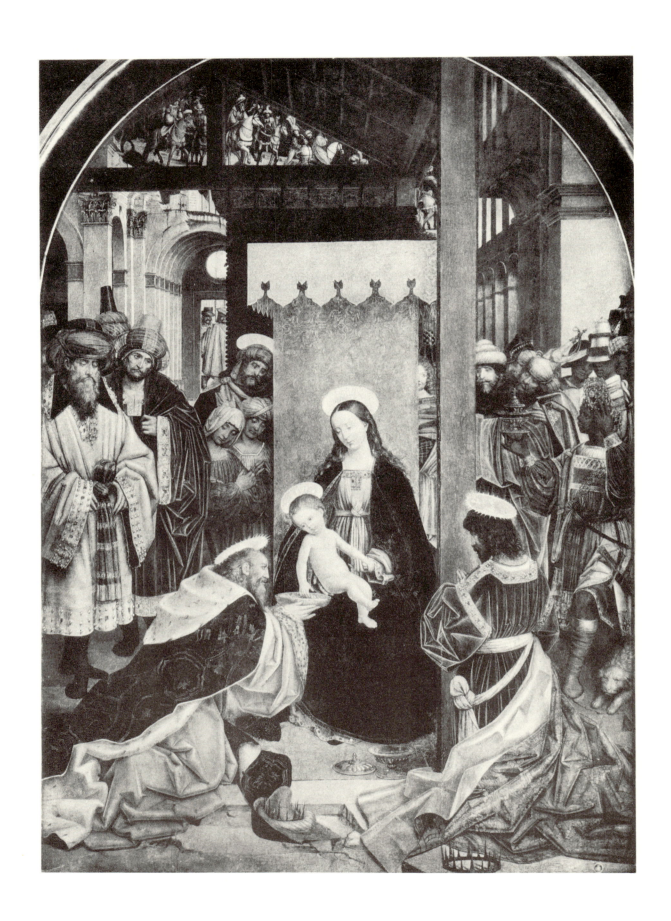

MARTINO SPANZOTTI
The Adoration of the Magi.
ROME. CONTINI COLLECTION

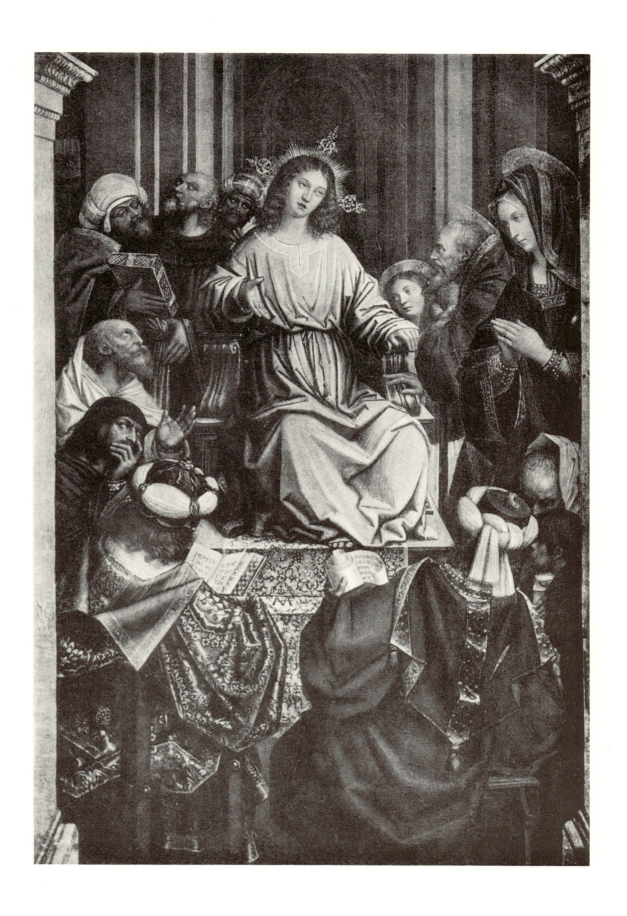

MARTINO SPANZOTTI
Christ disputing with the Doctors.
TURIN. MUSEO CIVICO

60

MARTINO SPANZOTTI
The Baptism of Christ.
TURIN. SACRISTY OF THE CATHEDRAL
Photo Pedrini

61

DEFENDENTE FERRARI
The Nativity.
BERLIN. KAISER FRIEDRICH MUSEUM
Photo Hanfstaengl

62

DEFENDENTE FERRARI
The Nativity.
SUSA. SACRISTY OF THE CATHEDRAL
Photo Ist. It. d' Arti Grafiche, Bergamo

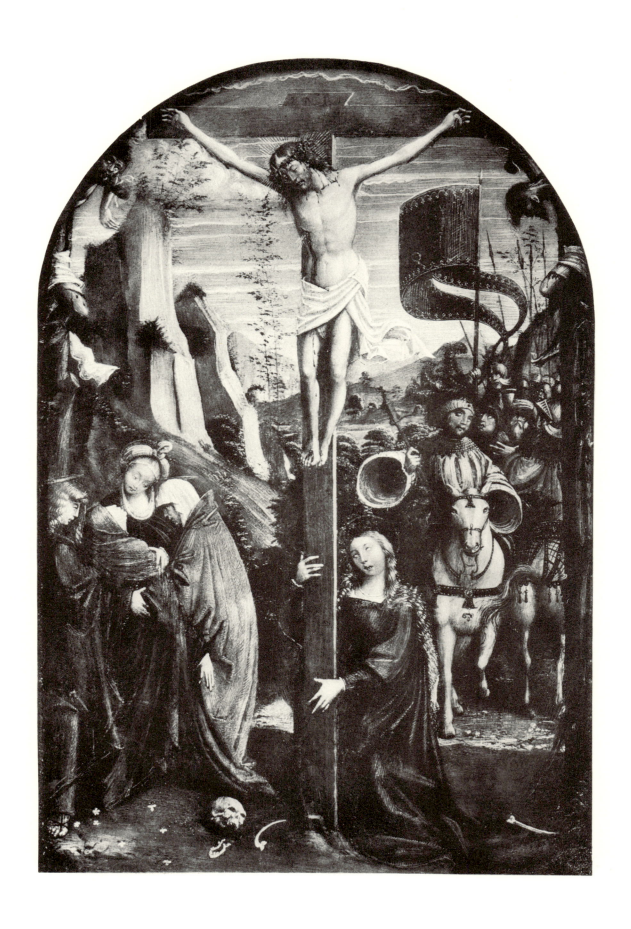

63

DEFENDENTE FERRARI
The Crucifixion.
TURIN. MUSEO CIVICO
Photo Ist. It. d'Arti Grafiche, Bergamo

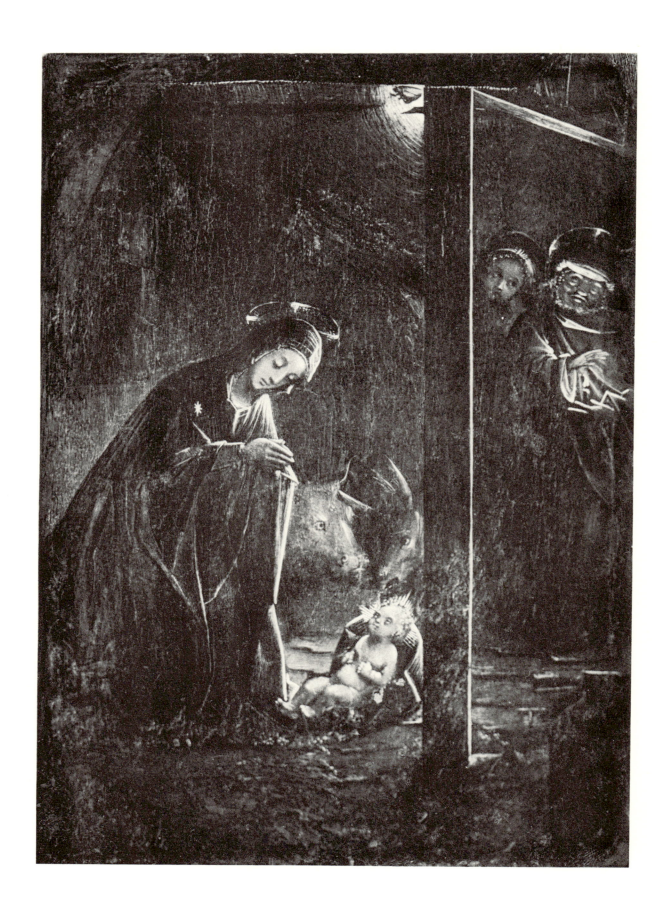

64

DEFENDENTE FERRARI
The Nativity.
TURIN. MUSEO CIVICO
Photo Dall' Armi

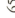

DEFENDENTE FERRARI

A. The Archangel Gabriel.

Photo Alinari

B. Virgin of the Annunciation.

Photo Ist. It. d'Arti Grafiche, Bergamo

TURIN. MUSEO CIVICO

65

DEFENDENTE FERRARI
St. Jerome.
TURIN. MUSEO CIVICO
Photo Dall'Armi

67

GAUDENZIO FERRARI
The Visitation.
TURIN. PINACOTECA
Photo Anderson

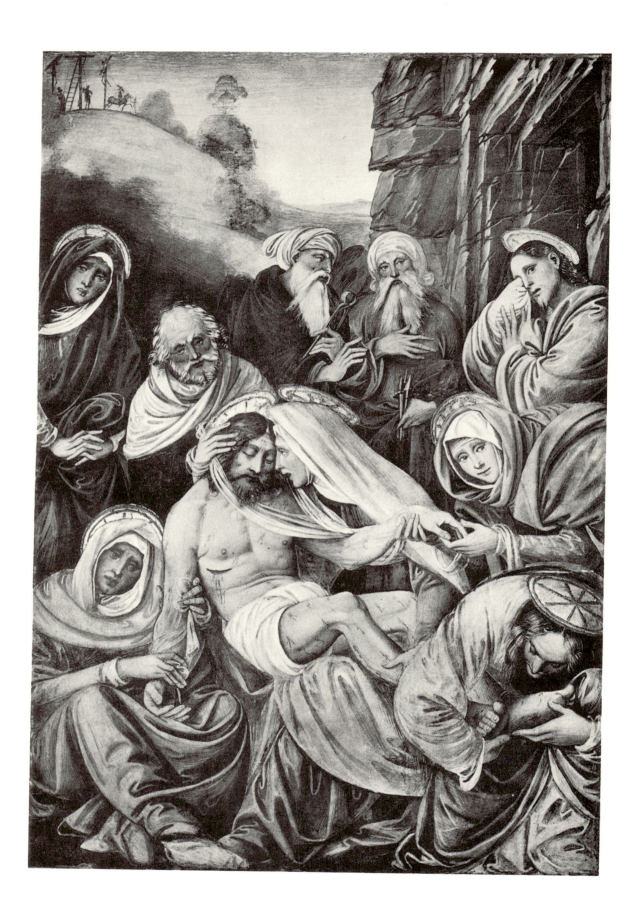

68

GAUDENZIO FERRARI
The Deposition.
Varallo Sesia. Church of Santa Maria delle Grazie

Photo Alinari

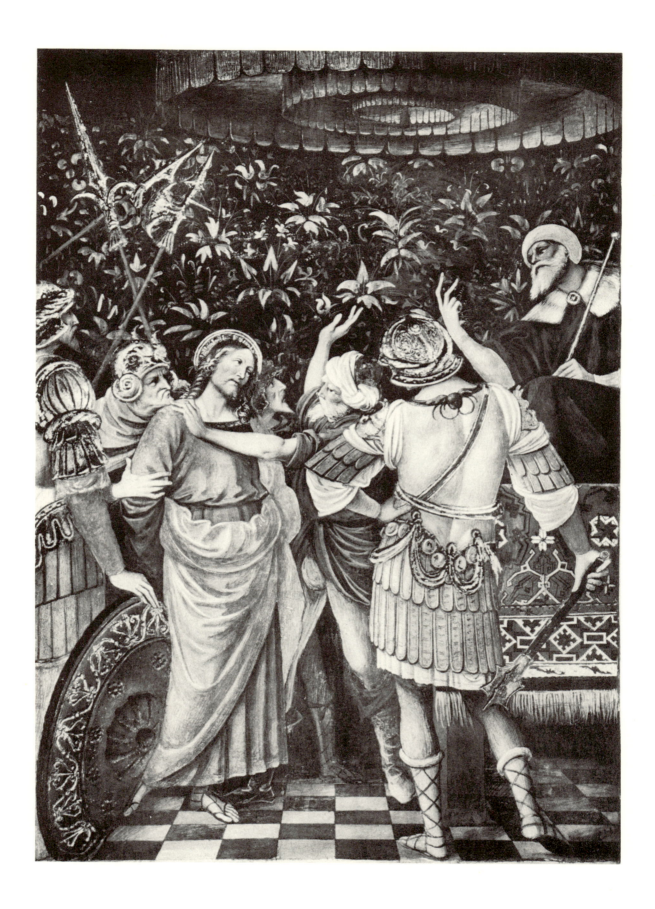

69

GAUDENZIO FERRARI
Christ before Pilate.
VARALLO SESIA. CHURCH OF SANTA MARIA DELLE GRAZIE
Photo Alinari

70

BERNARDO LANINO
The Nativity.
VERCELLI. CHURCH OF SAN CRISTOFORO
Photo Alinari

71

G. A. BAZZI called SODOMA

Fresco.

Monteoliveto Maggiore (Siena). Cloister

72

G. A. BAZZI called SODOMA
Allegory of Charity.
BERLIN. KAISER FRIEDRICH MUSEUM
Photo Kaiser Friedrich Museum

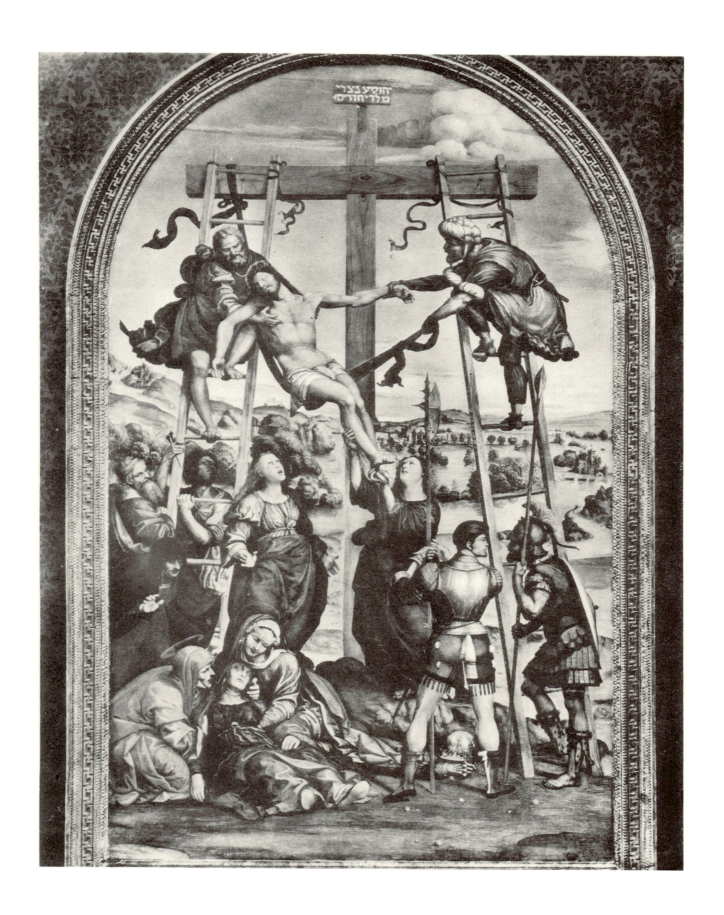

73

G. A. BAZZI called SODOMA
The Deposition.
SIENA. ACCADEMIA DI BELLE ARTI

Photo Anderson

74

G. A. BAZZI called SODOMA
Allegory of Love and Chastity.
PARIS. MUSÉE DU LOUVRE
Photo Archives photographiques d'Art et d'Histoire

75

GIACOMO DURANDI
Altar-piece of St. Margaret.
FRÉJUS. CATHEDRAL

Photo Giletta

76

JEAN MIRAILLET
Altar-piece.
NICE. MONT-DE-PIÉTÉ
Photo Giletta

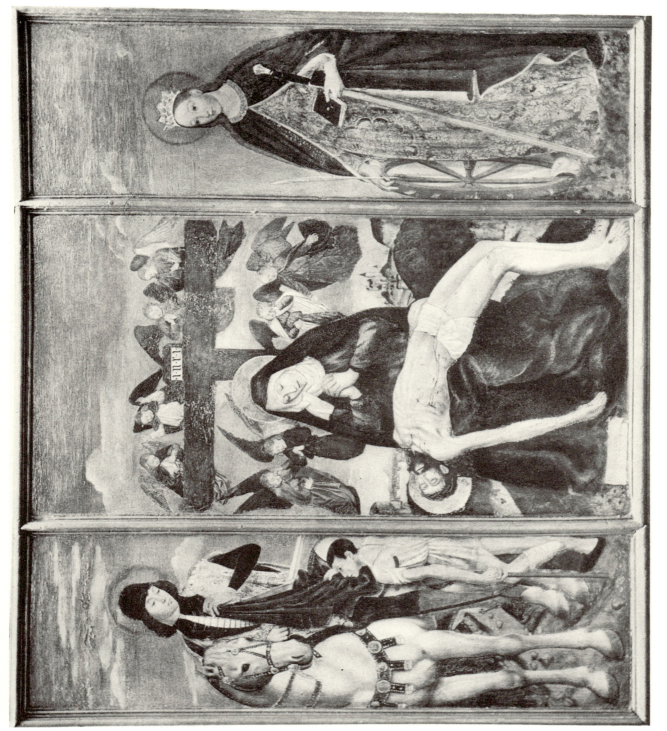

LUDOVICO BREA
Pietà.
CIMIEZ. CHURCH

77

78

LUDOVICO BREA
Altar-piece.
TAGGIA. CHURCH OF SAN DOMENICO

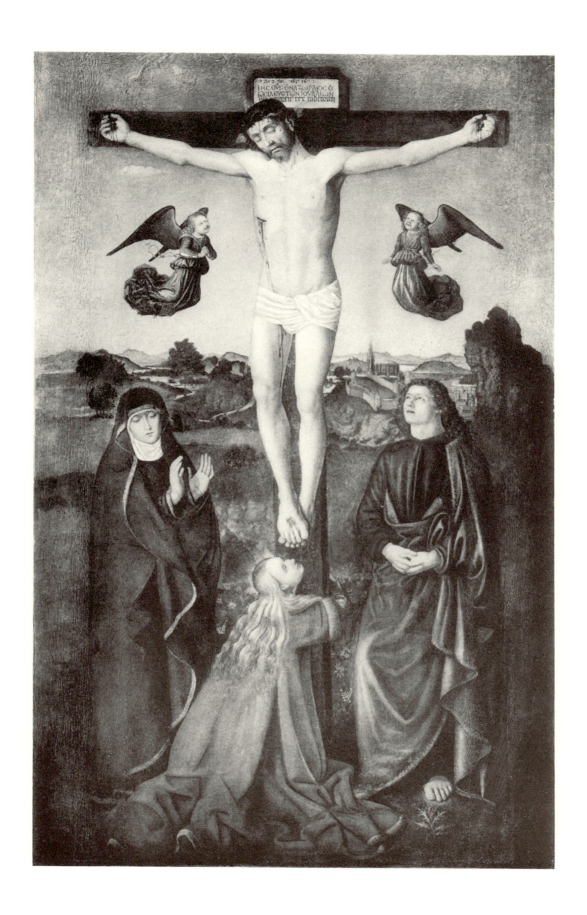

79

LUDOVICO BREA
Christ on the Cross between the Virgin and St. John.
GENOA. PALAZZO BIANCO

Photo Alinari

80

LUDOVICO BREA

Triptych.

SAVONA. CATHEDRAL

Photo Alinari